SWEDISH DESIGN
By Susanne Helgeson and Kent Nyberg

Copyright © Octopus Publishing Group Ltd 2002
Text copyright © Susanne Helgeson

First published by Bokförlaget Prisma,
Sweden, 2000

First published in Great Britain in 2002
by Mitchell Beazley, an imprint of Octopus
Publishing Group Ltd
2–4 Heron Quays, London E14 4JP

Executive Editor: Mark Fletcher
Editor: Emily Asquith
Proofreader: Penny Warren

A CIP catalogue copy of this book is available
from the British Library

ISBN 1 84000 641 2

Set in Bell Gothic and Trade Gothic

To order in the UK please ring
01933 317615 or visit our website at
www.mitchell-beazley.com

SWEDISH DESIGN

**THE BEST IN SWEDISH
DESIGN TODAY**

**SUSANNE HELGESON
KENT NYBERG**

Consider the idea that almost everything around us has been designed. That someone had an idea, made a sketch, tested it and thought about it, made another sketch, made a drawing, and a prototype. Made compromises and corrections and developed it further before finally putting it into production. A creative act by someone who wanted to express and convey a feeling, a function or simply a powerful form. Whose goal was to satisfy his or her – and the universal – ambition to experience the surroundings as aesthetically meaningful, both at home and in public settings.

All design that we encounter in our daily lives concerns us and affects us, whether we want it to or not. Design that, when good, appeals to the eye and heightens our pleasure and well-being – that is to say, our quality of life. Science has even shown that the more beautiful our surroundings are, the better we feel.

Good design also has other important functions. It is an excellent vehicle for competition and for creating a business identity – and in these roles it can lead to increased investment and employment opportunities. It also mirrors contemporary ideals and conditions, thus defining the times we live in. As such, design is one of our most important bearers of culture – one that is constantly further developed at the hands of skilled professionals who have arrived at an idiom uniquely their own.

This book, *Swedish Design*, is an attempt to highlight some of these individuals – who they are, what they do, how they think – to illustrate their, to our way of thinking, superbly well-formulated expressions. Designers who are taking the Swedish design tradition one step further, beyond our borders, and who have secured for Sweden a place

in the limelight of the international design scene for the first time since the 1950s. Who, in doing so, also reinforce the image of the vibrant contemporary culture of our country, along with our successes within the areas of information technology, music, and fashion.

Our point of departure has been the designers of utilitarian objects such as furniture, glass, textiles, and ceramics. We have, however, allowed ourselves to veer occasionally in the direction of art, industrial design, and crafts in order to illustrate the breadth of expression. We are also including producers and other facilitators from the ranks of a new generation of design missionaries, trying to show more clearly how they fit in. Briefly, it is a group that we may be proud of, a group worth knowing better.

Swedish Design is a book about individual expression and design, but it is more than that. It is more than just a thick magazine with a contemporary textual and graphic idiom. In order to give it an exciting rhythm and to show what happens when different kinds of creative artists meet, the designers, objects, and settings have been captured by some of today's most exciting photographers. The result is greater variety and encounters of a more personal nature – brief or long, as the case may be – rather than a factual account divided into traditional chapters. The focus is more on everyday hard work than on glittering art openings, more on feeling and experience than on theory and dry facts. It is, quite simply, a book with an identity completely of its own, whose ambition is to inspire the reader to new and deepened interest in Swedish design.

13 Susanne Helgeson Kent Nyberg

CONTENTS

Will the Future Have Good Taste?
By Ulrika Knutson

Ellen Key was convinced that future generations would have good taste, believing that tomorrow's humans would be superior to those of today in every way – with regard to taste, customs, and intelligence. However, it is not so clear cut. First of all, there is a distinction to be made between taste, customs, and intelligence, which makes the juxtaposition of these qualities suspect in itself. In addition, the very concept of taste is questionable – as anyone who has participated in a debate of quality versus beauty knows.

One reason why it is so difficult to talk about taste is precisely that the ideological superstructure, the moral aspect, is no longer there. This makes it extremely hard to maintain that one cup is more beautiful than another, because what matters is that the coffee is hot and strong!

Taste and fashion are intimately connected. The fashion industry is founded on the notion that nothing is more unattractive than yesterday's fashion. But unattractive no longer means what it once did, the definition of kitsch has changed, and we no longer have to be ashamed of praising yesterday's fashion. Why many still choose to be ashamed of bad or unsure taste is a mystery, for we now know that taste is nothing more than a convenient way for one social class to keep a lower class in check. That this should still be possible is surprising considering that the "moral" argument is no longer a valid weapon.

Taste has been a hotly-debated topic in the field of contemporary art for at least 40 years. Andy Warhol – inspired by Marcel Duchamp – assigned the starring role to a soup can, while Jeff Koons, against the backdrop of the all-accepting 1980s, went one better with his outrageous puppies made from live flowers, and his gigantic china statues of Michael Jackson and Bubbles the chimpanzee.

Swedish artists have also played with the notion of taste. Ernst Billgren produced mosaic foxes and badgers as well as ingratiating oils of deer, dead foxes, knights' armour, and turn-of-the-century fortresses. He worked frenetically, putting a Lapp cap on Mona Sahlin, and a kitchen apron on Olle Ljungström. Of course it's fun – but still nothing but a tiny ripple on the sands of time.

Art, inexorably caught in the claws of time, now thrashes about helplessly. It was a different predicament at the turn of the century, when time had art in a vice-like grip, and refused to let go for almost a hundred years.

Two words: Carl Larsson. Calle and Karin, a fiendishly ideal couple – or perhaps, rather a fiendish couple.

Last year, I – like so many others – made a visit to the Nordic Museum, my heart in my throat, to take a look at the Larssons. Sundborn is terrifying though. At first glance, it seems harmless. Suzanne is watering the geraniums, Pontus is relegated to the corner, little Britta is toddling in the snow with her branched candle and her red Christmas apples. Mother Karin is busy embroidering pillows and finding the perfect spot for her art nouveau washstands and pitchers, while the father is decorating the ceiling.

But lurking behind the depiction of a creative idyll is a philosophy about the utterly designed life that bears the signature of Ellen Key. Nobody reads Ellen Key today – she is forgotten, and an object of ridicule. In 1901, however, she was Sweden's most widely read author, Strindberg and Selma Lagerlöf included. Her polemical book (in favour of modern child-rearing) titled *The Century of the Child* was printed in the millions. It was a pedagogical pamphlet, proposing that from the anti-authoritarian child a new human being would spring.

Ellen Key was the leading ideologue of the aesthetic popular movement. Her ideal was living in an old vicarage "where the furniture has the colour of pearls, the floor is shiny white, and beautiful rag rugs describe little paths on the floor. Where white, home-made curtains allow the sunlight to shine on beautifully tended flower pots, a simple home-made tablecloth covers the table, an old blue and white tiled stove stands in the corner...." This ideal was embodied in her own time by Carl and Karin Larsson's *A Home*, their book about Sundborn. When Key discovered Larsson's watercolours at the 1897 Stockholm Art & Industry Exhibition she was delighted. They illustrated an ideology – a personally created home in light and bright colours, where harmony and sanitation ruled supreme; where everyday life was sacred, and where human beings took precedence over the surroundings. And above all, they showed a home where children dominated the rooms.

Pictures of Sundborn are difficult to take in, for they are almost worn out after a hundred years of being reproduced on postcards, stationery, Christmas plates, calendars, and biscuit tins. In these pictures, the Larsson children are playing the part of the new, free, careless, and natural children, uninhibited by authority, or by psychological and pedagogical oppression. They are shown with one braid carefully tied, the other one coming undone, a top buttoned the wrong way and a stocking sagging. "Christmas Morning"

is a picture full of noise. It is early in the morning, but already a drum is being played, and a tin trumpet is sounding a fanfare for new life. One doubts that the Larsson children were normally allowed to behave like that, when they were not posing for a painting.

Half a *Century of the Child* later, Pippi Longstocking, the child of the century herself enters the stage. She too has one careful braid and one that has come undone, her top buttoned up incorrectly, and a sagging stocking. Her home is messy and full of life, and her kitchen is a family room long before Lena Larsson had coined the expression. Pippi was the first of Astrid Lindgren's many fictitious rebellious children who would conquer the world. They might be considered Ellen Key's surrogate grandchildren. As a young woman, Astrid Lindgren made a pilgrimage from Vimmerby to Strand on the shores of Lake Vättern, where she had arranged a meeting with Ellen Key. Waiting in the parlour, she admired a motto in the ceiling, a quotation from the poet Thomas Thorild: "*This Day – A Life.*" Ellen Key is actually the inspiration for Uncle Melker in *Saltkråkan.*

It is probably true to say that at least once in their lives, everyone goes on a family trip to Ikea. The children are left in a sea of balls, while the adults fill their baskets with furniture that will withstand the abuse of the children, Karin Larsson-style washstands, Carl Larsson napkins and wallpaper with rows of red bows. No one can escape.

Evidently, the National Board of Police, was also inspired. The standard European Union passport, whose inside cover is given over to images specific to each country, has for Sweden, as an emblem of our Swedish vigour and love of nature, Carl Larsson's "Fishing for Crayfish."

The triumvirate of Ellen Key and Karin and Carl Larsson invades the Swedish consciousness. Artists today experience a vice-like grip that these figures from the past still have on our taste and thoughts. Strindberg would have said "to hell with them," as he did a hundred years ago, but he had every reason to be envious of Ellen Key's radicalism.

Key had views on everything from racial purity to marriage, the wasted potential of women, morals, militarism, democracy, popular education, and – interior decoration.

Her pamphlet *Beauty for All* was written in 1897. In it are arguments against the 19th-century home with its antimacassars and beaded fringing, and defenses of the clean lines of white bedroom furniture, of stillness and ghost stories in front of the fire. She makes strict injunctions: "no

cheap knick-knacks, no dusty Turkish divans, no thin floral store-bought tablecloths, no imitation mahogany, no gaudy oleographs in gilt frames, no artificial flower patterned china vases adorning the chest of drawers!"

It becomes confusing as to whether it is the sanitary aspect or the décor that is in question. The *too* designed life – which is no longer just about Swedish liberty, fresh air, and dining room furniture, but about the human state. The dust caches of the nation. Swedish Grace. It has a different ring in recent years after the forced sterilization debate of a few years ago when Sweden once again became the subject of international debate – almost as in Ellen's heyday. But not in a positive way, in fact quite the contrary.

Vitalis Norström was a conservative professor of philosophy, and Ellen Key's foremost critic. In 1902 he fiercely opposed *The Century of the Child*, arguing in favour of punishing children. He disagreed with Key's philosophy of love and her theory of the evolution of a new kind of human being, reaching for the light. As a strict Christian, he considered suffering to be the true fate of Man, rather than happiness, be it individual or collective, and he disapproved both of her ideas on racial purity and interior decoration.

We now accept Bauhaus steel tubing, row houses, collective kitchens, and modernist sculptures. The years 1947 to 1962 were a golden age in Swedish art, architecture, and design. Well-planned suburbs were built, each with a studio in the attic where artists, subsidized by the state, would create the original works of art that would be disseminated widely by the Society for the Promotion of Art. Macaroni cheese was consumed from brown and green ovenware on yellow and grey linen cloths, and the Handicraft Society was given another, perhaps its last, lease of life.

The 1960s came as a breath of fresh air, and the influence of '60s art on design ideals, interior decoration, and taste was enormous. Old hierarchies crumbled to the floor, and Rauschenberg's goat made a meal of the pieces. Ancient authorities probably viewed the young designers as bulls in a china shop. Barbara, the inflatable doll, had her own chair in transparent plastic, and Bertil Vallien spray-painted a ceramic sculpture fire engine red, much like Goldfinger spray-painting the girls in a James Bond film.

The actual target, however, was Good Taste, but this was too daring in 1960, as the concept of taste had already been surpassed by the notion of *quality*. Architect and polemicist Lena Larsson's epoch-making article, "Buy,

Use, Toss," in the design journal *Form*, bravely nudged the notion of *quality of things* closer to *quality of life*.

By now, people's homes have been decorated and furnished. Sigvard Bernadotte's thermos jug is filled, the collection of books, magazines, radio, and TV are crowded together on the *String* shelf system – *furniture with a purpose*. People have what they need, but rising affluence leads to over-consumption – something that was not previously given a great deal of thought. Lena Larsson writes: "An interesting and often overlooked factor is the question of over – and under-consumption – i.e. the fact that today's consumer often prefers so-called dispensable products to the indispensable: you buy a car before you buy a larger home, for example. You buy wall-to-wall carpeting, but a bad mattress. You buy a comfortable sofa before you buy good quality beds. You buy demitasse spoons before you buy cleaning tools. You buy a TV before doing something about the old bathtub."

Lena Larsson's article was not an appeal for disposable things, but a reminder of the winds of change that were already blowing: to the young and affluent, quality meant "security and change" – not durable furniture and bulging linen cupboards for the next generation.

To those who set the tone and to the arbiters of taste she wrote, somewhat cautiously: "It may be a normal psychological fact that a rising material standard initially must speak in domineering tones and is given to loud, maybe even cheap and flashy, expressions. Who asks of a first-grader that he should be able to recite Horace? What is our message to today's consumer? The sofa or the beds? Carpeting or demitasse spoons?"

As late as 1960, a socially conscious democrat like Lena Larsson was able to speak in terms of "flashy" and "cheap." A few years later this would no longer be possible.

I was a teenager in the 1970s when the "project for the millions" was being built, the inner cities were being torn down, the "in" clothes were jeans, platform shoes, and Bogner down jackets. We drank our beer and ate our pizza on brown-stained chairs with green seats in a room decorated in orange wallpaper with flocked medallions – to us, concepts such as *Beauty for All* and *More Beautiful Everyday Things* were a joke. It was not an aesthetically appealing decade, and it was probably no coincidence that the fundamental (and false) argument between form and function was a product of that time.

The 1980s followed with its gelled hair, shoulder pads, and mohair sweaters with butterfly motifs. Then the 1990s arrived and suddenly good taste was not only in evidence, but was mass-produced. You had to look long and hard among the hangers of a high street chain store like H&M to find a vulgar piece of clothing. Everyone wore discreet tones of grey, ranging from smoke to graphite, and ate in stylish restaurants sitting on chairs made of blonde wood, perusing tasteful graphically designed menus.

At Ikea, we find the same blonde bentwood, natural and pared down, in degradable materials that shout CHARM and DISCREET, apart from a few playful designs that compete for our attention.

The middle market, both the mass-produced and the exclusive, has thus breathed new life into good taste, but this time without any moral overtones. Good taste can now be bought, which is an important distinction from the past. Public settings, however, are at the mercy of ugliness. Creating a public setting calls for at least a plan, and planning runs counter to the very heart of both market liberalism and post-modernism. It is a philosophical quandary that perplexes today's architectural theoreticians.

Carl Larsson's copyright expired in 1969. What would he and Ellen Key have had to say about the thousands of biscuit tins with motifs from Sundborn and about the lasting trend of Gustavian sofas and art nouveau garlands that they inspired? Ironically, Ellen Key detested anything that was slavishly beholden to a trend.

A child of her time, she disliked the way our games and folk music had degenerated, deploring the fact that polkas had had to yield to "indecent and ugly modern, Negro, and bordello dances." Aesthetic sense is clearly not absolute nor a construct by Goethe, and designing a new and beautiful world may prove impossible, even in Sweden.

Ellen Key did not think so: "No one believes that beauty is capable of transforming an evil man into a good one, an ignoble man into a noble one, a base man into a high-minded one – nor can it transform the evil, coarseness or baseness that characterize the spirit of a certain age. All of us – creators as well as consumers of art – are indirectly, if not directly, dependent on the spirit of the times."

Ulrika Knutson is cultural editor of MånadsJournalen.

1845
2060

WHY IT LOOKS THE WAY IT DOES (AND LOOKED THE WAY IT DID)

Cultural manifestations of every kind have always reflected the social climate. This is also true of design. What follows is a brief overview of modern Swedish design history by way of introduction.

It began with the motto of the Swedish Society of Crafts and Design: "Swedish crafts breed Swedish independence", followed by Ellen Key and her call for beauty. The importance of Modernism for the Swedish welfare state or "People's Home", the Swedish glassworks' global sucess, and the golden age of industrial design. Then the unforgettable 1955 Helsingborg Exhibition and the Pop trend of the 1960s that preceded the aesthetic crisis of the 1970s. And now we find ourselves creating a commotion and inspiring new confidence, while Jasper Morrison, an Englishman, rediscovers the fundamental values of Swedish design, further strengthening our self-confidence. The journey ends at the end of a century where contemporary Swedish design and its protagonists have every cause for celebration.

NILS MÅNSSON MANDELGREN

JOURNAL FOR THE HOME

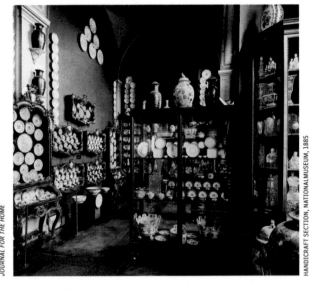

HANDICRAFT SECTION, NATIONALMUSEUM, 1885

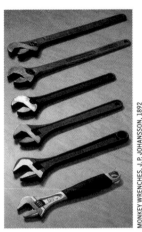

MONKEY WRENCHES, J.P. JOHANSSON, 1892

1845: FOUNDING OF THE SWEDISH SOCIETY OF CRAFTS AND DESIGN

Prior to the abolition of the guild system in 1846 there was widespread concern about the future among Swedish craftsmen. More than the threat of foreign competition they feared that quality would be lost now that "anyone" was free to take up a craft. At the same time, the drive for basic education for the working class gave rise to a comprehensive adult-education system. The Swedish Society of Crafts and Design – whose motto was "Swedish crafts breed Swedish independence" – was founded on the initiative of artist Nils Månsson Mandelgren for the purpose of safeguarding Swedish craftsmanship and supporting the Sunday drafting school for craftsmen that he had started in 1844. This school was eventually to become Konstfack, the University College of Arts, Crafts and Design. The purpose of the society was to promote good design and to work towards improved housing and public spaces. This was to be accomplished through the publication of journals, books, and designs, and by organizing courses, competitions, and exhibitions.

1859: *JOURNAL FOR THE HOME*, DEDICATED TO THE SCANDINAVIAN WOMAN

The first magazine devoted to interior decoration in Sweden, *Journal for the Home* echoed the prevailing interest in the home at the time. The debate conducted within its pages helped lay the foundation for the clean and simple aesthetics that were to be known much later as *Swedish Modern*. In its pages, every conceivable topic was discussed – from giving children the largest and sunniest room to the dangers of colourful wallpaper, which "lends an air of vulgarity to the room."

1872: THE MUSEUM OF ART INDUSTRY

Located in Stockholm, this was Sweden's first design museum, and was founded on the initiative of the Swedish Society of Crafts and Design. London's Victoria & Albert Museum, also the first of its kind, had been founded twenty years earlier, in 1852 as the Museum of Manufacturers. The museum was located at Brunkebergstorg and the collection had been acquired through purchase and donations. Its aim was to educate both consumers and manufacturers about technique, function, and aesthetics, and to improve quality within these areas. Both old and newly produced craft objects were shown. The collection was later transferred to the National Museum of Fine Arts, which opened a section devoted to handicraft in 1885. Its exhibitions and new research have made an important contribution to the field of design.

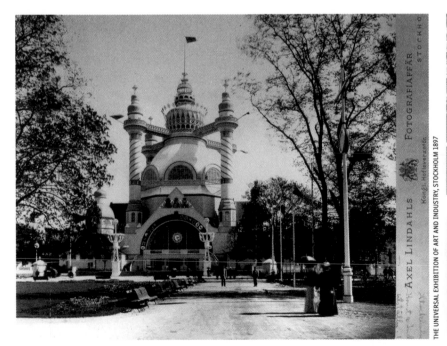

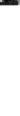

THE UNIVERSAL EXHIBITION OF ART AND INDUSTRY, STOCKHOLM 1897

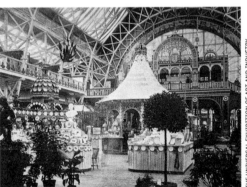

THE UNIVERSAL EXHIBITION OF ART AND INDUSTRY, STOCKHOLM, 1897

FERDINAND BOBERG

BEAUTY FOR ALL, 1899

ELLEN KEY

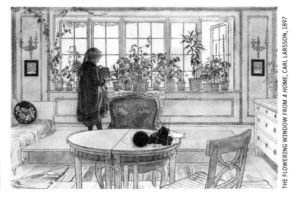

THE FLOWERING WINDOW FROM A HOME, CARL LARSSON, 1897

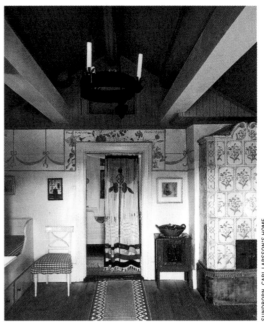

SUNDBORN, CARL LARSSON'S HOME

1897: THE UNIVERSAL EXHIBITION OF ART AND INDUSTRY The Stockholm exhibition included Finland, Denmark, Norway, and Russia. It featured work by, among others, Ferdinand Boberg, who had designed the NK Department Store building, Rosenbad, Thielska Galleriet, and Prince Eugen's Waldemarsudde. The styles represented were mainly historical or inspired by the rural tradition, and the Swedish Society of Crafts and Design observed in its summary a noticeable rift between handicraft and art industry where the craftsmen "often limit themselves to functional form focused on utility, leaving out beauty."

1899: *BEAUTY FOR ALL* This pamphlet was written by author, polemicist, and suffragette Ellen Key to voice her unhappiness with what she considered to be the inferior products at the 1897 Stockholm Exhibition. In it she criticized the lack of refinement in the work she saw, and the evidence of mass-produced goods, seemingly devoid of the input of artistic design. The pamphlet called for the universal right to a beautiful and functional home, and pronounced that art and beauty would produce happier human beings and better citizens. People needed more light, air, and better sanitary conditions, she said, pointing to Carl and Karin Larsson's home in Sundborn as a model. The Swedish Society of Crafts and Design concurred and instituted an employment office in 1914 to help artists find work within the household goods industry – mainly glass, furniture, and china – in order to improve the quality of mass-produced, low-budget design. Key's appeal in this famous pamphlet thus laid the foundation for the modern "clean" Swedish design culture.

1916: THE RÖHSS MUSEUM OF HANDICRAFT IN GOTHENBURG The museum was opened thanks to a generous donation from two brothers, Wilhelm and August Röhss. Its collection was initially limited to older Swedish and European crafts, which eventually were complemented by Japanese and Chinese objects. From the 1920s, the museum began to acquire contemporary crafts and design – which it still does today – now focusing on Scandinavian objects. The Röhss Museum for Allied Art and Design, as it is called today, is still the only museum in Sweden exclusively devoted to design, crafts, and industrial design.

1917: THE HOMES EXHIBITION More precisely, "*The Swedish Society of Crafts and Design Exhibition on Furnishing Small Apartments*", took place at Liljevalchs Konsthall. It showcased the

23

SVENSKA SLÖJDFÖRENINGENS TIDSKRIFT

SWEDISH SOCIETY OF CRAFTS AND DESIGN

NK LOGO, DAVID BLOMBERG, 1902

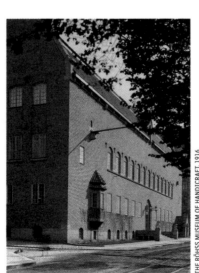

THE RÖHSS MUSEUM OF HANDICRAFT, 1916

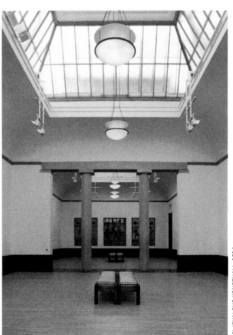

LILJEVALCHS KONSTHALL, 1916

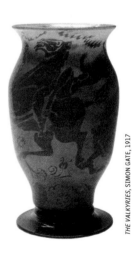

THE VALKYRIES, SIMON GATE, 1917

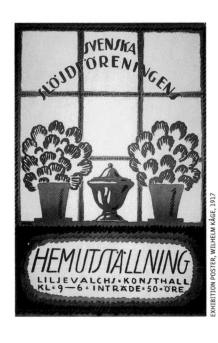

EXHIBITION POSTER, WILHELM KÅGE, 1917

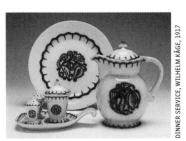

DINNER SERVICE, WILHELM KÅGE, 1917

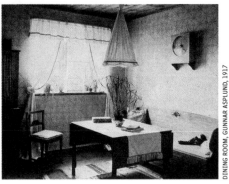

DINING ROOM, GUNNAR ASPLUND, 1917

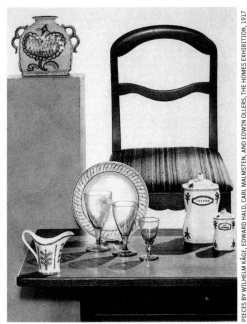

PIECES BY WILHELM KÅGE, EDWARD HALD, CARL MALMSTEN, AND EDWIN OLLERS, THE HOMES EXHIBITION, 1917

results of a competition held the preceding year which was held in order to encourage the manufacture of items of "functional, inexpensive, and tasteful design." The winning entries were put into production, thus linking artists with industry. Many of the exhibiting architects and artists went on to become some of the most celebrated names in Swedish design: Carl Malmsten, Simon Gate, Edward Hald, Gunnar Asplund, and Wilhelm Kåge among them. The exhibition was a great success and is today considered a milestone in Swedish design and in the development of the art of interior design. In its pursuit of purity and simplification it constituted a break with conventional styles.

C. 1919: MODERNISM An international movement associated with art, architecture, and design that developed in Europe during the first decades of the twentieth century. Its philosophy was to create a utilitarian style which mirrored the new democratic ideals and social reforms of the era, a design that broke from tradition and joined the age of the machine. It was also founded on the belief that art and manufacturing should join forces to produce well-designed, mass-produced goods for all social classes. Its key ideals were geometry, simplicity, purity, light, and function.

The German Bauhaus, one of the most important schools for craftsmen and artists, played an important part in the development of Modernism. Its goal was to shape the entire human environment, from the smallest utilitarian object to clothes, art, and architecture, based on the conditions of the new era. It also aimed to erase the borders between art and crafts. The school was founded in 1919 by the architect Walter Gropius, and its inner circle includ-

ed, among others, painters Paul Klee and Wassily Kandinsky, and architects Marcel Breuer and Ludvig Mies van der Rohe, who allegedly coined the expression "Less is More" – that is, finding strength in simplicity. The Bauhaus was dissolved in 1933 partly because of Gestapo restrictions and demands.

Modernism in Sweden arrived with the 1930 Stockholm Exhibition. Known as Functionalism, the movement's foremost representatives were Gunnar Asplund and Bruno Mathsson.

1919: *MORE BEAUTIFUL EVERYDAY GOODS*
This social-aesthetic propaganda pamphlet from the Swedish Society of Crafts and Design was yet another important contribution to the design debate. It was written by art critic Gregor Paulsson, later head of the Society from 1920 to 1934. The pamphlet stressed – as had *Beauty for All* pre-

LE CORBUSIER

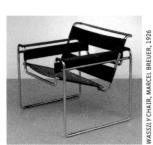

WASSILY CHAIR, MARCEL BREUER, 1926

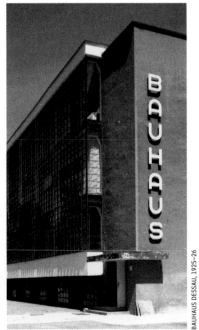

BAUHAUS DESSAU, 1925–26

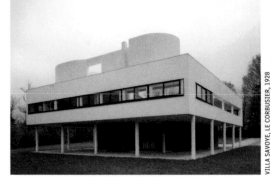

VILLA SAVOYE, LE CORBUSIER, 1928

STAATLICHES BAUHAUS IN WEIMAR 1919-1923

BOOK COVER, HERBERT BAYER, 1923
ABOVE: BAUHAUS LOGO,
OSKAR SCHLEMMER, 1922

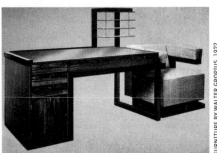

FURNITURE BY WALTER GROPIUS, 1922

VACKRARE
VARDAGSVARA

S.S.F.

SVENSKA SLÖJDFÖRENINGENS
FÖRSTA
PROPAGANDAPUBLIKATION
UTGIVEN TILL SVENSKA MÄSSAN I GÖTEBORG
1919

SⱵS

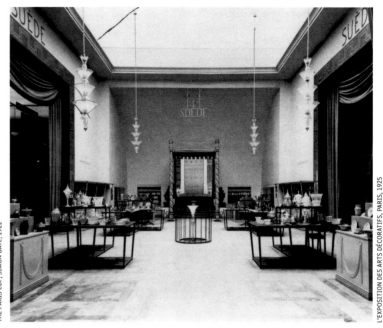

viously – the importance of collaboration between industry and art. Since modern beauty was entirely dependent on the possibilities offered by technology, Paulsson said that the artist must bow to the demands of industry. It was imperative for beauty to go hand in hand with technology and economics in order for exports to grow, while industrial serial production of more beautiful everyday things meant that more people could enjoy them.

The concept of *More Beautiful Everyday Goods* was to influence different areas of Swedish art and industrial production for over half a century.

THE 1920S: SWEDISH GRACE, PARIS, AND NK It was Morton Shand, an English critic and editor of *Architectural Review,* who coined the expression "Swedish Grace" to describe both Swedish architecture and design of the period. It was defined as a delightful, elegant, and graceful style, with its roots in the eighteenth century. This idiom in general, and designers Gate, Hald, and Malmsten in particular, were much admired at the 1925 Paris World Exhibition, which also marked the foreign début of Swedish glassworks. Other examples of this style include Liljevalchs Konsthall, designed by Carl Bergsten, and Louise Adelborg's china service *Swedish Grace*, which is still produced by Rörstrand.

The Nordiska Kompaniet (NK) department store was deeply involved in the Paris World Exhibition. Its founder Josef Sachs, then a board member of the Swedish Society of Crafts and Design, wanted to introduce the general public to both Swedish and international crafts, designers, and artists. Between the 1920s and 1960s, the department store hosted a number of different exhibitions of art, furniture, glass, ceramics, silver, and china by leading designers.

The 1920s also saw the construction of a number of monumental public buildings such as the Stockholm City Hall, the Concert Hall, and the Stockholm City Library – designed by Ragnar Östberg, Ivar Tengbom, and Gunnar Asplund, respectively. The City Hall and the Concert Hall were furnished by NK.

C. 1925: FUNCTIONALISM Like Modernism, Functionalism built on the idea that the design process should utilize the new techniques offered by industrialization. Mass production offered new possibilities for product design. Scandinavia started to experiment with laminated bentwood, while the Bauhaus were turning to the opportunities of bending steel tubing for furniture design. Design-

25

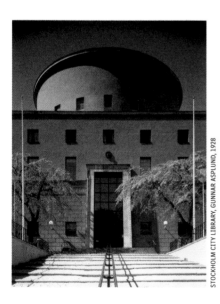

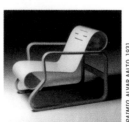

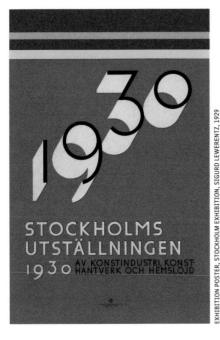

STOCKHOLMS
UTSTÄLLNINGEN
1930 AV KONSTINDUSTRI, KONST
HANTVERK OCH HEMSLÖJD

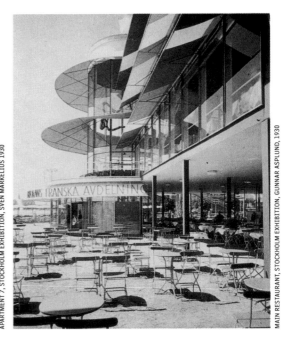

ers took function and material as the point of departure, and Sullivan's "*Form Follows Function*" was commonly accepted. Furniture was small and light, with straight lines, and everyday utilitarian objects were almost totally devoid of decoration. Mass production for the collective had replaced handicraft production for the individual.

The vision of Per Albin Hansson (Sweden's Prime Minister from 1932 to 1936 and 1939 to 1946) called for the "People's Home" – a Social Democrat metaphor for an all-inclusive, caring society – to be built in pure Functionalist style – and, to a large extent, this is what happened. In 1922, SIS, the Swedish Standardization Agency, was founded to oversee housing and to ensure satisfactory minimum living standards. As well as being a design style, Functionalism was also a comprehensive social programme that included a new approach toward living and city planning. Architect Sven Markelius designed one of Sweden's most famous Functionalist icons at 6, John Ericssongatan in Stockholm – Alva Myrdal's concept of a building for collective living, designed to create a better human being.

1930: THE STOCKHOLM EXHIBITION By 1930, Swedish crafts had reached their peak, both technically and artistically, and, since the 1925 Paris Exhibition, had international recognition. The Swedish Society of Crafts and Design now wanted the Swedish public to see how these products were designed according to Functionalist principles in a modern industrial society. The Stockholm Exhibition, with Gunnar Asplund as its chief architect, was internationally important as a showcase for recent Swedish architecture and design. It included mass-produced furniture designed to be both inviting and comfortable, as well as a large number of affordable Functionalist homes for modern urban living. Four million visitors came to look at the exhibition. Not included among them ,however, was Carl Malmsten, who was unable to come to terms with the new Functionalist ideals.

Two of Scandinavia's leading designers had their breakthrough in the early 1930s. Alvar Aalto, one of the world's most influential modern architects, and Bruno Mathsson, introduced their bentwood furniture at this time.

1937: THE PARIS WORLD EXHIBITION, SWEDISH MODERN, AND THE NK TEXTILE STUDIO Among those participating at the Paris World Exhibition were several leading figures of the period, including Simon Gate, Edward Hald, Wilhelm Kåge, Astrid Sampe, Bruno Mathsson, Carl

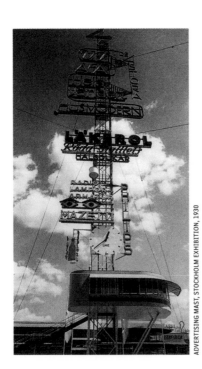

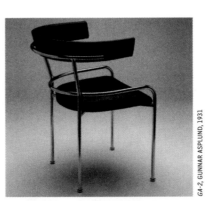

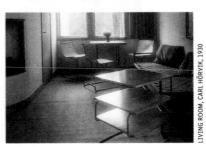

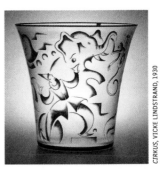

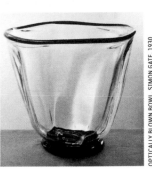

SIMON GATE

EDWARD HALD

ASTRID SAMPE

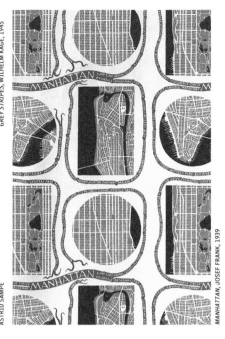

GREY STRIPES, WILHELM KÅGE, 1945

MANHATTAN, JOSEF FRANK, 1939

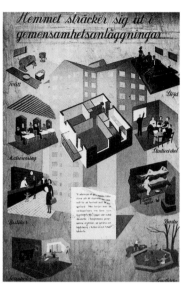

HOUSING POSTER, 1945

Malmsten, and Josef Frank. Their design was gathered under the umbrella term "Swedish Modern," an expression coined by British and American journalists. The keywords were lightness, blonde colours, clean lines, and sparing décor. It was Swedish Modernism but it had its roots in the country's traditions, including Carl and Karin Larsson's Sundborn. Simplicity and humanism, were important elements of what was an informal, comfortable and inviting style, for everyday use as well as for festive occasions.

When the NK Textile Studio was opened in 1937 with textile artist Astrid Sampe as its director, Swedish design history was made. She not only introduced new techniques, but invited artists, architects, and graphic designers to produce new patterns. They included Olle Baertling, Stellan Mörner, Arne Jacobsen, Alvar Aalto, Sven

Markelius, Anders Beckman, Olle Eksell, and the inimitable Viola Gråsten. When Sampe retired in 1971 the Textile Studio unfortunately closed down.

1939: THE NEW YORK WORLD'S FAIR Sweden participated in the Fair under the motto "Swedish Modern – A Movement towards Sanity in Design." The participants included Josef Frank, regarded by the critics as one of the leading representatives of the modern Swedish style that was so widely admired by the New York public. Swedish industry was quick to take advantage.

1940S: FOCUS ON INDUSTRIAL DESIGN AND HOUSING. The label "Swedish Modern" endured throughout the decade and awareness of the importance of design began to spread to other areas. Manufacturing businesses such as Elec-

trolux, Husqvarna, and Saab capitalized on the importance of design as an effective means of competition. The most famous of Sweden's early industrial designers included Sixten Sason and Sigvard Bernadotte, "the Silver Prince".

Much attention was devoted to the question of housing at this time. Traditionally, homes had not been very spacious. A third of the population lived in over-crowded conditions, and Sweden was next to last in Europe in regard to per capita living space. A new type of development now saw the light of day: buildings up to seven stories high built around a public place which incorporated services such as a post office, bank, shops, and cinemas.

Foreign architects, who had been influenced by Sweden's pioneering buildings in the 1930s, continued their pilgrimage to what had become the stronghold of Functionalism.

27

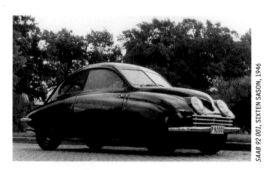

SAAB 92 001, SIXTEN SASON, 1946

BRUNO MATHSSON

BERNDT FRIBERG, STIG LINDBERG AND WILHELM KÅGE, GUSTAVSBERG, 1945

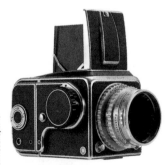

HASSELBLAD 1600 F, SIXTEN SASON, 1949

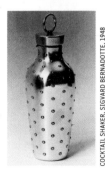

COCKTAIL SHAKER, SIGVARD BERNADOTTE, 1948

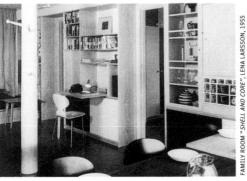

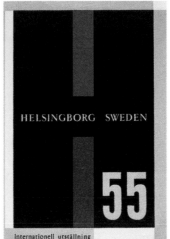

HELSINGBORG SWEDEN

55

Internationell utställning
av bostäder, konstindustri,
inredningar och formgivning
10/6 – 28/8 1955

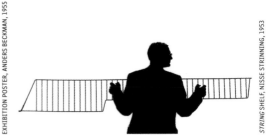

In 1947 NK opened a completely new department called *NK-Bo* (NK Living). It had a more modern feel and was headed by architect Lena Larsson whose radical ideas changed accepted views on the subject of interior design.

NK's radical and successful experiment lasted from 1947 to 1956, and from 1961 to 1964.

1950S: SCANDINAVIAN DESIGN AND H55

The expression "Scandinavian Design" was coined in the 1950s when Nordic design exerted a strong influence on design elsewhere. It was characterized by functional, elegant, and sober everyday necessities that everybody could afford. The world perceived it as a symbol of Sweden's democratic welfare society. The Swedish standard of living in the 1950s was the highest in the world. Leading designers included Astrid Sampe, Stig Lindberg, Nils Strinning, Ingeborg Lundin, Signe Persson-Melin, and Karin Björquist. A reaction against the blonde elegance was setting in within certain design circles. It took the form of strong colours and free, expressive forms, which came as a foretaste of the 1960s. Herta Hillfon and Erik Höglund were among its proponents.

"H55", or rather, the 1955 Helsingborg Exhibition, summed up half a century's worth of ideas on the subject of better everyday living, and also hinted at living trends yet to come. The exhibition, which reflected the overly optimistic view of the period, attracted 1.2 million visitors, all eager for new and modern design. It was from H55 that the first TV transmissions in Sweden were broadcast, and regular television began the following year. This development was to exert a strong influence on people's homes: the "parlour" – formerly off-limits to children – was suddenly turned into a TV room where the whole family could share in the events of the world. This called for a completely new arrangement, and it was at this time that Lena Larsson promoted the "family room" and conducted courses in modern living, teaching people to use "the entire home for the entire family." The first Ikea store opened its doors in 1958.

1960S: POP FASHION AND RADICALISM. The

homogenous view of what constituted good taste in the 1950s now began to break down and suddenly anything became acceptable. Pop, plastic, strident colours, inflatable furniture, and eye-catching patterns were all typical of the era. Fibreboard was the perfect "use-and-dispose" material – an expression coined by Lena Larsson in an attempt to persuade the Swedes to free themselves from the

28

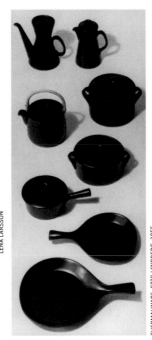

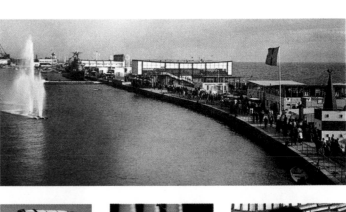

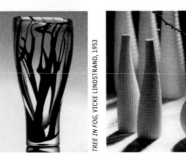

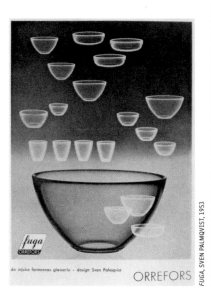

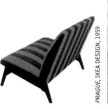

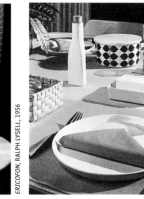

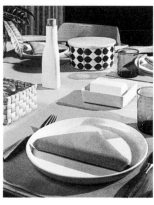

FUGA, SVEN PALMQVIST, 1953

PERSSON'S SPICE CUPBOARD, ASTRID SAMPE, 1955

PRAGUE, IKEA DESIGN, 1959

IKEA, ÄLMHULT, 1958

ERICOFON, RALPH LYSELL, 1956

SET TABLE, STIG LINDBERG, 1960

tyranny of conventional, heavy objects. Today we still live with the free and easy view of life that permitted all aspects of life during the 1960s. The suburban developments of the Housing for the Millions Project called for new furnishings, and Ikea offered suitable and inexpensive solutions.

The leading designers of the time included architects Börge Lindau and Bo Lindekrantz, and textile designers Inez Svensson, Gunilla Axén, and Birgitta Hahn. Bertil Vallien and Göran Wärff were some of the names among the new generation of glass artists.

In 1964, the Swedish Society of Crafts and Design opened the Form/Design Center in Malmö whose lively exhibition and lecture programme is still in operation today.

During the political revolt of 1968 the ideals of Functionalism came under fire and aesthetics

became a bad word, to be replaced with the new buzz words ergonomics and environment.

1970S: CRISIS AND COLLECTIVE. The design of the 1970s reflected the prevailing political climate of social commitment.

The oil crisis meant that industry decided to focus on technology rather than on design, and, as a consequence, artists and designers suddenly found themselves without work. A number of designers' collectives were formed to help them weather the crisis and to protest against the standardization of industry. One of these collectives was the colourful "Group of Ten" (*Tio-gruppen*), which is still in existence today. Jan Dranger and Johan Huldt were a somewhat smaller, but highly productive collective within furniture design. Their successful business, Innovator, achieved enormous

success abroad – especially in Japan.

Ergonomic design was seen by some as a concept of political correctness. In the 1970s, design for people with special needs became the great Swedish – and international – design success. A&E Design and Ergonomi Design Gruppen still produce aesthetically and functionally superior products for people with special needs.

In 1976 the Swedish Society of Crafts and Design changed its Swedish name to Svensk Form.

KF, the Swedish Consumer Co-op Association, introduced its line of blue-and-white basics in 1979.

1980S: *CONCRETE* AND POST-MODERNISM
In 1981 Jonas Bohlin's concrete chair *Concrete* was launched in Sweden. It inhabited a grey zone somewhere between furniture and sculpture, demonstrating that functional demands could be

29

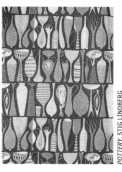

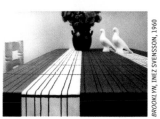

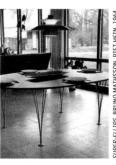

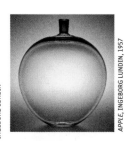

SIGURD PERSSON

POTTERY, STIG LINDBERG

BROOKLYN, INEZ SVENSSON, 1960

AIRFIELD, ASTRID SAMPE, 1955

SUPER-ELLIPS, BRUNO MATHSSON, PIET HEIN, 1964

BERTIL VALLIEN

INGEBORG LUNDIN

APPLE, INGEBORG LUNDIN, 1957

"HOUSING FOR THE MILLIONS", FARSTA, 1966

SIGVARD BERNADOTTE

INEZ SVENSSON

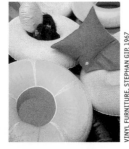

VINYL FURNITURE, STEPHAN GIP, 1967

REVOLUTION MEANS REVOLUTIONARY CONSCIOUSNESS, STURE JOHANNESSON, 1968

BO LINDEKRANTZ AND BÖRGE LINDAU

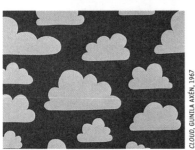

CLOUD, GUNILA AXÉN, 1967

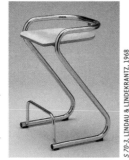

S 70-3, LINDAU & LINDEKRANTZ, 1968

POP GLASSES, GUNNAR CYRÉN, 1967

made to yield to artistic expression. Many industrial designers and architects were disgruntled, because as they saw it, *Concrete* was not a chair. This reaction was hardly surprising in view of the Furniture Institute's design ideals, based on "optimal measurements for optimal function," that had been established and followed since 1967. Swedish standardization now had to take a back seat as Jonas Bohlin's new attitude toward design encouraged others to experiment.

Sven Lundh, a furniture manufacturer from Källemo with an eye for unbridled creativity, made 100 numbered copies of Bohlin's concrete chair. The original price was 2,000 crowns, but by the spring of 1999 it commanded a sum of 170,000 crowns at auction.

Källemo also manufactured the work of Mats Theselius, who, like Bohlin, made objects that were in the grey zone between furniture and art.

In 1983 *Svenska Dagbladet* wrote: "Post-Modernism has arrived. Architects want to design houses that are fun. They want to re-establish architecture as an art form, using irony and playfulness. They are protesting against the failure of Functionalism and its strict rules of form."

Swedish designers were also influenced by foreign trends, especially by the Memphis Group, headed by the Italian architect and designer Ettore Sottsass who espoused the Post-Modernist banner. With its sharp colours and vivid patterns and shapes Post-Modernism was a clear revolt against the mass produced, utilitarian products of Modernism and Functionalism. An individual form of expression was now set to take on function adapted for everybody. Anything was allowed: exclusiveness, provocation, humour, as well as combinations of materials such as concrete, iron, glass, and exotic woods. Furniture was art.

With large amounts of disposable income in consumers' pockets, an increasing number of companies went in search of young talent in order to utilize new experimental design as a selling point. However towards the end of the decade, the market for expensive designer furniture began to fail.

1990S: NEO-MODERNISM; SIMPLICITY RULES
Blonde simplicity dominated during this decade, even though variety and expressive contrasts still remained under the surface. Designers looked to the past and re-labelled the reconstituted design from the 1930s, 1940s, 1950s and 1960s with names such as Retro and Neo-Modernist. A new set of young designers now appeared within the conservative furniture business, among them

VILLA SPIES, STAFFAN BERGLUND, 1969

THE FIRST COLLECTION OF THE GROUP OF TEN, 1972

THE GROUP OF TEN

TUBE, ANDERS PEHRSON, 1972

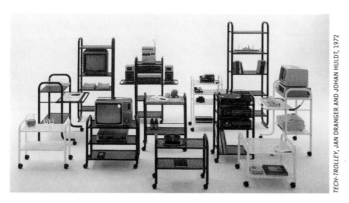

TECH-TROLLEY, JAN DRANGER AND JOHAN HULDT, 1972

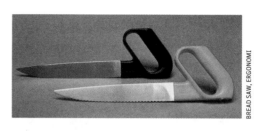

BREAD SAW, ERGONOMI DESIGN GRUPPEN, 1973

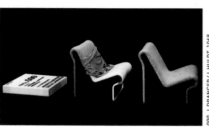

099, J. DRANGER/J. HULDT, 1968

TOM AHLSTRÖM AND HANS EHRICH (A&E)

JORDAN 1230, A&E DESIGN, 1974

BLUE AND WHITE BASIC PRODUCTS, KF, 1979

Stefan Ytterborn whose collection in Milan 1992 seemed to provide the answer to the question of what was to follow the 1980s. In 1994 he founded Swecode (Swedish Contemporary Design), a group of young producers who attracted much attention at trade fairs and exhibitions, including those held in Milan and Cologne. For the first time in a long while, the world suddenly took notice of Swedish design, and several Swedish designers started to work with leading producers abroad.

This is how Ytterborn explains the Swedish success: "We had both the background and the credibility for the values that were in demand. We offered quality and expression that would last, as well as environmental concern, for example using birch, beech, and maple rather than exotic woods from the rainforest. We were skilled, well-educated communicators, in touch with the contemporary

international scene, and we worked with foreign designers, thus widening our circle of contacts. Interest in design was in the air, both at home and abroad, and we marketed ourselves in a fresh, relaxed, and different way by introducing other means of cultural expression such as music, fashion, and food."

During the 1990s the Swedish design schools were flooded with applicants inspired by the successes of Thomas Sandell, Jonas Bohlin, Mats Theselius, and Claesson Koivisto Rune, among others. New design journals came on the market, and businesses focusing exclusively on Swedish contemporary design sprang up in large cities and small towns alike. The auction houses joined the trend, with auctions featuring Swedish and international design from the 1950s to the 1990s, which attracted a new, young and affluent audience.

Ikea, too, contributed to the new wave of design with its "PS" collection, which featured basic modern products for the home.

A FOCUS ON THE 1990S AND THE DESIGNERS OF THE NEW GENERATION.

1990: The Asplund furniture gallery opened, featuring a mixture of Swedish art, furniture, and rugs, and it rapidly attracted a young, design-minded audience.

1991: Klara interior design store opened its doors, showing the very best in young, contemporary design for the home. The founders were Jonas Andersson, Klara Tengbom, Christian Springfeldt, and Stefan Ytterborn. The latter had already staged a lively exhibition in 1987 in order to provide a meeting place for Swedish and for-

31

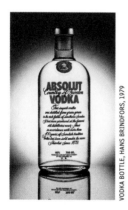

VODKA BOTTLE, HANS BRINDFORS, 1979

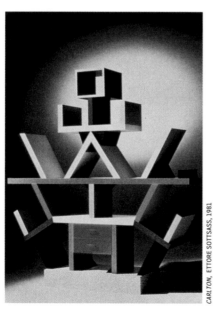

CARLTON, ETTORE SOTTSASS, 1981

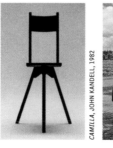

CAMILLA, JOHN KANDELL, 1982

SVEN LUNDH / CONCRETE / JONAS BOHLIN 1983

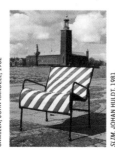

SLIM, JOHAN HULDT, 1981

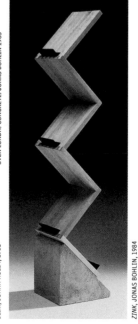

ZINK, JONAS BOHLIN, 1984

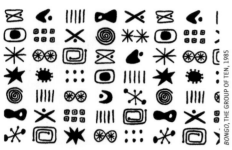

BONGO, THE GROUP OF TEN, 1985

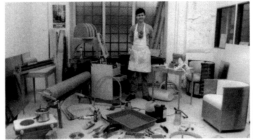

MATS THESELIUS

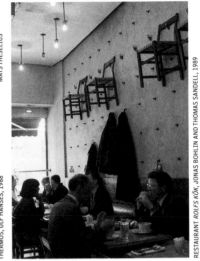

RESTAURANT ROLFS KÖK, JONAS BOHLIN AND THOMAS SANDELL, 1989

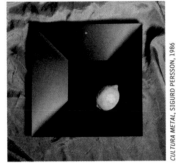

CULTURA METAL, SIGURD PERSSON, 1986

CITY LIBRARY, BIRGITTA HAHN, 1988

THERMOS, ULF HANSES, 1988

eign designers. Between 1987 and 1995 Ytterborn introduced the public to such international notables as Jasper Morrison, Matthew Hilton, Marc Newson, Konstantin Grcic, Ross Lovegrove, James Irvine, and Alberto Meda. In this way, new friendships, international contacts, and collaboration were developed.

Jasper Morrison's idiom, which shared many of its fundamental values with Sweden's design tradition was given the epithet *Scandinavian Modern*, and had its international breakthrough around the turn of the decade. By "rediscovering" and making these Scandinavian connections more widely known – inevitably with his own inimitable twist – Morrison inspired new confidence among Swedish designers.

• The "Element" group introduced the first of three collections of everyday objects in the spirit of the new 1990s simplicity. The initiative came from graphic and textile designer Tom Hedqvist and architect Thomas Sandell who invited Pia Wallén, Jonas Bohlin, Ann Wåhlström, and Pia Törnell, among others to participate. The emphasis was on simplicity, humour, pleasure, and function. Many products from this collection became icons of Swedish 1990s design, including Törnell's candlestick *Arcus*, Sandell's *Wedding Stool* and Wallén's blanket *Crux*. During the 1990s, many Swedish businesses began to adopt the idea of collections created by a number of well-known designers.

• Mats Theselius introduced *Hermit's Hut* at the Stockholm Furniture Fair, a collection that demonstrated what he considered to be the bare essentials of human life. It was an unambiguous statement at a time that simultaneously saw a growing need for solitude and reflection, and a galloping rate of production and consumption.

1992: Stefan Ytterborn's manufacturing enterprise "cbi" exhibited the works of twelve young designers at the Milan fair. "The response was incredible. Everyone acted as if we had come up with the answer to an as yet unformulated question as to what was to come after the 1980s."

• *Stockholm New* was launched. The magazine became the most elegant exponent of new trends within Swedish design. Thanks to its founders, Christina Sollenberg Britton and Claes Britton, articles on Swedish fashion, design, architecture, lifestyle, film, and music found an audience abroad. Their goal was to secure a place for Sweden and Stockholm on the international design scene.

32

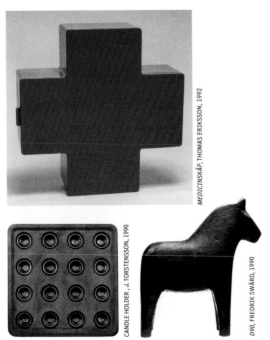

MEDICINSKÅP, THOMAS ERIKSSON, 1992

CANDLE HOLDER, J. TORSTENSSON, 1990

D90, FREDRIK SWÄRD, 1990

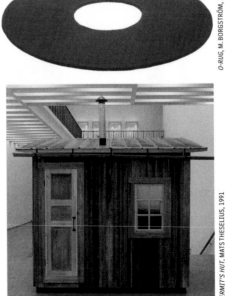

HERMIT'S HUT, MATS THESELIUS, 1991

O-RUG, M. BORGSTRÖM, 1990

FIRST "ELEMENT" COLLECTION, 1991
BELOW: "ELEMENT" LOGO, BJÖRN KUSOFFSKY, 1991

LOVE ARBÉN

CRUX, PIA WALLÉN, 1991

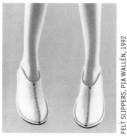

FELT SLIPPERS, PIA WALLÉN, 1992

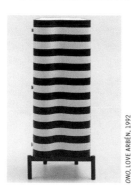

ONO, LOVE ARBÉN, 1992

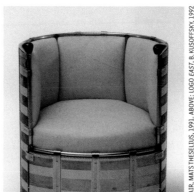

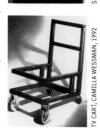

MOOSESKIN ARMCHAIR, MATS THESELIUS, 1991. ABOVE: LOGO EAST, B. KUSOFFSKY, 1992

STEFAN YTTERBORN

TV CART, CAMILLA WESSMAN, 1992

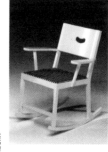

ÄNGEL, THOMAS SANDELL, 1994

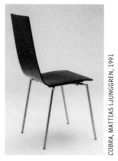

COBRA, MATTIAS LJUNGGREN, 1991

• Some twenty young, international designers were invited to contribute to *Progetto Ogetto*, the prestigious Italian manufacturer Cappellini's line of everyday objects. Four Swedes were represented in the international line up, they were Pia Wallén, Ann Wåhlström, Thomas Eriksson, and Thomas Sandell.

1993: Perceiving a need for young Swedish designers, Jonas Bohlin and Thomas Sandell proposed a new course of study devoted to design for Beckman's School of Design. The goal of the three-year course was to develop the creativity and design style of the individual while maintaining close contacts with the business world. The prestigious faculty and guest lecturers included nationally and internationally prominent figures. In addition the general public was invited to further their interest through an ambitious series of seminars on design.

• "Futurniture", a company working with design-driven communication, staged a major design exhibition at Galleri Glas in Stockholm. In the course of two months, six different exhibitions featured around 100 new creative talents. It was contemporary, fun – and much needed. The idea was subsequently exported to Paris under the name *Jeune Création Suédoise*, attracting widespread attention.
• DesignTorget opens, providing an outlet for many less established designers in a prime location in the heart of Stockholm.

1994: Swecode was founded by a group of designers including Asplund, cbi, Box Design, David design, and Forminord. The initiative came from Stefan Ytterborn, and the stated purpose was "to create a niche for Sweden as a credible origin of

contemporary design in the international context." The first joint event staged was at the 1995 Cologne furniture fair.
• Björn Dahlström rented a van and a booth at the Milan furniture fair, where his arm chair *BD:1* created a sensation with the audience and the media.
• David Carlsson, head of David design in Malmö since 1988, introduced his first new designers' collection which included work by Olof Kolte, Jonas Lindvall, and Helene Tiedemann.
• Lammhult launched Gunilla Allard's *Cinema* line, which provoked an extremely rare international media response.

1995: Ikea launched its first "PS" collection in Milan. The project was created and led by Thomas Eriksson, Thomas Sandell, and Stefan Ytterborn. The collection consisted of around forty products

33

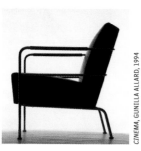

CINEMA, GUNILLA ALLARD, 1994

STOCKHOLM II, A&E DESIGN, 1995

VILLA WABI, CLAESSON KOIVISTO RUNE, 1994

IKEA PS

PARTS OF IKEA'S FIRST PS COLLECTION, 1995. LOGO-TYPE, BJÖRN KUSOFFSKY

THOMAS ERIKSSON

THOMAS SANDELL

PIA WALLÉN

MIKAEL VARHELYI

GUNNEL SAHLIN

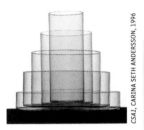

STOCKHOLM
NEW No.4

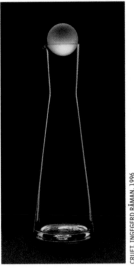

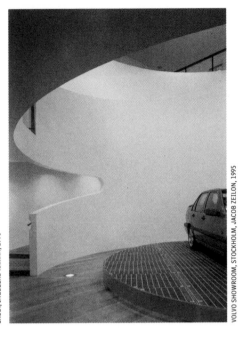

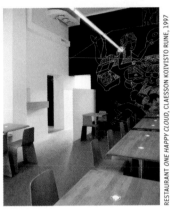

by nineteen young, Swedish designers. It successfully represented democratic and modern design for the people.

1996: Björn Dahlström and Carina Seth Andersson exhibited jointly at the new Volvo showroom designed by architect Jacob Zeilon in Stockholm's Kungsträdgården, which opened in 1995. Dahlström showed his furniture and Seth Andersson her glass cylinders.

1997: Jonas Bohlin was responsible for one of the most impressive exhibitions of the decade, LIV, at the Färgfabriken gallery in Stockholm. Pieces included his boat and his furniture collection *LIV*, in addition to material documenting his boat row to Paris in 1994.

1998: "Living in Sweden", an exhibition and event organized by Swecode, caused a storm at the Milan fair. The exhibits shed light on different facets of Swedish cultural life, including music, fashion, and food, and featured *Stockholm New* magazine. All the international design giants and journalists were in attendance at the fair.

• The November issue of *Wallpaper*, the influential British lifestyle magazine and bible of many design devotees, featured a hefty Stockholm supplement. Half a million international readers were able to read that Stockholm was one of the world's most modern design cities and that Sweden was home to some of its leading designers.

1999: "New Scandinavia – Aktuelles Design aus dem Norden" was a major exhibition at the Museum für angewandte Kunst in Cologne. Contemporary Scandinavian furniture, industrial design, glass, ceramics, textiles, and graphic design were on display. The museum was responsible for the selection of pieces from the five countries, and sixty percent of the participants and the objects were from Sweden.

• The Swedish Embassy in Berlin, designed by architect Gert Wingårdh, opened. The Ambassador's residence was redesigned by architect Lasse Vretblad and furnished by Claesson Koivisto Rune who took the opportunity to demonstrate the vitality of contemporary Swedish furniture and product design. This commission by the Ministry for Foreign Affairs provided a showcase of internationally acclaimed and award-winning contemporary Swedish design.

• "H99" – a follow-up to "H55" – opened in Helsingborg in August. The interior and product design shown at the fair, which was visited by half a million people, was both traditional and forward-

34

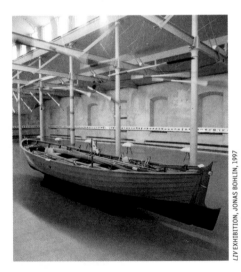

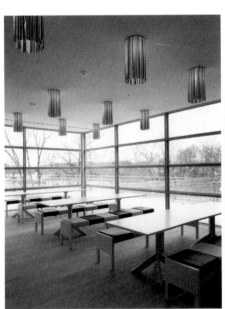

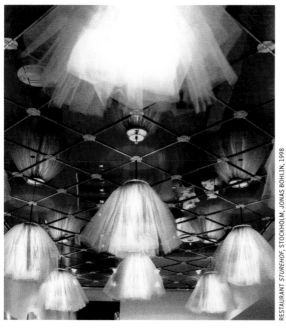

RESTAURANT *STUREHOF*, STOCKHOLM, JONAS BOHLIN, 1998

WALLPAPER

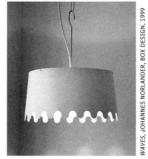

WAVES, JOHANNES NORLANDER, BOX DESIGN, 1999

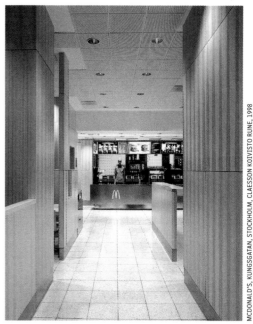

MCDONALD'S, KUNGSGATAN, STOCKHOLM, CLAESSON KOIVISTO RUNE, 1998

looking. The focus was on extremely luxurious solutions for apartments, and fun ideas for small moveable houses. Ikea stood out as the company that had best built on the democratic ideals expressed by "H55".

· Nationalmuseum opened a permanent exhibition "Modern Design 1900–2000", which provided an historical overview of design during the 20th century, from the 1917 Homes Exhibition to the modern day. Included were all the important milestones in Swedish design, arts and crafts, graphic design, and industrial design.

2000: A Government Commission on Form and Design puts forward a recommendation for a "meeting place for design" to be opened in Stockholm in 2001 that will gather knowledge and present exhibitions within the field of design. It will aim to provide a much needed forum and source of inspiration for the practicioners and devotees of the Swedish design tradition. The Minister of Culture proclaims 2001 an Architectural Year for the stated purpose of increasing general knowledge and understanding of the importance of architecture.

· *Forum*, the journal of Sweden's interior designers, picks the top ten twentieth century interiors. On the list are the kitchen of the restaurant Rolf by Thomas Sandell and Jonas Bohlin, and also Bohlin's Sturehof. Also in Stockholm are the Forest Chapel by Gunnar Asplund, The Bank of Sweden by Peter Celsing, and the Stockholm City Hall by Ragnar Östberg, Carl Malmsten, and others. In Malmö the list includes the premises of Watchmaker Inge Lundberg by Sten Hermansson, Pågen Bakery by Ralph Erskine, and The Chapel of St. Gertrud and St.

Knut by Sigurd Lewerentz, the Gothenburg Concert Hall by Nils Einar Eriksson and Axel Larsson, and Wilhelm Peterson-Berger's summerhouse *Sommarhagen* on Frösön, decorated by Peterson-Berger himself.

· *Stockholm New* assembles the participants from "Living in Sweden 1998" in New York to find a wider audience for contemporary Swedish design.

· Charlotte Christiansson opens the boutique Svenskt at the *Centre Culturel Suédois* in Paris, which exhibits, among others, Jonas Bohlin, Box Design, John Kandell, Mattias Ljunggren, Åsa Lindström, and Mats Theselius to rave reviews.

· A comprehensive, retrospective solo exhibition of Björn Dahlström opens in Berlin.

· *Swedish Design* is first published.

35

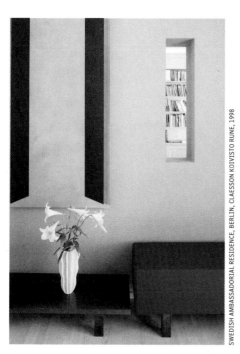

SWEDISH AMBASSADORIAL RESIDENCE, BERLIN, CLAESSON KOIVISTO RUNE, 1998

New Scandinavia
Aktuelles Design aus dem Norden

"NEW SCANDINAVIA" CATALOGUE, COLOGNE, 1999

Svensk Form

abc

1900 2000
Den moderna formen

LOGOTYPE, BAS RETAIL, 1999

NEW GRAPHIC PROFILE FOR SVENSK FORM, STHLM LAB., 2000

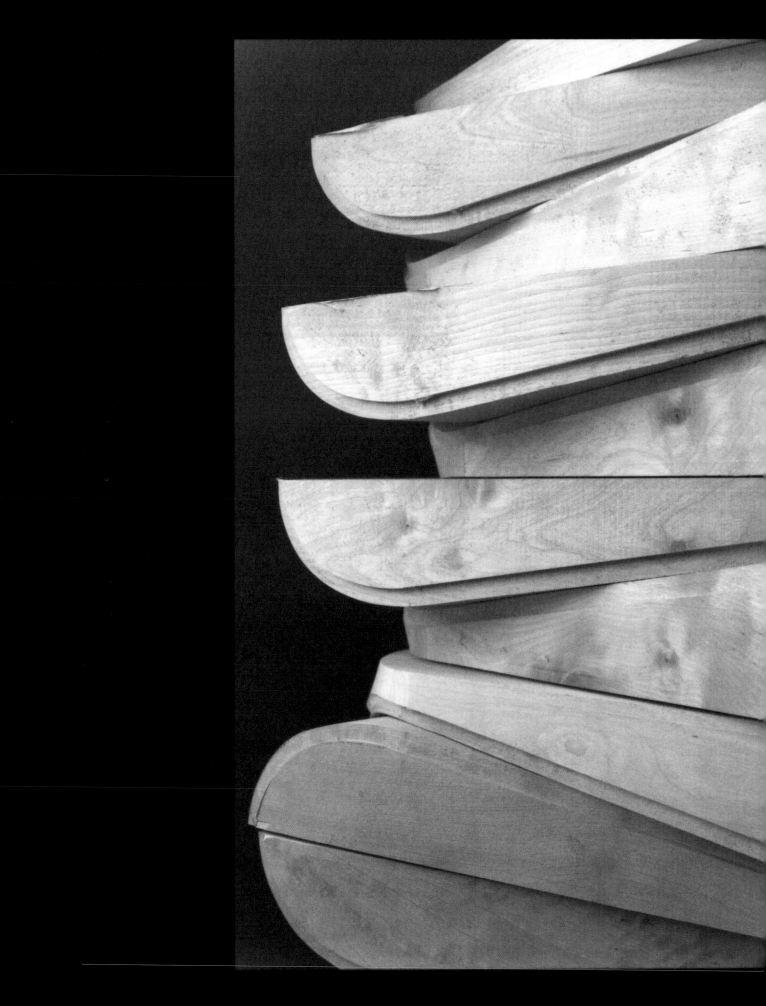

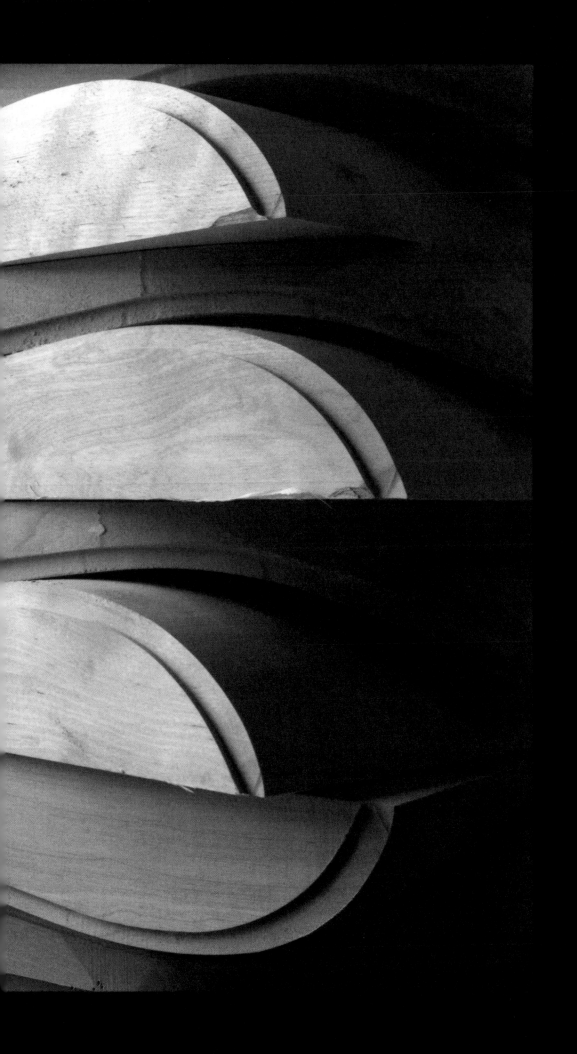

The Need for Design
By Sara Ilstedt Hjelm

"Design your own photo!", reads the sign on the booth, meaning that you can decide whether to keep the picture or take another one. Designing your home, your hair, or even your education are other possibilities, all of which carry the same message: all of us are – or can become – designers.

The 1990s saw a tremendous rise in the number of design school applications, and the introduction of many new design-related courses such as information design, media design, and engineering design. Design was integrated into technical and economic studies and became an accepted research topic within fields such as marketing.

Desktop publishing made it easy and inexpensive to produce your own printed material, and basic typographic and layout skills are now part of general education. The Internet revolution meant that everyone could have a homepage – a graphic self-portrait, capable of reaching the whole world. In the space of ten years, design went from being a specialized field to general knowledge.

Professional designers watched this development with scepticism, wondering whether technicians, economists, and quasi-designers would take over. In fact, increased interest in design has brought an upsurge, rather than a decrease, in the demand for good design. The professionals represented in this book have created a wave of interest in design, and their aesthetic and practical expertise is borne forward by widespread public interest. This new design interest encompasses fashion, home and living, DIY programmes on TV, and magazine articles on how to build and make things. Interest in gardening is on the rise, as is interest in traditional handicrafts and building methods. What is emerging is a changed view of the concept of design that harks back to the 1980s.

The word design originally comes from the Latin *designo*, meaning to reproduce, designate, portray, or describe. Today, design is the accepted term for giving products – be they handmade or machine-made – their final form and in everyday speech, the word usually refers to the form or shape of an object.

The word design thus has a double meaning, describing both the shape of an object and the process behind it.

It could be said that everybody is involved in design to some extent; it shapes our lives and affects the course of events to some degree or another. People with a wide range of occupations create "products" – for example economists construct brands and organizations, politicians devise pension systems, and engineers build motorways and traffic systems. All of these different people design products that have an inherent function as well as a practical and aesthetic form. A motorway has to work, but it is almost as important that it be carefully constructed and adapted to the environment. Aesthetics – that is to say form – is vital to the way we perceive things and whether we like them or not. For example, research shows that people find it easier to become part of an organization if they perceive the organizational plan as aesthetically pleasing.

"Design is used to change a given situation into a desired one," says the American architect and sociologist Donald Schön. This definition broadens the concept of design to encompass almost all human activity that entails a conscious attempt to change something for the better, so that to redo our kitchen or bring up children is very much a design activity. As a sociologist, Donald Schön is able to discern exactly how our common actions shape society and its structure: our values and our culture mark the houses we inhabit, our cities, and our possessions. These may be seen as the physical manifestation or imprint of the way we are, which helps to explain why houses and objects differ from one culture and setting to another.

A common factor in this development is the fact that the user is becoming ever more important in the design process. In the 1950s and 1960s it was commonly thought that perfect housing or perfect products could be designed by applying rational and scientific methods. Then, the goal was a large-scale solution that would result in mass-consumption and a mass market, but today we no longer think in such large-scale terms. People are individuals, with different needs, and while common denominators do exist, the best way of arriving at a good product is to test it on ordinary people. In IT design as well as software development there is

increased reliance on anthropological studies by researchers who study the lives of ordinary people.

This may seem unnecessary, as surely we know the way we live? Unfortunately, that is not always the case. Engineers and those in charge of technical development are often quite ignorant about how people live or what they actually want. Many products on the market have too many complicated functions which no one has the patience to learn to master, and which exist only to raise the price of the item. How many people actually use all the settings on their answer phone, or all the different functions on their VCR? It is as if those who created the products did not take the would-be user into account. This is slowly changing, and hopefully the future will bring us products that are both aesthetically appealing and divested of many of their unnecessary functions.

Today's individual, with an interest in design and creativity, is no longer content to be a passive consumer of things created by others, but instead wants to be part of the process. This is also true of entertainment and leisure activities, and it is thought that in the future, we will be less inclined to purchase things and be more disposed to consume experiences such as travel, music, and entertainment. Being with others is what people prefer most, and those products that support everyday communication will undoubtedly become more numerous.

The Internet and the World Wide Web are one example. The Internet developed as a way for people to communicate with each other through chatting, discussing, disseminating information, and socializing. The simple text-based cutting edge computers of the early 1990s have grown into the graphically advanced computers that we use today, in which graphic form has become increasingly important. Sweden has a worldwide reputation as an IT nation, and in the US, *Swedish Modern* is no longer synonymous with Josef Frank but with the portal Spray and The Cardigans.

One successful Swedish-designed product on the Internet is the three-dimensional virtual island, Dobedo. Dobedo was conceived as a product for the general public; a place for flirting, socializing, and playing identity games. For social communication to function it has to be visual, and allow for the expression of identity and feelings. Social interaction calls for spatiality in order to convey presence, and a text-based site would simply not work. Instead, Dobedo was created as a virtual vacation island, filled with cartoon-like characters, and the concept proved enormously attractive.

The island is teeming with talkative and flirtatious people, who enjoy themselves as freely and carelessly as on any Mediterranean island. Today Dobedo has half a million visitors (twice the population of Iceland) and their number is increasing. Dobedo's "clients" are not passive consumers but actors in a drama of their own making. Dobedo's beaches have a life of their own, full of cliques, their own language and lifestyle. The designer is responsible for the basic concept and for setting the stage, but the users design their own experience of the product through social encounters.

Dobedo borrowed the metaphor of the island from the 1990s television show, *Expedition: Robinson,* which took place on a deserted island. *Expedition: Robinson* gave rise to a completely new genre within television: the "docu-soap" or "reality show," which offers documentary merged with soap opera, in which you create your own entertainment by following the adventures of a group of "ordinary" people exposed to extreme situations.

On the most recent Swedish reality show *The Bar*, Internet and television merge. The viewers are able to follow the participants around the clock through five strategically placed web cameras. You can also vote on whom to expel, send emails to the participants, or join the programme by visiting the bar, which is situated in Stockholm's Old Town. Reality shows have become an international success and the ideas have been sold to TV companies around the world.

These developments place entirely new demands on the designer. The designer of the future may be someone who designs events, not objects, and someone who creates the preconditions and parameters for experiences and human encounters. This is true of the new broadband technique now invading our homes which, in the long run, will change our lives as electricity did in its time. What services should be provided, and what form should they take?

Whatever happens, there will always be a need for someone to design these new products and services. Someone with a feel for form, knowledge of materials, and insight into human needs and dreams. A designer.

Sara Ilstedt Hjelm is an industrial designer, writer, and doctoral candidate in the field of Human/Machine Interaction.

PORTRAITS

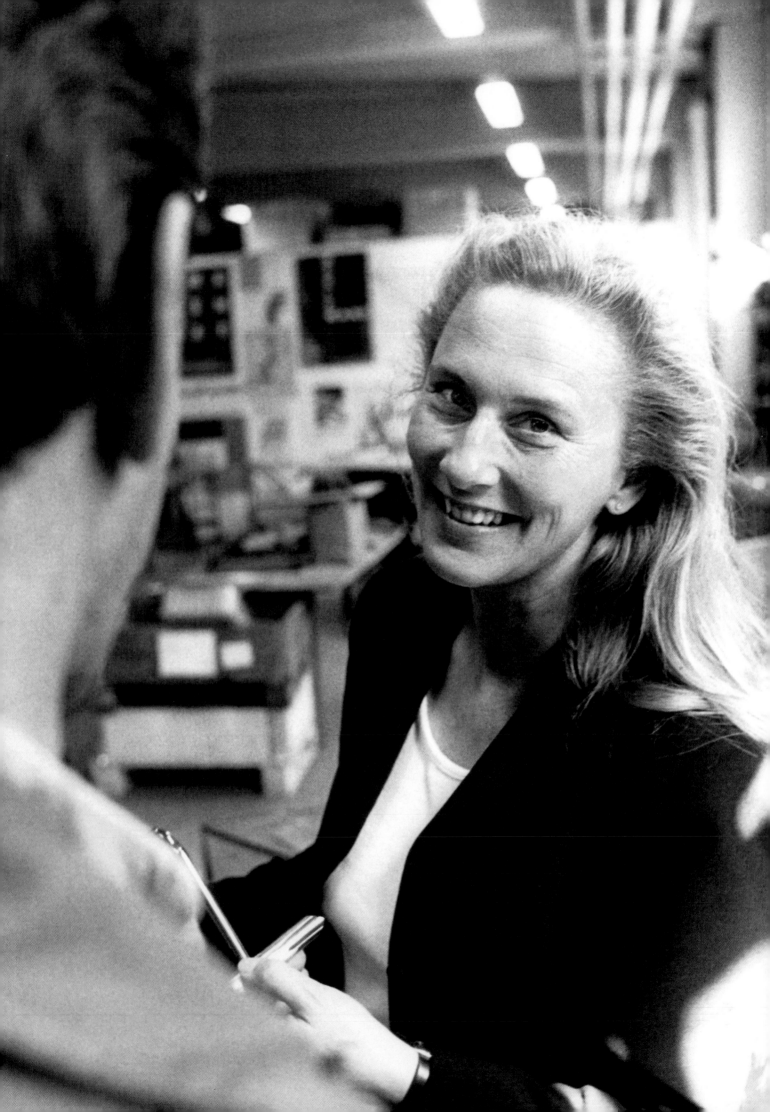

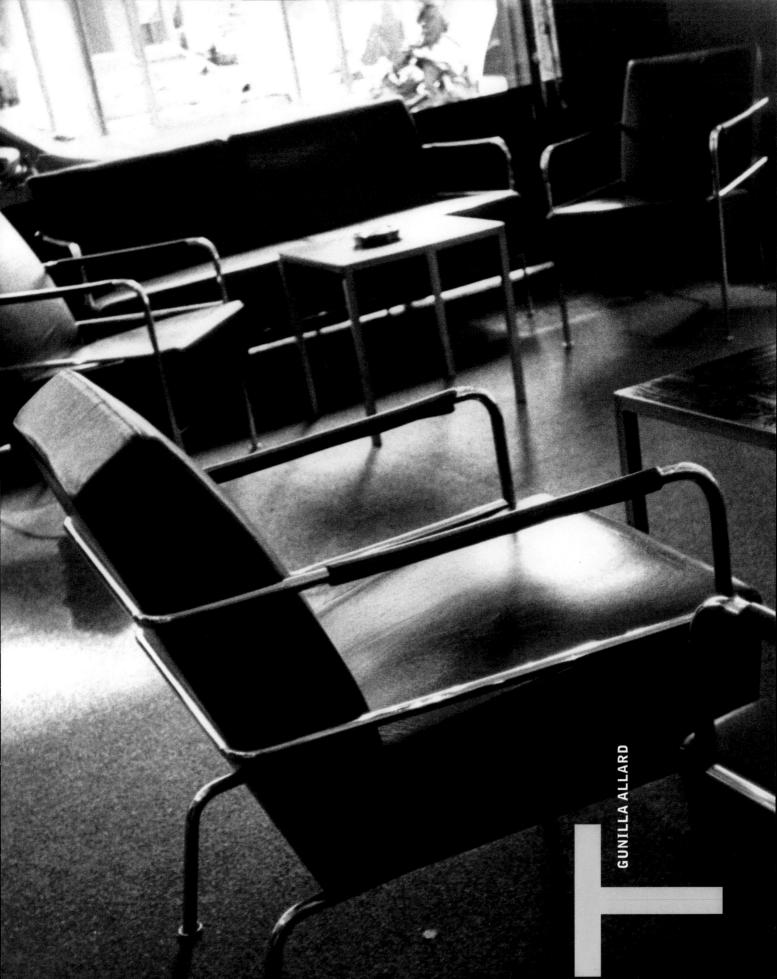

GUNILLA ALLARD

Gunilla Allard has pulled off one of Sweden's greatest sales coups for one of the country's oldest furniture companies. Allard, who joined Lammhults Möbel[1] in 1988 after 43 years of male design hegemony, appealed to international taste with the design of her armchair *Cinema*.

Allard, described by the French weekly *L'Express* as "the most talented of Sweden's handful of female furniture designers," arrived straight from Konstfack, the University College of Arts, Crafts, and Design in Stockholm. It was her success with *Cinema* in 1994 that emboldened Lammhult to hire another female designer.

Allard is often asked whether the fact that she is a woman affects her work. "The answer is yes. I work with a different set of measures – introduce a different scale. They are more graceful, thinner, smaller."

For Allard, being a woman means having an eye for detail and paying careful attention to the smallest thing. "It is my responsibility to do my utmost when it comes to the details – everything must be completely thought through and very precise. The better crafted the details, the harder a product is to copy." There is always the risk, she says, that she may come across a well-made copy of her beloved *Cinema* one day. For pirates don't limit themselves to videos, fashion, and technical gadgets. "They are incredibly brazen and I often half jokingly tell my agents in the Far East to watch out."

We discuss her position as a female designer further, and the fact that the root of her success and her distinctiveness may actually be the fact that she is a woman. Allard has long been fascinated by metal – a "male" material – and the possibilities it offers. "The material lends itself to thin and light constructions and I find the metal industry very exciting and challenging. Wood, on the other hand, often produces large and heavy pieces – dimensions that I don't think I master in the same way. Wood does not have to be clumsy, of course – just think of Thonet[2] chairs."

"The graphic aspect of being able to see a clear line in the objects appeals to me. That may also be a male thing," she says, but adds that she "loves being a woman. I think we women have an advantage in the way we communicate and co-operate. It is easier for us than for men to talk to anybody, to seek help and ask stupid questions when we have to."

Allard's successful "Chicago" and "Cinema" ranges hold up to close scrutiny. She shows me a detail of the armrest: on the outside is 19mm tubing, uncovered for four inches and then encased in leather. When the tubing appears again by the backrest its diameter is 16mm. It is an ingenious detail and an exquisite piece of craftsmanship – as are the hidden joints and precise seams. She is proud of the team of product developers, upholsterers, seamstresses, assemblymen, and prototype makers. "When I describe the details and the work behind them to the customers, they often say 'now that I know that, I'm perfectly prepared to pay a little extra.'"

Her furniture is primarily intended for public settings, which is traditionally Lammhults' principal market. "But we are beginning to see all kinds of people going for *Cinema* – it appears to be equally well suited for the home as for a hospital. I wanted it to be within everybody's reach, so I couldn't let it get too expensive."

When designing a new product Allard always has to bear the financial aspect in mind. Another concern is the durability – both of the design and in terms of quality. "It is important that my designs will still be holding up in twenty years, both as far as function and design are concerned. It is my responsibility and my way of doing my share as a designer. Much of the furniture made today is so fashionable that it doesn't hold up to visual wear and tear. It is therefore important that the basic shape must not be too trendy – trendiness should be saved for clothing or surface treatments."

Allard's eye for timelessness is mostly due to her past as a stage designer. "I have worked with all kinds of settings from every period, which has given me a good sense of history," she says. Directors Allard has worked with include Ingmar Bergman, Vilgot Sjöman, Suzanne Osten, and Jan Troell. It was stage design that began her interest in furniture, for she found herelf fascinated with the craftsmanship and the design of the sets. There are clear similarities between the design world and the world of film. "Film deals more with dreams and illusions – once a shoot is finished

44

2: Michael Thonet (1796–1871) was a German pioneer in the mass production of furniture. His ideas on bentwood originally met with rejection, but after moving to Austria in the wake of bankruptcy his fortune changed for the better. He launched his café chair – today known as Thonet No. 14 – In 1859. It became an icon for modern, mass-produced furniture, and by the First World War more than fifty million had been sold. Thonet's company later took up production of the pioneering steel furniture of Marcel Breuer and Ludvig Mies van der Rohe, among others.

1: Lammhults Möbel AB was founded in 1945 and is one of Sweden's leading furniture companies specializing in Scandinavian design. Sixty-five percent of the total production is exported to Japan, Germany, the United States, the United Kingdom, and Denmark. Simplicity, quality, and timelessness are three important qualities of its pieces.

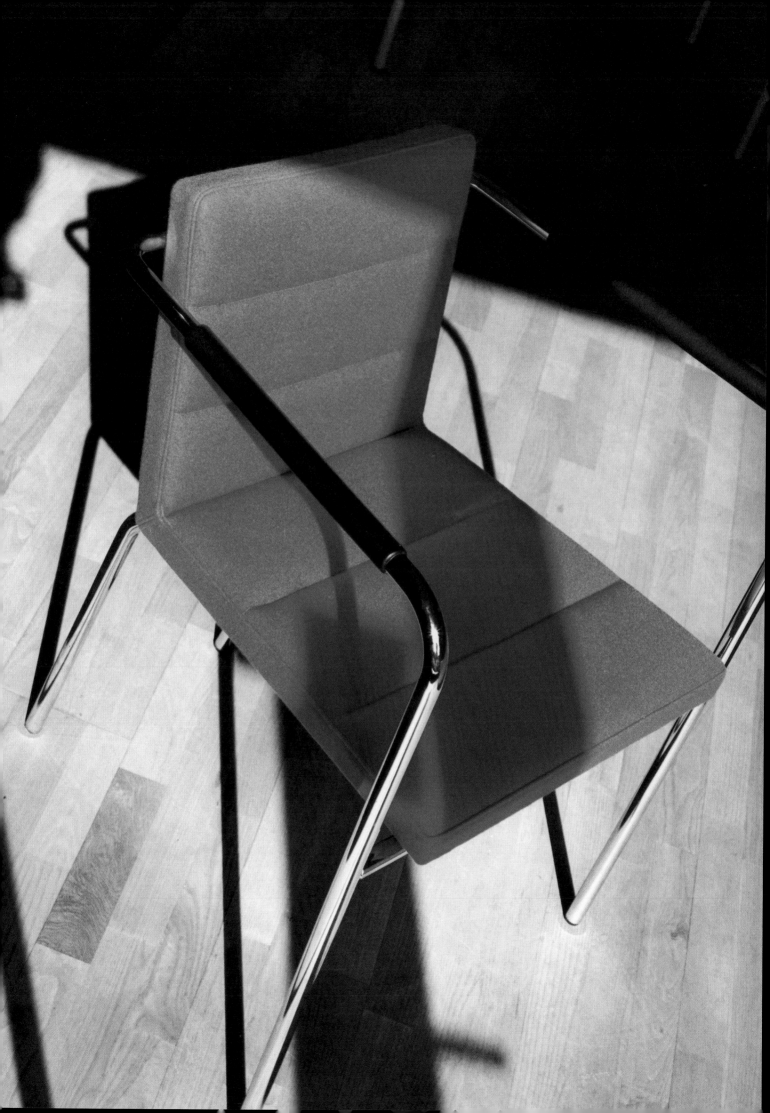

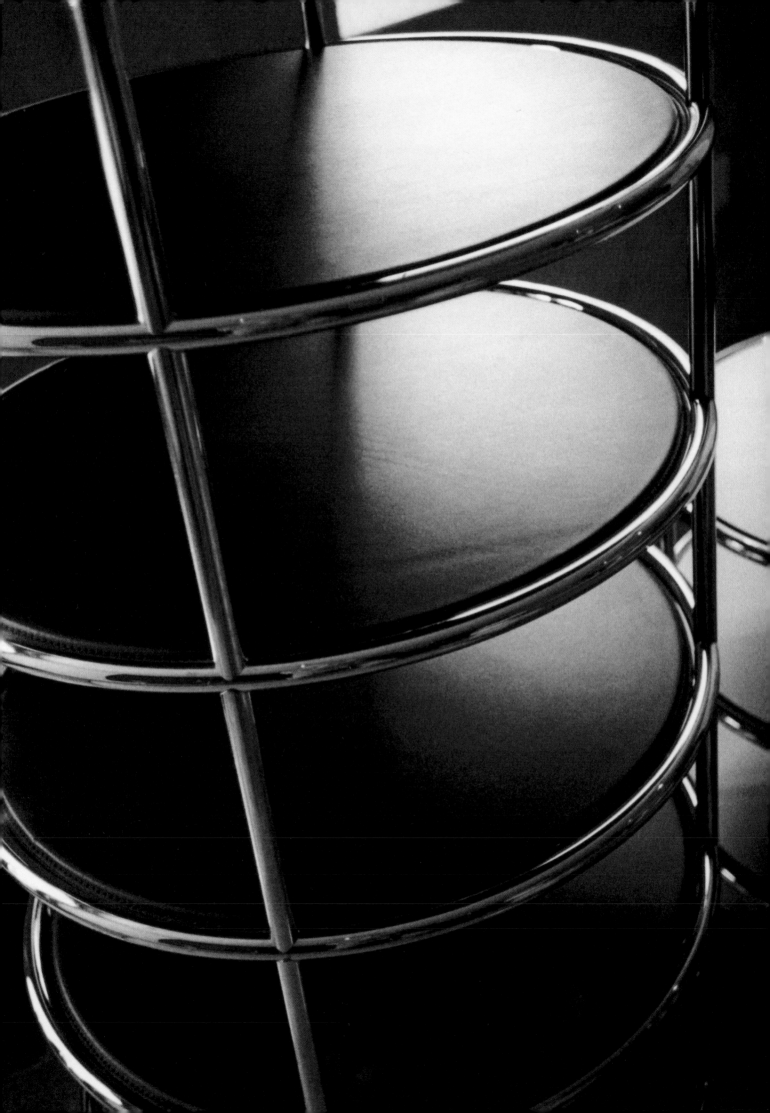

Left:
The teacart in the *Chicago* range comes in various diameters and heights.
Below:
Chicago chairs in front of Mount Fuji in Japan.

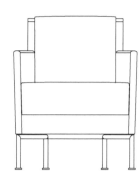

everything is taken down. Furniture design is more lasting, and thus more demanding. The products must be durable and must be able to take a lot of abuse." Although Allard's focus is on furniture, she continues to go back and forth between the two worlds. One serves as inspiration for the other.

Allard has a passion for the 1920s and 1930s, and her sources of inspiration include Gunnar Asplund[3], the Bauhaus (see Design history, p24), antiques, and architecture. "Actually, it can be anything." After the initial inspiration, Allard mulls the idea around. "It must be allowed to take its time – that's the way I am, never in too much of a hurry."

The next stage is sketching which she does over and over again before turning to little paper models that allow her to test the proportions. Several paper models later she produces a full-scale one-to-one scale drawing. "It is so time-consuming that I have time to really think through all the details." Then a prototype is made – the first of seven or eight. Comfort, production, aesthetics, measures, details, and function – everything must be right. "You have to be able to walk around a piece of furniture and find the same excitement, see the same beauty from every angle. That's why a three-dimensional prototype is so important," she says. In the last stages, a computer programme draws a precise prototype before it goes into production.

"A large amount of stubbornness in combination with faith in the idea are essential qualities in a designer," Allard maintains. The process of producing *Cinema* took seven years, from initial idea to the international sales success. The timing of the launch is as important as the rest of the idea and the production process, as the market is not always as ready as the designer and the producer. Sometimes, however, everything falls into place. As in the case of Gunilla Allard.

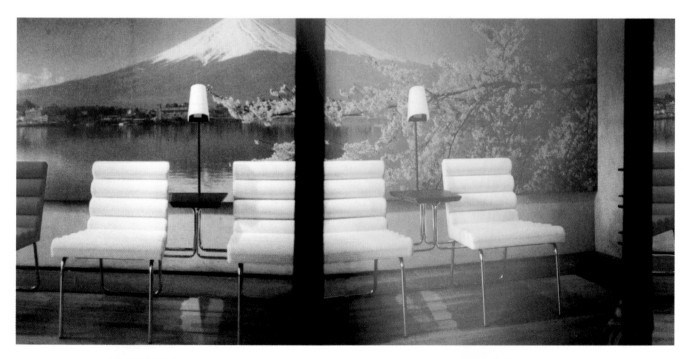

3: Gunnar Asplund (1885–1940) was Sweden's leading architect between the wars. As chief architect of the 1930 Stockholm Exhibition, he introduced the concept of Functionalist architecture to Sweden. His works include the Forest Cemetery in Stockholm, the Stockholm City Library and Karlshamn High School.

4: The Georg Jensen Award was set up to encourage a young generation of Scandinavian craftsmen and designers. The award of 50,000 euro, to be used for studying abroad, is awarded every other year on the anniversary of Jensen's birth in 1866. Jonas Bohlin was the recipient in 1988, and Gunilla Allard in 1996.

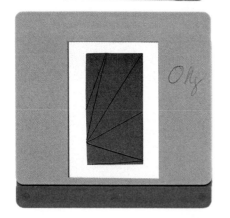

CARPET "AIR"
DESIGN:
THOMAS SANDELL

ASPLUND
+46 8 662 52 84

CARPET.CONDEX
DESIGNER
PIA WALLÉN

+46 8 662 52 84
ASPLUND

ASPLUND:
TEL:46 8 662 52 84

DESIGN:EERO KOIVISTO

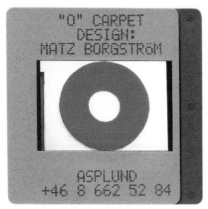

CARPET, "KRICKAN"
DESIGN:K. RÅSTRÖM

ASPLUND:
TEL:46 8 662 52 84

CARPET,CRISS-CROSS
DESIGN:
MICHAEL SODEAU

ASPLUND:
TEL:46 8 662 52 84

ASPLUND

"O" CARPET
DESIGN:
MATZ BORGSTRÖM

ASPLUND
+46 8 662 52 84

CARPET. RUGGLES
DESIGN:
LLOYD SCHWAN

ASPLUND TEL:
46 8 662 52 84

PLUTOS EYES
DESIGN:
STEFANO GIOVANNONI

ASPLUND
+46 8 662 52 84

CARPET "LINES"
DESIGN:
ALFREDO HÄBERLI

ASPLUND
+46 8 662 52 84

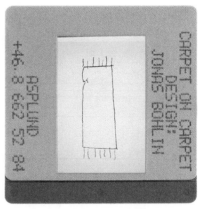

CARPET ON CARPET
DESIGN:
JONAS BOHLIN

+46.8 662 52 84
ASPLUND

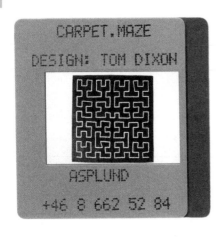

CARPET.MAZE

DESIGN: TOM DIXON

ASPLUND
+46 8 662 52 84

CARPET "CHEESE"
DESIGN:
ANNI GNEIB

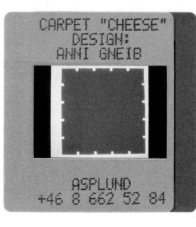

ASPLUND
+46 8 662 52 84

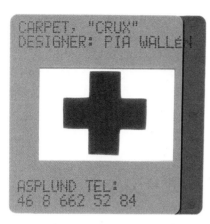

CARPET, "CRUX"
DESIGNER: PIA WALLÉN

ASPLUND TEL:
46 8 662 52 84

Carpets by
Matz Borgström
Edition Asplund
Nybrogatan 34

Carpet
by Thomas Sandell
for ASPLUND

CARPET
LINES
BY: ALFREDO HÄBERLI

ASPLUND
+46 8 662 52 84

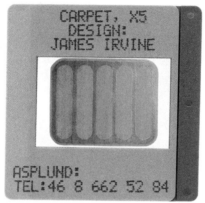

CARPET, X5
DESIGN:
JAMES IRVINE

ASPLUND:
TEL:46 8 662 52 84

CARPET
MARC DE LUXE
BY: MARC NEWSON

ASPLUND
+46 8 662 52 84

6 ng.

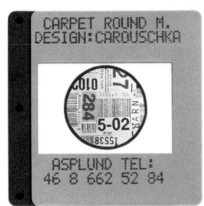

CARPET ROUND M.
DESIGN:CAROUSCHKA

ASPLUND TEL:
46 8 662 52 84

CARPET
"SOAP BUBBLES"
BY MARIA KAARIS

ASPLUND
+46 8 662 52 84

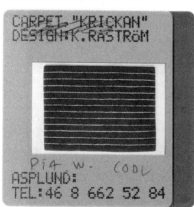

CARPET "KRICKAN"
DESIGN:K.RASTRÖM

PIA W. COOL
ASPLUND:
TEL:46 8 662 52 84

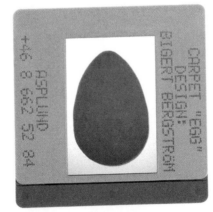

CARPET
DESIGN:
BIGERT BERGSTRÖM
"EGG"

+46 8 662 52 84
ASPLUND

CARPET "DOT" BY PIA WALLÉN
ASPLUND
+4686625284 · TELFAX +4686623885

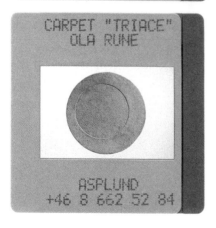

CARPET "TRIACE"
OLA RUNE

ASPLUND
+46 8 662 52 84

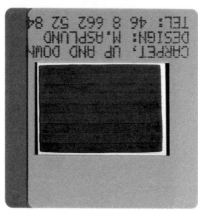

CARPET, UP AND DOWN
DESIGN: M.ASPLUND
TEL: 46 8 662 52 84

CARPET, UP AND DOWN
DESIGN:
M.ASPLUND

ASPLUND
+46 8 662 52 84

The producer is the link between designer, manufacturer, and the market. Sometimes these functions have been rolled into one, whereby the producers employ their own designers and manufacturer, sales and marketing directors. Today, more and more designers work for different independent producers on a freelance basis, whose primary task it is to find suitable manufacturers. They are also responsible for launching the product on the market through retailers – sometimes through their own stores.

In the past, many of Sweden's furniture producers were able to stay in business only by selling to the public sector, which seldom made major aesthetic demands and tended to focus on function alone. Today this sector has shrunk considerably and design and aesthetics have become equally important to identity and competition. A number of new producers have entered the market, introducing a modern view of sales and marketing. This has contributed to the great interest in contemporary Swedish design worldwide.

Below:
Michael and Thomas Asplund.

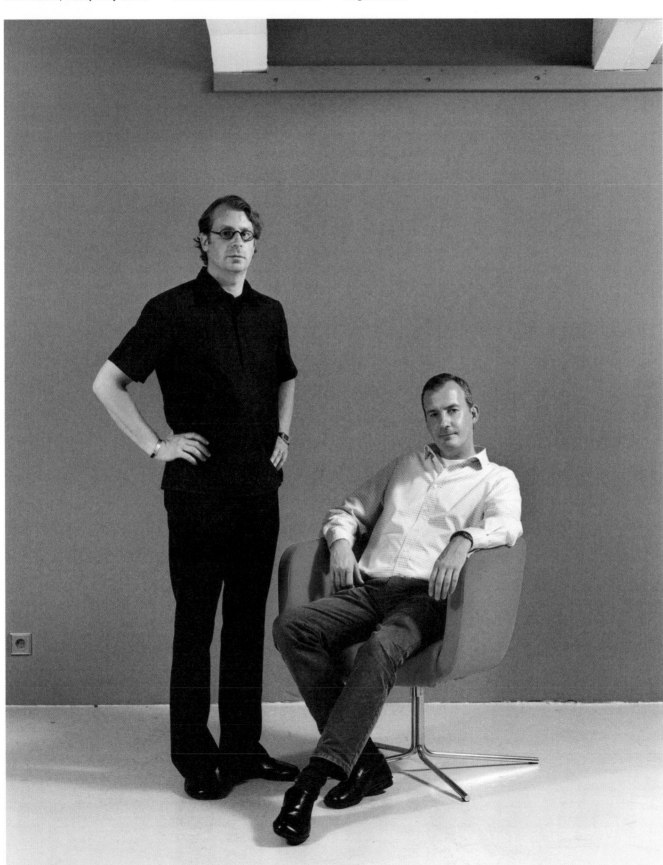

"Our international reputation rests primarily on our carpet collection, which is now sold in all parts of the world except Africa. In Greece, the carpets are often hung on the wall, but interestingly, there are no real differences in taste between various cultures."

Page 52:
Examples of diferent designer's work in the Asplund collection.
1 Lissoni
2 Sandell
3 FSB
4 Råman
5 Morrison
6 Bohlin/Sandell
7 Morrison
8 Newson
9 Sandell
10 Citterio
11 Giovannoni

You must be part of the times and you must be doing what you really want to do, according to the Asplund brothers. Thomas was working for a bank but took leave in order to help his brother out at the art fair, "which was much more fun than what I was doing at the time." Michael, then an art dealer was wondering how to combine his business sense with his interest in colour and design.

With a sure sense of the spirit of the time, they opened Galleri Asplund in 1990 and showed furniture as art and *vice versa.* The public was not used to this, but they were intrigued. To begin with, most of those who came were architects. "We had a group of very knowledgeable and faithful customers. We would call them on a Friday and ask if they were interested in one of Jonas Bohlin's 77 marine steel plate chairs. By Monday they would all be gone," Michael says, adding that in terms of money available for spending, those times were hardly typical.

Michael had got to know Jonas Bohlin when they worked together on a project for Swedish design company Källemo during his time as an art dealer, and then Bohlin helped them design their first store/performance space. Light sculptures by Oscar Reuterswärd and rugs by stage designer and artist Caroushka Streiffert alternated with dance performances. The whole idea was to mix art, furniture, and rugs, with the aim of producing their own collection. "When the market began to run out of steam in the early 1990s, we knew what kind of things were still selling. That was when we started to produce things ourselves, purely as a way of surviving, to broaden our activity and reach a broader customer base," Michael says. Their first product was a CD-rack by Thomas Sandell, and they also "inherited" products from *Element,* a discontinued vanguard collection that had included Sandell, Bohlin, and Pia Wallén. It did not take long before a different kind of audience started to pour in.

After a few years they moved to a bigger space, which allowed them to stock larger pieces of furniture. Their design criteria were the same then as they are now: pieces had to be clean, simple, elegant – with the potential to be a classic of the future. They also began to deal with foreign designers such as Jasper Morrison (see p. 299), Marc Newson[1], and Stefano Giovannoni[2]. These were big names that added weight to their own name, but there were also benefits for Swedish designers through the collaboration that grew out of these new friendships.

The Asplund design store could today be described as an amalgam of cutting-edge design. "We are always on the lookout for good products and designers, and as soon as we see something interesting we contact them. It is hard to find first-rate designs that are suitable, however. We almost never find them at fairs, but more often just stumble upon them by chance. It might be some workmen who leave a Spanish magazine behind, for instance, with a picture of the most beautiful washbasin in the world."

Their business is founded on three components: contract sales to the trade (geared to businesses and architects), the store, and their own collection. "Our overall aim is to have a smoothly functioning organization and to put together quality collections. We devote a lot of attention to working with the designers, because we need them, and they need us. It is also important to cultivate our foreign contacts and to put on exhibitions in the store from time to time. It's a kind of bonus for our customers and a good way of educating them about contemporary design."

Their greatest source of pride is the expanding range of carpets. "No one had ever tried putting together a large, modern carpet collection, so we really found a niche. A carpet should be calm and meditative;it has to be able to stand alone, as well as being subordinate to the interior design. It is also important that the collection represents both Swedish and international design idioms. Our international reputation rests primarily on our carpet collection, which is sold in almost all parts of the world.

They remember the first time Pia Wallén's "Konvex" carpet appeared. The phones didn't stop ringing. Unfortunately it was too expensive when it was made in Sweden, but after looking around they found a quality manufacturer in India who offered even faster delivery. "In the future, we would like to produce more things of our own so that we'll

1: Marc Newson, who recently designed 021, an experimental car for Ford, is regarded as one of the world's greatest all-round designers. Born in Australia in 1963, he trained as a jewellery designer and sculptor. He had his breakthrough with furniture inspired by surfboards, but now works across a broad spectrum and has created furniture for Cappellini, shampoo bottles for Vidal Sassoon, restaurant and airplane interiors, and a bicycle for Biomega. In Scandinavia, he has made a carpet for Asplund, crystal for Iittala, and an ashtray for Blend.

2: Stefano Giovannoni, born in 1954, is an Italian designer and the big star at Alessi for whom he has created a large number of bestsellers – everything from plastic biscuit jars to saucepans, all of which are humorous and colourful. In 1985 he and Guido Venturini founded the King-Kong group whose products and interiors were based on their interest in science fiction cartoons, science, and poetry. Giovannoni has also worked with furniture and fashion, for Magis and Levi's, among other companies.

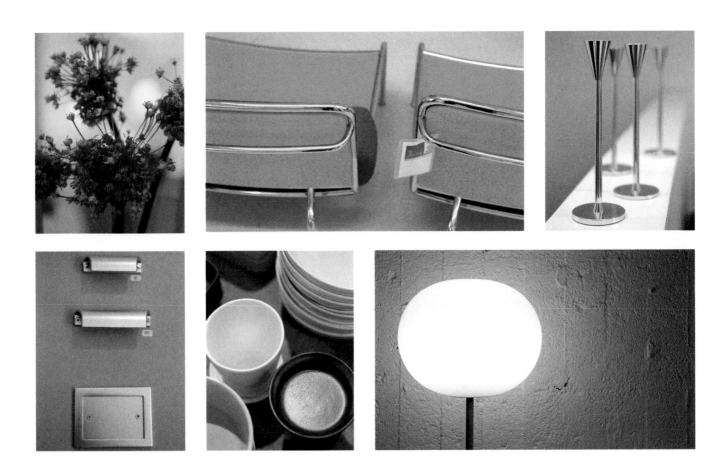

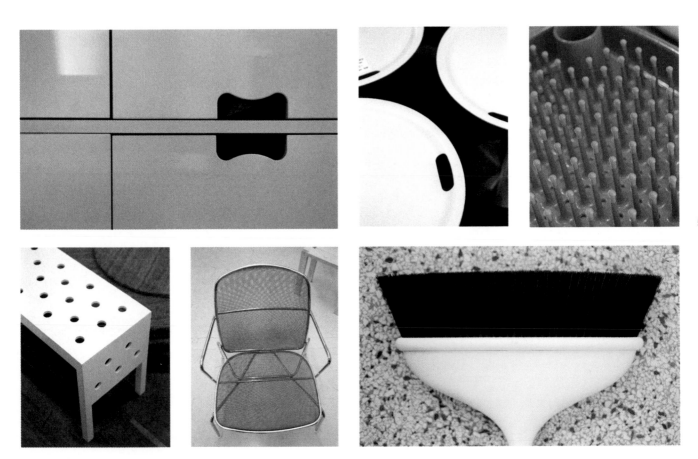

have the sole rights to the designs we like. But that obviously means that more time will be taken up with administration, when what we actually want is more time for product development and sales." One of their greatest worries is slow delivery times. "This may happen for many reasons: the seamstresses may be off sick, the manufacturer may prioritize larger orders, or the trucks may only run on Tuesdays and Thursdays. And there is usually nothing we can do about it," Michael explains.

When they felt that the range was ready, the Asplund brothers broke into the world market. It was at this time that Swecode – intended to function as a marketing umbrella for four young Swedish design businesses (more on p.34) – was born during a voyage by rowboat to Paris organized by Jonas Bohlin. Swecode participated collectively for the first time in Cologne in 1995, working together and sharing the costs. The Asplunds came on board at the Milan furniture fair a few months later. People came, looked, and liked what they saw, and on the international furniture market Swecode became

synonymous with contemporary Swedish design. "Even though we split the costs it was still exorbitantly expensive, but we thought 'if we're going to go for it, let's go for broke.' But when we got there, an inferiority complex set in. Everything was gorgeous, the showcases were huge, and the finishes fantastic. After a few days things were better – we realized that we really did have something to offer."

The second time Swecode exhibited in Cologne was particularly memorable. "We couldn't get into the fair, so we set up shop in a freezing old warehouse. Instead of an exhibition, we made an installation with stage lighting which was enormously effective."

Since then, Swecode exhibitions have attracted much attention. "The various ranges complement each other. We work well together and like spending time with each other. It's been dynamic and harmonious and we have learned a lot. Today we need each other less, but we still share agents and different activities to focus attention on design that we really believe in."

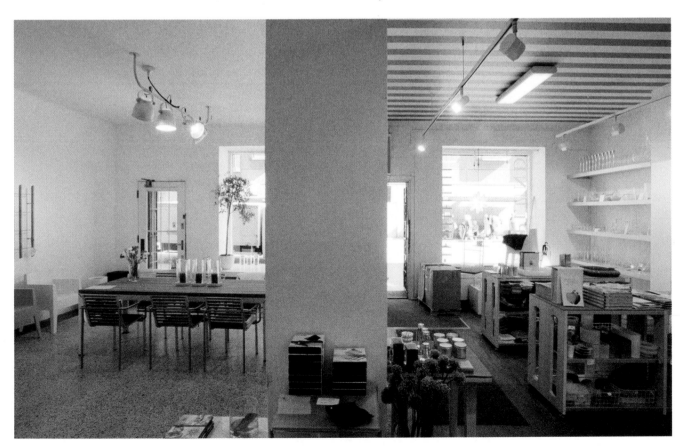

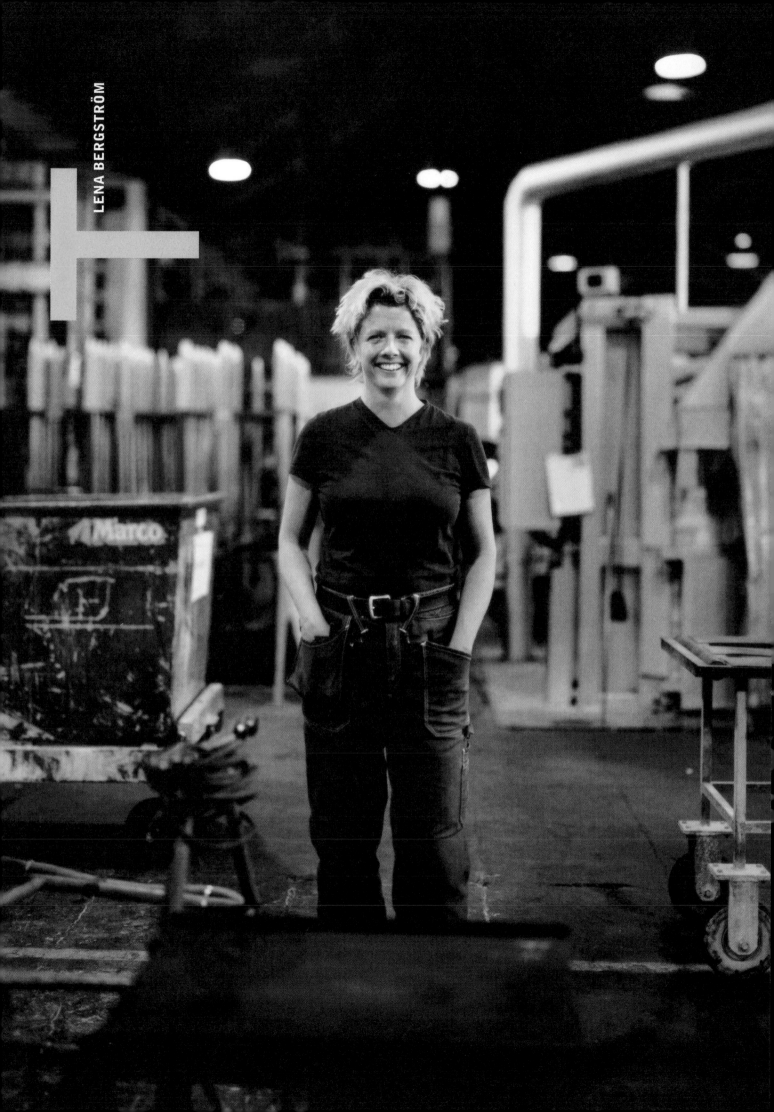

LENA BERGSTRÖM

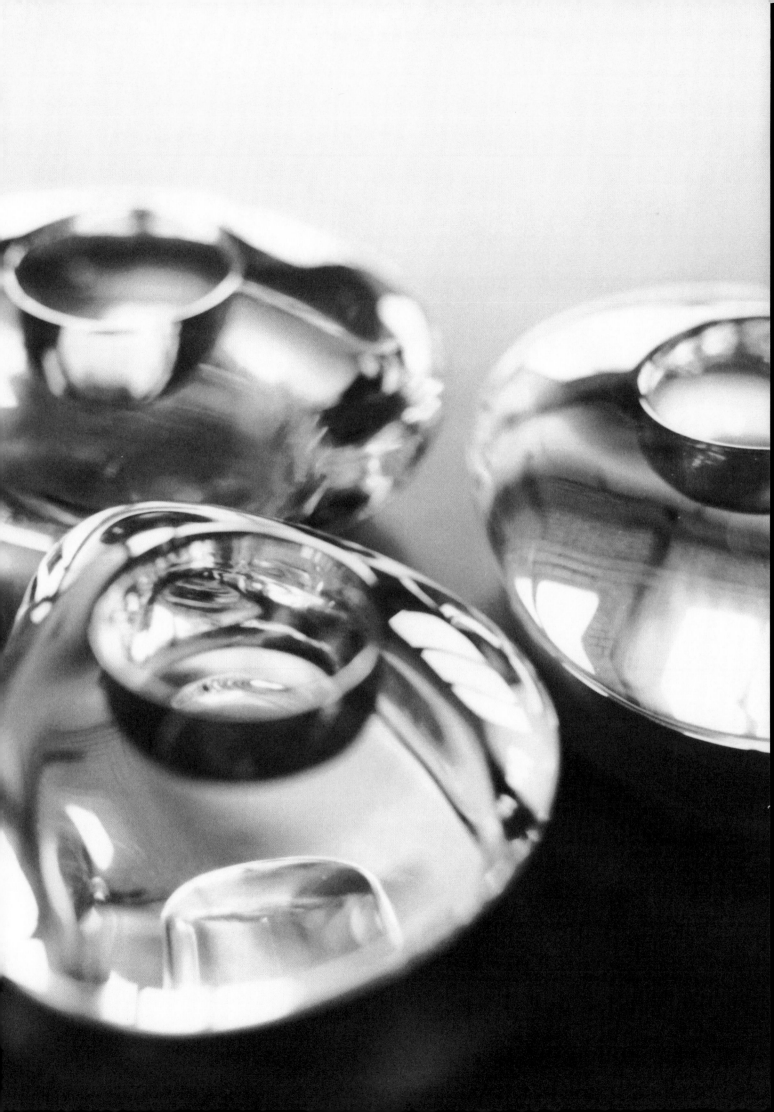

Page 57:
Lightstones. Graphic and soft, their asymmetrical shape produces interestingly uneven shadow effects.

Right:
Velvet vase.

Energy. The first thing to strike me on my way to Lena Bergström's apartment is the panel of buttons in the elevator. Her apartment is marked by a beautiful tree in the external staircase. On entering you come to a little white entrance hall, followed by a large white kitchen with Lena's products lined up on top of the cupboards. The atmosphere extends all the way out to her balcony, where Japanese and Swedish grasses grow in big pots, and a huge sage bush and a lilac tree flank the white-painted furniture.

The apartment contains a few carefully chosen pieces of furniture and objects from the 1950s and 1990s together with pieces from Bergström's own collection, other well-known designers, Ikea, and flea market finds. "Sometimes I am embarrassed that I have so many of my own pieces out, but what the hell, I make things that I would want myself, after all!" Lena explains with traces of a soft Umeå accent. The phone rings and when she hangs up she explains that her home is also her office. For a long time she had a studio, and lived with her husband in a miniscule apartment. Then they found the Östermalm apartment, complete with a fireplace, and Bergström says, "I guess someone up there thought I deserved it."

After a few minutes I realize that Bergström is someone people might call when they felt a bit down. Her happiness and bubbling talkativeness are contagious. Her aura, to use a New Age term, is highly charged. This is a good thing, because her life is quite frenzied. Or perhaps it is her next to inexhaustible energy that accounts for the fact that she has so many commissions in progress. She could be described as a multitasker. "I want to do so much, and I am always competing against myself. Things keep popping into my head so that I am never short of ideas. What can I do when they just keep coming?" The answer is simple: she takes each idea and follows it through.

Today, Bergström refers to herself simply as a designer of glass, textiles, carpets, and accessories such as blankets, pillows, and scarves, all of which is carried out with the same level of enthusiasm. "My ideas on design and colour can be applied to almost anything. A while back I found a sketch for some wallpaper that I had made a long time ago – and it turned out to be precisely the pattern I needed for a concert hall I was working on. Ideas are just stored in my brain and pop up seven years later when I need them."

Her work as designer involves more than just sitting around thinking up new products, in fact she sometimes has to act as a business executive. This involves talking and consulting with sales representatives, company directors, and customers, plus attending meetings on production, finances, and sales, in addition to commuting and marketing trips. There is negotiation – about fees and royalty payments. She related how she was once asked during a

58

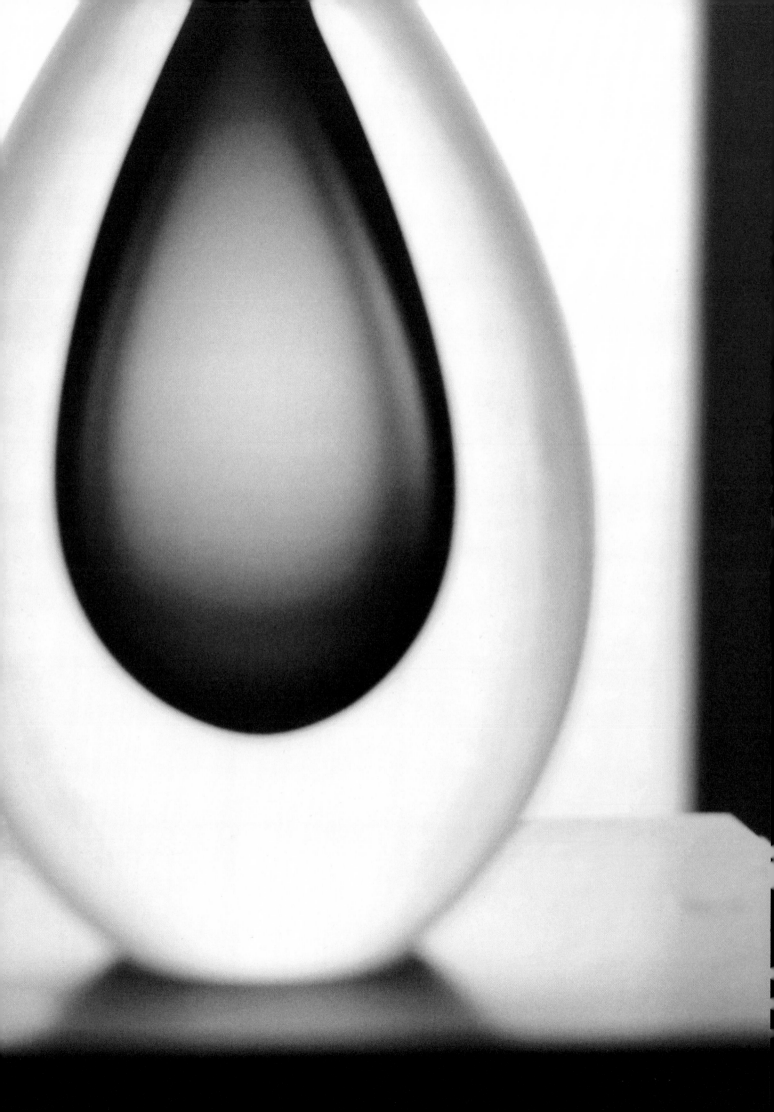

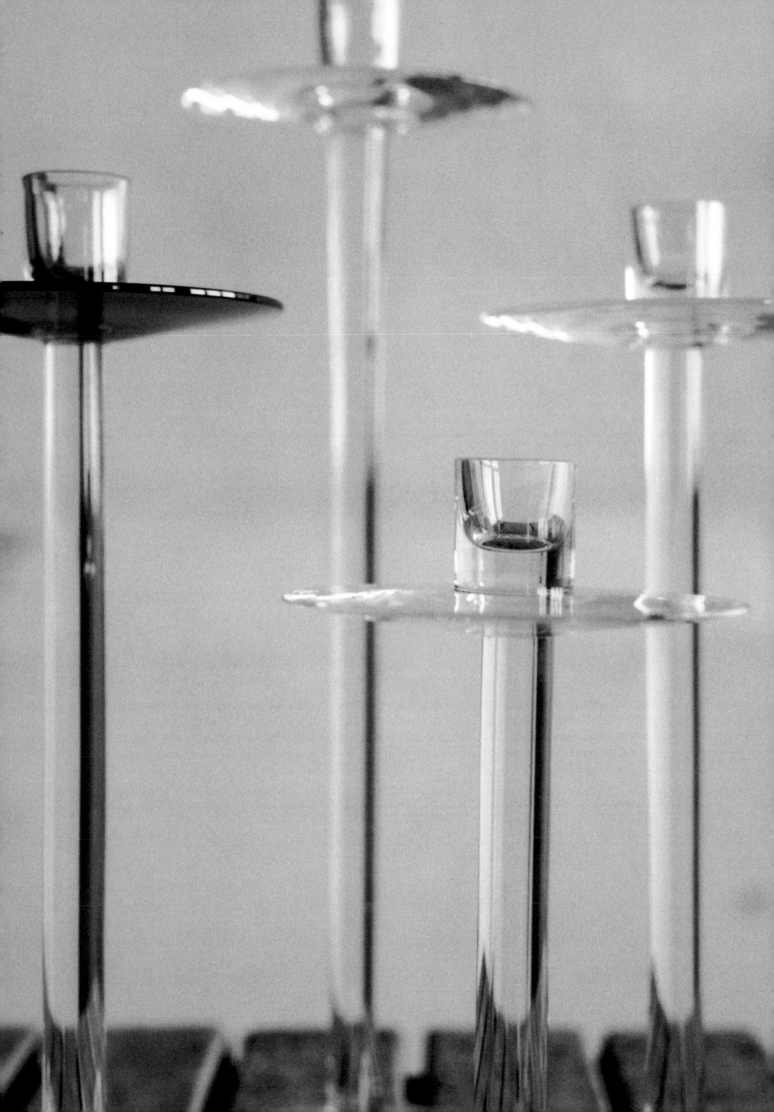

Left:
Cyrano candlesticks.

Below:
"It might have been my fascination for architecture that suddenly made the image of a cone come to mind."
The range also includes spheres and cubes that are soft to the touch.

negotiation, "Just who do you think you are?" "It is terrible that so many people take advantage of the often shaky self-confidence among designers and their inability to negotiate. You have to stand up for yourself."

"People outside the trade seem to think that being a designer is easy: that you just think something up, but the ideas have been processed in your mind, over and over again, before you can set them down on paper. And the real work still lies ahead. Behind every product there is hard work, even though it may look easy." One example is her *Puck*[1] candleholder in clear glass, which took a very long time to sketch. "I really had to keep at it, one millimetre here, one millimetre there to make the shape graceful, yet heavy. Everything had to be just right; the depth of the hole for the tea light, the height, and the diameter. And people think it is easy! I hate it when someone says, 'Anybody could do that'. They couldn't, and just saying so shows a lack of respect. I also dislike dishonesty, and I get angry when people are nasty, it is not right to treat others badly."

Unexpectedly, when Lena is angry she falls silent. Much of her inspiration, in fact, is derived from the very opposite of anger – that is to say from pleasure and communication. Other sources of inspiration include word games, and her own interests such as architecture and fashion. "Or inspiration might come from a passionate description of some new material – I get full of enthusiasm and am quick to see an application." A picture of the slit in a skirt inspired her glass vases named *Slitz,* while the thought "there are so few good presents for men" led to a range of drinking glasses called *Kampai* ("Cheers!" in Japanese). Originally a shot glass with a hip flask, the range grew to include a graceful all-purpose glass. It was her own feelings of anxiety and the stress evident in society as a whole that inspired her to make *Stones,* a modern version of the "worry stone," and designed to hold a flower. "Everybody has probably collected stones at some time, and *Stones* reminds me of the sea and of vacation."

In high school in Umeå during the 1970s Bergström opted for social studies subjects, which allowed her to devote

61

Inspired by an exhibition at the Museum of Eastern Antiquities, Lena likes to speak of the Japanese expressions *utsu* – to perceive the invisible – and *ma* – the silence between two sounds. "When I learned this, I suddenly saw the light: it is not just a matter of the object itself but also the empty space that surrounds it." She finds peace in her studio at Orrefors (below).

Below:
A vase from the *Wa* range.
Right:
Cyrano plate.

1: Bergström created Puck *after admiring the shape of a hockey puck, which she considers strongly graphic. She made sketch after sketch. "I kept at it, one millimetre here, one millimetre there", in order to make the shape graceful, yet heavy. She wanted the tea light to be even with the upper edge so that the puck would give the impression of a block candle made from glass. Everything had to be just right, including the depth of the hole for the tea light, the height, and the diameter. However, when it later went into production, technical adjustments had to be made. The puck has no seams, it is poured; the glass runs down into a mold that has a slightly larger "release" at the bottom to demold the product after it hardens. This release had to be adjusted a number of times for everything to be just right. During her "puck period", Bergström also made a candlestick shaped like a long stem with a mini-puck as its crown, which is yet to go into production.*

Below:
The mistake that became one of Bergström's
greatest successes: the original vase,
Squeeze, 1996.

63

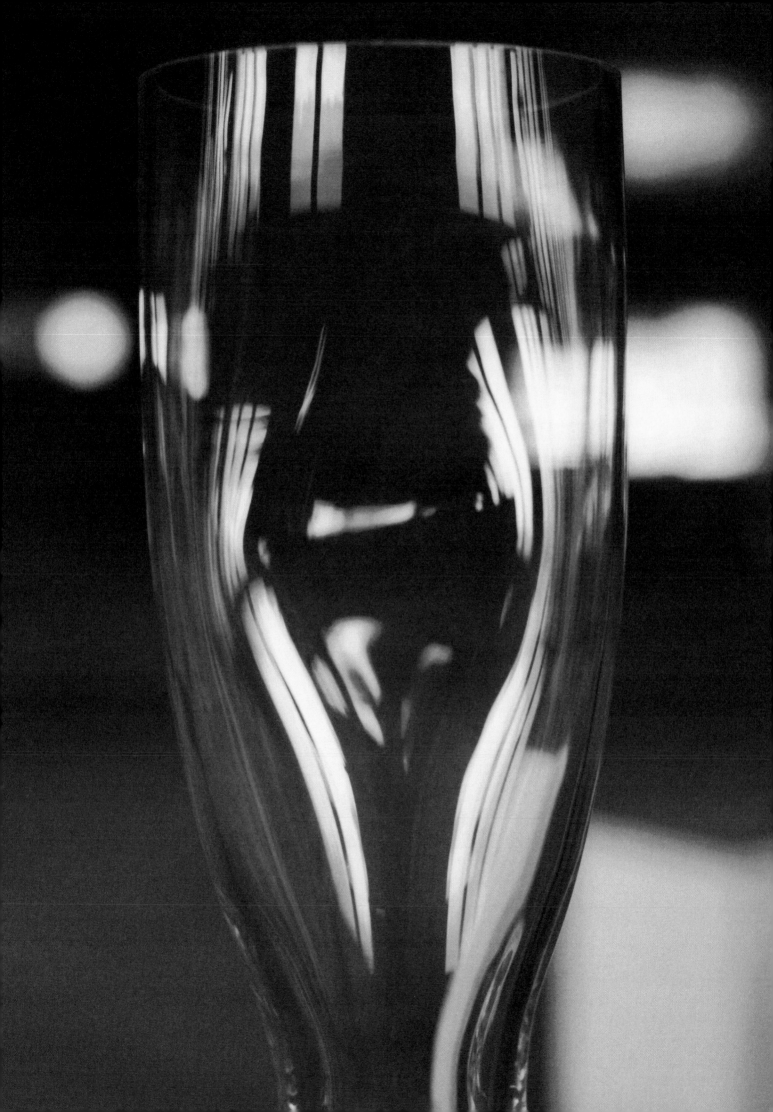

her time to music, drama and, above all, to advanced drawing. She remembers as a child having the ability to be totally absorbed by what she was studying. For example, when she found a special kind of radish, the largest she had ever seen, she saved it carefully, taking it out to look at it from time to time – until it rotted.

"After high school I becames a window dresser for Domus and suddenly I became focused. I thought I would give it three years and see what happened. I don't often make plans – they never turn out the way you hope they will anyway, so I prefer to be surprised."

She fell in love and went with her boyfriend to Stockholm, where she applied to Grundis[2], an art college, and was admitted. She loved textile design so much that she spent a term at the Friends of Textile Art where she learned about eight different materials and the same number of weaving techniques. She was then accepted at Konstfack the arts, crafts, and design college in Stockholm. "I was actually enrolled in Textile Art but kept moving around, checking out the other workshops to acquaint myself with other things. I have always found it exciting to start with a material and then ask myself 'what can I make from this?' I adored rummaging around in rubber and hardware stores. I found some incredibly beautiful rubber strips, among other things – surely it would be possible to make a rug out of them!" This infatuation with rubber came to fruition in her graduate exhibition at Konstfack.

In her early days as a freelance designer she moonlighted as a waitress at the Grand Hôtel, living on yoghurt and crispbreads. She would work between eight and twelve in the morning and then go to her office. Six months of hard work obviously paid off, for she then began getting grants and commissions. One day Orrefors[3] called to offer her a job.

In the introduction to an old interview with Bergström I come across the expression, "glass that is soft, textile that is hard." An apt observation, because that is precisely the way it feels. "That's the way I am – both soft and hard," Bergström says. "It is healthier to have several modes of expression rather than just one." Her hard glass often has soft shapes. Just look at *Squeeze* – the result of a mistake after the glassblower became engrossed in a conversation. "Chance can be very beautiful. Sometimes it's great not to be in absolute control and just allow things to happen."

Bergström's preference for "hard" textiles is expressed in her aversion to draped fabrics. "They must hang straight up and down, preferably in three-foot widths. I had to fight with the manufacturers to get that width – it had to be five-foot widths, for that was how it had always been, they said. But fabric must never feel like a heavy wall", she says, "even when it is considered an integral part of the architecture." She also dislikes fabric when it feels too musty – it must be fresh and airy. In addition to narrower widths, the solution sometimes lies in holes, pleats, and transparency. A fascination with corrugated cardboard provided the idea for her award-winning fabric *Komplisserat*. She also likes black, white, or explosive colours that are never too jaunty, and are always graphic. "Having fun gives me energy. Good vibes are important, I get very excited when I meet nice people."

Team spirit is also important to her, both in her relationship with the glassblowers, and in her favourite sport, basketball. After having been an active player for twenty years, a snapped tendon put a stop to what she refers to as "old-lady basketball at the hobby level." One hobby that she finds herself increasingly devoting time to is wine and food in the company of good friends, as often as possible. "Pleasure makes people kinder, and if I can make people kinder with my products, then I will be happy."

Bergström is also happy when she works with small businesses, especially family-run businesses. She tells me about a collaboration with *Designer's Eye*, for whom she produces fabrics, pillow rolls, hassocks, scarves, and handbags in wool. "As I began to sketch, the ideas just came to me –they had evidently been lying dormant just waiting for the right moment. When *Designer's Eye* said 'we'll take everything' my happiness was complete. It was the first time a producer had said that to me.

"There is usually deep and genuine commitment behind small family businesses that have been passed down through generations. They still have a heart – unlike the big businesses. It is easy to fall in love with something like that!" Her commitment to the country's small enterprises goes back to a holiday job she had as a fourteen-year old. "If we only knew how to utilize all the good ideas around us, Sweden's future would be brighter. It is better to make money from lots of small businesses than a few big ones, and if established business won't listen, we'll just have to take things into our own hands. And above all: the status of handicraft must be raised." With regard to the future, she says, "I want to decide everything," and her bright eyes grow even brighter as she bursts into laughter.

2: Grundis was an art college in Stockholm that gave students the opportunity to experiment with different media and forms of expression. Unfortunately it no longer exists.

 3: The history of Orrefors Glassworks goes back to 1898 and a former ironworks deep in the forests of Småland. Johan Ekman, a consul from Gothenburg, purchased the business because of its forests in 1913. Ekman had no interest in glass but nevertheless decided to continue the business for a trial period, hiring Albert Ahlin from Ed as managing director. This set things in motion. Ahlin proved to be an extremely creative leader, hiring skillful craftsmen and constantly pursuing new ideas. Under the influence of the German glass industry he developed an interest in art glass and managed to instill the same ardent enthusiasm in Ekman. They contacted the Swedish Society for Crafts and Design for suitable artists to engage and hired Simon Gate in 1916 and Edward Hald in 1917. The new Graal technique was perfected later the same year.

More information may be found in the book Orrefors – etthundra år av svensk glaskonst (Orrefors – 100 Years of Swedish Glass Art).

Below:
The award-winning fabric *Komplisserat*. The strong fascination exerted by corrugated cardboard gave rise to the idea behind it. Bergström says of her pillow roll "I drag it around like a security blanket, on the floor, in my chair, or as a pillow".

Right:
Wa glass range."It is mouth-blown, heavy and massive, clear glass to show the world what we are capable of," Bergström says of *Wa*, which means harmony, circle, nothing. Something that just *is*.

66

JONAS BOHLIN

"It is more important to water the
crooked tree than the straight one, since
beauty resides in fragility."

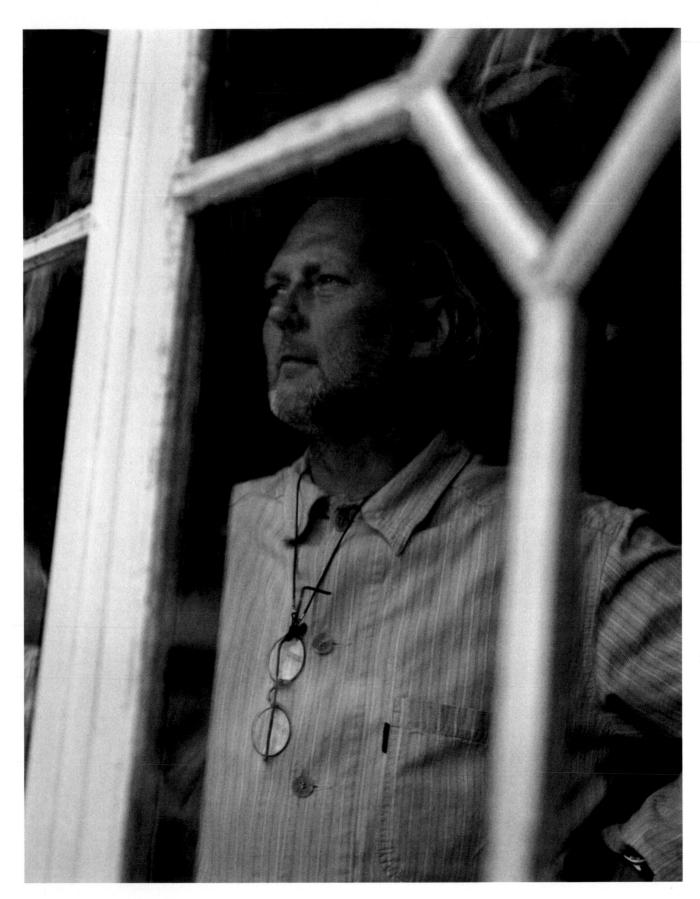

Pages 68–69:
Spring Signs rug för Kasthall.
Left:
Jonas Bohlin.
Below:
LIV furniture and summer cottage.

Thought provoking. After my first meeting with Jonas Bohlin I was almost run over by a bus. Ignoring the red light, I was walking without paying attention, because Jonas Bohlin had planted a number of questions in my mind. They are questions that demanded concentration, with the result that I was paying no attention to the traffic.

Walking slowly, now safely on the sidewalk, I wondered whether I am one of those people who put their extremes in one box and then scramble them so that they meet somewhere in the middle. Or am I like Bohlin: do I go with the extreme ideas and make them a reality?

Much of Bohlin's work mirrors his personality, with its mixture of seriousness and humour, masculine and

feminine, happiness and sorrow, and adult and child. "I prefer to work from an emotional stance, not an intellectual one, both as a person and as designer. I have to perform a tightrope act between different extremes, to try to express a feeling before it is ruined. I often say that if I am like water, my objects are like ice: what I experience is expressed in the way I act and in the things I design. Everything I know I have learned from life itself," he says. "Life constantly alternates between two extremes as if charging the batteries of our lives. Plus and minus, life and death, good and evil. It creates life, balance, change, and growth." As if to continue the point, his elegant showroom contrasts with the empty barn he would love to live in. His choice of materials also represenst extremes – tulle and cast-iron, lightness and weight.

Much to my relief, Bohlin's seriousness is never far from laughter, and it is his "principle of the extremes" that has allowed him to retain his position as one of Sweden's most inimitable designers, with an idiom all his own.

His *LIV* (Life) stool is a typical Bohlin piece of furniture – it clearly demonstrates this encounter between heaviness and lightness. A pillow resembling a cloud rests on three iron legs. It was presented at an exhibition called *LIV*, which documented Bohlin's most important journey to date: rowing from Sweden to Paris with 53 friends in 1994[1]. "The only thing missing on the trip were pillows, so when I made the stool it was meant a way of extolling pillows. But the stool is also about dreams and clouds." The first time I saw it, I immediately thought in terms of a kind of poetic anatomy, which could also be used to sum up his style. The same is true of his tulle lamps, whose ballerina legs may be missing in reality, but not in the imagination.

His interior design for the Sturehof restaurant in Stockholm works as a physical process: you enter past the teeth – the white tiled bar; down toward the lungs – the blue walls of the dining room; past the pulsating bar in red – heart and circulation, love and lust. In the early hours, customers move to the so-called O-bar. The Sturehof has become a popular place for people who want to be seen.

Bohlin's and Thomas Sandell's design for the Stockholm

1: After fourteen years of mental preparations and one year of financial commitment, it was time to realize the idea of rowing to Paris. Bohlin, a born sailor, describes it as one of his many impulses "that have to be nursed, that must be allowed to lie dormant and mature for several years before being put into practice." The project was intended to weave together form, art, work, and nature into – it was hoped – a rewarding experience for everyone concerned.

He designed and commissioned the boat LIV and all the necessary equipment, including linen costumes for the fifty-three crew members and himself. (LIV read as Roman numerals equals 54).

The crew met up along the way, resting according to a carefully constructed schedule. The trip took 116 days and was followed by an exhibition of the same name in the spring of 1997 at the Färgfabriken exhibition space in Stockholm. The furniture collection LIV, presented at the exhibition, came into being roughly at the same time as his son was born. The collection, made up of 20 products, was elegant, light, and playful and included tables and chairs on dancing legs, tutu lamps, and cloud stools. The largest room contained the LIV boat. Above it, in the ceiling, 54 oars – one for each crew member – were moving slowly. Photographs on the walls documented the trip. The audience was transported, to say the least.

restaurant *Rolfs Kök* (Rolf's Kitchen) in 1989 attracted the same kind of attention. It was the starting point for an important trend of high-profile restaurant interiors.

However attention can be suffocating. The interest that surrounded his concrete chair, *Concrete,* was like "adding a full-stop to something, which had not even begun." He says that he has sometimes felt more like the "concrete man" than Jonas Bohlin. The piece caused an uproar in established circles when it was first introduced and it was said that "*Concrete* cannot be called a chair because it violates established norms; it is heavy, impractical, and uncomfortable." Sven Lundh, producer of the chair, defended it steadfastly and vigorously. He maintained that it possessed an aesthetic quality that the rest of the Swedish furniture industry found difficult to understand, because their evaluation was based on how long a chair could withstand the test machines. (See p.30).

A lesser-known aspect of the story is the fact that the chair was first presented as part of an installation together

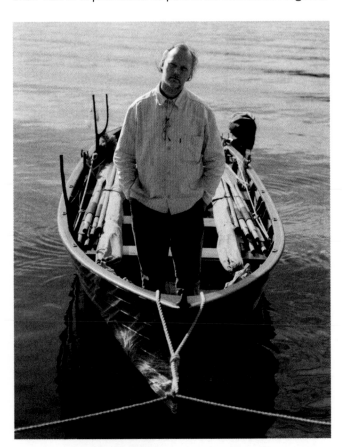

with a pair of toe shoes at Bohlin's graduate show at Konstfack in 1981, where he demonstrated his early fascination with the heavy/light dichotomy. His years at the college were not without problems. Bohlin, who is an energetic and committed individual, often annoyed people by taking matters into his own hands. His graduate installation *Labyrinth-Formula* consisted of four small rooms inside a larger one. Each room had a specific mood, individuality, and choice of material and colour. The objective was to show the impact that various states of society have on each other – like the parts in a formula, or details of a whole.

The greatest design challenge, according to Bohlin, is to put together a form of your own, out of what already exists. "When I succeed, it is the form that has found me, rather than the other way around. It is a matter of discovery rather than design. I have never been motivated by selling furniture and making money but by making discoveries." To illustrate, he describes how the design of his magazine shelf *Zink* came to him. He happened to drop a pile of books on the steps of the subway exit at Zinkensdamm. "The books landed in a certain way, and the design became obvious. It was a big success, and for a while it seemed that there was a *Zink* in every office and in every public setting I visited."

Bohlin's discoveries are often made in conversation with others, and he is quick to formulate an idea. I tell him about an idea I have for a cookbook, and it takes him just under three minutes to finish the sketches for a cookbook idea of his own that also functions as a piece of furniture. "I am often invited to lunch to discuss various ideas and then I hear nothing afterwards. I'm not very good when it comes to hanging on to my ideas." At the same time he feels that it is his responsibility as a human being to help others and to share his experiences, ideas, knowledge – in short, his love "which includes concern."

As a committed person it is easy for him to say yes to various requests for his time. "For example, when I was elected president of the SIR (Swedish Association of Interior Designers), or when I was asked to oversee the creation of a department of design at the Beckman School, or when

"What I experience in life and in nature is expressed in my design. Everything I know, life has taught me."

75

Left and below:
Bohlin's *Qvint* dinnerware for Rörstrand
which was awarded the Special Jury
Award as part of Excellent Swedish
Design 2000.

Nationalmuseum wanted me on its Board." Is he easily flattered or a just control freak? "Well, I think it's more the need to feel clever."

"How do you manage to move in and out of all these roles?" I ask. In reply I get an idea for an exhibition. "Imagine an obstacle course where every obstacle consists of a role change. A clock is ticking, registering how much time you need to adapt to another function. I think that it depends on the connection between how long it takes and how easy or difficult it is. The exhibition idea may become reality one day."

It is typical of Bohlin to think in terms of art before he thinks of design. I remember one of his first exhibitions, an installation of 365 pieces of firewood painted in shades of ultramarine blue, an exquisitely beautiful woman playing the accordion, and a portrait of a Madonna on the wall. He explains the firewood as representing the smallest common denominator of life – it gives off energy. He painted a piece of firewood for every day of the year, the shade determined by his mood that day. The Madonna was a symbol of complementary spirituality and motherliness, the ultramarine colour symbolized The Ultimate, and the bellows of the accordion were a connection with the firewood. The whole formed a life.

He used one of the pieces of firewood to introduce himself to the Architecture Museum when Thomas Sandell invited him to work with him on the interior. "There was Thomas with gorgeous pictures of completed projects and there I was with a piece of firewood in my pocket!" In the end, the Museum of Architecture gave the commission to Sandell without Bohlin, "because – who knows – I might have made it too trendy! To tell you the truth, I never did understand that argument," Bohlin says, laughing.

Bohlin is a man who does not try to hide his need for attention, "the hunger for love is the motor of creativity – apart from the joy and sorrow of discovering things and yourself. Unfortunately people are not very good at expressing themselves verbally when it comes to some-

thing they like. I get many more slaps on the back than honest opinions."

Jonas hopes to realize his dreams of a sculpture studio in the country that would allow him close contact with materials again, and to "piss against an oak tree, sing to the moon, and go skiing before the snow falls", to let go and try something new. In the near future, many more people may get to know and appreciate his work. In spite of his success he has yet to make a big impact abroad – but perhaps now is the time. After recently assuming control of his own production and merging his office with a showroom and store, he now has plans for establishing more exhibition spaces abroad. "Of course I would like to communicate with an international audience, but it takes a lot of work and investment. Right now, I want to be with my son, take care of my health and my artistry. So maybe I'll decide to walk around in my summer sandals, after all!"

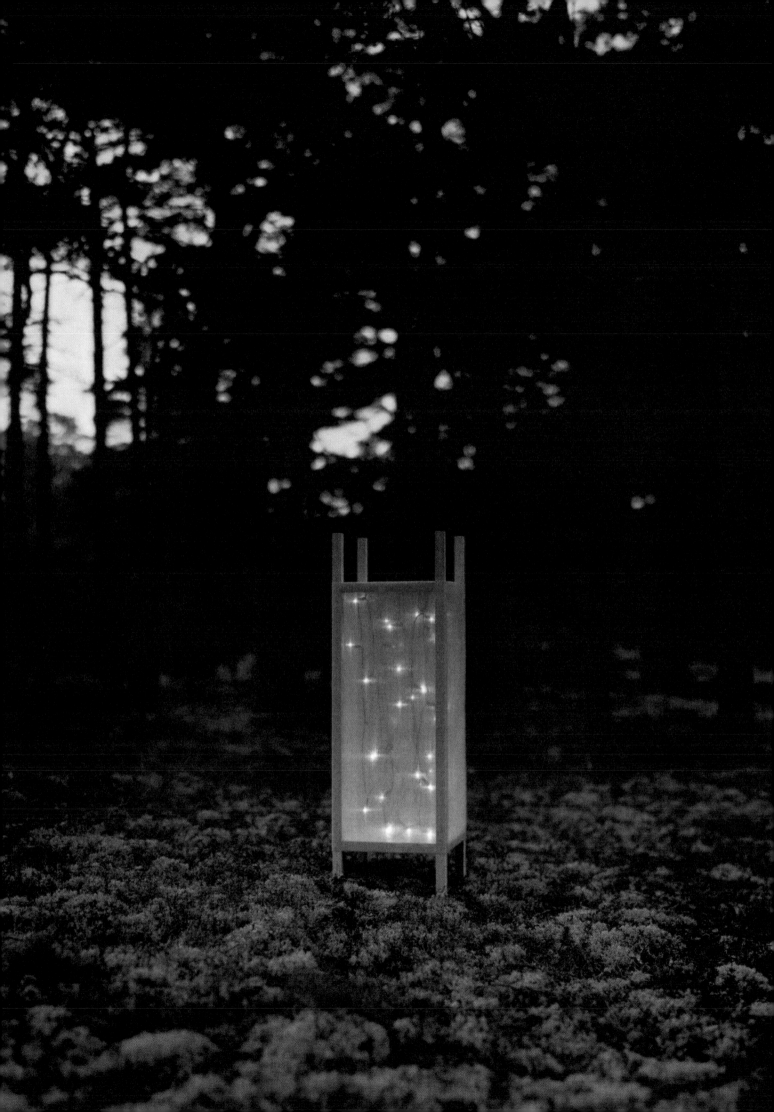

Left:
Milky Way lamp.
Below:
Space chair.

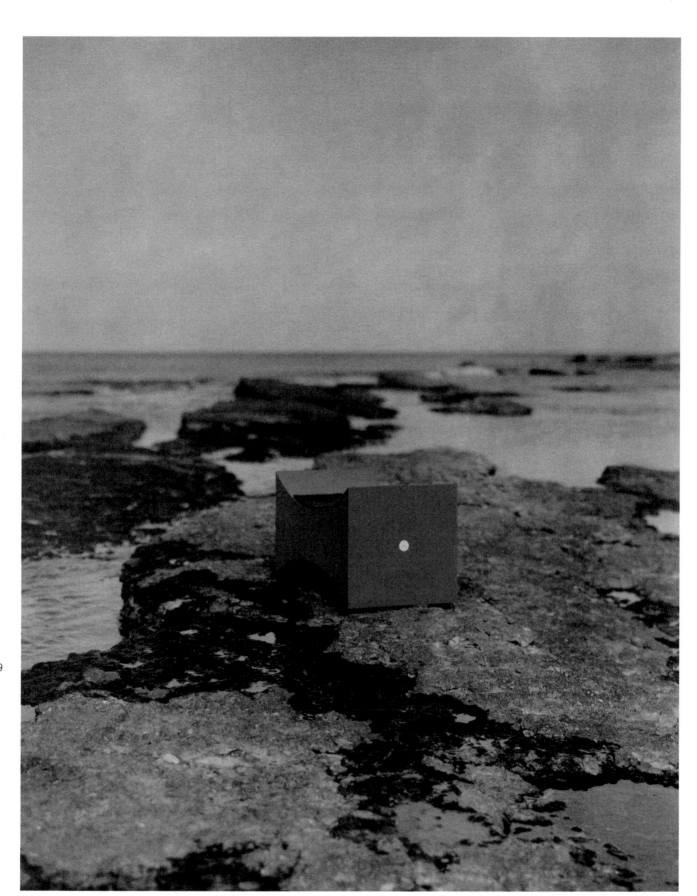

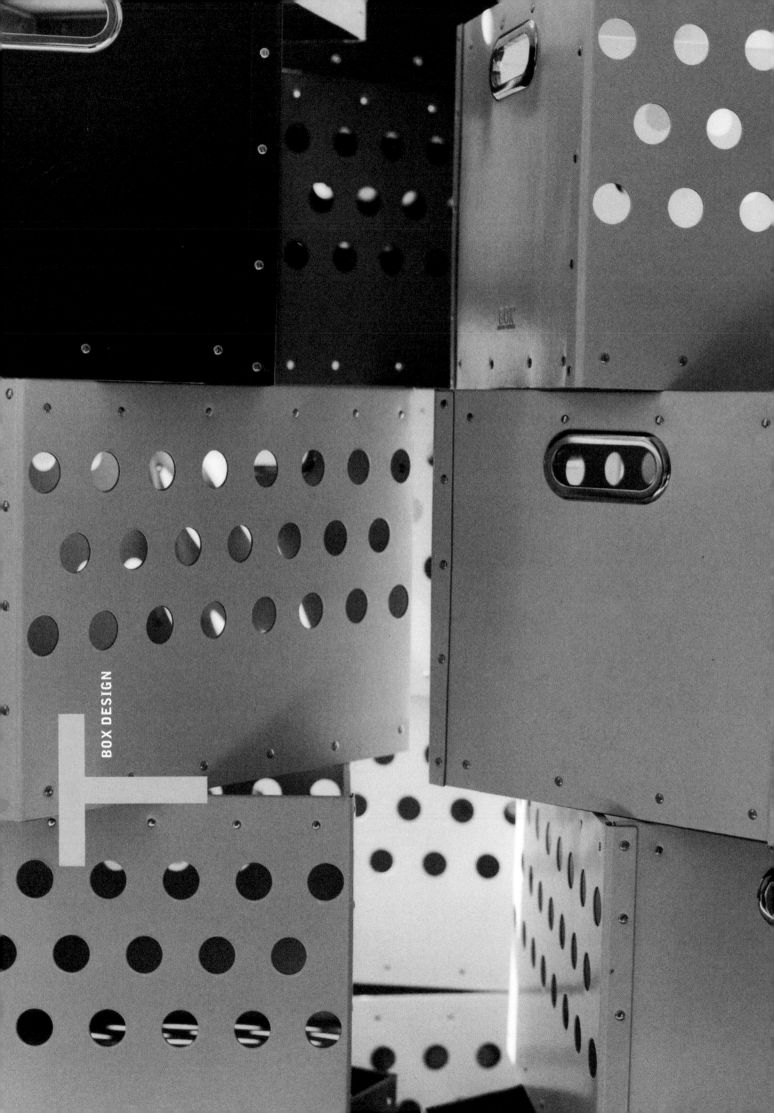

BOX DESIGN

Pages 80–81:
Ann Morsing and Beban Nord, founders
of Box Design, they ask "Where are all
the women in our field?"

We are running our own race, say Ann Morsing and Beban Nord, of Box Design. The topic is the need for participation in the discussion of Swedish design and whether the Swedish furniture industry is too conventional and in need of fresh ideas. "When you have a business to run and a total of five children between us, there simply isn't enough time."

It is quite unusual for two women to be running a business in the design field. Neither of them understand where women designers and architects disappear to after graduation. "It's too bad, since we have both found it to be an advantage to be a woman in this line of business. It would be nice if more women would venture into business on their own or make a name for themselves in an architectural firm."

They describe a lunch for designers during the Milan furniture fair a few years ago. All but three of the participants were men. "It brought the gender distribution into focus."

"Maybe it's because we don't have to be in the limelight the whole time, the way men do. We prefer to work quietly, calling our company Box instead of highlighting our own names. We ought to be more media savvy, but that takes time – and time is something we don't have!"

Morsing and Nord are delighted when other women see them as role models. "It's always nice when we can encourage others by telling them how we work, what a lot of fun it is – but it's also tiring. There is too little creative time in relation to the time spent on administrative matters, especially in furniture design, but we are happy to share our experiences."

They started Box in the midst of an economic slump, having been fellow-students at Konstfack, and they put together their first collection in 1993. "We just felt that we had something to contribute, that our products had an expression that was entirely our own. Strictly classic, yet modern, with a soft, feminine touch. Since we are both interior designers, we saw what was lacking when we were working in various environments, and our collection is largely built on what was missing. It's an exciting profession since it often involves psychology. It has to make people feel at home at the same time as it has to work well – and always within financial constraints." They complement each other well, they say, and

have the same view on the business – the way they would like it to develop and be perceived by others. In addition, and perhaps most importantly, they have fun together.

Box was one of the co-founders of Swecode in 1994, a group of young pioneering producers. Since then, they have made a name for themselves at home and abroad. Over the years they have put together a small, but strong range, based on two fundamental concepts: sound design and quality.

They describe their design style, "It grows out of the needs of the room, with the proviso that it must be very cohesive, involving products that both complement and reinforce one another. It consists of both our own design and that of others. There is also a feminine aspect that comes into play – an urge to create unity and connection. Male designers tend to be more object-oriented."

Morsing and Nord discuss the importance of harmony in dimensions as well as proportions, and I ask what the difference is. "Dimension is about the thickness of the wood, measurements and size, while proportion is about the balance of the whole, the way one thing interacts with another."

Our conversation turns to what they call a kind of design disease. "It is probably true of everyone who works within aesthetics: you are constantly thinking about how things look. You see and register everything – it is as if your thoughts are governed by the eye." They laugh and describe how they sit in the subway thinking, "How can she wear that hat with that coat?" or in the dentist's waiting room "which could become quite nice with just a few minor changes." Always seeing how things might be improved on. "It is not that we think that our taste is better, but it is the inability to stop thinking that way!" Both friends and strangers ask them for advice on interior decoration. "It's like sitting next to a doctor at a dinner table – no matter what you do, sooner or later you end up discussing your physical complaints."

"Because of this way of looking at things we often get ideas, which we jot down on post-it notes. They may be totally off the wall and we sometimes get sidetracked into fits of laughter when we go through them. But just as often they actually result in a new product. We keep chewing it

83

Box Design has added several designers in recent years: Johannes Norlander made *Waves*, a hanging lamp, and *Flower*, a table. Lloyd Schwan made the bookcase *Help*.

The first Box Design piece of furniture to attract widespread attention was the storage cabinet *Frost*, which also exists as a chest of drawers. At the bottom, *Pelle Box*.

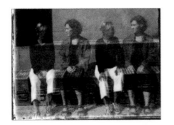

over, chew it over some more and then we draw it. We actually have a lot of fun together and are each other's best sounding board. Neither of us could manage on our own – it is much too solitary! Our idea, sketching, and drawing processes are never fraught with anxiety, the way they are for some. On the contrary, we often have too many good ideas but are prevented from realizing as many as we would like. Once a piece of furniture is about to go into production the fun becomes hard work. The most difficult thing of all is finding good sub-contractors. Quality and price must be just right and their notion of quality must be the same as ours.

Morsing and Nord produce their furniture in Sweden, "Just in case we have to check on a prototype in a hurry. Having it nearby is practical, but there is nothing to say that it has to be produced in Sweden. Going abroad involves language difficulties and quite often higher startup costs, even though it might be cheaper in the long run." They hope that Swedish industry will keep developing its skills and become more daring in using new designers as well as investing in new techniques and materials. "Everyone has to meet the new demands of today and be part of what's happening. The government has already responded to this need, initiating different kinds of encouragement. It's good, because it benefits us all in the end."

Speaking of industry, I ask them to tell me about their bestseller, the *Box PJ* lamp that has had me somewhat puzzled. Isn't it an updated version of a lamp made by an anonymous engineer in the 1940s? "Of course it is. It's so-called "redesign". We simply wanted to keep a good product and bring it up to date. The beautiful original had been compromised in production along the way, so we called the manufacturer and asked if we could show him a new idea. We had brought back the clean, original shape, added some new functions in the form of a foot for a floor or table lamp and made it more appealing to a wider audience. When it became a hit and sales skyrocketed it was suddenly too difficult to keep up. They suddenly told us 'no, we don't want to do it' and dropped everything connected with the lamp. After much looking, however, we have finally found a new

manufacturer. It is great when you find something nice that's already around. Like the base of our armchair *Power Box*. Why make a new one when there is already a good one to start from? We just changed the surface treatment and made a new central support."

Timelessness is important to Morsing and Nord, as are balance and calm. "Today's society needs a quiet foundation, at home and in the workplace. That is what we want to convey with our collection." They compare contemporary Swedish design to a cart-horse. "No, that is a bit too much. But it is both functional and reliable, that's for sure!"

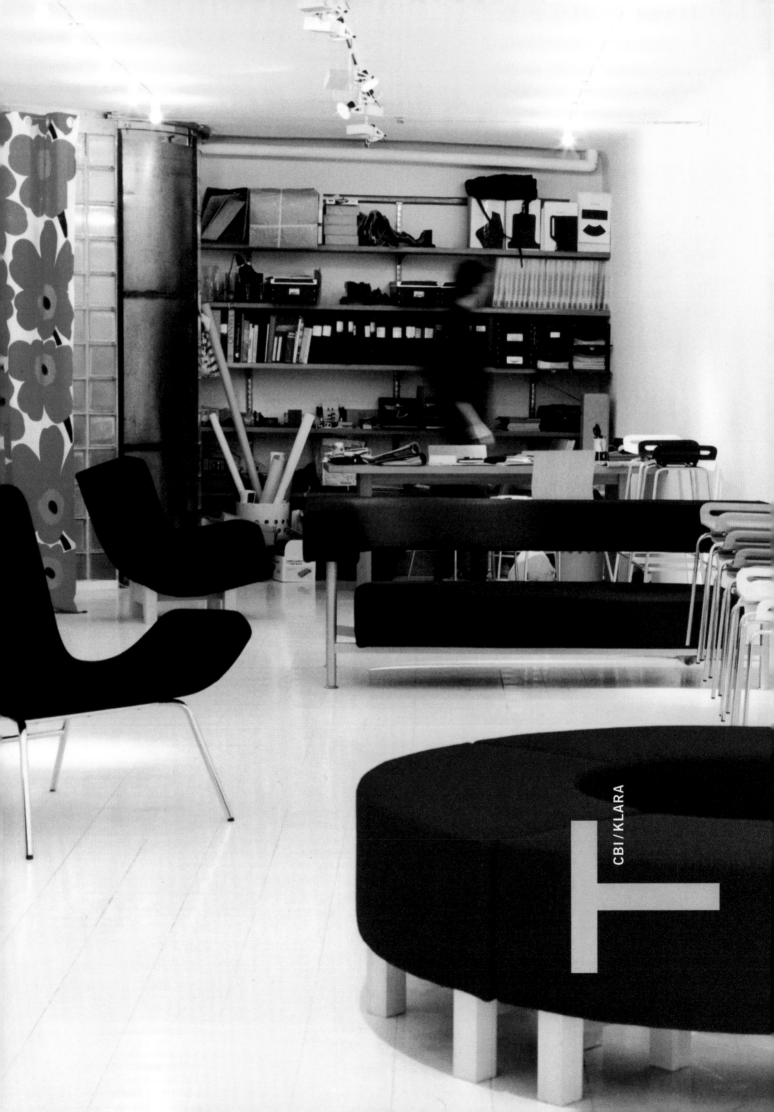

CBI / KLARA

Page 88:
Klara design store, Södermalm, Stockholm.

Page 89:
The cbi showroom with benches and
easy chairs by Björn Dahlström and sofa
by James Irvine[1].

Below:
Christian Springfeldt. He says, "It is
wonderful to know that a Japanese
person is actually seated on a chair
that I have produced!"

"Swedish designers are good at putting
the pen down in time. Others always
have to add something!"

"Today's consumers are more aware of what they are buying and why," says producer Christian Springfeldt who runs cbi[2], and the interior design store Klara. "It is easier to interpret the needs of a limited group of people. Therefore I try to satisfy relatively few people with a small, but carefully chosen and stylistically far-ranging selection of products."

These select few are an ever-growing number of design-conscious individuals who were ecstatic when Klara opened to the public in 1991. There you could find everything from Duralex glass to toys and sofas, expensive and inexpensive items, Swedish and foreign products – all in line with a carefully considered, contemporary design code.

Christian Springfeldt had been working with Stefan Ytterborn, and when they opened Klara together he became responsible for product selection with Jonas Andersson and Klara Tengbom. The timing was perfect as the hysteria of the 1980s had given way to a new economic climate. "The time had come for stylistically pure everyday goods that anyone could afford, so that's what we went in for. It didn't take long before a lot of young designers who wanted us to sell their products came knocking at our door. We then realized that it would be much cheaper to produce the products ourselves, and that's how we also became producers."

Since then, Christian has entered into agreement with the new co-owners, two manufacturers, and designer Björn Dahlström. "I finally feel that I can focus on what I want to be doing: selling and being responsible for the creative side. I want to have time to be a sounding board for my designers. I had been sole owner since 1996 and I felt that it was time to go for a larger organization. Before, I devoted ten percent of my time to things I liked and 90 percent to hassle, organization, and administration. Today, it's the other way round."

He describes the harsh economic realities that face the minor players on the Swedish design scene, and how easy it is for the expensive fairs and exhibitions to drain their finances: "We are entrepreneurs, and every penny we earn is eaten up by our growth. We have taken it upon ourselves to introduce the world to young Swedish design and we have to cover everything ourselves, while our competitors in countries such as France, Holland, and Spain have government subsidies to cover this."

He sees no reason why Sweden could not become as good at exporting design as music. "If only the manufacturers would understand that design is an important vehicle for competition! Designers are still often seen as 'difficult types', apart from which, they are not used to the export business. The Swedish public sector has been their biggest customer for too long, imposing no demands on them whatsoever."

Springfeldt describes Klara's and cbi's range as being characterized by quality design which is both timeless and contemporary. "Klara is our economic foundation, the *prêt à porter*, while cbi is more *haute couture*. Our customers first encounter me and cbi's products through Klara, where the interface is broadened. Close contact with the consumers is necessary if we are to understand what they want. Many things influence this – people are extremely finicky about their surroundings, they may be governed by economic considerations, what it takes to make them feel at home, etc."

The designers represent a mixture of Swedish and international names, with one or two exceptions. "What's important is the product – not the name," says Christian. High quality is also a must, and today cbi's products are manufactured in Sweden, "which is not important in and of itself, but it is easier to keep an eye on the production if it is nearby. If I can help

1: "The year following our introduction of James Irvine's sofa there were eight copies of it at the furniture fair in Milan. They had stolen the basics and added a lot of crap. None are left today, only the original remains." James Irvine is British but lives and works as a designer in Italy and has long been head of design for Sottsass Associati. He was born in 1958 and one of his chief signatures is flexible and lightly upholstered wood furniture, for B&B Italia and Cappellini, among others. One of his most recent projects is a bus for Mercedes.

2: The name cbi comes from the original co-owners Mats Carlsson and Ola Billmont. cbi is one of the businesses that comprise Swecode. For more information see p.34 and p.300.

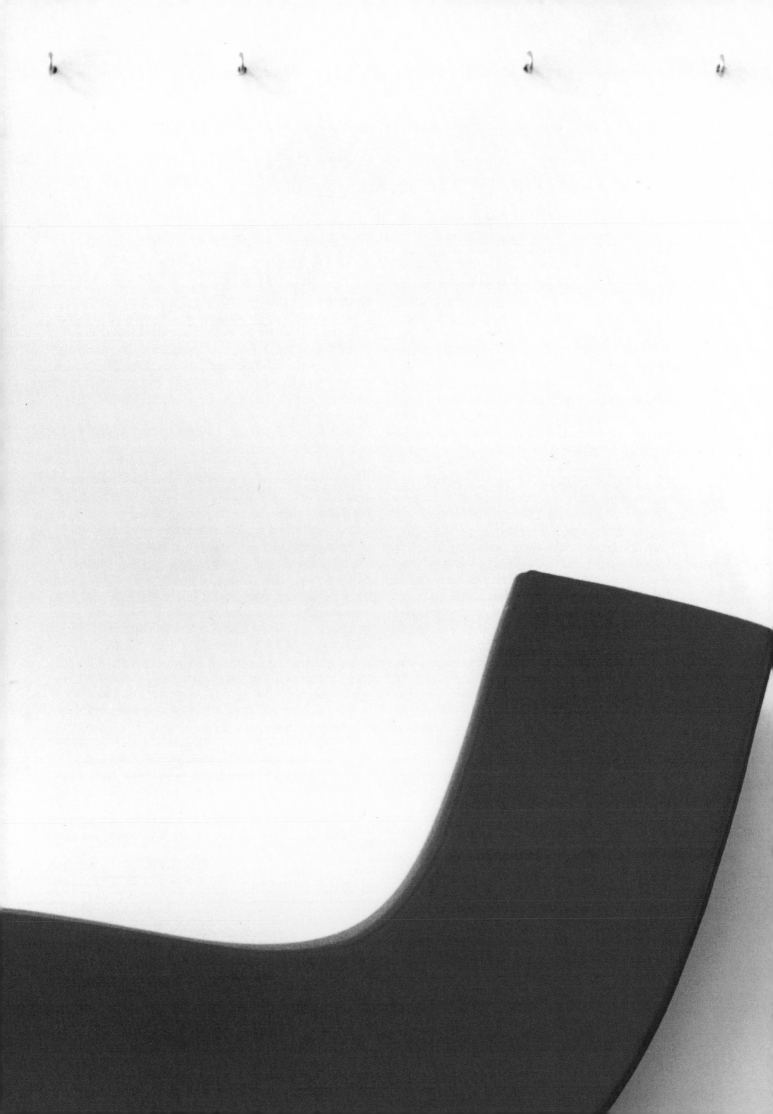

Left:
BD:1 by Björn Dahlström.

Christian helped Katrin Hefter find the contacts she needed in order to produce her lamp herself. "She sells it in Sweden and I sell it to the rest of the world, which works for both of us."

Below:
Clockwise: Danish *Le Klint* lamp; *BD:6*, stackable chairs; *Kivi* Candle lanterns by Heikki Orvola for Iittala; and Kaj Franck's *Teema* dinner service.

When Stefan Ytterborn was one of the co-owners of Klara he managed to persuade Iittala to resume production of *Teema*. It became a bestseller.

support Swedish furniture industry along the way that's a good thing. Besides, it's a fact that the Scandinavian design heritage is more easily produced here – they understand it better than foreigners do."

He cares about his designers and the way they develop. "I prefer a designer to be free to jump from one producer to another as I would not be able to produce a bicycle or a saucepan, if that is what they wanted." Those who approach Springfeldt with a proposal get, if not a firm commitment, then at least a suggestion of which producer might better suit their needs. "Being a designer today is an 'in' thing, and I am absolutely drowning in proposals. It's a lot of fun, but I

hate having to turn nine out of ten away. I can only afford to take on two or three new things a year, since it usually costs at least 100,000 kronor to put a new item into production."

What he dislikes about Sweden is first and foremost the lack of a dynamic debate on design. "There should definitely be one in the trade journals, but also, more generally, in the daily papers." He also thinks that there ought to be a "shit list prize" for those who plagiarize and for the media who encourage plagiarism. "For example when interior decorating magazines exhort their readers to make their own Matz Borgström rug! The consumers must be made to realize that pirating design is like buying a pirated video downtown!"

He has also come up with a better idea than the present Excellent Swedish Design Award, which he finds predictable, and much too costly for the candidates: "neither students nor 'private' designers can afford it. But," he quickly adds, "I am glad it exists, if only to increase public interest in design. When the jury awards a prize to Björn Dahlstöm's electric drill, engineering firms become more attractive and have an easier time finding good people – it's been a problem up till now as everyone wants to go into IT these days."

"My idea is to put the application fees in a pot that goes to one or several winners who get a kind of Nobel Prize in design, where a major Swedish company guarantees the amount of the award. It would inject new life into the field!"

He plans for cbi to become more aggressive on the sales front. "The US and Japan are huge potential markets, and I will be opening a showroom in Tokyo in the near future. The Japanese are always interested in knowing the history of each product – you are not just selling a surface. I hope to be able to give them and my other customers precisely that: strong design and an interesting idea – products with soul."

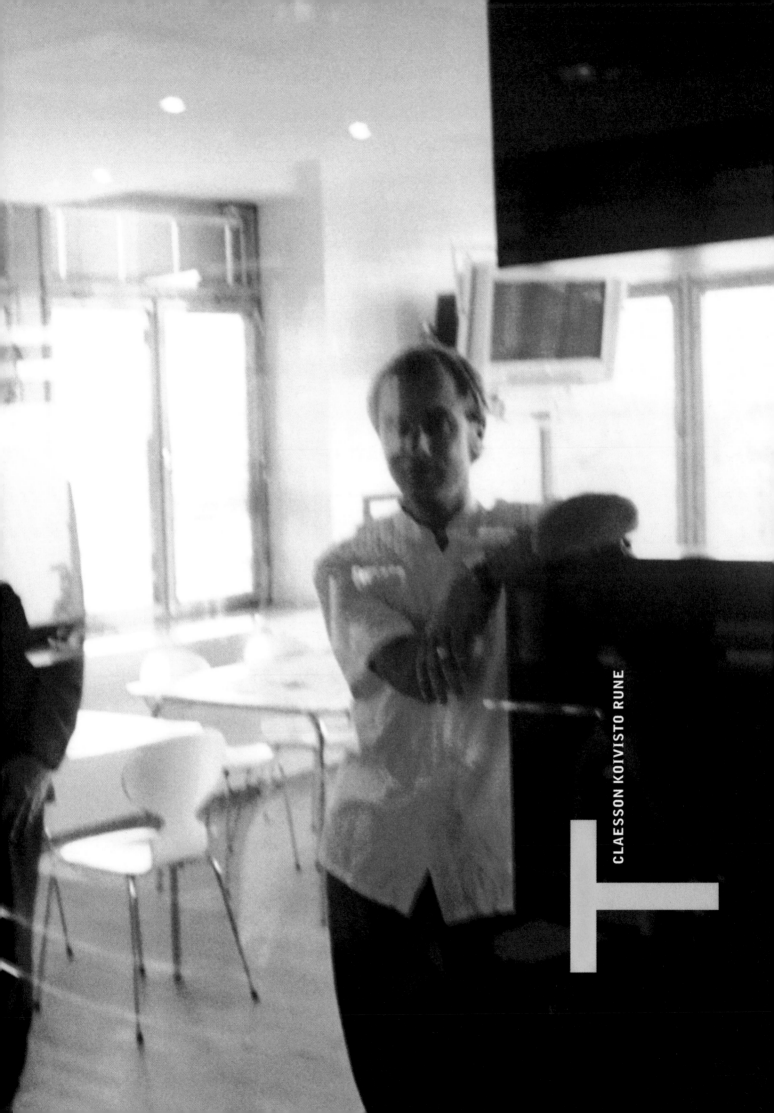

CLAESSON KOIVISTO RUNE

Below:
Bottom picture from left to right: Mårten Claesson and his daughter, Ola Rune, and Eero Koivisto.

"Everybody keeps getting confused by us, including journalists and clients. Once, Eero's father-in-law even mistook Mårten for his son-in-law!"

"Empty is not boring!"

"Actually, people are not moles!"

""Less is still more!"

"Swedish design is elegant but never arrogant. Intelligent rather than intellectual," according to Claesson Koivisto Rune. It is, in other words, friendly, with a functional concept that is nice to look at without being exorbitantly expensive.

Once upon a time there were three men who met at the department of interior architecture and furniture design at Konstfack. They were always the last to leave a party, often deeply engrossed in discussion. They were the ones to make demands of the teachers and who, though mere students, were involved in projects that supposedly required many years experience as a designer or architect. They acquired a reputation as know-it-alls and the fact that their projects were successful enough to be written up in the design press rubbed up many the wrong way. But when they later started a business together, they were both praised and criticized for their work and their attitude.

Throw in a pinch of Swedish jealousy and the unspoken rule of the trade that "you're not supposed to do that," add to that the unshakeable conviction that you have to remain true to your ideas, and the story of their successful collaboration could easily have become a hair-raising thriller.

Luckily, reality proved less dramatic for Mårten Claesson, Eero Koivisto, and Ola Rune. They have been running their business, Claesson Koivisto Rune, with an office at Söder in Stockholm since 1993. "At first it said 'Architects' after our names, but it felt silly, so we took it away. Our work is so much more! As a result, people keep dropping in and asking if this could possibly be a gallery, if the place was for rent, or what was happening here."

An explanation is therefore called for and it expresses much of the trio's fundamental idea that "the room should be empty." Or to be precise: they allow the fundamental architectural elements – volume, surface, light, and shadow – to dominate without adding more. The only thing in their office that can be seen from the street is a table and some chairs – everything white, as are floor and walls. After closing time, the room is bathed in a faint, misty blue light from hidden sources which, on a dark fall evening, conveys the feeling that a spaceship has landed in the middle of the city.

The fact is that when their graduation project, *Villa Wabi*, landed at Segels Torg in Stockholm, their thesis – stark and stripped of objects – was regarded by the Swedish design world as a veritable UFO. Many designers have obviously had a passion for simplicity and purity, but this trio had carried it to an extreme.

"Our aesthetic is to seek the kernel by peeling away everything non-essential and concentrating instead on the proportions of the room, its materials, etc. This creates a beautiful and restful emptiness which we more than need as a contrast to the chaotic world we inhabit. We want our design to instill peacefulness. We extract powerful experiences from just a handful of objects and details."

The simplicity of the rooms bearing the trio's signature reminds me of a stark meditation room, inspiring instant calm. Instead of the incense of the meditation courses, Claesson Koivisto Rune uses cedar for the details in one of the rooms. In this way, their architecture appeals to yet another sense and becomes charged with emotion.

I am looking for the term "essentialism" in the dictionary of the Swedish Academy, but can't find it. For isn't this precisely what their philosophy is all about? We need a table, chair, eating utensils, a plate, and a glass but not a tablecloth, chair cushion, or table mat. If what we really need is optimum design and function, nothing more is needed to obscure or reinforce. In their own homes they have only ten things out in the open – which "makes cleaning a breeze!"

Feeling is more important than function, they say, but they are able to understand why some people see their settings as a personal statement. "There is nothing to hide behind, nothing to fasten your eyes on the way we are used to. When you don't know how to react, your fear translates into automatic rejection, 'I don't understand it, so it can't be good.'"

This incomprehension is hardly surprising since the Nordic tradition is largely governed by the climate – cold temperatures call for rooms that are warm and cozy. The farther south you go in Europe the more spartan the space. That may be the reason why 80 per cent of everything written about Claesson Koivisto Rune is in the foreign press. "There is more ready comprehension and respect and, above all, a vital interest in professional design," they say.

In regard to this Koivisto points to some concrete differences between Swedish and Finnish design consciousness.

"A good object should be different
from others in concept."

Right and opposite:
Claesson Koivisto Rune was given a
prestigious commission by the Ministry for
Foreign Affairs, who asked them to design
the interior of the Ambassador's residence
at the new Swedish Embassy in Berlin.
They chose furniture and objects by vari-
ous designers representing the vanguard
of contemporary Swedish design, them-
selves among them.

Below:
Private residence in Stockholm.

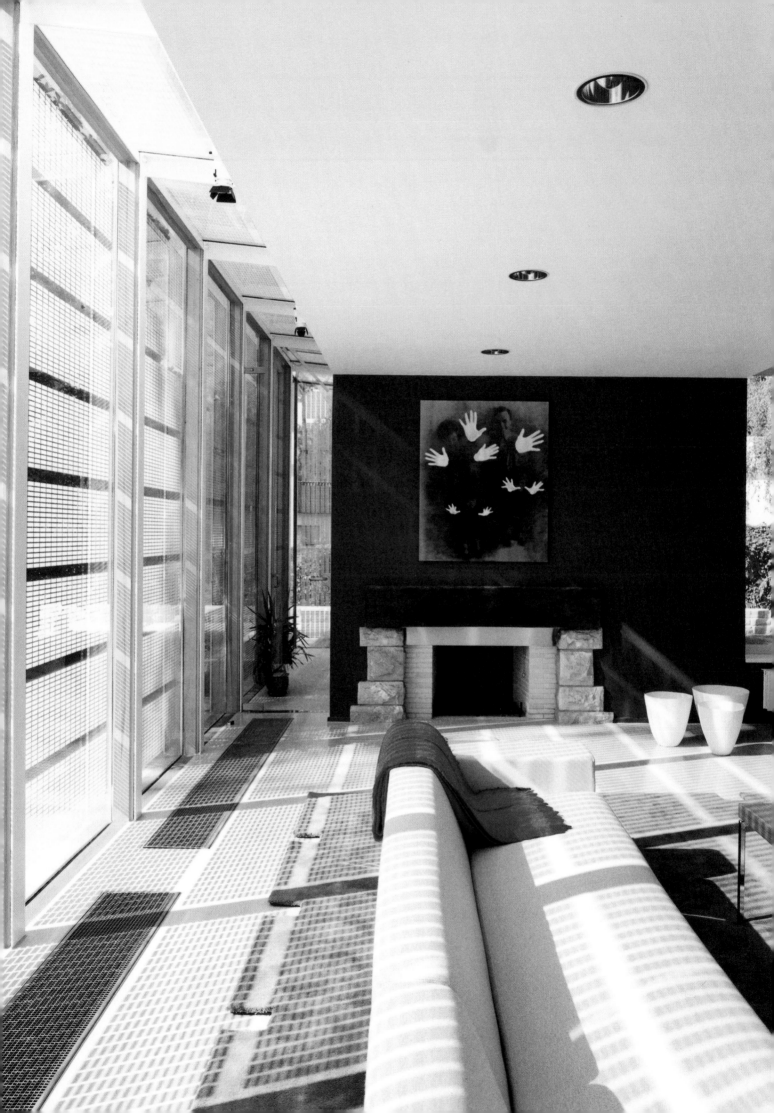

Right:
1a, b "Consider Arne Jacobsen's *Swan* and *Egg* easy chairs. They look good from any angle. *Tinto* (for Offecct) is a chair like that, geometrical from all sides."
2 *Camp* wall clock for David design.
3 Claesson Koivisto Rune ask themselves the same questions as the American designers Ray and Charles Eames did in the forties and fifties: "What do fifty of these chairs look like if you line them up, and what happens in between? And what would the father of minimalism Mies van der Rohe say?" Probably "sehr schön" when confronted with *Bowie*, designed for David design.
4 Bathtub for Italian Boffi.
5 "*Dropp* for Scandiform should allow you to sit while gesticulating without getting caught on the armrests."
6 *Berliner* for Swedese is a favourite from the collection "We discovered that many architects had been using Le Corbusier's *Petit Comfort* in public settings. So we made a modern variant, a more cheerful one!" (Note the smile between the lower edge and the seat.)

In Finland, even the cleaner knows who designed the building. Alvar Aalto's picture is on the currency and you would rather buy a glass by Kaj Franck than an inexpensive, imported one. Knowledge leads to understanding and respect.

In order better to understand the design idiom of Claesson Koivisto Rune, the design community and the media have tried to come up with a label for them, finally settling on Minimalism. We all know that it feels safer to be able to assign everything to its own niche. They themselves maintain, however, that they do not consciously belong to any "ism," but are simply working with a kind of architecture that is meant to appeal to the senses, and that the starkness of their idiom adds strength to the few details that remain. They would rather fill their homes with scents, food, togetherness, and experiences than with a lot of material objects.

When they graduated from Konstfack in the spring of 1994 there were no jobs. The construction and furniture fields were in a slump that would take years to recover from. "The only thing to do was to start a company of our own, without the faintest idea of how to run a business." They all lived in rented accommodation, so they decided to use Claesson's mother's address in Lidingö as their postal address. "It gave a solid impression and looked good. The truth was that we were actually working out of each other's minimal kitchens."

After a while fate smiled on them. Architect Love Arbén[1] was appointed to a professorship at Konstfack. As a result, he had to cut down on his office staff and offered the trio an opportunity to share the space for a minimal sum. "We stayed at Love's for three years, learning the basics of how to run a project. It was incredibly inspiring to share the space with someone who really lived for his work."

Arbén has described Koivisto as a preacher, Rune as an artist, and Claesson as a bookkeeper. They describe themselves as siblings, where Koivisto is the big brother, Claesson the youngest, with Rune in between – which is the way it is in real life. Kloivisto is the driving force, the one to get things going, Rune is the conciliatory diplomat, always stressing the details, and Claesson the analyst and summarizer who makes sure that order and economy prevail.

It is interesting to witness the interplay between them, their deep commitment, their shared sense of humour, and the way they constantly interrupt each other: "our collaboration is in complete contrast with the jobs we undertake – it is utter chaos!" Fortunately they do not bear grudges and their partnership is never jeopardized since, first and foremost, they are friends. "Our relationship is not based on our work but on the person, and the foundation of our friendship is our common passion for architecture and interior design," they say. Besides there is no risk of anyone becoming too cocky – he would be immediately taken down a notch!

They occasionally undertake individual projects and these "act as a spur for the rest of us and we immediately butt in. The difference is that when we do individual projects, the final word always rests with the person in charge. In our common projects all of us have to be equally satisfied," they insist. One for all – all for one.

No matter what they do, the initial focus is always on the idea itself and much energy and time are devoted to it. What, why, and how are thoroughly explored before they even reach for the sketching pen and turn to talking about the design itself. "What we shape is more the idea than the actual product or environment."

Today, Claesson Koivisto Rune is designing furniture for eleven producers at the same time and they don't see any risk that they will wear out their name. "We have already turned many down. Remember that many foreign designers work for up to 40 different producers.

"There used to a kind of mine-owner mentality in this field, with the designer practically indentured to one single company. Today, the situation is more dynamic, which has meant higher quality," they say, describing their common efforts to introduce some new and young freelance designers. "When we see something nice, we often call one of our producers to let them know. We once threatened to leave David design if he did not take on the product we recommended: Monika Förster's lamp *Silikon*[2]. Greater competition and variety sharpens the edge, to everyone's benefit. Besides, it gives us a kick to help others, as others have helped us!"

1: Love Arbén, born 1952, is an architect, qualified in both building and interior design, which is rather rare. He currently holds the title of professor at the College of Arts, Crafts and Design and was one of Sweden's most renowned architectural pioneers during the 1980s and early 1990s. His philosophy is that of empty space, or as Mies van der Rohe put it: "Less is more." Arbén has designed a number of well-known products for Lammhults. His work is represented at the National Museum of Art and the Röhss Museum.

2: See Monika's lamp on page 123.

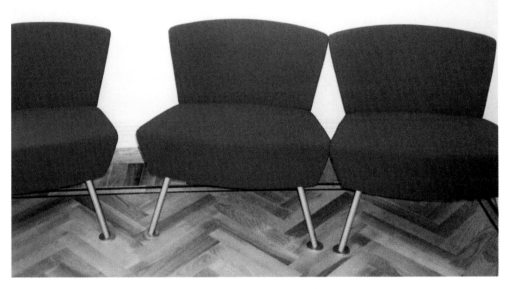

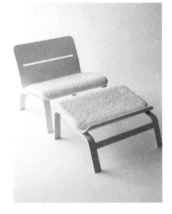

BJÖRN DAHLSTRÖM

108

I want to do men's coats and cell phones, says Björn Dahlström who has worked on animated film, furniture, pneumatic drills, carpets, tents, toys, logos, bicycles, and saucepans, among other things. Something tells me that whatever Björn Dahlström wants to do, he will do, and I gladly confess that I am much impressed. Björn is the closest thing to a Renaissance man that I have come across. He moves freely between various forms of expression, materials, and media, with uninhibited imagination. Maybe this freedom is rooted in the fact that he is self-taught – which makes him no less fascinating.

How does a man who would rather make a rocking rabbit than a rocking horse think? "The runners look like long feet and rabbit ears are perfect to hold on to!" He thinks everything through to the end; he takes time to dig deep, in search of discoveries and new possibilities. "All design is actually communication, so it is all about analysing what it is you wish to communicate. How do you reach people, how do you encourage them to buy and use something? How do you make them understand the function?"

His own motto, and the answer to these questions is clear design. Children immediately realize that they are to hold on to the ears. They would also – were they allowed to – immediately comprehend how his Primus burner (a soldering gun) works. It looks like a pistol with simplified and readily comprehensible functions – basically only an on/off button.

The analytical process that preceded his saucepans for the *Hackman Tools*[1] range provides an excellent example. He made a total of ten pieces of cookware – the pots in a new, sophisticated sandwich technique developed by Hackman. The inner and outer layers are stainless steel with an aluminium core. But how did he arrive at an optimum size, the placement of handles, their shape and angle, the exact height of the ridges in the bottom of the grill pan and the dome of the lids?

"We had an advisory group consisting of chefs from Norway, Sweden, and Finland as well as myself. All we had to do was to discuss in depth the answers to all my questions. My role, before I produced any sketches, was simply to ask questions. What existed already, what was good and bad, respectively? What did they want? They might point out that they wanted the juices from a piece of meat to run in a special way and it was my task to see to it that that is what happened."

Many of Dahlström's industrial processes are similar. Problems are solved within a group of specialists – biotechnologists, material and technical specialists, and marketing and sales representatives. "As an industrial designer it is easy to think that you have to know everything, but luckily there are specialists to work with. We Swedes are good at teamwork, we seem to be used to arriving at consensus solutions." And the earlier he enters the process, the better he feels.

But the job isn't finished once the product is in the store. In the case of the saucepans, Björn was also there, accepting praise and criticism. "Some women found them too heavy, and I was able to explain that the chefs' group had prioritized heavy metal. That function and performance had come before weight." He finds it pointless to try to come up with a product to everyone's liking. "I think that a product with strong integrity and identity, clearly designed for a specific user, has a greater chance of surviving in the long run."

In this context, he tells me about a visit to a factory which, for a time, was entirely given over to toys of his design. "It was like Santa's workshop – the entire factory and the warehouse were full of my things. I was overwhelmed with happiness!" And, believe me, his eyes light up as he smiles at the memory.

His feelings were the same when Skeppshult offered him a test run on the first few prototypes of what he refers to as his dream project: being allowed to design a bicycle. "They took me out in the backyard; the sun was orange, casting long shadows. They were a bit secretive and at the same time enormously proud of the result. I kept riding and riding – it was marvellous! It was hard to sleep that night."

"I had long been asking myself why it was that innovative thinking when it came to bicycles was synonymous with new materials. Was it not possible to think innovatively using the old ones? So I called Skeppshult and told them that I wanted to develop further the traditional steel tube bicycle, transforming it into an attractive, high-performance, technical instrument of good design." It took him two years before that test run at sunset. "There was something very special about

1: Hackman is one of Finland's largest companies, whose acquisitions include the Swedish Rörstrand. In 1996 they approached design strategists Ytterborn **⊢HACKMAN**® & Fuentes (see p.303) and asked them to come up with the basis for a new company and design strategy. The Hackman Tools collection was part of this effort, for which Dahlström and Seth Andersson made cookware, and salad bowls and cutlery, respectively.

Other participating designers were Harri Koskinen and Stefan Lindfors from Finland, Glen Oliver Löw from Germany, Antonio Citterio and Renzo Piano from Italy, and Ross Lovegrove from the UK.

"If you are to survive as a designer in this tiny country, you have to have breadth."

Below:
Clockwise: the letter "T" became the *BD:5* easy chair; the *Joystick* hiking staff designed for the Italian company Magis who wanted to produce items to encourage outdoor activities. On seeing the first sketch, the owner "had a heart attack from happiness"; the Skeppshult *Z Bike* which got its name from the characteristic shape of its frame; the aluminium *BD:3* candlesticks.

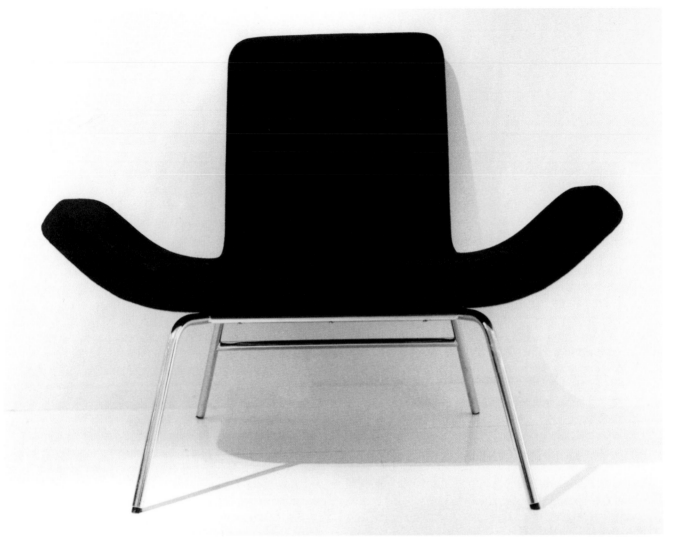

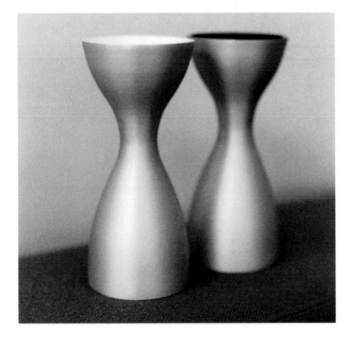

110

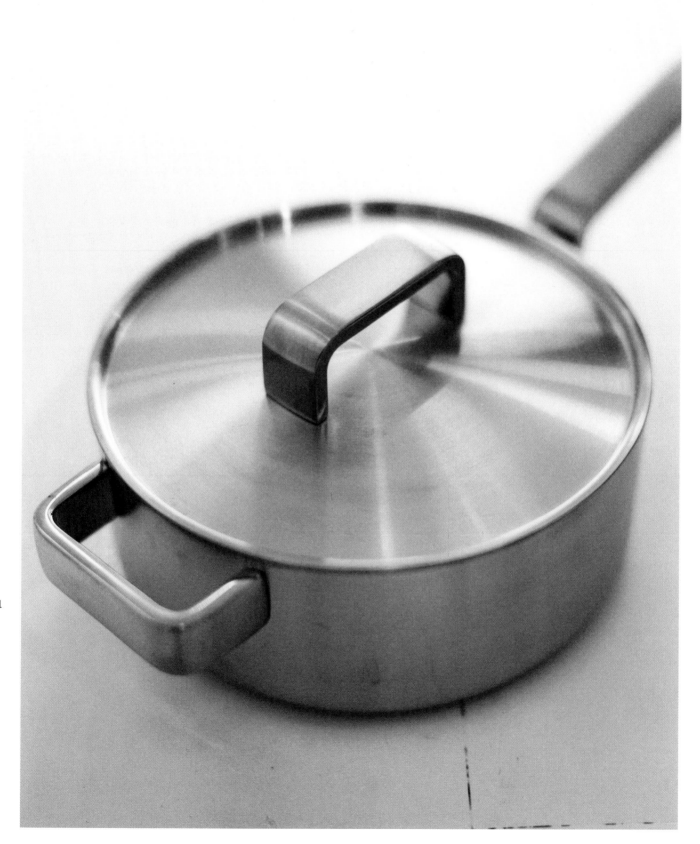

making a bicycle – it is, after all, your first piece of capital goods. It is both a means of transportation and the most beautiful thing you have ever owned. You never forget your first bike. With regard to 'my' bike: it was up to me to give the user his money's worth for the 12,000 crowns it cost."

Dahlström often calls up a suitable manufacturer to present an idea of his, as he did with his tent. "I asked myself who in the whole wide world would I most like to make a tent with. *Fjällräven,* of course. They are on a first-name basis with all of Sweden, everybody knows 'the Fox'!"

Sometimes it is the other way around, of course. He was once called by a manufacturer who asked whether he had any good uses for their new computerized router. The result was an entire series of children's furniture in particle board.

Dahlström works like an inventor, particularly with furniture, where he has a much freer hand than with his industrial commissions. "There is no one to order me around, it is my safety vent. I am allowed to build entirely with my own ideas and needs. Much of my furniture is based on experiments. How large or how small can an easy chair be? How much can I strip away and simplify without losing the basic concept?"

In making the famous *BD:5* (the name made up from his initials and a sequential number) he cut out a number of T-shaped pieces of paper of different sizes. Then he twisted, turned, bent, cut away, added, crumpled up, threw away, and started all over. Over and over again, until the proportions were just right. "I am a perfectionist and fully capable of starting from scratch at the last minute after weeks of sketching and drawing. I don't get much sleep!"

His sounding board is Christian Springfeldt of cbi. This company, of which Björn is still a co-owner, was long the exclusive producer of his furniture. Today he works with many other partners, several of them Italian, making everything from furniture to hiking staffs.

His ideas are often born out of purely personal needs. "If it takes two hours to get the heat going in my summer cabin then I need a comfortable chair with a built-in sleeping bag. Or after a stress-filled week – isn't that just want you want: something to crawl into and feel the stress melt away?" Of

course. His chair *Relax* is not just nice to look at, it is also designed for easy distribution and comes in a flat box, ready to assemble. For furniture design is not only about design. The more attention paid by the designer to economy and transportation, the better the chances of it selling well.

"Of course I feel a certain responsibility for that aspect as well. I also try to teach the companies I work with the importance of good design; I don't like to compromise but I don't give up easily. I want them to understand that design is more than just screws and bolts, that it is caring for image and brand name. I am not a polemicist, but I see my products as my contribution to a debate. I am happy to stand up and talk about them, discuss what my thinking was, and so on."

Ten years ago he thought much about the fact that here he was, contributing more things to a world already filled with things. "But then I realized that if I add something unique to every product, take it one step farther, add something that is missing – then it's OK. As a consequence, every single product of mine requires a lot of careful thought."

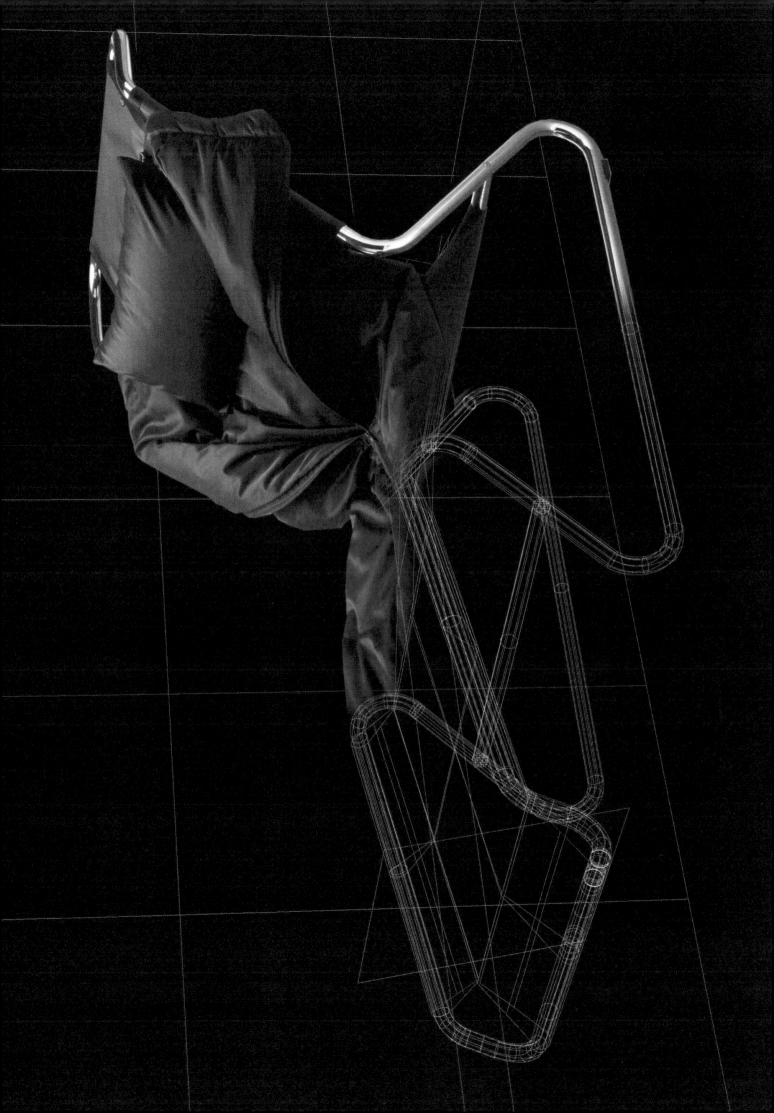

Below:
Dahlström with the *BD:6* chair. After first working with animated film and then as art director for an advertising agency, Dahlström started his own business as a graphic designer in 1982. "Advertising was not my thing!"
Right:
BD:6 chair.

114

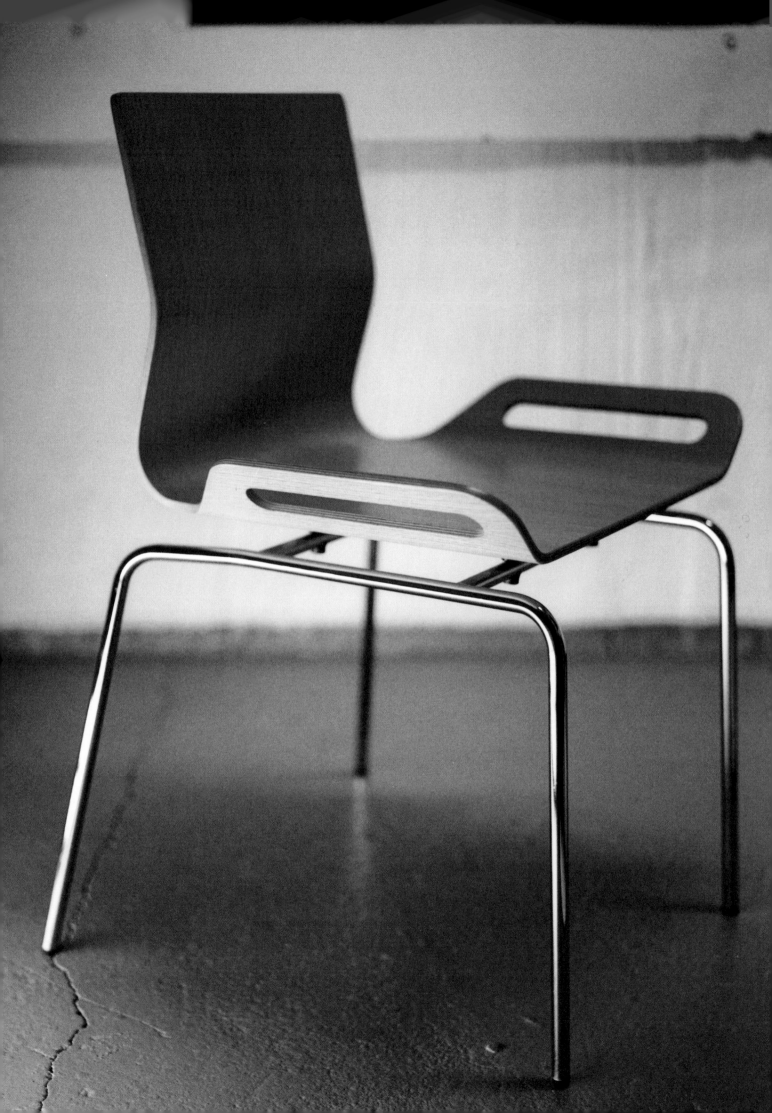

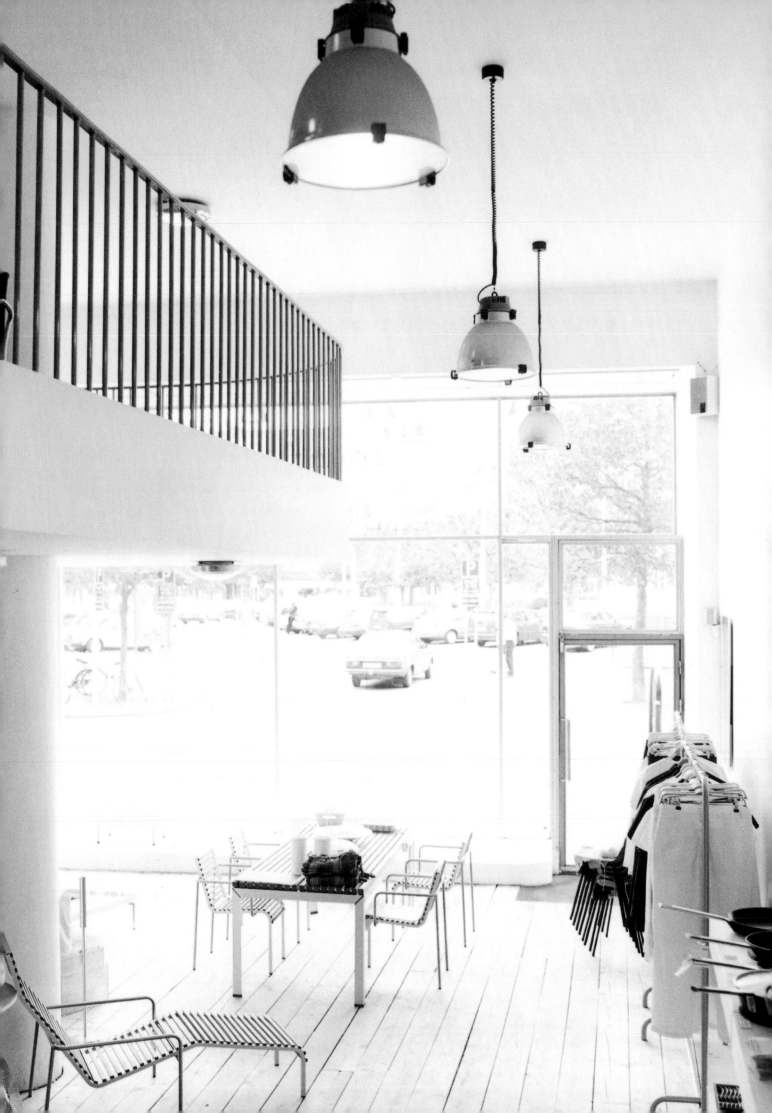

Lifestyle, totality, and synergy are what it's all about according to David Carlsson, owner of David design. Not just producing and selling furniture. "Peddling the stuff is not enough. Today's consumer is pickier, and now that so many products resemble each other, a different set of selection criteria are at play. People are looking to what the company stands for. That's why I hope that you will find credibility, a unified vision, and a clear line in what we at David design are doing. And, I hope, honesty and a warm, relaxed attitude."

The latter quality is the first thing I encounter when I step in from the magnificent Stortorget, Malmö's central square, onto the beautifully mellowed floor planks. I give them a cheerful "Hi, there!" and it seems as if everyone in the shop falls silent before breaking out in laughter. "That's not the way we say it here," says David with a laugh, giving me a brief and intensive lesson in how to greet people in the local dialect. "Hulleeh-oh" I sound, and after a few tries I've got it.

We walk around while David talks about thinking in terms of the whole picture and of the importance of creating a strong brand name. "David design is here to make the life of the consumer a bit better through the things we carry, to improve people's quality of life in some way. To free thoughts through simple lines in a clear idiom. That's what is at the very bottom of our heart and our convictions!" He talks about how the business concept – to work with design-oriented products and services – is complemented with a kind of filter of certain key words through which everything they do and produce must pass. "It is like a check list of both hard and soft values to ensure that the whole is right. We have just invented a word for it: Davidishism," says the father of this "ism," proudly.

The totality includes everything from customer contact and marketing, to the range of products and the relationship with the designers where "the social aspect is terribly important. You can't just talk about the job and design." Even so, there is a kind of unified thinking among target groups, as it turns out that they not only like the same type of furniture and decorating style, but often the same type of music, fashion, technology, and food. "This is where lifestyle and synergy enter the picture. Why not offer all of it, now that we are on firm ground? Why not complement the brand name, store, collection, and agencies[1] with David books or David records?" says David who has a long background in music, both as a performer and administrator.

"It is terribly important to me to get a kick out of what I am doing, to feel that both myself and the business are developing. Being stuck with furniture – however good or contemporary – would be boring. There are no limits, really, and since I slid into this field on a banana skin, it is easy and feels right just to keep on sliding, without letting David design slip from focus. It goes without saying that from an economic point of view it would obviously be smarter to concentrate and focus our efforts. But it is more fun to have a broad span!"

The banana skin image is nice. Since his own business background is based on the fact "that I hate being told what to do," he hesitated between opening a café or a design store in the late 1980s. "After working in music for so long, I wanted to do something totally different. Something of my own. Either a kind of French *bar tabac* or something with design. Then the lazy streak in me – the one that has no deep philosophical reservations whatever – said OK, why not? So I started selling the usual design icons of the time such as Philippe Starck[2] and Xavier Mariscal[3]. Nothing Swedish – there was nothing fun at the time. But then along came Thomas Sandell and we did an exhibition together – I think it was 1990 – and suddenly it felt like something exciting was actually happening here at home. Then followed another exhibition with a whole group of young Swedish designers. Lisa Steen, Elisabeth Ancker, Thomas Eriksson, and Sandell again. All from Stockholm."

Slowly but surely, David switched over to the Swedish track, and with it came a deep, loving interest in design. At the same time, it annoyed him that everything was completely dominated by Stockholm. The result was his first collection of Malmö-based designers: Olof Kolte, Jonas Lindvall, and Helene Tiedemann. "Being tired of the capital Mafia may sound like a ridiculous reason to develop a collection, but that was actually the case! I am really happy to be based here in Malmö and I feel a greater affinity with Copenhagen

1: David design is the Swedish agent for the English company Bisley, whose products include metal storage systems. It also is the worldwide agent for Pia Wallén's own collection.

2: Frenchman Philippe Starck, born in 1949, might be described as one of the world's most productive and versatile designers of the 1980s and 1990s.
He is known as a cross-disciplinary enfant terrible and media favourite. Starck has designed everything from hotel interiors and motorcycles to toothbrushes and juicers.

3: Spanish designer Xavier Mariscal, born in 1950, established his somewhat eccentric style during the 1980s. He is also a graphic designer and his idiom, often with humorous touches, has been compared to that of a cartoonist. Who doesn't remember Kobi from the 1992 Olympic Games in Barcelona?

Pages 116–117:
The store at Stortorget in Malmö was for-
merly home to *Skånska Brand* insurance
company.

Below:
David Carlsson, a stone's throw from his
house in Falsterbo.
"We mustn't be so damned Swedish, but
must see to it that our rational heritage is
mixed with what is international and contem-
porary. Function and solidity we are already
good at – now we need some sex appeal!"

119

and the continent than with Stockholm." Nevertheless, his collection has become more mixed over the years and now also includes some artists from the nation's capital.

"I would sure as hell hate to be a designer," he suddenly says. "It must be terribly hard to be so dependent on others, to have to compromise both design and execution in order to meet the demands of producers and manufacturers alike. And to have to sell yourself – they ought to teach you how at school! Small wonder then that so many disappear after graduation, totally unprepared for the crass reality that awaits them. And many of the others become terribly stuck-up and seem to lack all semblance of humility. It kind of strikes me as utterly wrong for someone who is about twenty three and just out of school."

We agree that trying to sell yourself used to be a no-no, especially among architects. "It is very Swedish, this jealousy that makes people come down on those who help themselves, who go against the conventional. I'm talking about very experienced people like Claesson Koivisto Rune, whom I work with, for example. They booked some meetings with the design press at the furniture fair in Milan that actually paid off, so that they were written up and got some commissions – all completely professional – this was even more frowned upon by their Swedish colleagues."

David design was one of the producers that helped found Swecode (p.34) in 1994 in order to pool their resources and launch themselves abroad. "The idea was fabulous: a group that shared the vision of getting the message out about contemporary Swedish design. We realized that we were tiny, and that our only salvation was to join forces. Swecode made it much easier and quicker to get established abroad. But we were still in a co-operative format, so in 1998 I felt that it was time to move on and take another step, this time on my own."

David Carlsson does not share the view of most Swedes that the current trend of simplicity originated in the 1950s in Scandinavia, but sees it as a natural awareness of a world that is filled with pollution and excesses from the 1980s. A reaction was needed and it became synonymous with a yearning for simplicity. A simplicity that we were ready to produce in the early 1990s.

He also questions whether the considerable attention from international media has actually resulted in increased sales figures for any Swedish furniture manufacturer. "Many consumers have been given an opportunity to read about our stuff, true, but the question is how many of them actually buy a Swedish product and not an Italian – equally stark and

Funk storage units by architect Per Söderberg. He made them both for his own needs and as an interior design project when it turned out that David needed a storage system for his range of products. The modules are available in three widths, four heights, two depths, and with both high and low legs. The doors can be either solid, in about ten colours, or "filled" with wood veneer, Plexiglas, or metal. "It is interesting to see the shape acquire a function", Söderberg says, referring to the large, rounded handles. "I am leaving the customer great freedom to create the final style."

Above:
Clockwise: *Hockney* Sofa by Eero Koivisto. *Wool*, knitted wine-coolers by Erika Mörn. Ola Kolte is the designer of *Bowl*, a lighting series. *Byrne*, a chair also by Eero Koivisto.

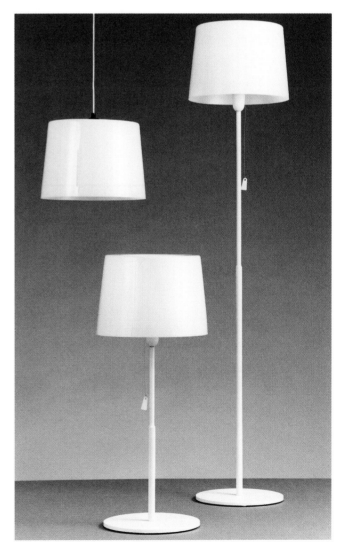

"If someone were to call from Austria, wanting to put on a design exhibition featuring David design, we have five key products that clearly reflect who we are. *Bowie*, *Byrne*, *Hockney*, *Silikon*, and *Funk*. In addition, they sell well!"

Below:
Bowie by Claesson Koivsito Rune.

What do *Hockney*, *Bowie*, *Byrne*, and *Toop* have in common apart from the fact that their producer lives in Malmö?

Answer: The artist Hockney, the musicians Bowie and Byrne, and arts writer Toop are all called David and are extremely well known within their respective fields.

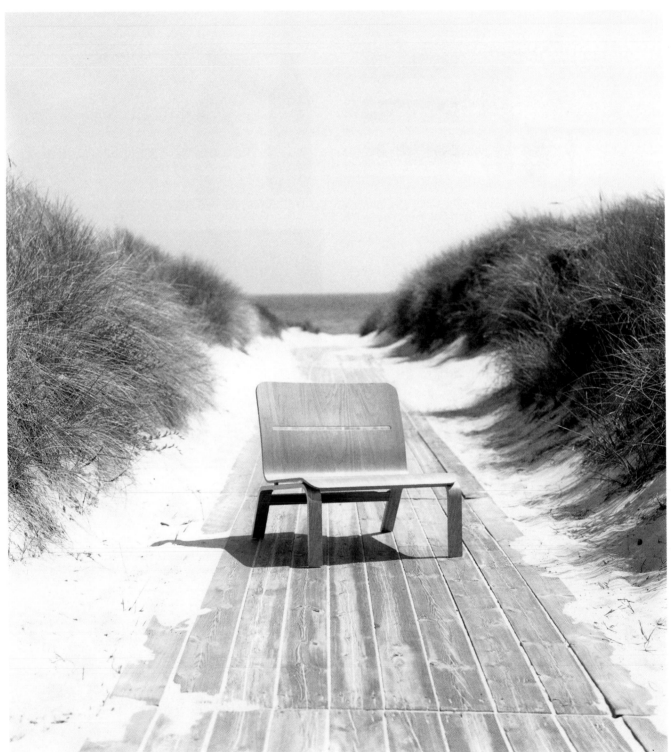

122

often of better quality? I think that the attention has primarily made it possible for us smaller producers to find a kind of shortcut, a chance to pick up speed a little faster. To increase our collections, acquire more space, more agents, etc."

In order to respond better to the international market David has hired a marketing director and a person in charge of logistics. "Now it is up to us to build from the inside, with a strong organization. To become better at what we are doing and at the same time look to establish more David stores. In Sweden, as well as in London, Paris, Berlin, and New York. The idea is for me to free myself in order to work more with actual business development, new strategies, and visions – I am really raring to go. I realize that I am not good at everything. I also want better overall control of our brand name. I am still very much the entrepreneur who wants to enrich the soul of the business and lead everyone toward the same goal. And I hope that everyone who is part of the business gets a kick out of becoming larger, better-known, and going international. Oh, my God, I sound like a commercial, " 'Draw the bow, strive towards the same goal. Together you will reach undreamed of results,'" he says laughingly, "but I actually think that that's the way it is."

The collection has long been his special baby, and it is constantly being added to and developed. "I don't have any special favourites. They are rather like children, I love them all equally." Three questions are vital in making the selection: Is it good design? Does it strengthen the collection as a whole, and does it fill a void either with regard to function or need? "There must also be room for spontaneity and flexibility, however – and there is, or we would never have taken Erika Mörn's knitted wine-coolers aboard! The hardest thing is to say no – as with everything else in life."

David also wants the customer to know the history and idea behind the product. "I think that the more you learn about design and the more you have things explained to you, the more you understand and the more you like. And the product becomes more valuable to the user. As in the case of Monika Förster's *Silikon* lamp: once you understand her thinking, it ceases to be just a blob of rubber!"

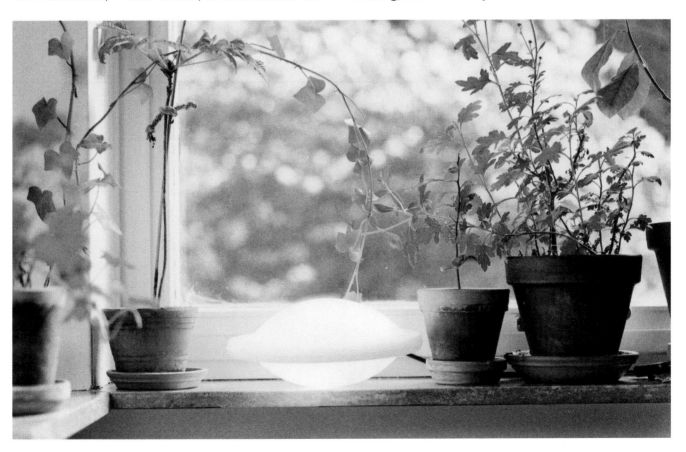

DESIGNTORGET

There is something comfortable about John Hamberg and Jerry Hellström, the owners of DesignTorget, like an old married couple. They have a perfect understanding of each other and are used to being interviewed, often completing each other's sentences. When I got to know them during a joint project in the spring of 1997, I took Hamberg to be a somewhat restless innovator and Hellström as more thoughtful and restrained. They agree with this, but point out that they often differ in opinion. Hellström is good with words, good at decorating, and has a wide network of contacts, according to Hamberg, while Hellström praises Hamberg's organization and production. They are a couple who complement each other when it comes to business.

It was Hellström who conceived the idea of DesignTorget in 1993 after some time spent as a consultant for Kulturhuset. "Do something with that useless space at the ground level," the director told him. This was during the worst period of the economic slump and barely half of the country's designers and architects had jobs. It was this sorry state that gave Hellström the brilliant idea of creating a market for designers and craftsmen who were having a rough time. To rent out a space in the limelight!

The final concept was simple: why not exhibit your wares on a rented pallet in one of Stockholm's most frequented business sites. The City and Kulturhuset were happy to give the proposal their blessing, helping defray initial costs for rent and staff. Hellström did a mailing to about 3,000 industrial designers, interior designers, and craftsmen, that he got from a number of membership lists. The answers came trickling in, and Hamberg recalls that when he got his invitation he thought there was something fishy about renting a space for a day or two. His business, Gasp, which sold furniture and products by recent graduates, young designers and enthusiastic amateurs, rented three pallets and hoped for the best.

On the opening day, September 13, 1993, all seventy pallets were filled with everything from eggcups, soap dishes, and tea cups to notebooks, hats, small furniture, and pillows. A retired librarian, Hellström's ex-wife and an Employment Development employee were manning the cash registers. There were more journalists than exhibitors at the press conference, but thanks to the media word quickly got out. Success was assured and everyone was happy.

Once DesignTorget was an established fact it became apparent just how many people there were who retired into their workrooms after a day spent as a nurse, teacher, airline pilot, or lawyer to devote themselves to woodworking, sewing, weaving – just being creative. Nevertheless, it was mostly design students and professional designers who offered their wares for sale. Products kept streaming in and eager customers were lining up.

As is the case with all good ideas, you wonder why on earth no one had thought of it before. The need had been there for a long time. To design and, to a certain extent, create your own pieces is easy as pie, compared to trying to find an outlet for them. DesignTorget offered the possibility of selling products and testing the market in exchange for some rent and commission. The exhibited products had to be articles for everyday use, of good quality, originality, and newsworthiness, and preferably with a whimsical touch. Hamberg and Hellström both stress that the individual behind the item is not important – it is the product that is being judged. However they are naturally pre-disposed toward the workshop for the mentally challenged. They are extra pleased when their products are accepted – and Hamberg and Hellström want everyone to be happy. It *should* be fun!

Hamberg became co-owner of DesignTorget in Spring 1994 and soon came up with the idea of exhibitions devoted to a specific theme. Over the years, they have invited designers to contribute to themes such as kitchen counter, bathrooms, entrance halls, toys, Gothenburg souvenirs, and hotel rooms. The underlying plan is to attract potential producers, but these are a difficult breed. They have, however, managed to put over thirty products into production over the years.

They eventually started to produce and purchase items themselves, primarily to cover the need for products during months like January when sales are low and exhibitors consequently fewer. They have also purchased whole ranges by exhibiting designers. Hamberg chuckles with delight at the memory of helping someone out by buying ten necklaces made from moose droppings, just because they were such fun. He also remembers other anecdotes: the bank employee who had made a gentleman's valet to hang clothes on, which sold very well. When they called the bank to order more, the man was terrified and protested "it was just a lark!" And another fantastic piece of furniture in the shape of a wooden unicorn, the size of a deer, with a lid that could be opened to form a writing desk with lots of little drawers. Unfortunately, the artist never got his asking price – 65,000 crowns! Hellström points out that they sometimes accept a unique item which may turn out to be impossible to sell, but which has to be shown because of the idea behind it or the craftsmanship.

They have since opened branches in Gothenburg and two more in Stockholm. When the store at Götgatan was finished in Spring 1997, DesignTorget Mode (fashion) was launched. The idea was to provide customers with unusual fashion items, often made in small series by up-and-coming designers. The space was designed with clothes in mind, since it would have been hard to sell clothes from pallets. At the opening, there was a jumble of different creations by fashion students, already established fashion designers, and amateur seamstresses. The styles varied greatly. A little more than a year later, Hamberg and Hellström decided to sell off DesignTorget Mode, however, and concentrate on what they knew best: gadgets.

An Idiom, a Personal Voice

By Peter Hallén

In the West we celebrate originality, in the East the artist follows a tradition, hoping, at best, to take it a bit further. All copyright disputes between East and West have their origin in this relationship between copy and original.

For us in the land of the evening sun, it is all about creating something new – inventing something – in the true Modernist spirit. But how long has this been the case in our culture?

It was the Italian principalities that first turned their backs on anonymous religious art and began to commission travelling geniuses to paint portraits of princes as well as pictures of religious subjects. You painted a story or portrayed your client in a flattering light. Gone was the picture as sacred object, in its place was an artist with a voice of his own, who depicted a story of something experienced or retold.

For approximately 600 years we have thus celebrated the creator rather than the subject or that which the subject symbolized. We have revered the voice of the artist – his expression – as well as the intellectual content of the story he paints – his idiom. Now, around the turn of the millennium, this development has reached a point where many works of art can no longer be understood unless the viewer is familiar with the position of the artist.

This is less true of applied art such as architecture and design, but even here, the creator has become a brand name, gilding and lending lustre to a product. The businesses of certain individualistic cultures such as Italy or Finland are better at capitalizing on this phenomenon, than countries that represent a more collectivist culture, such as Japan or Sweden. The products are more valuable when the sender bears a famous name.

The traditional way for industry to remunerate the designer – through royalties – is a peculiar phenomenon: the designer is expected to work for free up to the point when the product has been both manufactured and sold. We are currently in the midst of a process where this is destined to change and where the costs for design development will become part of the budget. This is very much true of Sweden, where those who commission the design seem to have a hard time understanding that designing is a profession.

Much of this is rooted in the relatively recent urbanization of Sweden and in the spirit of agrarian self-sufficiency that still characterizes entrepreneurs within the manufacturing industry. You can do it better yourself.

How should a designer or architect who wants to become part of the game – sometimes on utterly cynical terms – go about it, in order to become both good and successful? This may not be something they talk about, but in the final analysis, I think that for people in the design field, the potential for success is an extremely important factor. Success is necessary, for without it, talented designers will not be able to use and develop their talent and full artistic potential.

This full potential is the term used to determine, in a legal sense, whether the artist may demand financial reimbursement for the work or if he or she will ignominiously be revealed to have given birth to a piece of plagiarism – somebody else's full potential. How do you attain your full artistic potential within the field of design?

For the artist as well as for the designer the tiny little word "address" is a key to how to touch others, how to speak to them and tell a story in pictures or design. If you speak as if you were addressing a specific person, you may very well find that someone is listening.

When you sit there, facing a blank piece of paper or a dark computer screen, what do you do? How do you capture an original thought and how do you give it a form that may appear interesting or pleasant both in and of itself and in the eyes of others?

First of all, I think we have to realize that the world is a laboratory where everyone is engaged in experiments that you may assimilate and learn from, be inspired by, and benefit from. You have to venture forth in the world, fuelled by curiosity and eagerness to learn – and learn not to drown in the flood of information that is currently washing over us. Don't turn over every stone, only those that appeal to you, those that will become your destiny in life. Or, as I remember Zorba saying: "don't study a glass of water through a magnifying glass – you will only see the insects and the worms. But drink and refresh yourself, enjoy the water's life-giving power."

You must be prepared. You can't sit around waiting for inspiration, you must acquire work habits that stand you in good stead for those moments when nothing is going right and inspiration has vanished into thin air. Your method must be based on avoiding the negative tendencies, traps that you keep falling into, behaviour that you repeat without wanting to, mannerisms and laziness.

Your method must also be tailor-made for you – it must take you forward when your own motivation is lacking. It must help you realize that if you put one foot in front of the other, and then the other in front of the first one, it will take you somewhere.

Then it is time to explore the new place you have guided yourself to and add this new experience to all the old ones – together, they will become the foundation for the project that you are trying to formulate. The thoughts and visions that you are trying to capture in your drawings, sketches, scribbles, and words.

It is important to accumulate essential information, to expose your senses and your creative intellect to all the impressions you need for your giant leap. The leap across the abyss that only a moment ago seemed unbridgeable and in chaotic disorder.

It takes practice to keep reproducing that which you perceive as beautiful, over and over again, that which you admire from the master's hand, in order to acquire his skills and possibly use them as your model. Your eyes and your guts will eventually teach you to arrive at the right measure, the proportion that your body prizes beyond the intellect. You will learn that the tiny little voice you hear is worth taking seriously. The voice that keeps whispering to you to seek what is true beyond the demonic power of ideas, to listen to ideas that make you forget all your preparation.

Play with the ideas. Let them approach you lovingly and joyfully without allowing them to dominate you. Never forget that it is you who are in command and it is you who determine which ideas can stay and which must yield.

Consider everything beforehand, the sooner the better. Do not follow ideas that try to seduce you while competing among themselves for your attention.

It takes silence and stillness to know what is true and what is right. Simple questions, quietly asked, in humble anticipation of an answer and certainty. And, if you ask the right questions, the answer will not be long in coming.

Peter Hallén is a design architect.

130

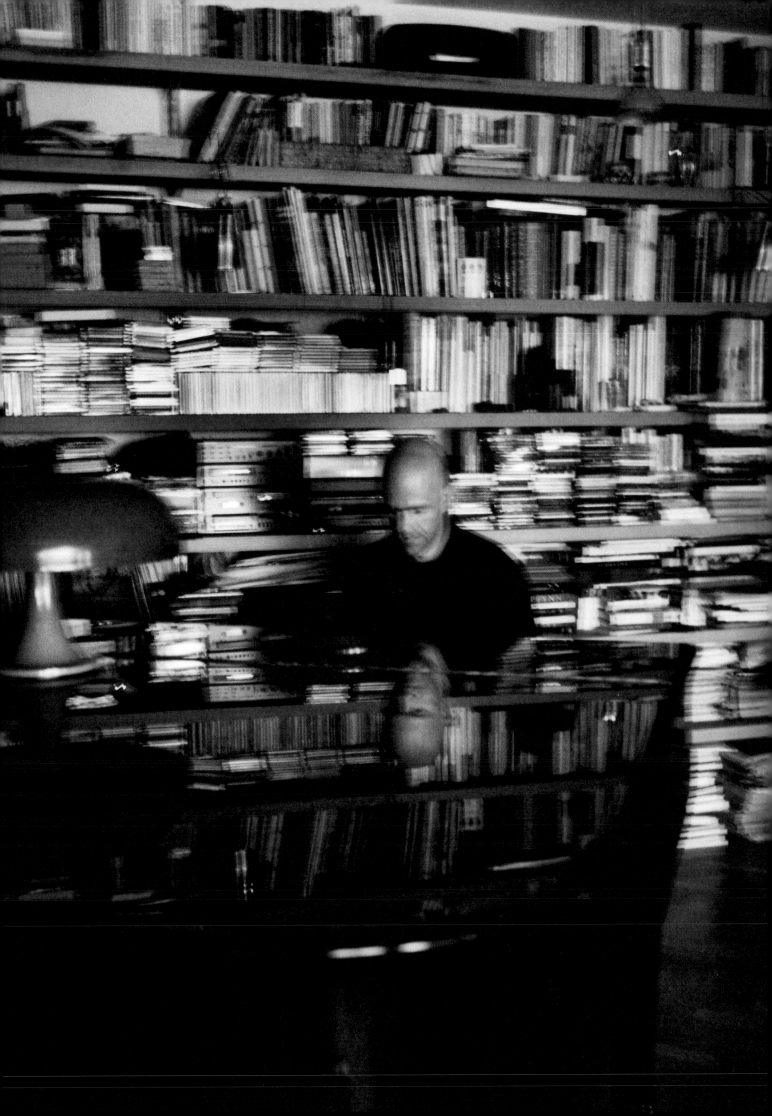

THOMAS ERIKSSON

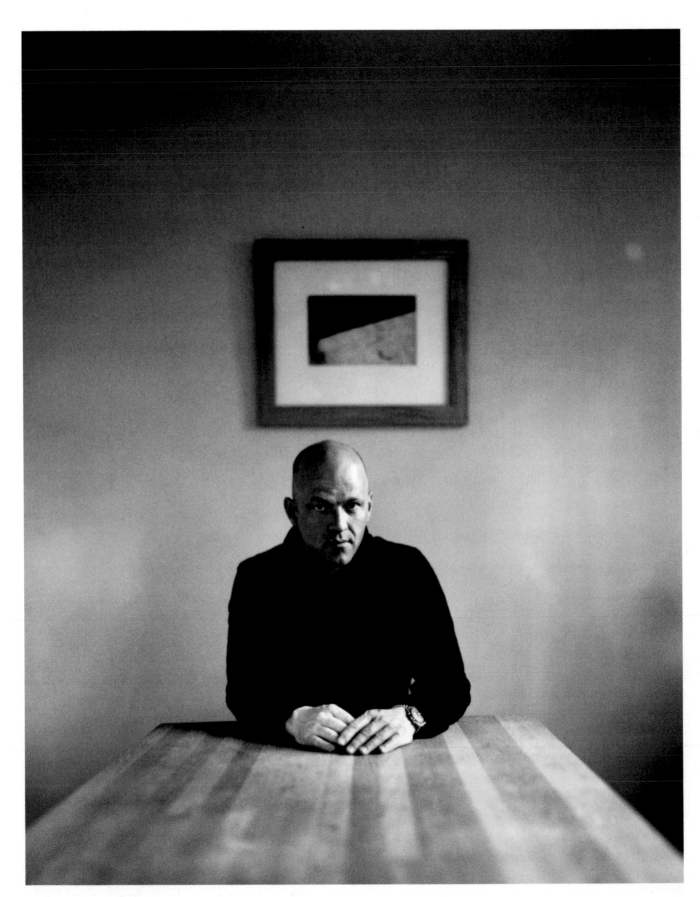

Page 132:
Thomas Eriksson, the music fan, at his grand piano.
Page 133:
A mood board, which explains the project's unity from the point of view of the materials. In this case the SAS Scandinavian lounges.

"A true visionary who knows everything." That was my friend's opinion of his former boss, architect Thomas Eriksson. "As close to human jet power as it is possible to get. Operates mostly at a speed of 180kph!"

My first thought was to follow Eriksson at a comfortable jogging pace during a day at work, but the plans had to be cancelled when it seemed impossible to find a suitable time. Besides, I seriously questioned whether my condition would stand such an exercise.

I had my first interview with him after he had cancelled four times. "It is a bit hard right now, I am completely done in after a submission this morning. What do you want to talk about? We can talk about anything," Eriksson says joking seriously. And then he begins to talk about my career. Mine! Yet another rumour confirmed: he always finds time to help and encourage others. "It is true, to give is greater than to receive!" Humility in the midst of self-assuredness. And the sentences keep flowing in spite of his exhaustion. I bring a tape recorder to the second interview, just to be on the safe side.

Eriksson is definitely more the Latin type than one from the Ångermanland region of Sweden. A quick thinker, sometimes with several chains of thought at once, and temperamental. Someone capable of changing topic five times in one sentence, finding his way back and tying it all together elegantly at the end. He often interrupts himself, saying "I could talk about this all day," or "I have to slow down." I suddenly notice that he is making a sketch in the notebook he always carries, all the while talking with me, as sharp as ever.

He prefers clients who are out for change, who want to grow and are unafraid of giant leaps. "My goal is to deliver a bit more than I was asked for, to try to find new angles of approach, to create change," he says. He describes his large project with SAS (Scandinavian Airlines) "where we were able to give them something beyond the expected answer to the question of how they were to create a stronger and better defined profile and also improve their service."

The best scenario, according to Eriksson, is when the client is deeply and obviously motivated, when he wants more than just a nice-looking office or an elegant store.

"Certain conceptual tasks may also involve creating a new content and adding new values.

"Today, it is all about being clear and really understanding what, how, and why new or changed needs must be expressed. There must be something of value under the surface, a content, and we have to understand what it is and make it visible. And you are only as good as your client: a good answer requires an accurate question. The questions 'What time is it?' and 'What is time?' give you completely different answers." It becomes apparent that Eriksson's work consists of analysis and strategy as much as pure architecture and design, and that the all-pervading theme is clarity.

He does his homework thoroughly to fully understand how everything hangs together and to attain clarity, while attempting to see things through the client's eyes. "I never feel the need to assert myself by maintaining a special Eriksson style but always work out of the needs of the client and the situation. To do otherwise would be unprofessional. It is different with products and furniture. The work is both freer and more concentrated. Some say that people find my products on the chunky and robust side – the way I am myself! There is probably something to that, since I dislike things that wobble, don't hold together and can't take a knock. I am not about to walk around on tiptoe for the sake of a thing. You could slaughter a reindeer calf on my dining table for Ikea's "*PS*" collection!"

He says this with the same force and vigour that he uses to discuss environmental pollution and e-business. "Environmental concerns are still playing to the galleries, even though much has been accomplished. Our whole future is at risk unless we hurry up and solve the problems. And e-business just makes things worse with its immoral behaviour. In order for me to save ten crowns by buying things on the Internet, the distributors buy up whole fleets of airplanes to send Nike shoes all over the globe. And then deliver them to my office in a delivery van. The environmental waste is scandalous."

The greatest challenge facing the future, according to Eriksson, is to make sensible and relevant products available while at the same time safeguarding the environment "in a world where everybody always wants everything."

This page:
Almost everything was specially designed in order to ensure the SAS lounges had both personality and functionality, down to the smallest detail. In that way, they were able to utilize Scandinavian craftsmanship and quality was guaranteed.

Everything, including food, art, and literature, is carefully selected in order to blend in with the atmosphere of welcoming hospitality.

The logo was modernized, and a completely new typeface – *Scandinavian* – designed and applied to everything from airplanes to name tags and packaging for earplugs.

The Swedish King did not see the pixel design on the nose cone as flags. Unfortunately, we don't know what he saw them as.

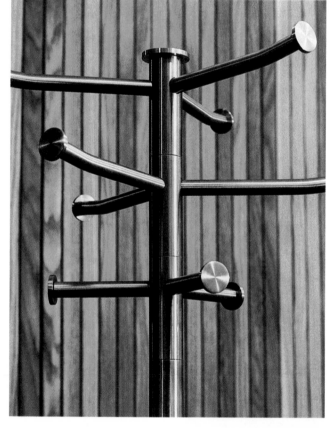

The Scandinavian Airlines (SAS) project began as early as 1992 when Thomas Eriksson Architects was asked to create open, accessible lounges where the travellers could relax and feel at home, all according to the traditions, values, and objectives of SAS.

The brief was to provide welcoming hospitality, in a living room that invited relaxation, social interaction, reading, working, or eating.

The first place to get the new look was SAS EuroClass lounge at London's Heathrow. Since then, the concept has been carried through at more than twenty large airports around the world. A unique art collection has also been built up in collaboration with the Moderna Museet in Stockholm. Travellers are not only

offered balm for the soul, but also the opportunity to learn more about contemporary Scandinavian expressions through several books on art, design, photography, architecture, fashion, and travel.

Eriksson's best compliment came from a traveller who said to his companion: "let's take the next plane!"

The largest design commission in the history of Swedish design, SAS 2000+, was initiated in 1997. SAS wanted a completely new profile with which to face the future. It encompassed everything from the logo, aeroplane design, and menus to the pepper packets, tickets, and the airline hostesses' uniforms, not to mention the earplugs and a new typeface. In order to tackle this unique challenge, Eriksson, graphic

designer Björn Kusoffsky, and project director and strategist Göran Lagerström formed Stockholm Design Lab. The trio had long been working together with SAS and other clients. In this way the client had only one, instead of three, contractors", Eriksson says.

The two-year full-time project got under way after extensive market research, involving both international and Swedish consultants.

In 1999 they received the Special Jury Award as part of Excellent Swedish Design. The citation reads in part: "SAS has realized that a new profile is not a matter of appearance but of content, that credibility demands consistency and that no detail is unimportant or too small."

Below:
Clockwise: detail of the façade of main offices of Kapp-Ahl, next to *E-table* for Cappellini, *PS klocka* for Ikea and *Spacelight*, hand-tufted carpet for Kasthall, *Wallpaper*'s London office; and the interior for an advertising agency in Stockholm.

"When I was little I used to draw, almost frantically, on almost everything. Cake cartons or the lid to Grandpa's kitchen bench – it made no difference."

Nowadays, Eriksson's sketches are more organized, in nice, hardbound notebooks. He fills several hundred a year. "They are my analog hard disks!"

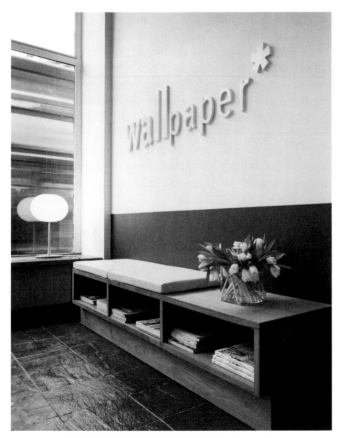

Eriksson first wanted to be a surgeon, a profession that he finds not unlike what he is doing today on one level. "It is all about listening softly and responding forcefully, to think it through before you operate. The fact is that before, I wanted to save lives, make a humanitarian contribution. The year I applied to medical school, I was third on the waiting list at Karolinska, at the same time as I was accepted at the school of architecture of the Royal Institute of Technology – so that is what it turned out to be. It was a bit like finally coming home," he says. Eriksson has always been fascinated by the creative world: music, film, and theatre –"which provided nourishment for incredible flights of fantasy." Today, he gets a kick out of sharing his "inner cinema" with others in order to visualize an idea. To make others see, experience, and believe in his ideas.

After graduating from the Royal Institute of Technology he got a permanent job in an architect's office, where he worked for a little over two years. "I think I came across as a bit over enthusiastic," says Eriksson, who kept dreaming of a firm of his own. This became reality when he was given his first project, a small development of private homes. Then followed a stream of various jobs within interior and stage design. He also tried his hand at making furniture: a coffee table, *Valpen*, for cbi was his first piece. Then various products for Cappellini's collection *Progetto Ogetto*, among them the famous medicine cabinet, *Medicinskåpet*. "In the case of *Valpen*, I had a girlfriend who needed a coffee table, and the idea for the medicine cabinet developed during a period when I was rather down in the dumps. I was sitting around playing with various icons, Greek and graphic signs in my sketchbook, then I filled a whole page with red plus signs just to remind myself that life was quite wonderful, after all!"

When they called from MoMA (Museum of Modern Art) in New York to tell him that the cabinet was now part of their permanent collection, Eriksson felt a "brief flash of happiness" – and then it was time to tackle the next project. Does he actually have time to experience his emotions and finish his thoughts at a tempo that is healthy? "Maybe not. I respond quite intuitively, it just keeps coming. As soon as

138

positivity

someone says something, I have an idea. It may be totally wrong, of course, but I immediately have an opinion. It's like a kind of constant flow, a waterfall where I just have to reach out and fill my drinking-vessel, my *kåsa[1]*. Besides, I find that I have to invest my entire soul to arrive at the best possible result. I am pretty good at putting myself in the shoes of others and I often function as a catalyst and setter-in-motion. I firmly believe that everything is possible, and it is – thanks to my love for solving problems, the enormous joy I take in my work, and my fantastic and clever co-workers. Teamwork inspires me, it is as a team that we realize our ideas."

Then he breaks out in a deep declaration of love for his employees and partners who do not hesitate to call to ask if he needs help with his boat over the weekend. I learn that his expression "The office gives me a total high," means "I am proud and happy with my business."

Unlike others who are seized by "the anxiety of the blank sheet," Eriksson is in his element. Offer him a little finger and he is quick to sketch not just the hand, but body, soul, life situation, and living environment. "I am sometimes deliberately provocative in order to elicit a reaction or to wake someone up. 'I have no intention of doing what you want, but this is what I'll do instead.' If the customers are always happy, it becomes boring. They should preferably make a discovery or be positively surprised. Then we have succeeded!"

He finds his Swedish clients are very cautious, reluctant to take risks, and the Swedish market is too small and homogenous. "I would like to quote Kandinsky[2], who describes humanity as a triangle, slowly moving sideways and upwards, led by the point. The upper layer is composed of people within the arts. And the point itself consists of those who most normal people would find totally insane, but whose work and actions are slowly propagated through art, music, architecture, and fashion. It penetrates into people's consciousness, lives, homes, and everyday life. A few years later, the ideas of "the mad utopians" may be found at Ikea, and suddenly everyone wants what was once regarded as complete nonsense. Take Alvar Aalto, for example. His furniture was totally foreign to his contemporaries, but before long everybody wanted it. Jonas Bohlin's tutu lamps are a good example of things that are ahead of their time today."

"Speaking of Jonas – he is so good at conveying affection and spirituality. I would like to see more of that in our design: we should infuse some blood into our simplicity as a complement to common sense, reason, and purity – the heart of Swedish design. I think the world is at a stage where people appreciate the values we represent and our ability to make a lot out of little. The future demands of us not to exaggerate and waste, but to be economical with our resources in order to make them reach more people. 'Scandinavianism' is therefore a sustainable 'ism', because it is fundamentally sound."

1: A kåsa is a drinking-vessel from Norrland, in the north of Sweden. Formerly hand-carved out of birch bark or wood – now, like everything else, they are usually made from plastic.

2: Wassily Kandinsky (1866–1944), one of the originators of abstract painting. His career began with law and economics studies in Moscow, where he was born. He also lived in France and Germany, working as a graphic artist and art theoretician and served as professor at the Bauhaus in Germany.

139

ANKI GNEIB

Anki Gneib comes and goes. First there were shelves in the form of Persian letters. Sculpturally graphic, with totally un-Swedish expressions, they had their own distinct style. Those who knew the language could read the words: "Not", "Messiah", and "Muhammad", loosely translated. Then a long silence. Then another shelf, the slanting *Squeeze*, named Piece of the Year and seen everywhere. Again silence. Then in 1999, a Hälsingland cabinetmaker presented the winner in a pine competition: Gneib, with her *Hambo* range. There she was again, this time with an almost Japanese idiom intertwined with ideas from Hälsingland. Later that year, a giant-sized version of her *Cheese* carpet was installed in the Ambassador's residence in Berlin. Is it now time for yet another silence after this latest burst?

"No, I'm ready to devote more time to product design after several years of full-time work in an architectural firm. Since Konstfack, I have devoted myself mostly to interior design jobs. This has to do with being a breadwinner – hopefully, I'll be able to combine the two in the future. It is only during my two maternity leaves that I have had time to develop ideas for products that have been slowly maturing over the years," says Gneib. She has just begun a collaborative project with Arvesund Trädesign, a company with an unusual business concept. They salvage the lumber from old derelict barns in Norrland, turning it either into new houses like Mats Theselius' *Eremitens Koja* (*Hermit's Hut*) or furniture, designed by Gneib and others. "It's a different and fun idea," she says, showing me some of the first prototypes, in which the beautiful greyish blue, weathered wood has acquired new lustre in modern design. The history of the barns has been carefully documented as part of the concept.

141

She mentions again how long it takes her ideas to mature and comments that there has to be a good reason for the product and plenty of time to work on the details, either in the form of a commission or because an idea of her own has had time to mature and become clearly meaningful. I don't want to make a product that looks like twenty others – that's totally pointless. The jobs I've got so far have been the result of competitions and exhibitions, and it sometimes takes aeons from when I first show them my concept to actual production. My *Cheese* carpet took five years, from the moment it was first shown until Asplund incorporated it into their collection. But reflection and conceptual maturity are important, both to the designer and to the producer."

Working with interiors, her favourite jobs are places designed for social interaction, like restaurants. "They're like a kind of public living room. People have to meet, feel comfortable and at home. It's a challenge to make it work for everybody: guests, chefs, waiters, and cleaners. It's not enough to add some new chairs to make it look snazzy. You have to integrate food, service, lighting, furniture, graphic design, and so on. You have to research everything thoroughly to make sure that everyone who works in that environment has a good and functional workplace. I also have to know my own limitations and rely on other experts who must be integrated into the project from the beginning. Unfortunately, those resources are often lacking."

Gneib hates it when an idea for an interior is carried out just to make it look good, without any regard for actual needs. "It's like building a nine-foot tall bar with ladders just to be cool! I want my work to survive trends and have a discriminating quality that will last, without being boring. Although it would be fun to be allowed to really let go some times!"

Much of her inspiration is based on the needs of the client and the history of the business in question. "I usually try to understand what is missing, what I can add, and whether there are other needs for other markets. Then I look in a drawer where I keep a lot of basic ideas to see if there is anything that I could use as a basis. Or, I may have been walking around with a design in my head, one that could be turned into most anything. The question is only what to apply it to. The competition for which I made *Hambo* was about making furniture that tied into the peasant culture of Hälsingland. The result was a combination of an old idea and newly acquired knowledge of the woodcraft tradition of Hälsingland."

For the rest, she finds life a good source of inspiration. Once, just as she was about to make a shelf, a fellow student gave her a book about the *Koran* and the way Persian letters

had to be stylized in order to be made in mosaic. That's how her *Tecken* shelves were born. "If I have to try to explain my design, I would say that I look a lot at the surface which has to convey a strong graphic impression combined with an un-expected element – without being too complicated. *Squeeze* is nothing but squares that have been combined, although at an angle. I thought for a long time that it must already be on the market, as the idea was so obvious. In brief, it's easier to let my products speak for themselves than try to explain them."

Quality and concern for the environment are important to Gneib. "If you buy an expensive chest of drawers, I feel it is my responsibility to see that it lasts a lifetime, that it is durable. Quality products, made in small series, unfortunately don't sell very well. Ikea's volumes have taught the Swedish people that furniture does not have to cost anything. Of course it's too bad that small furniture series often have to be so expensive, but when you see how carefully crafted they are and how high the quality is, I feel it is justified."

Gneib knows what she is talking about, having started as an upholsterer. "After high school in Örebro I apprenticed myself to an upholsterer, since I had always been interested in furniture craft. I then attended Eskilstuna Folk High School where I tried other kinds of handicraft, then painting courses at Örebro Art School before applying to HDK[1] in Gothenburg. Unfortunately, I was not accepted, but Konstfack, the College of Arts, Crafts and Design, did accept me. I had absolutely no desire to move to Stockholm but I did. At Konstfack, I zeroed in on wood and spent most of my time in the carpentry shop where I was completely free to test my ideas in full scale. It was only later, after school, that I learned to go at it rationally, without losing track of the original idea."

After her carpentry experience, Gneib found it natural to work in wood "maybe mostly because I've been sitting at home at the kitchen table drawing right angles. I would love to try other utilitarian objects as well, maybe smaller items, and maybe in other materials such as plastic and ceramics. And glass – a very complex process. I have teamed up with Inter-stop[2] which makes upholstered pieces, textiles, and lighting for the home. It will be very exciting to see how I function and express myself in materials other than wood."

142

1: Read more about HDK (The School of Design and Crafts at Gothenburg University) on p.317, which also contains information on Konstfack.

2: The furniture company Interstop is situated in Tibro. In spring of 2000 they launched a collection, Living Emotion, in which furniture is complemented with accessories such as pillows, throws, lamps, and carpets, in order to offer unity for the various needs and functions of the home. Gneib's contributions were presented in early 2001.

143

Sanna Hansson has a different way of viewing her profession, herself, and her surroundings. She even produces most of her products herself "since it's primarily a matter of haute couture products designed to transmit an idea."

She explains the expression: "I want to initiate a dialogue. It's important to me to be able to meet people at different levels through my products. To be both intellectual and idea-oriented and at the same time playful and simple in my expression. I hope that the fact that I use humour to discuss topical social issues makes it easy for people to find their way to the concept behind the product." In that way, Hansson works more like an artist than a designer, since with her the idea always comes first.

"I am interested in human beings and the way they think," she says, showing me *Five foot-eleven,* an example of her work. It is a thin sliver of a mirror, 2.5 inches wide and the same height as the ideal fashion model – five feet eleven inches. A target has been sand-blasted at forehead height to symbolize the media's skewed idea of the ideal woman. The back of the piece has a different function: it is a place to hang clothes. A functional piece of furniture, of course, but also much more than that.

"I have just completed a research trip to New York, São Paulo, Shanghai, and Cairo to study how different nationalities relate to the things around them, and how cultural shocks, mobility, and IT, to name a few things, have facilitated and changed design traditions. At the moment I am designing a collection of a kind of 'mulatto products' in order to start a discussion about this."

Hansson received a lot of attention after her graduation from the Beckman School. "I was incredibly lucky, the time was just right – I exemplified what the media wanted to write about. I would have been stupid not to capitalize on it." Future clients lined up. Källemo wanted to produce her graduation project about outsidership, *Gående Bord,* and the Electrolux Design Office asked her to come up with a concept for the vacuum cleaner of the future. "I had absolutely no plans to become a furniture or industrial designer, however – quite the contrary, these areas have always felt foreign to me. All the same, I accepted their offers, since it is both important and exciting to try new things. It didn't take long before I felt that I wanted to move on."

The first time I call her, she is just back from London where she lives half of the time and where she has gone to visit her business strategist. When we finally meet she says, after chatting for four minutes, "if you are the least bit smart and if you cultivate what you know best, you can go as far as you want," and "I see to it that I get what I need and want in order to develop. Here, at home in Sweden, my directness is often seen as offensive, but when I'm abroad, I never feel that anyone reacts adversely."

Hansson, who calls two cities home, wants to work across a broad range and avoid getting stuck in any one design category. Apart from furniture, she has worked with everything from advertising and stage design to design strategy and as a designer talent scout for Snowcrash[1]. "The flip side of working broadly is that customers and clients do not know what niche to put me in."

1: Snowcrash is a Swedish design company with its roots among a group of young Finnish experimental designers. They introduced a unique range of furniture and lamps at the 1997 furniture fair in Milan. Two products soon acquired a worldwide reputation: Globlow, *a self-inflating lamp, and the computer recliner* Netsurfer. *Read more at www.snowcrash.se*

Pax, Pilaster, Schablon, and *Solitär*:
John Kandell – Master of Validity.

Had John Kandell still been alive *I would have called him to say hello. "Hello, free thinker! Hello, great Minimalist! Hello, inspirer of the young! Tell us about the refined simplicity of your rough-sawn* Boklåda *from 1981. What does it feel like to know that your* Pilaster *shelf, designed in 1989, has become one of the icons of Swedish design of the 1990s?"*

In his design, Kandell augured a decade that he was not to experience, making him intrepid, ahead of his time, and free from conformity and regimentation.

As an interior designer and sculptor he was a master at stripping away that which was not essential, while retaining that which lent the object a clear identity. He had the ability to see the inner qualities of a piece of furniture, not just the outward manifestations. Those who are unable to do so easily get stuck in a trend – a word he detested (as he did the use of the word "design" in his own language – he preferred the Swedish formgivning*). His ambition was to endow his objects with long-lasting validity. And he succeeded.*

I asked his close friend and working partner Sven Lundh to tell me more.

149

"He was sitting in the former tobacconist's shop at Nytorgsgatan 11, which had become Ulla's – his wife's – weaving studio and their joint exhibition space. It was in the early 1980s. He was seated on his black *Bon Bon* chair, dressed in a poplin coat, with a crumpled cloth hat pulled down over his forehead. His shoes, loafers, were polished to a sheen. He radiated a sense of complete self-confidence, registering every visitor, regarding them seemingly without interest.

"I had never met Kandell before, but I knew of him and had intended to contact him to see if we might do something together. I had been impressed by his pieces for the exhibitions of the HI group in the early 1960s and his later piece *Parallell* for Kjell Haglund, Haglund & Söner.

"There he was, his little studio filled with tiny cupboards, or rather cupboard-like objects. Some seemed spontaneously joined, painted and equipped with ingenious

clappers as locks. Some were exquisitely crafted, made in collaboration with his friend, carpenter Lars Larsson.

"Kandell had grown tired of the lack of understanding shown by the furniture trade and lost all urge to design furniture for mass production. Not until years later did he start working with the Källemo furniture company – a collaboration that was to increase his skill and earn him a reputation as one of the late-twentieth century's leading furniture designers.

"Kandell possessed an uncanny perceptiveness, as well as an unusual degree of self-confidence. He was also more knowledgeable than most. Many of his architect colleagues testify that they could always turn to him with an especially difficult design or colour problem.

"He completed his formal education at Konstfack in 1941 and returned to teach there from 1951 to 1956. But his real education came from his time with Sven Ivar Lind, where he was employed from 1948 to 1961. Professor Lind had been a partner of Gunnar Asplund, and it was he who completed several of his partner's buildings after Asplund's death in 1941.

inget bekymmer tynger den som ser havet.

"No problems exist for those who look out to the sea."

It was at Sven Ivar Lind that Kandell learnt all that he was to carry with him throughout his life.

"All that he had stored up during his time away from design found an outlet during the 1980s in his partnership with Källemo. His retrospective chair, *Bon Bon,* (see p. 149) was designed for Sven Ivar Lind's interior for the Treasury at the Royal Palace in 1968 and put into production in 1985. Kandell received new recognition in the 1980s when a number of museums exhibited his work.

"Ulla and John had a cottage in Simslångsdalen, the forested part of Halland, a house with low ceilings and narrow doorways. In one of the doorways, a twisted, whitewashed juniper stick was suspended. It kept knocking against you every time you walked through the door. I felt that I couldn't really ask what it was for; as though I ought to understand, but I finally had to ask. "Something is happening there," was always Kandell's reply.

"After several years of this same answer, Kandell suddenly said: "You may have the stick now, I'm done with it." Whatever thought process he had been wrestling with had been resolved. He was through with the juniper stick. It had been an important part of his creative thinking process – now he could let it go. The story says much about his seemingly irrational ways, the remarkable path behind an artist's inspiration.

"His pioneering *Boklådan* was designed in 1981 and four copies were made by master carpenter Lars Larsson, before being put into production in 1986. The ideas at the time were relaxed in terms of design and colour. The restrained, well-proportioned designs executed in polished craftsmanship that had characterized Kandell's earlier work suddenly changed and his furniture took on a different expression. He had been a gifted student in sculpture at Konstfack and he painted throughout his life. He referred to sculpture and painting as his 'exercises' – exercises that led to the furniture that he found most important, where colour and form were strongly expressed. Källemo allowed him free rein, and his *Vilan* easy chair, *Pax* stool, and *Schablon* chair were given African-inspired ornamentation – not to mention his *Solitär* armchair, sometimes called 'the chieftain's seat.'

"The ornamentation and his inability to think in straight lines horrified the conservative establishment. Imagine – notches on the front legs! Eventually, an increasing number of people came to realize that this is what distinguishes an intellectual expression from something that is average. His furniture from this period has forever assured Kandell a place in twentieth-century Swedish furniture history.

His *Pilaster* shelf from 1989 was created for no other reason than to fill a personal need – his own apartment was overflowing with books. It was this piece that was chiefly responsible for making Kandell well known. His irritation with the piles of books on his floor kept growing during the course of a sleepless night. "You ought to hang the piles on the walls instead," he thought. He said – in the spirit of Picasso, his great inspiration – that "a picture should be so simple that you should be able to send it to New York by phone." He called not New York but Källemo with his idea for *Pilaster* the very next day.

"His last piece was his *Victory* armchair, with the V-sign on the back."

John Kandell died on January 17, 1991 at the age of 65.

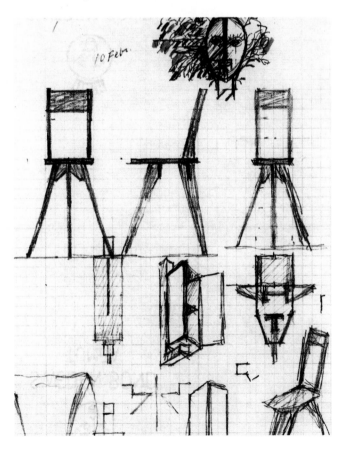

Sven Lundh
Director, Källemo

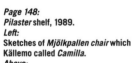

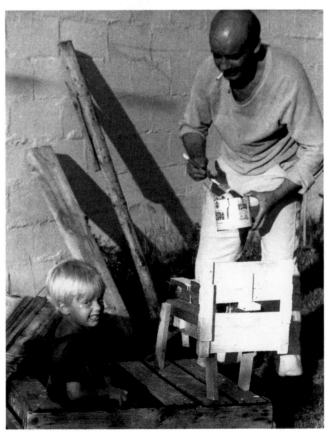

151

Page 148:
Pilaster shelf, 1989.
Left:
Sketches of *Mjölkpallen chair* which Källemo called *Camilla*.
Above:
Clockwise: Kandell at sea outside his summer cottage in Blekinge; *Boklådan*, made for one of his and Ulla's exhibitions, Trä Textil, 1981; his cupboard *Brunelleschi* is a kind of epigram of great architecture; master carpenter Lars Larsson, who made several of Kandell's pieces; Kandell and his youngest son about to paint the wooden dog, *Molle*; looking through his cupboard, *Dambadet*; the restaurant Rolf's Kök in Stockholm, designed by Jonas Bohlin and Thomas Sandell with Kandell's *Schablon* chairs from 1987; strict and playful *Solitär* chair, 1986.

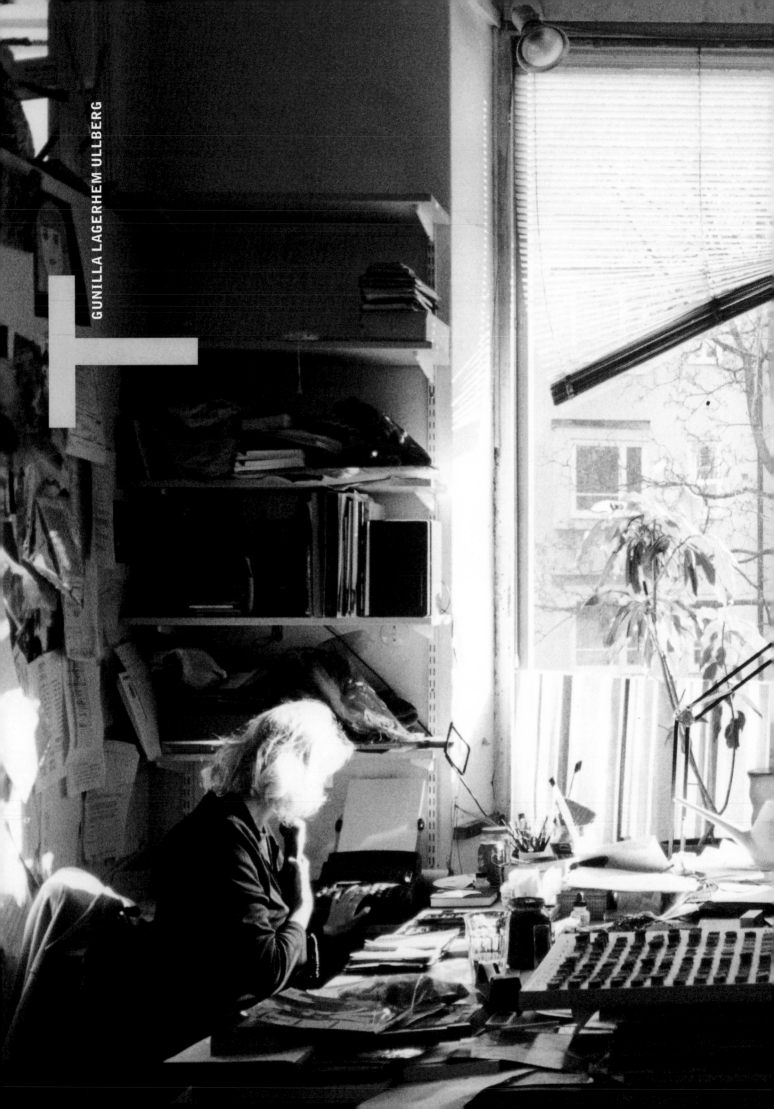

GUNILLA LAGERHEM ULLBERG

Page 152–153:
**Creative chaos in the former dairy at
Stockholm's Söder.**

Below:
Gunilla Lagerhem Ullberg is purveyor to the Court. So far she has made a state banner, to be displayed at state visits, carpets for the royal chapel at Drottningholm, and Tre Kronor, the new palace museum, in addition to fabrics for the palace gift shop.

Sensation is paramount. I am circling the outside of Gröna Lund, Djurgården on my bike. I can't find the Friends of Textile Art gallery where Gunilla Lagerhem Ullberg is having an exhibition. Despite my interest in design, I have never quite counted handicraft among the contemporary forms of expression, so I don't know the way and have to ask. The third person I ask has the answer. She points the way without the slightest hesitation – just across from the main entrance to Skansen.

Ullberg has made some floor pillows in satin stitch and cross-stitch in raffia, in colours ranging from Nordic blonde to full-bodied Oriental red. Blue, beige, and earth tones. Above them hovers a piece of sheer linen with little round mirrors sewn on describing a graphic pattern. They reflect the outside light right now, but could just as well mirror the flicker of a tiled stove. It is incredibly beautiful and has a very modern feel. In contrast, selected traditional and historical items from the heritage of Swedish textile design are displayed in the same exhibition space – equally impressive. The fact is that Ullberg's pieces are the perfect combination of then and now. Traditional techniques in a modern guise.

There is a touch of something alive, close, and everyday – in the positive sense of the word – about Ullberg herself and her settings. Both with regard to her temperament and fingers, and to her eye and studio. She is warm, a little messy, her hair ruffled. And when I ask her about the root of her expression she answers: "Feeling. I feel in my body how it should be. I have always felt the need to express myself in some way, and since words were not an option, thought and hand had to take over. Once a dyslexic, always a dyslexic!"

The first time I visit her studio – a former dairy with stuff everywhere – I realize what is meant by "creative chaos". She laughingly agrees: "I save everything as a potential source of inspiration and ideas, since I am sometimes seized by fear that I will never again be able to think of anything."

Scattered in piles and hanging on the walls are everything from new kinds of yarn and pieces of fabric for inspiration to posters for the same purpose, her daughter's leopard print rubber boots and water-colour sketches of new ideas. On the

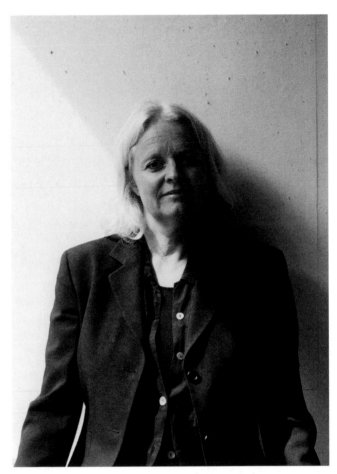

windowsill there is a jumble of pots with newly planted seeds, paintbrushes, and the stale crusts of a cinnamon roll.

She is constantly running back and forth during our conversation, rummaging in drawers and on shelves to show me various things. One of her many posters – a pattern by Josef Frank – served as inspiration for her *Arkipelag* fabric, which is very much at odds with her usually quiet and laid-back design with restrained graphics and colour. It looks like large, flowering islands in a blue or greyish brown sea. "My idea was that this is what it looks like when you look up at the sky from under flowering trees," she says – and, of course, I can see it now.

Below:
Clockwise: The carpet *Gina* for Kasthall,
"A carpet is a good piece of furniture!";
yarn samples and some of Ullberg's
embroideries; the *Arkipelag* textile,
inspired by Josef Frank, her *Moss*
carpet in wool and linen.

"My things must not become one-day fads."

156

Below:
"Luckily we have a large summerhouse," says Ullberg who shares her 68-square-foot apartment in town with her husband, three children, and a dog.

Karla, a textile for Kinnasand (right) and one of the early sketches for the *Skiss* carpet (left).

She wants to do things that touch you, that have something to offer. "There must be poetry in what I make. I find it important to be able to turn a concept around and apply a wallpaper pattern to a carpet – or something might look like metal but actually be a textile. That things might be classic but yet contain something new. I want to be able to move between extremes, from free embroidery to the strictest of strict. You should sometimes be able to tell that a hand was involved, but not always."

"My creative strength is that people recognize my things. Take rag rugs and *rya* rugs, for example. They are part of everybody's life. The challenge is to go a step further, to take another turn – with the material, the technique, the pattern. Like adding tufts of linen threads to make the *rya* rug extra shaggy. I remember my Mum and Dad sitting at the kitchen table tying *rya* rugs – oh yes, it was very much in vogue at that time, primarily among men, for some reason! Then my sister and I would use them as gym mats. We lived on those rugs!"

When she applied to Konstfack, Ullberg lacked the prerequisite background in weaving technique. She had, however, attended both Grundis and the Nyckelvik Schools, attended evening courses at Konstfack while in high school, and had much encouragement from her parents who were painters and *rya* rug makers. For a long time she wanted to become a textile artist, but between her third and fourth year at Konstfack, during one of her three maternity leaves, she found her niche – making rag rugs, that were more utilitarian objects than art. Creating rug after rug, she explored every conceivable technique. Among other things, she explored double-sided rugs, using a different colour scale on the reverse. Even today many of her rugs are reversible, adding to their timeless quality.

"Finding a solution for a problem is the most wonderful thing imaginable. When you suddenly see how to realize an idea. But it is just as much fun to sketch and watch the idea take on different forms and grow. And it is wonderful to stand on the factory floor when my rugs are being woven. The environment alone is extremely inspiring and the craftspeople are incredibly skillful.

"Certain ideas are harder to realize than others. That's why I would like to learn more about all the new materials – to understand how they could be used in my work. It's a bit frustrating to know that so much is happening in the world of materials right now. I have even heard of a fabric that contains vitamins! How can I stay informed? I can't just call up and ask to go on a fact-finding visit to Japan, which is at the forefront just now. I wish the government would offer designers inspirational and educational trips to foreign manufacturers. It would give us a chance to show them abroad what we can do," Ullberg says longingly.

But she is not complaining. Both Kasthall[1] and Kinnasand[2] with whom she mostly works are way ahead in terms of development, and their collaboration is fruitful in more ways than one. Ullberg has received close to twenty Swedish Design awards – and, she adds, she has been incredibly lucky from the very beginning. I wish she would say "skillful".

NK, Ikea, and the Swedish Society of Crafts and Design were enthusiastic about her graduate show, wanting her rug designs. She then started to work on a freelance basis, which is how she came into contact with Kasthall, for whom she is the only permanent designer. "Every now and then I greet customers at NK, tell them about my carpets and offer advice. People often think it over for a long time before buying a carpet and when they see in the paper that I will be there they turn up to ask questions before deciding. It's fun, it gives me status as a designer and puts me in direct contact with the consumer."

Her dream at the moment is to branch out, to realize more of her ideas. "I want to do too much. As soon as I finish a design, I immediately see thousands of different applications for it – in a public setting, in the home, or just for clothing. At the same time, I would like to have more time to just potter around in my greenhouse." Textiles or garden, threads or trees, Ullberg's creativity is in her fingers.

158

1: Kasthall Mattor och Golv (Kasthall Carpets and Floors) is a venerable Swedish company who have been in the carpet-weaving business since 1889. In addition to weaving, it also does tufting. (see p. 171.)
Kasthall is happy to accept special orders for unique carpets in any pattern, design, colour, or size.

2: Kinnasand goes back to 1796 when the Sanden farm in Kinna was the centre for extensive and wide-ranging textile production that employed most of the women of the surrounding area.
Today, Kinnasand specializes mainly in home textiles and fabric wall hangings, as well as being a subcontractor for carpets. It has a German subsidiary.

By the time she graduated from the Beckman School of Design in 1997, it was clear that Eva Lilja Löwenhielm was a force to be reckoned with. The awards she had pulled in included a fellowship from Ikea as well as a sum of money from *Elle Interiör*, and she ranked fifth in *Årets Embryo*, a prize awarded by *Form* design journal and given to students showing extraordinary skill and talent.

The big question was whether she – like so many "talented girls" – would disappear into an anonymous existence in some architectural firm. In fact, Löwenhielm has gone her own way under her own name. She has received a stream of interior and product design commissions, and has attracted widespread attention, both for her products for Ikea and for her interiors.

"It is very hard for me to describe my own expression and how I'm different. I want to convey something that will make people want to return to my environments and feel good in them – that will make them want to use my products again. At the same time, I am always mindful of the fact that my things must not be too expensive for the consumer. Economy in production is vital. When scraps from a stool can be turned into hangers and picture frames, then I'm happy!"

Eva's form of expression can be summed up as creating a peaceful foundation for all kinds of rooms and functions. It is an attempt to counter the stress that prevails outside these settings.

"I want to leave out something for you yourself to add. I never dictate that this is the way it has to be – I just provide the point of departure. Obviously I don't want my things to be seen as lacking in identity, however, they must have expressive power of their own."

And, indeed, they do. One reason may be that before attending the Beckman school Löwenhielm worked as an assistant to Lars Hall, director of the advertising agency Hall & Cederqvist/Y&R. She thus went from working in a graphic, two-dimensional idiom to an equally graphic, three-dimensional one. "In both instances, clarity is paramount." Regardless of whether we are dealing with a logo, a graphic profile, or a cube-shaped hassock, rectangular cupboards, or soberly patterned carpets. "Clean shapes and lines also make for longer aesthetic life."

We talk more about product life, which she insists is linked to quality. "Sometimes financial considerations do not permit the degree of quality that I would like. However, if you make a product that is not meant to last a lifetime, you must make sure that it is degradable," she says, referring to some of her products for Ikea. So far, she has made a series of accessories for the bathroom: large hand-tufted rugs, an easy chair, and a combined mirror/clothes-hanger.

She thus expresses herself in everything from entire room solutions to textiles, ceramics, and furniture. She has also tried her hand at working in glass. She is about to launch a glass service designed for Reijmyre Glassworks and at the moment she is not quite sure what lies ahead. It may be that she will have time to turn her attention to the problem of how to beautify and integrate ugly technical items in the home, or create offices without bulky computers. These issues, along with pure product design, are uppermost in her mind these days.

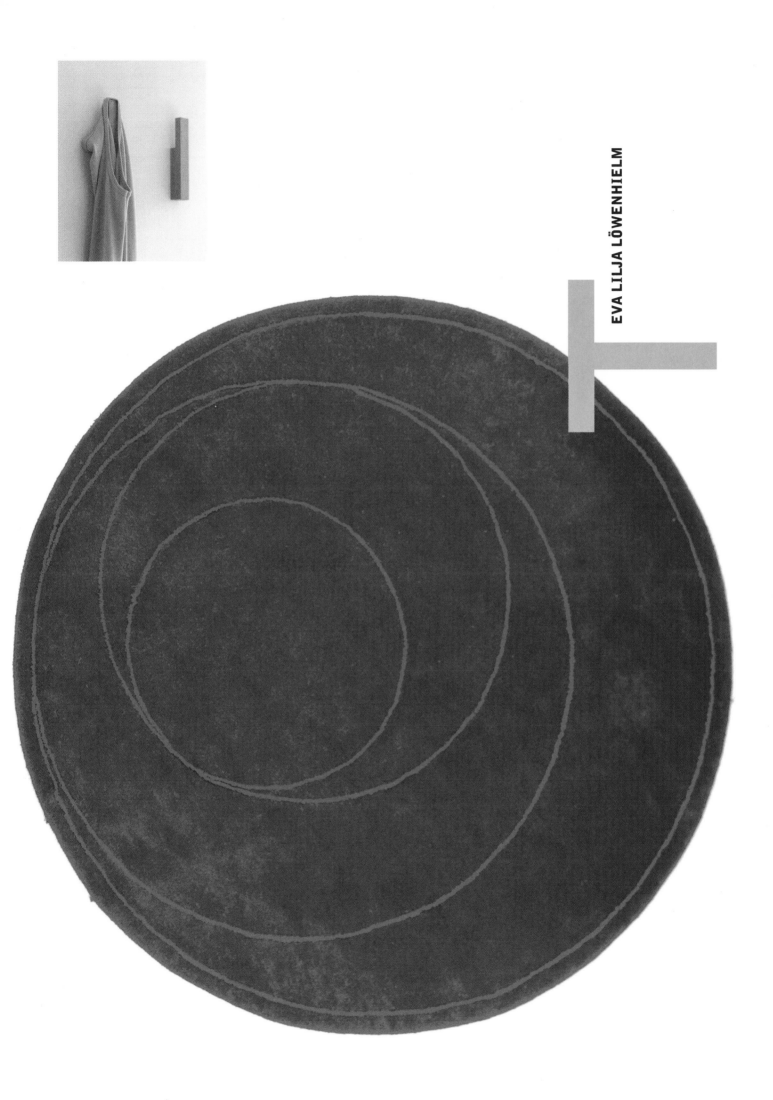

EVA LILJA LÖWENHIELM

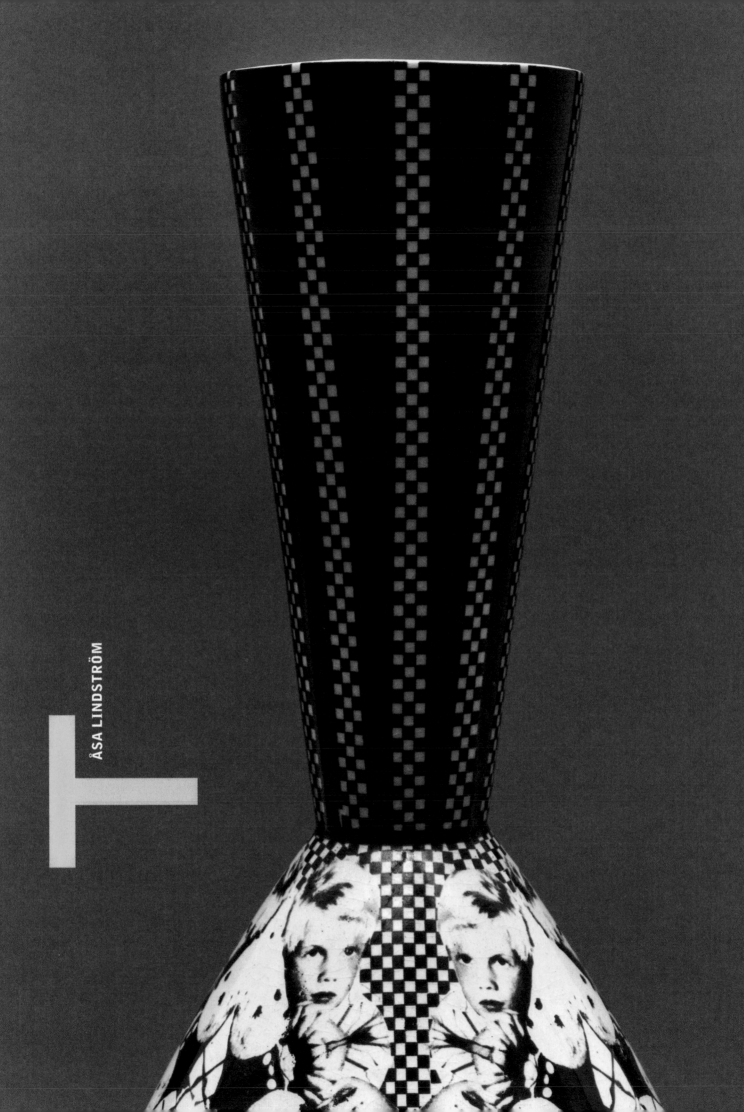

ÅSA LINDSTRÖM

Gilt-edged everyday realism is my first thought when I catch sight of Åsa Lindström's line of beakers at the craft co-operative Blås och Knåda. There are berries, vacuum cleaners, swirling ball gowns, smiling models from the 1950s, and stylized kitchen gadgets. One motif per beaker, duplicated *en masse*, over and over again, The pictures are often both vertical and horizontal mirror images, producing an optical illusion and a kind of timelessness. The inside comes in a variety of colours.

From a distance, the beakers convey a strict graphic impression, a monochrome pattern on a simple basic shape, with an edge of matte gold to touch your lips. The

closer I look, the more apparent the detail, and I send a thought of gratitude to the person who has broken with the prevailing anti-décor trend in this openly humorous way.

"I want my work to surprise and delight. I also want to leave those who buy my beakers an outlet for some creativity of their own by giving them some options to choose from. Some actually spend hours picking something – which proves that they care. I think that you are attracted by a familiar element in the pictures, in combination with something that feels new and modern. My beakers have many uses – the drink of your choice, toothbrush, flowers. And it is nice when someone thinks 'today I feel like the one with blueberries.' They are making an active choice. I always choose whatever beaker feels right for the day."

"It is great that so many people are actually willing to buy a beaker that costs close to 300 crowns. It may be that people want something personal, something that doesn't look like everything else. One lady even refused to tell her friend where she had bought her beakers – she wanted to be the only one in Jönköping to have one!" People tend to take better care of expensive things and also have greater respect for handmade items. This way they last longer and the garbage piles don't grow as rapidly."

Lindström has been hand-making beakers with different designs since her time at Konstfack in 1985. This may be seen as proof that it is actually possible to compete with industry. Not in actual output, but handicraft offers a greater possible range of colours and patterns, greater individuality and a variety which is evidently appreciated by the customer. "In my craft, I can do exactly what industry does and I can also produce an infinite number of varieties. This freedom is the most pronounced difference between an industrial designer and me, as a craftsman. The fact that my things do not have to be part of a long and drawn-out design process in order to fit a hi-tech production technique. Mass production inhibits creativity since it does not find it economically viable to make more than, say, five different colour combinations. And they strive for flawlessness – the product must be so clinically perfect that it becomes

164

"I want my work to surprise or delight," says Åsa Lindström who took her first ceramics course at the age of four.

Left and below:
Student Union, the Karolinska Institute,
11, Nobels väg, Stockholm.

"I love moments frozen in time."

virtually devoid of personality. I find that a minor aesthetic defect may sometimes be an added bonus – there is nothing wrong with detecting the human hand at work," Lindström says, making as many beakers as her time allows. "It is important that an object made for the hand to use is made by the hand," she adds.

As a sideline to the beakers she made some little shot-glasses, commissioned by the trade journal *Vin & Sprit* and now manufactured by Rörstrand. "In this case, I only acted as designer and left responsibility for the production to others." The motifs include a moose hunter on the alert, sexy *chanteuses*, golfers in knickers and impatient waiters. All in white china with black print and insides in platinum. "Coloured liquor, like whisky, takes on a wonderful glittering sheen because of the reflection," she says about these very popular gift items.

Lindström has a strong preference for pictures culled from the weeklies of the 1940s and 1950s. "It is as if people were more beautiful then, at least in pictures. And I love moments frozen in time." She has large piles of magazines at home and at first it was the pictures themselves that fascinated her. Soon, however, she became even more tempted by the possible patterns she detected. "Just making a mirror image can result in new and exciting motifs."

Technology has become her special niche and in order to study it in a larger context we go to the Karolinska Institute where she has a piece of public art. "These are my ceramic carpets," she says. It takes me a while to realize what it is I am looking at. Patterned ceramic tiles in black, white, green, and gold form – yes, really – carpets on the wall. They even have fringes! It is beautiful. I go closer and I see that it is not just a graphic pattern; it is people. And technical equipment of all kinds, related to health and to the body. Stern physicians, awe-inspiring iron lungs. My discovery goes on and on. The fringe, for example, is made up of a row of gymnasts with their legs apart.

"I started to collect hospital pictures which I then scanned into the computer, around 300 in all. Then I started on the selection and made a full-scale sketch to make the

pattern agree with the size of the tiles and to see what it would look like. The pattern was then printed on paper and coated with lacquer, the surface layer was soaked off and applied to the glazed tile before firing." Tile after tile, all by hand. She made almost 1,000 tiles for the three carpets.

Does she regard herself as artist, craftsman, or designer? "I work in all three capacities, depending on the job. It makes no difference to me – even though there are some differences, both with regard to status and to VAT regulations. But one is not better than the other, the main thing is to be true."

Lindström sees clay as the ultimate *ur*-material. "It's pliable, firm, and can be made into almost anything. At the same time, it has a life of its own, which occasionally makes it difficult to control. You often have to do some problem-solving to get to where you want to go, which is a challenge in itself. I am fascinated by a material that lasts the way clay does and intrigued by the fact that what I make may still be around 2,000 years from now."

Ceramic shards exist from ancient society while other materials have not withstood time so well. Even so, clay has long been looked down upon, because of its associations with handicraft, and the somewhat mossy reputation that goes with it. "I think that is about to change, as more people are discovering its advantages and its enormous possibilities; the fact that this ancient material may yield to new and modern forms of expression," Lindström says hopefully.

"My mother suggested that I become a dental technician – another job that involves working with your hands."

After three years in high school, Lindström enrolled in a ceramics course at Cappellagården on Öland. She then took a job at a daycare centre until she was admitted at Konstfack.

Following this, she accepted a position with Rörstrand, where she now works on a freelance basis.

Right:
Clockwise: The amphora in all its glory; the *Bollar* vase, small amphoras, and beakers; a detail of the décor at Ängbyplan; application of details and more beakers.

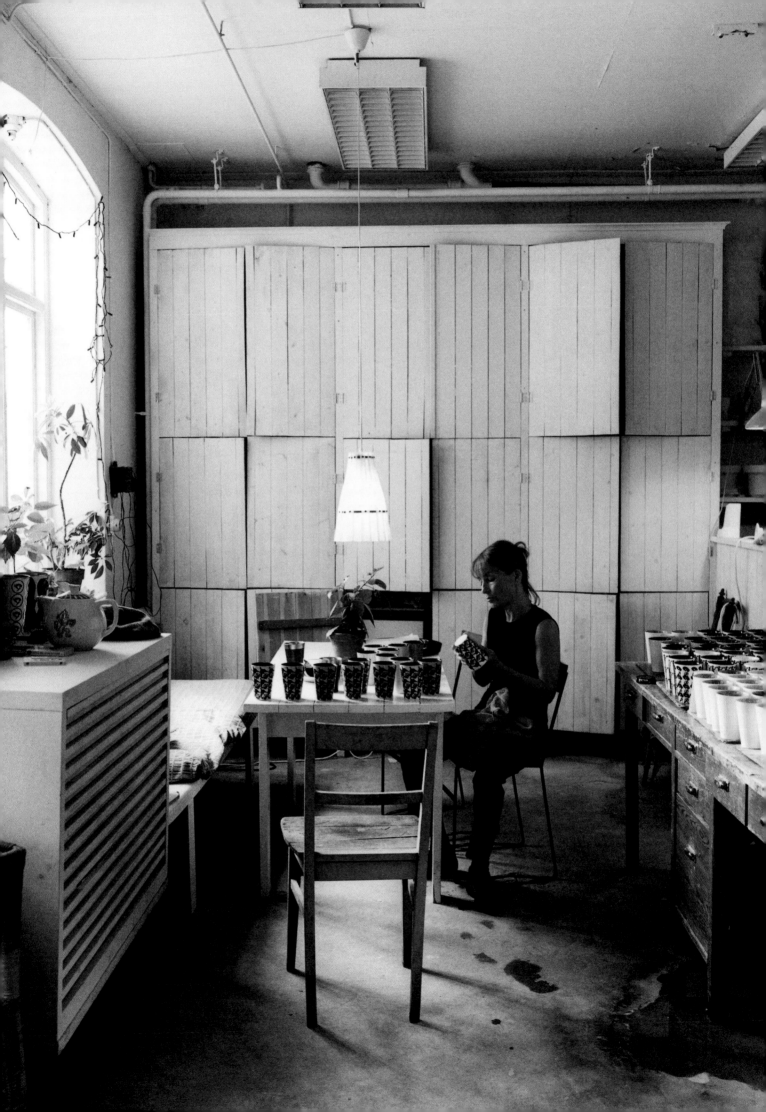

A SHORT GLASS GLOSSARY

ARIEL is a technique derived from graal (see below). A basic shape is first blown, consisting of several layers of glass and colour with sandblasted patterns. The basic form, the so-called blank, is cooled and the desired decoration is added through sandblasting, engraving, or cutting. Air is then introduced into the patterns of the various layers and the piece is coated with a thin layer of clear glass, thus trapping the air. The process is named after Ariel, the air sprite in Shakespeare's *The Tempest*.

BLANK is the name for the molten glass that is taken out of the crucible and which forms the basis of the object.

CRACKED-OFF GLASS see FLARED GLASS.

FABULA may be described as a kind of Graal technique. It was developed by Per B. Sundberg at Orrefors. Decals are applied to the blank before it is covered with clear glass and blown.

The FINISHING PROCESS may consist of sandblasting, engraving, painting, or cutting.

FLARED GLASS means that the mouth of the object is shaped by hand, with the aid of special tools. The edges are cut off with shears while the glass is hot. CRACKED-OFF GLASS is the opposite – the blown glass is knocked loose from the blowing iron and a so-called moil remains on the upper part of the glass. This is then knocked off when the glass is cool.

FLASHING is coloured glass cased with clear glass. The clear glass may be either on the inside or outside. The flashed glass method is used in Ariel, Graal, and Ravenna techniques where the pattern is cut, engraved, or sandblasted through the various coloured layers.

GRAAL comes from the Latin word *gradalis*, meaning bowl or cup. The blank is first blown into a bubble, after which several layers of coloured glass are added, one on top of the other. The glass is then cooled to room temperature before the decoration is engraved, sandblasted, or cut through the various coloured layers. Finally the glass is heated again, coated with an outer layer of clear glass and blown into its final shape.

MOLTEN GLASS consists of sand, soda, potash, lime, lead, and refining agents. Each glassworks has its own combination, the proportions of which are a well-kept secret. The lead content determines the type of glass. A small amount of lead makes for hard glass, suitable for engraving and cutting. Potash is simply the ash from deciduous wood. It helps the sand melt more easily.

RAVENNA is named for the mosaics in the city of the same name. A pattern is sandblasted into a slab of glass and then filled with pigment or coloured cullet. The glass is then heated and given an overlay of clear glass as it is blown into the desired shape.

SPEAKING OF CERAMICS

The word CERAMICS comes from the Greek *keramos*, meaning pottery clay, and describes all kinds of ware made from non-metallic and inorganic materials fired at high temperatures in excess of 500°C. Ceramics are widely used for everything from pots and household pottery to more specialized items such as sparkplugs and heat shields for space shuttles.

EARTHENWARE, a porous ceramic material, is fired at lower temperatures than stoneware and porcelain – (1000–1100°C.) It is rich in iron oxide, so it is often brown or reddish brown in colour.

FAÏENCE AND MAIOLICA are both types of earthenware with an opaque glaze, usually containing tin. They were developed in Faenza and Majorca, respectively, in an attempt to imitate porcelain.

FLINTWARE is neither porcelain, stoneware, nor earthenware. It is fired at the same temperature as stoneware, but the paste, as the fired substance is called, is not as dense. Flintware was developed because it bears greater resemblance to porcelain than does Faïence.

GLAZE is an outer layer applied by hand or by machine to produce a protective surface. This is fused with the piece and forms a vitreous coating which may be transparent or opaque, shiny or matte.

The INDUSTRIAL PRODUCTION PROCESS may involve a number of different techniques such as pressing, rolling, or moulding. The basis is a paste, which is shaped into the desired product while dry, moist, or liquid. The paste consists of various blends of, for example, clay, kaolin, feldspar, and quartz. Plates and flat objects are produced using a pressing technique, while bowls and cups are shaped by rollers. Asymmetrical products, such as pitchers, are moulded.

The objects are dried, polished, and fired before the glaze firing. The decoration is usually applied industrially after the glaze, in which case a final glaze firing is necessary.

PORCELAIN is the collective name for ceramic ware that is transparent when very thin. It is fired at high temperatures (1200–1400°C) making it dense and highly vitreous, largely transforming it into glass. There are several varieties of porcelain, such as feldspar china and bone china. Each of these differ in terms of colour (although they are only ever in shades of white), durability, and chemical composition.

STONEWARE is a semi-porous to hard ceramic material, usually fired at slightly lower temperatures to porcelain (1200–1300°C). It is not as vitreous as porcelain and is therefore not translucent when thin.

VITRIFICATION is the process whereby ceramic material is fused and hardened at high temperatures.

MORE ABOUT FURNITURE

BENTWOOD has a long tradition in Sweden. Gemla Möbel was the first to use the technique in 1903 in various Viennese pieces inspired by Austrian designer Michael Thonet's chairs, which have been in production since the 1850s. These used the steam technique, in which large pieces of wood are heated by steam and then bent according to a pattern. In the 1930s laminated bentwood was introduced in Sweden. With this technique, veneered plywood is heated and moulded into the desired shape.

FURNITURE PRODUCTION IN SWEDEN has increased by more than 20 percent from 1996 to 1999, putting production figures at 17 billion Swedish crowns. The domestic production capacity is unfortunately incapable of meeting the exceptional market demand and consumer interest. As a consequence, imports have increased by 19 percent during the same period. Sweden imports mostly from Denmark and exports to Norway.

MÖBEL is the Swedish word for furniture, from the Latin mobile, moveable. Before the Swedes were inspired to adopt the French word meuble and the German Möbel the word commonly used was bohag, household goods. This could include everything from knick-knacks to sleighs – that is almost everything that belonged to the home and was considered personal property.

The MÖBELFAKTA testing system was introduced in Sweden in the 1970s to ensure furniture quality and durability. Independent testing is especially important in the case of furniture for the public sector and contract purchasing. The testing categories are: strength and durability; surface resistance; fire resistance; safety; and upholstery. To secure the Möbelfakta seal of approval the piece has to meet strict environmental standards.

SWEDISH FURNITURE STYLES have always been influenced by foreign trends. The designs have become progressively cleaner since the mid-1700s when the playful ROCOCO style (c. 1750–1775) was introduced as a reaction to the solemn, heavy, and magnificent BAROQUE style (c. 1660–1750).

Louis XVI influences from Paris then gave rise to Sweden's GUSTAVIAN style (c. 1775–1810), which also reflected great admiration for the clean lines of classical antiquity. The excavation of Pompeii and other sites had begun in the 1730s and 1740s.

Then followed the EMPIRE style or, as it is called in Sweden, the KARL JOHAN style (c. 1810–30), which strove for even greater imitation of the forms of classical antiquity in general, and the Roman Empire style in particular. The Empire style's strict lines eventually softened into more swelling forms, and old designs were once more copied in the absence of something to succeed the Empire style. This period (c. 1830–95) was referred to as ECLECTICISM (a mixture of ideas and motifs from various sources). The style was mainly a blend of neo-Gothic, neo-Rococo, neo-Gustavian, and neo-Renaissance.

Around 1890 a new style developed in reaction to the flamboyance of Eclecticism. It was called JUGEND or ART NOUVEAU and was typified by understated, stylized floral decoration combined with a simple, functional design. This flourished in Sweden between 1895 and 1915, and heralded the cleaner lines of FUNCTIONALISM.

VENEERS (thin layers of exotic woods) were first used in Egypt in 3000 BC where it was used for inlays in costly pieces of furniture. Nowadays, it is mainly used in furniture production as a covering for particle board (made from compressed woodchips and glue), laminboard (of glued wooden rods) or fiberboard (made from compressed wood fibers without glue).

WOODS The most common woods used (usually in the form of veneer) in Swedish furniture production are: birch (Betula), beech (Fagus sylvatica), oak (Quercus robur), pine (Pinus silvestris) and cherry (Cerasus). Different kinds of particleboard are usually used between the veneer, however solid woods, such as alder (Alnus) and spruce (Picea abies) are also used as core.

TEXTILE TITBITS

Examples of embroidery stitches less familiar to the layman are double cross stitch, broderie anglaise, French knots, drawn fabric stitch, hemstitch, raised satin stitch, split stitch, feather-stitch, blanket stitch, honeycomb filling stitch, satin stitch, Romanian stitch, and bargello stitch. Needlework stores carry simple and educational descriptions of the various stitches and how to make them.

FRIENDS OF TEXTILE ART (Handarbetets vänner or HV) was founded in 1874 on the initiative of artist Sophie Adlersparre for the purpose of safeguarding textile skills threatened by industrial mass production. Weaving courses and exhibitions were held in order to further develop quality. A training programme for weaving teachers was initiated in 1924 and a programme for handicraft consultants in 1964.

FULLING is a mechanical treatment of wool fibres that makes them interlock, producing a denser and stronger cloth. Nowadays the cloth is soaked in a soapy solution – in ancient times it was water and fermented urine – and is then pulled through heavy grooved rollers. In the manual process – called felting – the wool is soaked in a soapy solution and rubbed vigorously until the fibres wad together. Woven wool cloth is called broadcloth when thin, and frieze when coarse.

TUFTING is a carpet technique which produces different qualities, all depending on the density of the pile. The top category, Classic, has 25 tufts per square inch, each tuft comprising six strands. The method is entirely manual. A synthetic canvas is stretched on a frame, as taut as a drumhead. The carpet pattern is then applied and the yarn is shot in place with tufting guns. Since the carpet is not tied, the threads must be fixed and glued on the reverse before the pile is cut.

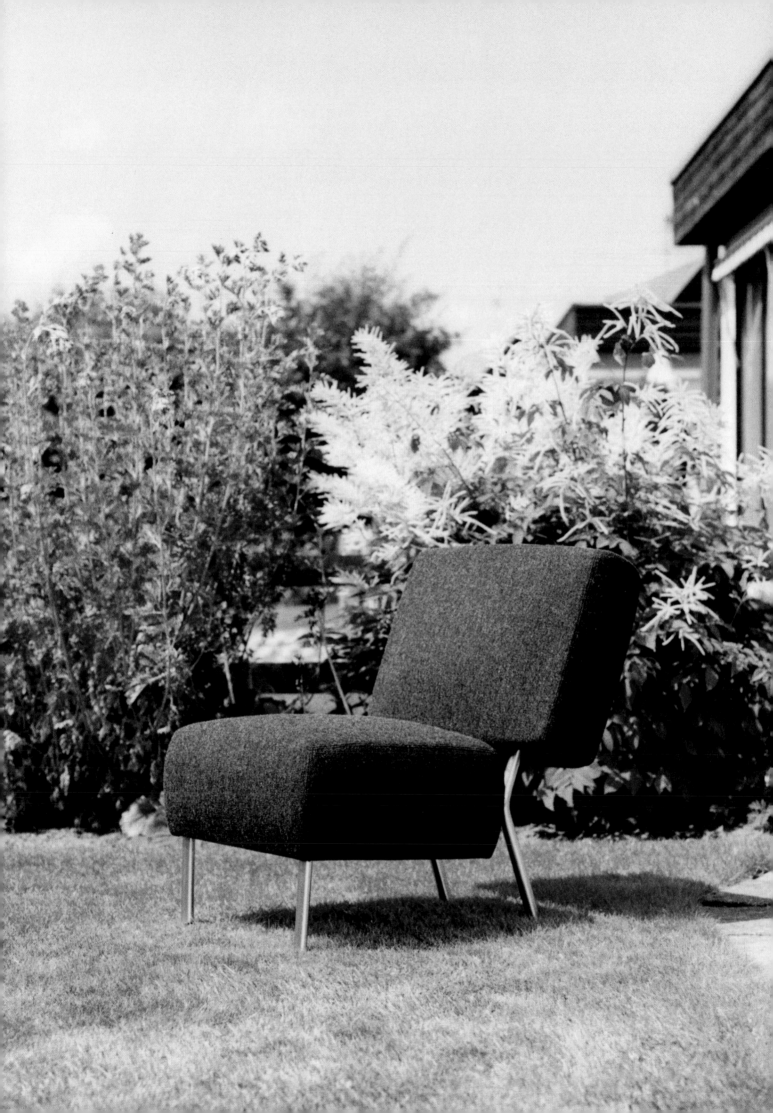

"It is a matter of investing little with much, of charging simplicity with maximum content and sustainable timelessness. Of utilizing and reinforcing the basic qualities inherent in the archetype and the materials themselves. Just as in life itself where the tiny, fundamental, everyday gestures are the most important."

The essentials of life. What are they, and how do you highlight them in an environment? How do you fill an empty space with something other than things, how do you create peace, security, empathy, and love? What kind of environment is needed to be truly in touch – with ourselves and with others? These questions are becoming ever more relevant as the noise of the surrounding world grows louder and harder to escape. There is hope, however, and architect Jonas Lindvall's idiom manages to come close to an answer.

"It is a matter of investing little with much, of charging simplicity with maximum content and a timelessness that is sustainable. Of utilizing and reinforcing the basic qualities inherent in the archetype and the materials themselves. Just as in life itself, where it is the tiny, fundamental, everyday gestures that are the most important." He provides a concrete example from his preparatory studies for the restaurant Izakaya Koi in Malmö, where he started by observing the behaviour of the guests and their reaction on entering a place where they know no one. "They were looking for some sense of security, some anchor. So I designed a bar on the bias, pushing it toward the entrance to provide those who felt insecure with a quick and natural haven. By lowering the ceiling I gave it a more intimate and friendly atmosphere – another way of showing that you care." Function became as important as the surface impression – it was more than just nice-looking. During my dinner there, I discover evidence of concern for the customer: instead of "desserts", the menu says "these won't be needed." A fun and endearing detail.

The fact that the customer may not notice this safe anchor does not worry Lindvall. "The most important thing is that I understand how the users want to feel in my settings, what their needs are," he says. He relates a story that moved him deeply. "I had furnished an apartment for a couple and one of them called me a year and a half later just to tell me how crazy about it they still were!"

The owner of the store Optiker Månsson, also furnished by Lindvall, tells me a similar story. "An Austrian optician who looked around the store for almost two hours and then actually shed tears because it was so beautiful." When I asked him why he picked Lindvall he said: "I knew that it would be something different and very special, since he designs the whole environment rather than just practical solutions. Besides, I like him as a human being."

Lindvall used to feel "depressed about having wasted his time on a lot of nonsense." But then he adopted the motto "what doesn't kill you will make you stronger." "Nowadays I see my chequered past as an asset – it is actually an advantage to have worked as a waiter when you furnish a restaurant. I attended various art schools as an evening student, I sold golf equipment, I worked as an illustrator and I started to study to become an optician before applying to HDK in Gothenburg to study industrial design. I think my experiences have given me a wider psychological perspective – something extremely valuable when you work with design. You have to understand people."

Of the students at the School of Design and Crafts (HDK) Lindvall was the first to attend London's Royal College of Art as an exchange student. After that, he spent six months at the School of Architecture of the Royal Danish Academy of Fine Art in Copenhagen. During his final two years he received a number of commissions within stage design and interior design – among them the Japanese restaurant which gave him his breakthrough and the courage to start his own architectural firm in 1994 – Vertigo[1] Arkitektur & Design.

"I remember that that was the year I designed my first house. When it was finished I was so envious of the owner; I wanted it for myself! But I'm a little bit like the baker's children who don't have any bread – I, myself, am living with an ancient shelf from Ikea, painted yellow." These contrasts are part of his personality – such as enjoying a karaoke bar occasionally rather than demonstrating his affinity with "the self-conscious Prada-bag-carriers of the design profession." Or listening to Bach with as much pleasure as to Miles Davis or Jimi Hendrix. Wearing tailor-made suits one day and slouching around in jeans the next. "I am attracted to a type that might be an Italian, well-dressed, Ferrari-owning company director, who is still a communist."

1: Vertigo is actually the medical term for dizziness, but Lindvall picked it for other reasons. "It's a graphically beautiful word that also means orbit and cycle. It is also a well-known label for hard rock music, which I sometimes listen to in order to clear out my brain."

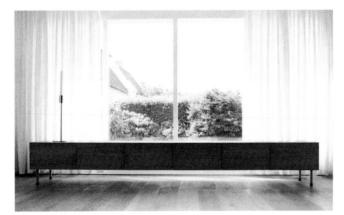

Left:
Lindvall has been called a "master of warm elegance." This specially designed stereo/CD/video storage unit has electric cords and antenna wires hidden in one of the legs.
Below: Speyside storage unit, produced by Kockums, bears the classic elegant Lindvall signature
Right:
The award-winning *Oak* for Skandiform.

"It is my task to work beyond what is contemporary, toward timelessness, quality, and function – to apply the brakes. Not to produce a frantic stream of new design."

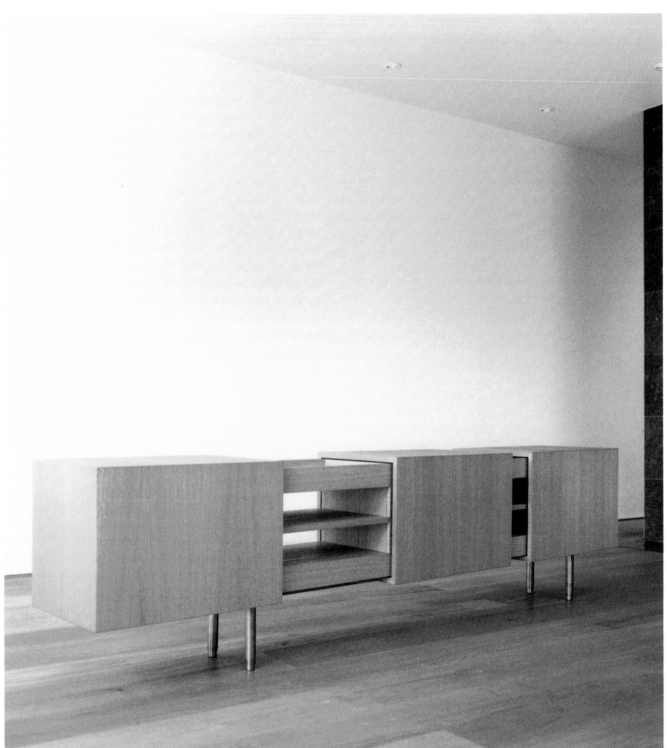

176

Lindvall also voices his concern about what he sees as "dishonesty toward the third party," with the built-in obsolescence of things as trendy new products hit the market with increased frequency. They are nice-looking things, but are often uncomfortable and badly made. Much surface, little content.

"It is my task to work beyond what is contemporary, toward timelessness, quality, and function – to apply the brakes. Not to produce a frantic stream of new design. Look at the Danes, they are still producing designs from the 1940s, 1950s, and 1960s which have withstood the test of time. That's true timelessness!"

His responsibility extends to the minutest of details and he loves solving technical problems: "I need to feel that I'm in charge of the entire production process. I could never hand over a sketch to a producer and ask him to solve the rest and then just check the prototype. Everything has to be just so. The more I know about each stage, the less expensive and the better the end result. A lot of effort is expended today on building brand names rather than quality – it's a pity."

In his opinion the media should be responsible for questioning and scrutinizing the products and offer constructive criticism. "It would keep us on our toes as designers and improve our design. Of course, I'm not sure whether my self-confidence could take it."

Speaking of brand names, Lindvall has been called a Minimalist and a master of elegance. "You're making me blush," he says. "Labelling is probably more important to others than to me. It is hard to try to explain my work objectively. I don't want to get stuck in a style and limit myself to an "ism". As for full-fledged Minimalist – nothing is harder. It's an extremely difficult balancing act. If you fail, it's just empty and bare. What you have to do, is to charge empty space and work with what may be abstractions to the user, but which are essential qualities. It may be light, proportions, or dimensions. My dream commission would be to be asked to take on the whole thing – design the house, the rooms, and the furniture. I suppose it is the same with all architects – you don't like to do a bit here and a bit there.

Designing furniture was the natural consequence of being asked to do a whole job. "I did a loft where the owner had bought a huge, ugly American TV couch which looked like a huge toad that had just landed. That forced me to create the optimal chair for TV-watching, since there was nothing on the market. Trying to do something that satisfied the needs of a large group was a real challenge. The result was an adjustable chair called *Metropolis*."

The producer of this and several other of Lindvall's pieces was Kockums Industrier – who came up with one of the most brilliant concepts in the modern industrial context. It was a way of utilizing a solid tradition of craftsmanship within an area such as shipbuilding, and applying it to another field – in this case, furniture design. The production never quite got under way for a number of technical reasons, so the project is currently on ice. "I really fought for this idea but unfortunately I couldn't change the way it came out. How does it go: *Sic transit gloria mundi*[2]! Even so, *Metropolis* was given an Excellent Swedish Design Award, (as was his chair *Oak* for Skandiform[3], which is still in production).

He often makes full-scale cardboard models of his furniture pieces "to forestall any unpleasant surprises. Before this, I have been making sketches in my head and on paper for quite a while. I may lie awake at night, turning over ideas, sometimes jotting everything down as I am obsessed by the thought that I will forget it all if I fall asleep."

His greatest source of inspiration is movies, that is, the stage sets of the film, the settings, and colour moods. "I am often so completely absorbed by what I'm seeing that don't hear the dialogue. It's the same with theatre," he says, adding that one of his dream projects would be to create a complete stage set in a guest house setting. "Imagine a modern guest house, with a blend of total peace and quiet and Danish comforts. That includes being allowed to smoke and eat fatty food, being allowed to be human! A place that gives a sense of safety and where you can have a good time."

It sounds like one of his mottos in life. "It is all about making life work, that's all there is to it. But making everything fall into place is still a challenge."

178

2: Roughly translated "Thus passes away the glory of the world." It was uttered by a Cardinal in 1488 as a little blue cloth was set on fire three times by a wax candle during the installation of the Pope at St Peter's in Rome.

3: Skandiform is a family-run furniture company founded in 1962 in Vinslöv, Skåne. It orginally specialized in furniture for the care sector, pieces with special functions for retirement homes, day lounges, and rooms for patients. Today most of its line is characterized by up-dated, modern, and simple design, suitable for both private and public settings.

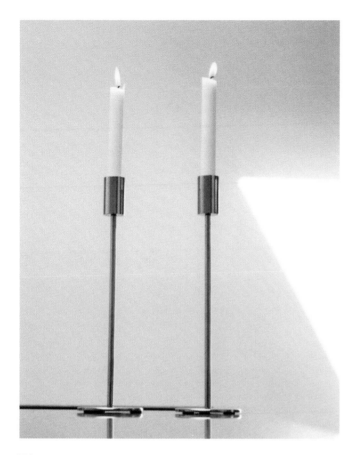

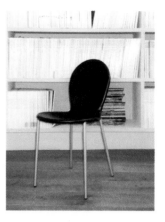

`This page:
Clockwise: *Noster* candle (305mm).
Its brother, *Pater*, is 548mm. Lindvall
says, "I suddenly realized that I wanted
some 40mm candles for an exhibition
but could not find any suitable
candlesticks. Six days before the
opening I designed them on a flight
between Stockholm and Malmö, and
Skandiform miraculously had time to
make some." Plan and final product for
Quasimodo, a good-selling set of clothes
hangers, available in different woods;
prototype of the *Fausto Copi* chair, 1992;
interiors of Villa Andersson, a private
residence in Landskrona.

179

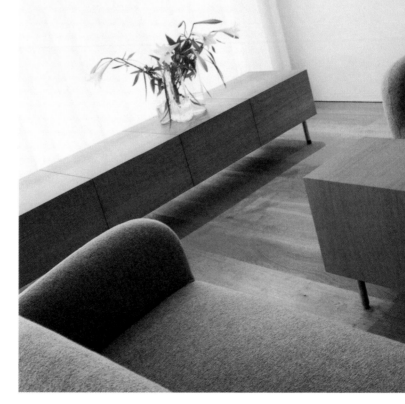

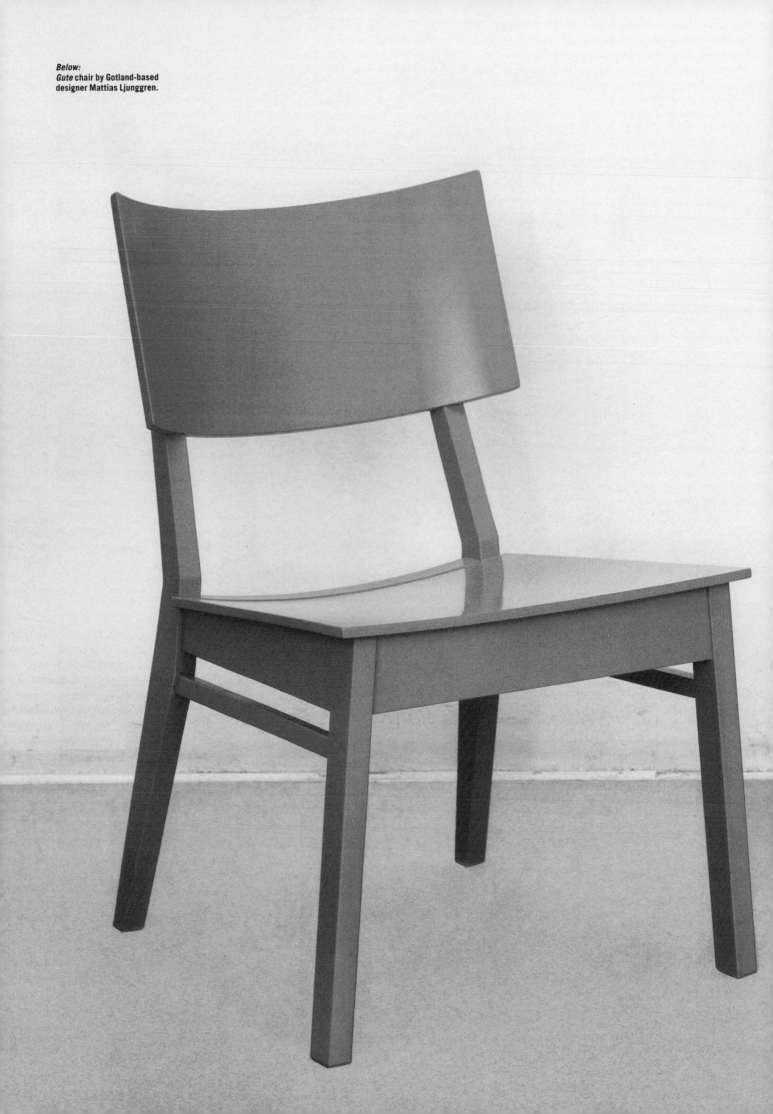

"**You must be able to see the soul.** Function must be so self-evident that the expression and character of the piece shine through," Mattias Ljunggren says. The *Gute* chair is a good example. You can't walk past without reacting to it. It is a hybrid between a chair and easy chair, in the tradition of Carl Larsson as well as of our own time. It looks uncomfortable, with its lack of upholstery, but its soft shape, colour, and embracing width are inviting. Once seated, you tend to stay.

"I wanted to make something that would oppose the light and blonde Scandinavian pieces that you see everywhere. Something not that beautiful, but that carried a different message. It is always fun to provoke a reaction, and *Gute* seems to appeal to a wide variety of people. It fits in everywhere, in the city, the summer house, at home, and in public settings." According to Ljunggren, his pieces are the result of production demands, function, materials, and his own personality. "I don't want them to be too extreme, they should blend in easily in different contexts and yet convey a powerful expression of their own. Complex, yet simple!"

The *Cobra* chair, designed in 1989, was an attempt to find "the purest possible chair design – archetypal and almost clinical, while at the same time enormously functional in combination with something different. I asked myself why it was that so many chairs looked the same, and found the answer in *Sittmöblers mått* (*Seat Measurements*), the Bible for many designers during the 1960s and 1970s. Instead of following its recommendations, I tested all the measurements myself, until I was comfortable. And the leg construction has a pointed rather than a rounded edge. It may not sound very novel, but it was at the time – both from the point of view of design and production technique. As a result, *Cobra* looks uncomfortably hard, but is actually extremely comfortable to sit in. Arne Jacobsen's *Myran* is quite the opposite: round and inviting but uncomfortable!"

Ljunggren designed *Cobra* while still a student at Konstfack and began producing it himself. "Just buying the tool to mould it cost 15,000 crowns, which felt like an insane investment to a poor student." Källemo eventually

"I am happy about my chequered background; it is very important to have done different things. It makes it easier to understand both people and the commissions." Ljunggren's previous jobs have included economist and photographer.

182

took over production and extended the *Cobra* range to include an easy chair, an armchair, a conference chair, stools, tables, and a combined sofa/daybed.

Seating furniture holds a special fascination for Ljunggren who designed his first piece of furniture – a table with storage space – aged eleven. "My fascination may go back to the fact that my maternal grandfather used to make lots of chairs as well as the fact that you spend so much time sitting." His first piece for Källemo was *Boxer*, an overstuffed armchair that actually started life as a candlestick. "As I start from a sculptural shape – a kind of concentrated form – it may become almost anything. I had just cast a candlestick in bronze when I realized that it was the perfect shape for an armchair!"

Ljunggren claims to work like a sculptor or a mathematician, as lines, proportions, measurements, and dimensions hold such fascination for him. As does the space surrounding the piece. "It is important to understand what happens to a chair when it is placed alone, as opposed to in a group – it is totally different as a single piece in a living room compared to fifty in an auditorium."

Speaking of sculpture, Ljunggren has had several gallery shows which have allowed him to forget about production and express himself freely. "It is a matter of showing furniture pieces in small, handmade editions rather than labelling myself as an artist. Having grown up in a family of artists I have always felt an automatic need to express myself," he says. "And I have found an outlet for it in various things – first in photography and then in design and interiors."

After his first job – as an economist in food production – he became a photographer in advertising. "It inspired me to move to advertising as an art director, so I applied to the Beckman School, but didn't make it. 'If you work on your drawing you'll make it next time,' they said. So I did, at a local high school. Then I studied woodwork at Nyckelviksskolan. There I realized that I wanted to go to Konstfack and I was admitted to study interior architecture and furniture design. It's very important to have done different things. It makes it easier to understand both people and the commissions."

"What frustrates me most is that, as a designer, you have so many more ideas than can ever be realized. Out of 100 ideas, you sketch twenty, draw and present maybe ten to the producers – out of which two to five may actually be produced, if you're lucky. Thank God I'm not as shy as I once was, so I have no qualms about contacting a producer with an idea I believe in. And if I find myself without a job, I assign myself a task, an idea to put into concrete form. You just have to keep going. What else can you do, when you just know that you have the most wonderful job in the world?"

Above:
Cobra chair. The chair is supposedly the one piece of furniture that a designer has to tackle. A kind of calling card, a signature: "this is my way of putting my unique stamp on the already enormous number of chairs in the world." The challenge is trying to see what is missing on the market, design-wise or price-wise. A chair has to be more than comfortable and adapted for the right sitting posture, it also has to hold up to scrutiny from all angles, much like a sculpture. In addition, it often has to be stackable. It is an important product, money-wise, both for the designer and for the industry. A specific chair may account for up to half of a furniture company's business. And the royalty from it constitutes the designer's meal ticket, as we all know.

NIRVAN RICHTER

Below:
Länstol. Hitherto the best-known Norrgavel product and the company's pride and joy.

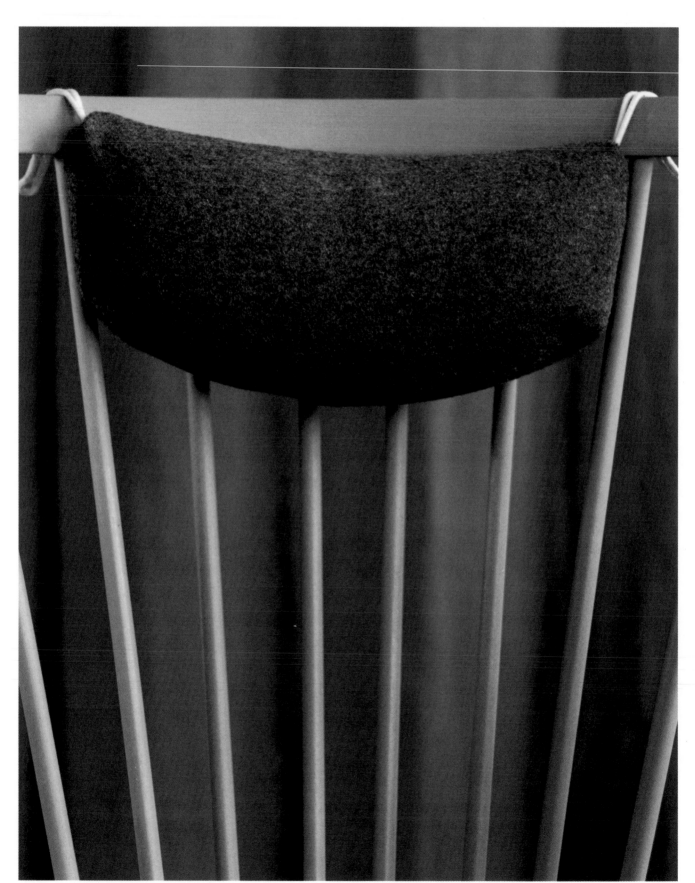

"What I really miss in our time is genuineness, dignity, depth, meaning, and presence. Qualities that lend meaning to our lives."

Presence is Nirvan Richter's one and only catchword and, to his way of thinking, also the meaning of life itself. In professional terms, it means that when he creates things for others to live with he takes his time, immerses himself in the task 100 percent, is never careless and never settles for a simpler solution. It may also mean that an idea may take ten years to bring to completion if necessary – as was the case with one of his most famous products, the sofa for Norrgavel[1]. It simply means doing what feels right.

"I don't think that my things make people happier, even if I might wish that that were the case. I am a realist – at the same time the 'saviour complex' is always present. The fact that I chose to express myself in furniture is partly because there were so many bad things on the market, with no feeling and of inferior quality. I was disillusioned with the fact that so many devoted themselves exclusively to the design and not to the relationship between the product and its user."

When Richter was a student at the Royal Institute of Technology's School of Architecture everything was going smoothly. After graduating, he worked for a few years in an architect's office until something happened. "For the first time ever I allowed myself to step back and take a good look at what I was doing. I suddenly realized that I felt like someone on the periphery, who is misunderstood." He saw how architects would devote their nights to the struggle for art while their days were spent at the beck and call of the construction industry. How an endless string of compromises led to a state of constant frustration and unhappiness. He also found the media focussing only on what was new and trendy, rather than on what was good.

"What I really miss in our time is genuineness, dignity, depth, meaning, and presence. Qualities that lend meaning to our lives. I wanted to find a niche where I could focus on these qualities and really shine, so I set two goals for myself: I would not spend my time drawing at a desk, instead I would feel the material with my hands." Said and done. He took some complementary evening courses in order to qualify for the Carl Malmsten School[2], where he learned everything that there is to know about wood and furniture making.

187

In February 1993 it was sink or swim. Richter decided to devote everything to furniture for the Karlskrona housing fair. He had no way of knowing that this decision would lead to something that no contemporary Swedish designer had ever before attempted. It marked the first tentative steps of the Norrgavel business concept: a unified collection of furniture for the home, by one and the same designer, and sold in its own stores.

"I wanted to see whether I could communicate with people through my products, the materialization of my dreams. It was not primarily about furniture, more a reflection of life."

When he had finished furnishing the apartment at the fair he was reluctant to let people into his creation. "I was so pleased with the result and I thought, with my usual pessimism: 'they'll just end up vandalizing it and stealing things!'" His misgivings proved unfounded. The result was the opposite: it was an unqualified success.

"It was completely overwhelming. People asked intelligent questions, they saw what it was I was trying to express,

1: Norrgavel (lit. North gable) is the name of Richter's company and store. It is inspired by the northern gable of his workshop in Lund. "Why not? It's a good name, since the gable is very characteristic of the place!"

2: The Carl Malmsten School was founded in 1927 by the well-known furniture designer, teacher, and writer of the same name. The idea was to preserve and develop traditional skills within furniture-making – one of our oldest professional crafts. This would be done by assuring the student "a technical and artistic education" with "hand and thought in creative interaction." The school, situated in Stockholm, today has college status and is tied to Linköping University. Five educational programmes are offered: furniture-making, furniture restoration, furniture design, upholstery, and guitar-making.

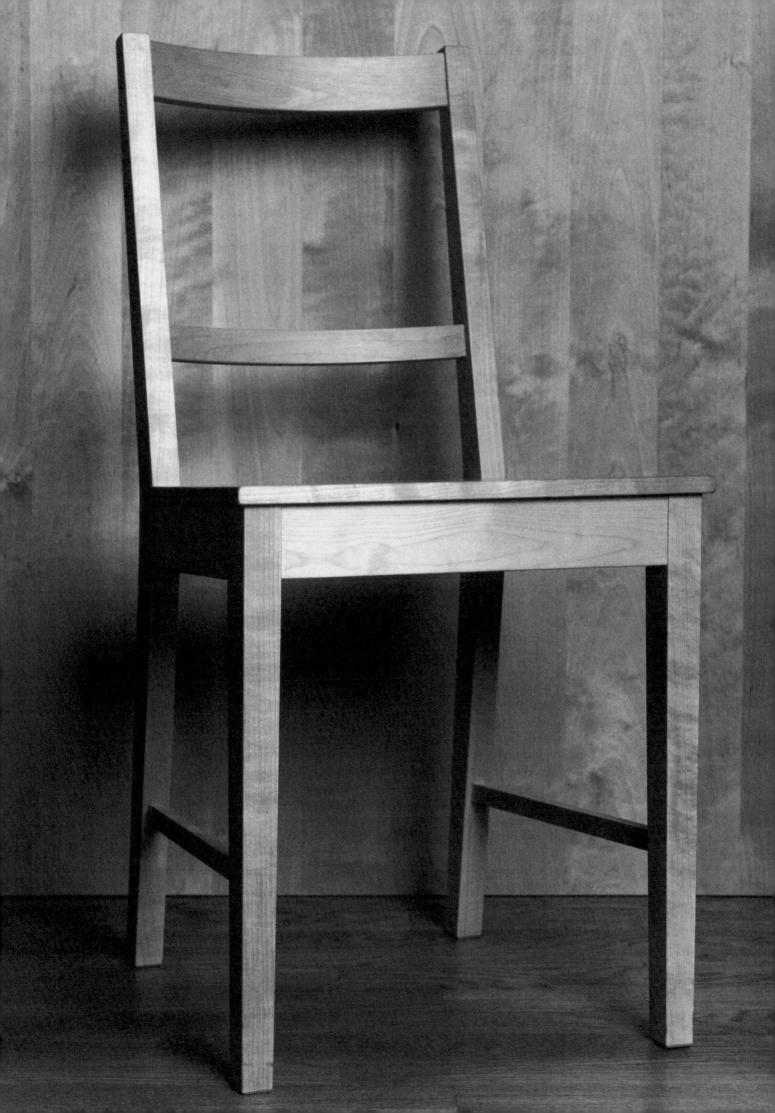

Page 188:
Curly Swedish sheepskin used on the
cushion of a footstool.
Page 189:
Richter's latest chair *Bas* in birch. It is
available in three surface treatments:
soft soaped, oiled, or tempera.

Above:
Clockwise: the Excellent Swedish Design
insignia next to Osho, Richter's teacher;
detail of the *Stol* chair; the *Länstol*
armchair in beech by the tiled stove in
Richter's home; shelf brackets in various
surface treatments and happy faces in
his workshop in Lund.

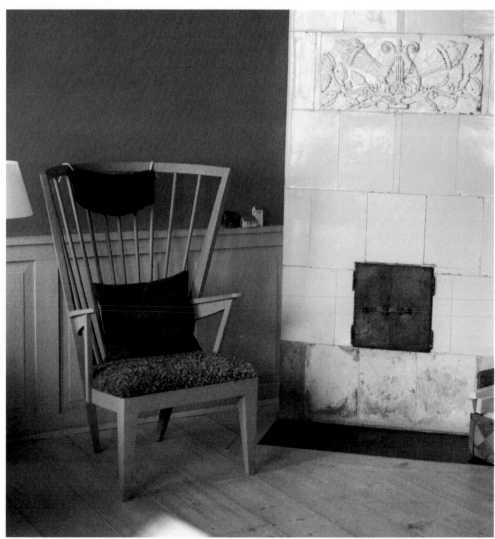

190

"Would you like to know how to create a perfect painting? It is simple. First make yourself perfect. Then you may paint any way that seems natural to you."
Richter's favourite quotation from the book *Zen and the Art of Motorcycle Maintenance* by Robert M. Pirsig.

they got my message even if they could not explain why it felt right. I felt that they had understood what it was that Norrgavel wanted: a home that breathed – a simple everyday quality. We received several orders even though we had nothing but prototypes, so the delivery time was extremely long."

It became apparent that Richter had managed to convey something that the public wanted. Naturalness, timelessness and harmony. Innovation and tradition. Focus on the user, blonde Swedish woods, soft soap, oil and tempera, soberly dyed linen. Leather from Swedish cattle and reindeer. High-quality furniture to live with and grow old with, no shortcuts. Small wonder then that they referred to him as the heir of Carl Larsson.

In order to unify the Norrgavel range and introduce new materials, Richter added glass, china, cutlery, and lamps by other designers and craftsmen. "Learning the furniture is like learning a kind of grammar. You discover what goes with what, you see the logic in the whole and also what is missing." He does not like to make things on demand, like when a colleague says "we need a bed and a mirror." "It is much harder to produce things like that than when products stem from a sheer desire to create."

The strength of the Norrgavel concept is its clear consistency. Since the Karlskrona adventure, stores have opened up in Stockholm, Gothenburg, Malmö, and Lammhult and several projects are under way. "I have a vision of opening stores in Copenhagen and New York – but I'll allow it to remain a vision, not a goal. If it happens it happens – there is no sense in trying to determine the future."

In trying to find the word that will best describe Richter, I finally settle for insightful. We talk about people today, how they confuse existential needs with material ones. How so much time is spent on survival rather than living. How we try to satisfy yearnings through consumption, and how, in our pursuit of the ideal image of life, we miss out on the meaning of life: to live in the here and now, to be present in small things. That is where he wants to go, and he is well on his way.

About five years ago, Richter decided to attend a course in self-realization in Mullingstorp. About the same time he came into contact with Osho[3], an Indian guru, and has since spent a year and a half in long-distance studies to become a therapist based on this philosophy.

"Learning more about myself has been extremely useful in my contact with others, and I have learnt to focus on the essential. Before, I found it difficult to achieve strength and harmony and I was heading straight for a burn-out. It was vitally important." In spring 2000 he travelled to Osho's principal meditation resort in Pune, India, for further studies.

After talking with him for only three minutes I notice how this philosophy has coloured his whole way of thinking. It is as puzzling as it is fascinating to hear him talk about his greatest challenge: to arrive at the realization that material things are not important. How does this tally with his role as furniture designer and, consequently, producer of even more things? "Of course I love design and I may feel that Norrgavel and the furniture are important in one way, that I invest all my soul and power in trying to attain perfection in what I create. That creativity has given me the air I need in order to survive. At the same time, I know that the total presence I seek I find best in meditation – that is where I truly live", he answers, adding that he would love to meditate for ten hours a day. What he also wants to do is to strive, through his actions and the way he conducts his life, toward the Indian name that Osho's disciples have given him: Anand Nirvan, loosely translated as Blissful Liberation.

3: The Osho movement has more than 500 meditation resorts around the world. The largest is situated in Pune, India. The message is primarily that of love, and courses are conducted in a number of meditation techniques. Osho himself died in 1989, but his many disciples carry on his message.

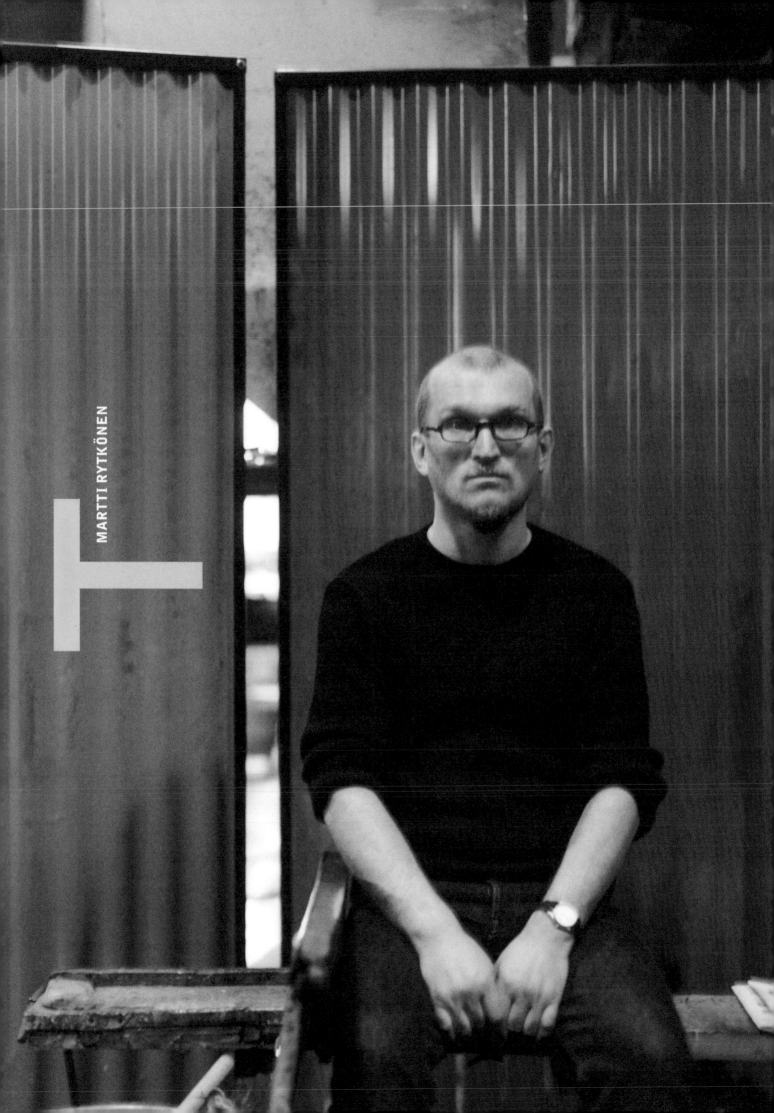

"If I didn't do this I would still do this. It is such enormous fun!" Martti Rytkönen says with great seriousness, but always with a dose of humour. "I would love to transfer the lyrics of both the Moomin Trolls and the Kalevala to my imagery, to use my products to tell a story," he says, offering me a sample: "En dam *ska inte klä sig som en skrutt, hon skall ha en hatt med truddilutt!*" (A lady should not dress like a twit, she should wear a hat with a twiddly bit.)

A Karelian scribbler. I can't tell you how many designers mention the word humour when they describe their products. It's not that I don't believe them, but it's hard to detect it in a stylistically pure chair, or a straight-sided vase.

The humour in Martti Rytkönen's glass is more readily apparent, more immediate and powerful. What about his sculpture *Ungkarlsblomman* (Bachelor Flower), a wonderfully practical potted plant in glass which definitely never needs watering? Or some of the titles of his products and exhibitions: *Hemmakväll vid TVn* (An evening at home in front of the TV), *Kaffepaus* (Coffee break), *Finska kossor* (Finnish cows), and *Sjöjungfruherrar* (Mermaid men). His sawed-out glass dogs ought to become an alternative to serious gifts on solemn occasions. "My products are simple but crazy."

Rytkönen was an Orrefors fellow in 1993, devoting himself to "crystal scribbles" that resulted in a set of sandblasted and engraved cups and decanters. "It was terrific to make spontaneous doodles on something as pristine as a shiny virgin crystal surface. 'Ruining' the untouched surface felt almost like a taboo. Being irreverent was both fun and liberating."

He was offered a permanent job the following year, the day before he graduated from Konstfack in glass and ceramics. A rather strange choice – the traditionally elegant Orrefors style in combination with Rytkönen's humorous and cartoon-like style. Orrefors wanted someone with a narrative idiom who worked in cut, engraved, and sandblasted glass – techniques that were among the glassworks' oldest traditions. Rytkönen was the natural choice and a good complement to the language and techniques of the other designers.

Rytkönen's idiom is rooted in his childhood in the forests of Karelia and the deep impression left by its lively narrative tradition. "Telling a story is my way of conducting a dialogue with the viewer. People tend to think of crystal as too dignified and expensive to touch, so I thought that if I combined it with humour they might dare to touch it!"

He enjoys irreverence and turning notions on their head. An example is his series of glass vases with a sandblasted picture in the middle. "I thought that this way you could have a piece of art at home that you could take out whenever you feel like it. Ordinary pictures just hang there – when you grow tired of my vases you can just put them away."

His work often involves engraving, so almost everything he blows falls in the category of art glass. One of his great inspirations is Edward Hald[1], whose work in the 1920s earned Orrefors a worldwide reputation. "I recognize myself in Hald's humour, ingenuity, and spontaneity." The engraving process is time-consuming, making the piece more expensive than a mass-produced product. He managed to find a workable mechanical engraving technique for his *Happy* range, however, which as a result is less expensive.

As we talk about how a childhood environment can shape the individual, Rytkönen recalls his rebelliousness as a teenager. "I tottered around in a pair of fake alligator-skin platform shoes – they only came in one size. My midriff was bare, it was cool to show your navel – but, God, was I cold!"

The cold, the forest, and nature are recurring themes in his modern, stylized romanticism. During his first year at Orrefors he produced a service, *Wolfie*, consisting of a bowl, decanter, and simple glasses with a sandblasted decoration of frolicking wolves and a solitary spruce tree. He describes sandblasting as something especially Nordic and Rytkönen-esque, and adds "I have never encountered a wolf, I'm happy to say, but the feeling that there was one lurking behind the corner of the house was always present."

A different kind of lurking threat was the one presented by the Russians who often occupied Rytkönen's thoughts when he was young. Freedom was therefore an important word to him – not least in his choice of career. He was tempted by acting and art, but spent some years working in the health and elderly care system in Norway and in Sweden. He thinks that everybody could benefit from working in the care sector. His experiences in caring for the old were especially rewarding. "Just listening to their tales was wonderful!"

He applied to Kyrkeruds High School by chance and was accepted. "For a long time I preferred ceramics. Not until after some time spent at Konstfack did I discover glass and its vast possibilities in earnest. It took me about five years to realize what working with glass involves."

194

1: Edward Hald, pioneer glass artist, first employed by Orrefors in 1917. His development of engraved crystal and the graal technique led to the international breakthrough of Swedish crystal at the 1925 Paris World Exhibition. Hald also designed ceramics, lamps, and glasses for everyday use.

Left:
A plate from Rytkönen's *Happy* range, for which he managed to devise a workable mechanical engraving technique.
Below:
Clockwise: *Bachelor flower*; *Hund* plate with his favourite motif; and dogs cut from lead crystal.

"I prefer working with art glass where no one interferes with my work. My favourite glass is perfectly clear. It possesses that nothingness that forms a fourth dimension – it's wonderful!"

195

Left:
Nightsky vase. Dark-blue cup on black foot.
Right:
"The *Sigma* candle-lantern is a Nordic jewel in lead crystal," Rytkönen says. He has devoted much attention to the cut surfaces, which exquisitely reflect the light of the candle.

How does Rytkönen reconcile his strong urge for freedom with his permanent position at Orrefors since 1994? "Oh, but freedom to me is doing what I like, so that's no problem. Besides, it deepens my commitment – it is easier to concentrate and in the end you acquire an international outlook that's very valuable," he says, adding that having the opportunity to work with a number of Orrefors' partners is a great bonus. He can continue his studies at Venini[2] in Italy, and Royal Copenhagen or Georg Jensen in Denmark, more or less any time he wants to. "It's important to keep growing, as quality is on the rise in the former Eastern European countries. Design is still an area where we are competitive. Sweden is ahead when it comes to art glass, along with Finland and the US." He insists that one of the main tasks of a designer is to find and refine his own speciality, thus creating a niche for himself. His greatest strength is that he is able to create a product with individuality for a large audience.

He admits to being worried that design will somehow have to conform to the European Union and become standardized – that he as designer will have to pay more attention to foreign tastes. "The danger is greater in Sweden than in Finland where the glass designers are gods and do whatever they please. I will never allow myself to conform to crazy EU standards!" Rytkönen also thinks that it is important for the various glassworks to retain their individual character: Orrefors produces classic, clear glass and heavy crystal, while Kosta Boda offers pieces that are more avant-garde and "circus".

He likes the fact that work and leisure tend to merge in the relative isolation of Småland – he is a nature freak and takes much of his inspiration from there. He always carries his sketchbook, even when mushroom picking. "When I moved here I thought, 'All right, I'm now living in the country' and tried to behave accordingly. It was not always easy to do things right, however. I planted potatoes that just disappeared, I made apple sauce which became covered with mould, I dried mushrooms in nylon stockings hung on a radiator to the ironic comments of my friends. Once I featured in the local paper for having triggered a fire alarm; a pull tab from a beer can had got lodged in the heater of my sauna!"

When I call his studio on one occasion he is listening to the Moomin Trolls who he thinks are cute and inspiring. "I would love to transfer the lyrics of both the Moomin Trolls and the Kalevala to my imagery and use my products to tell a story," says Rytkönen, offering me a sample: *"En dam ska inte klä sig som en skrutt, hon skall ha en hatt med truddi-lutt!"* (A lady should not dress like a twit, she should wear a hat with a twiddly bit.) He laughs.

In spite of the seemingly slow pace of the countryside Rytkönen does not have time to realize all his ideas. But he keeps dreaming: of textile projects, of putting fibre optics in the tails of the dogs, and of opening a zany shop selling joke products. There is a time for everything.

197

2: The world-famous Venini glassworks was founded in 1925 by the legendary glass artist Paolo Venini (1896–1959), who is regarded as the creator of modern Venetian glass. It is situated on the island of Murano outside Venice.

INGEGERD RÅMAN

Below:
Ingegerg Råman. "When I need inspiration
I open my cupboards and look at previous
designs. I turn them over and over to get
new ideas."

"It is a matter of being true to myself, to believe in and take advantage of my own expression. I have promised myself always to proceed from my own needs and the way I want it to be. When I don't, it just does not turn out well."

Beautiful consistency. In the middle of the picturesque old quarters of Djurgården there is an old bakery that houses the studio of potter and glass designer Ingegerd Råman. The bakery sign, a golden pretzel, still hangs above one of the large windows and the interior, highly visible from the outside, provides a welcome change from the romantic surroundings. We meet as she comes along one of the alleys, having walked all the way from her home at Kungsholmen. "I am not the sporty type, so walking is my only form of exercise. Besides, I think well when I walk," she says as she makes coffee and puts some Italian macaroons in one of her black clay pots.

I look around and am immediately struck by the consistency of Råman's design career that covers more than thirty years. Here are objects that have been in production since 1968 and which still sell extremely well. To remain as unshakably faithful to this clear a line – and for so long – must require both courage and strong motivation. Even in the bombastic 1980s, she remained immune to trends of acid blue and overblown tastes. And when Parliament and the Ministry for Foreign Affairs commission products from her, the traditional golden crowns have to yield to her simplicity.

"It's a matter of being true to myself, of believing in and taking advantage of my own expression. I have promised myself always to proceed from my own needs and the way I want it to be. When I don't, it just does not turn out well." And you do capitulate before the truth and the warm and relaxed naturalness that she and her products convey. It springs from her deep delight in things that are pure and beautiful.

"I have a feeling that this very moment, when I have started to receive my Social Security pension, will mean a chance to improve, that a new era will begin," she says, adding that it does feel strange: "For the first time in thirty years both my husband and I are permanently employed."

After eighteen years with Skruf, a small glassworks, she thought it was time to move and approached Orrefors. "One of the young designers wondered why they were taking on a fifty-six-year old. I told myself: 'Relax, I am strong, I am seasoned and I know I'll manage!'" She tells me that in African cultures, unlike in Sweden, experience is highly valued. "When a child dies, it is sad, but when an older person dies, it is regarded as disastrous for society as a whole, given the wealth of knowledge and experience that are being lost."

In spite of her experience and the validation offered by her surroundings, Råman still feels insecure, "If truth were told, the greatest disappointment about growing older is that I don't feel how I thought I would automatically: that I would be confident, and calmly go about tapping my well of experience when faced with a new task. Instead, I find myself thinking: Oh God, I managed to pull that off for the last time."

She sometimes thanks her lucky stars for her dyslexia, since it has contributed to strengthening her other senses and developing her skills as a craftsperson. "When I was young, people like me were considered uneducable. If my teacher, Lisa Iremark, had not made sure that I was allowed to attend an ordinary class I don't know what would have happened. When the others were busy writing I was allowed to draw and paint, and I have really valued the general education I received in spite of everything."

The "uneducable" girl was sent to a school specializing in home economics. It was not as awful as it sounds for Råman loves both cooking and everything that goes with it. "I am actually a real housewife, even in my creative work. When I need inspiration I open my cupboards and look at old designs. I turn them over and over and get new ideas."

As fate would have it, Råman was working in the kitchen at Capellagården on Öland in the mid-1960s when Eva Englund[1] was doing some work in the ceramics studio. "She taught me everything she knew, and I immediately felt that clay was really cool – and also hard physical work. Then I applied to Konstfack. After some time there I frankly felt that my brain was empty, so I went to Italy to study ceramic chemistry for a while in order to achieve some 'constructive balance.'" The most important thing she got out of Konstfack was a network of contacts and an acquaintance with glass.

After her studies she worked for a few years at Johansfors glassworks, only to return to pottery and her own studio for almost ten years until another glassworks, Skruf, asked her

201

1: Glass designer Eva Englund (1937–1998) has been called the heir and renewer of the graal technique. She worked for Orrefors between 1974 and 1990. Her pieces include a series of objects with misty animal and plant motifs – "crepuscular bowls," she called them. She started as a ceramicist and was one of Råman's closest friends.

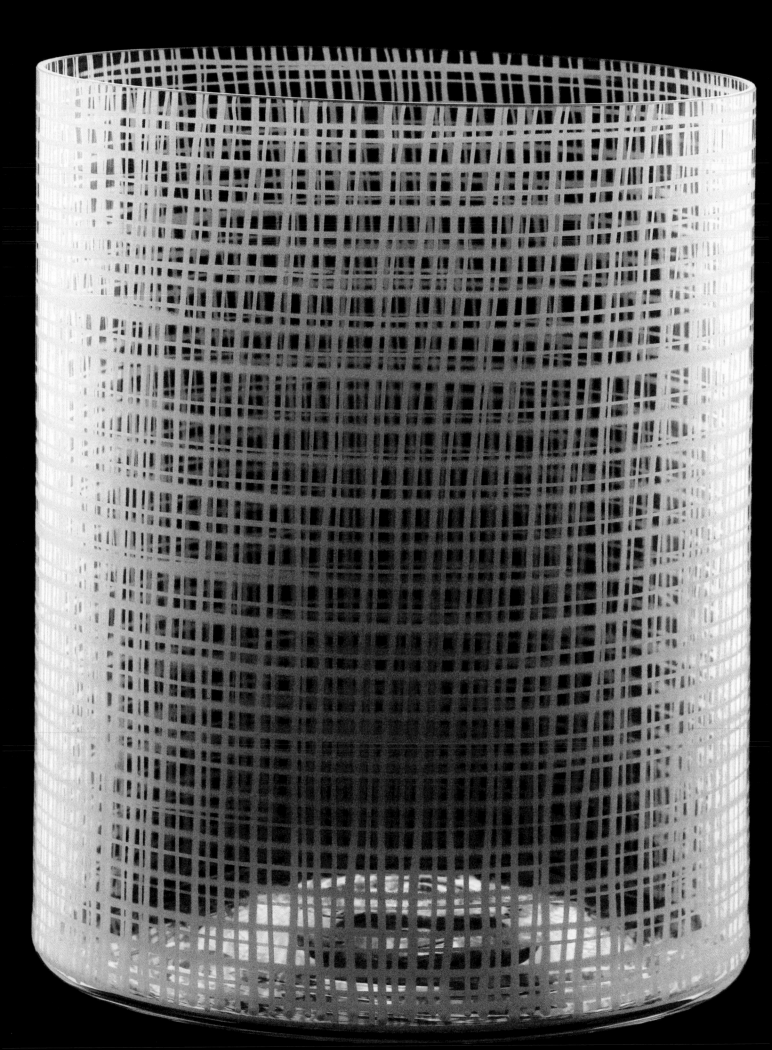

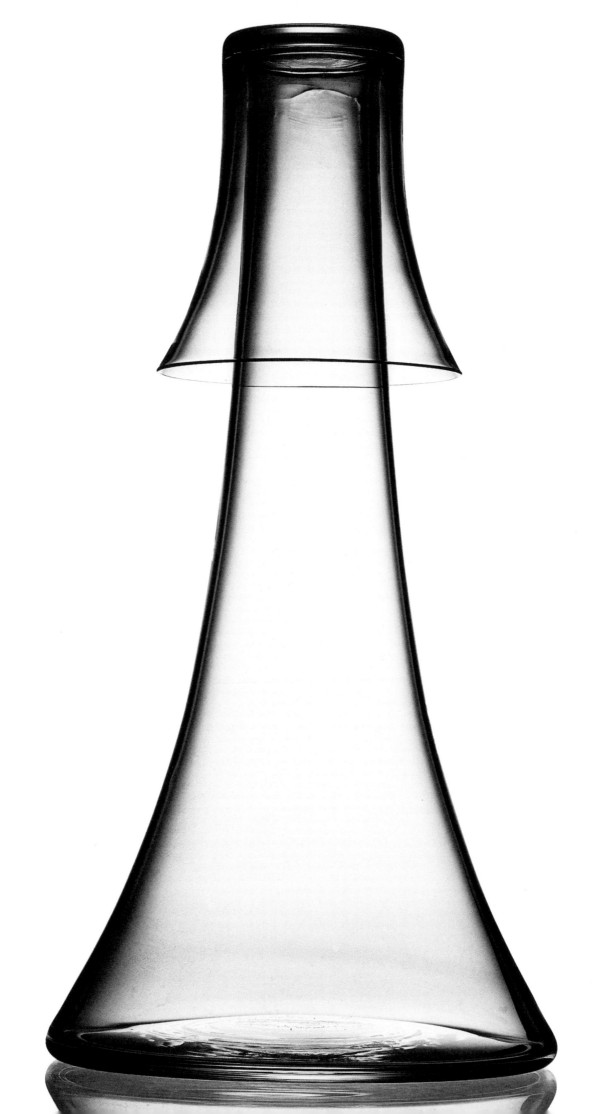

to be their designer. Råman felt that it was time for something different and it was to be a partnership that earned them multiple awards. "Every time one of our products was given the Excellent Swedish Design Award, I would breathe easier thinking: 'now I'm safe for another year.'" She was able to breathe easy for eighteen years running.

Her mission is to simplify and follow a clear, basic line, with minute but effective variations. "Since I consider myself complicated enough, my relationship to what I do must remain uncomplicated. By simplifying, I achieve harmony and clarity – an ageless shape which may be described as obvious." Maybe that is why her objects appeal to men; they seem to be attracted by that kind of uncomplicated straightforwardness. Her decorating style is equally clean and minimal – she has a need for empty space. It is no accident that she asked Claesson Koivisto Rune to help her with her summer house in Skåne. Her 750-square-foot kitchen contains nothing except for a 13-foot long table.

But simple does not equal easy. She talks about millimetres, the difference that two, three, or four make. "Not just for the form, but for the function. Like when a plate also has to serve as the lid of a bowl, or the handle of a pitcher needs to balance well in your hand." She describes the time spent mulling things over before the sketching stage – the time that a designer is never paid for – as difficult. "I have a hard time sitting down to start sketching and determining dimensions, because what if it doesn't work?"

When she finally makes the first three-dimensional prototype in glass or clay she has already tested every conceivable variation in her drawings in order to prepare in advance for any minor adjustments. Piles of sketches, executed on Konsum's parchment paper, have accumulated on her table. "It's embarrassing. What if someone walks by? It must look as if I am incapable of making up my mind."

The sketching process may take several days and no one is allowed to disturb her. She uses parchment paper from Konsum because it disintegrates after a few years. "I tell my husband that if I die first, he is to burn my drawings – the only things I want left are the three-dimensional forms." Equally important to the sketching process are Ikea pencils, which have the right degree of softness. "I pick up whole bundles of them when I'm there. I rather like the thought of making something beautiful with the help of a pencil from Ikea."

Function is as important to Råman's creative work as form. She has no interest in decorative objects and always proceeds from a need – her own. "Don't you see, when you prepare the first course you have to be able to stack plates on top of each other in the refrigerator. So I made a stackable lid which doubles as a small plate. And sometimes I forget to buy candles, so my candlestick also uses tea-lights."

While she was working on her candlestick one of her colleagues said of her: "Oh, she keeps making the same things, over and over!" It was then that Råman fully realized that her idiom actually does consist of a few small puzzle pieces. That her challenge is to keep turning them over repeatedly – to find infinity in the minutest of details.

She finds that Swedish designers have an international advantage in that they usually have mastered a craft and therefore have considerable insight into both materials and production. "We have to treasure that knowledge and not spread ourselves too thin by trying to do everything."

She thinks it is a pity that "certain designers use existing design without first conquering a language of their own. Just calling it retro is not enough, if all you do is to repeat an existing product without adding a personal touch. We ought to keep tabs on this, and every good producer should have people on the lookout for this. It's everybody's responsibility."

She tells me about *Lilla Servisen* – one of her best-known products. It first made its appearance in 1993 and she was pleased with the pared-down design that was a reaction to the grand gestures of the 1980s. "Now that I see everybody making things that are nested inside each other I do what I do when I am afraid of flying: I think positive thoughts and suppress the bad ones and turn my face toward the sun," she says with insight.

Then she adds: "Those are also the moments when I remind myself what a privilege it is to work with something as pleasurable as design."

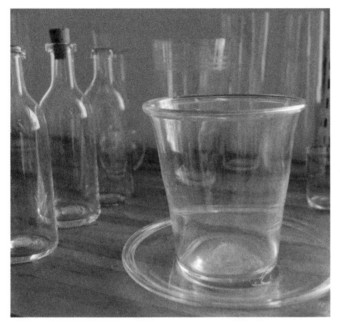

RÁMAN
KNACKA
HÁRT!

205

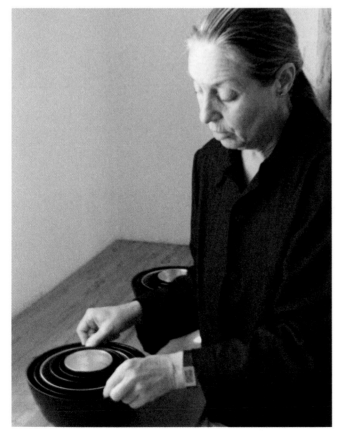

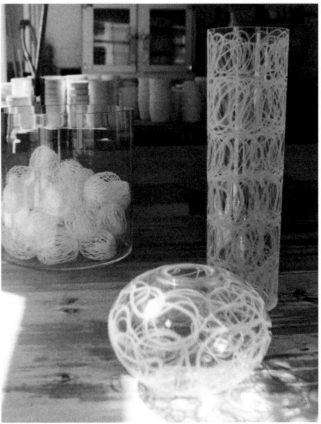

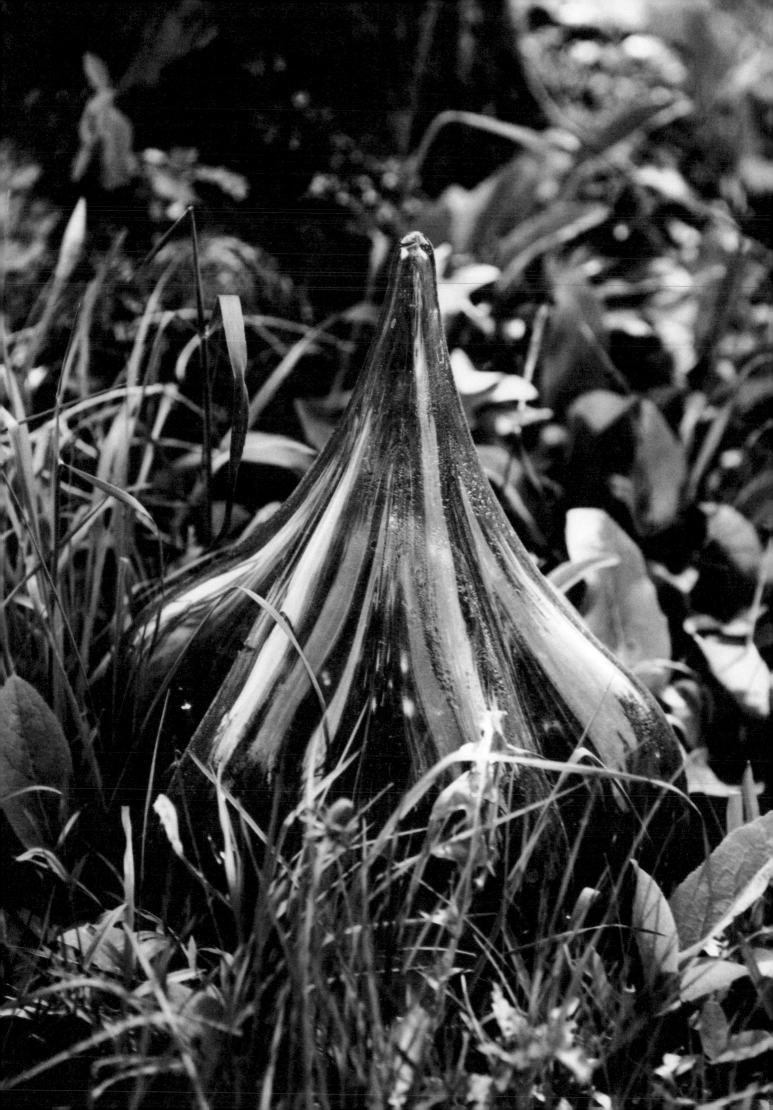

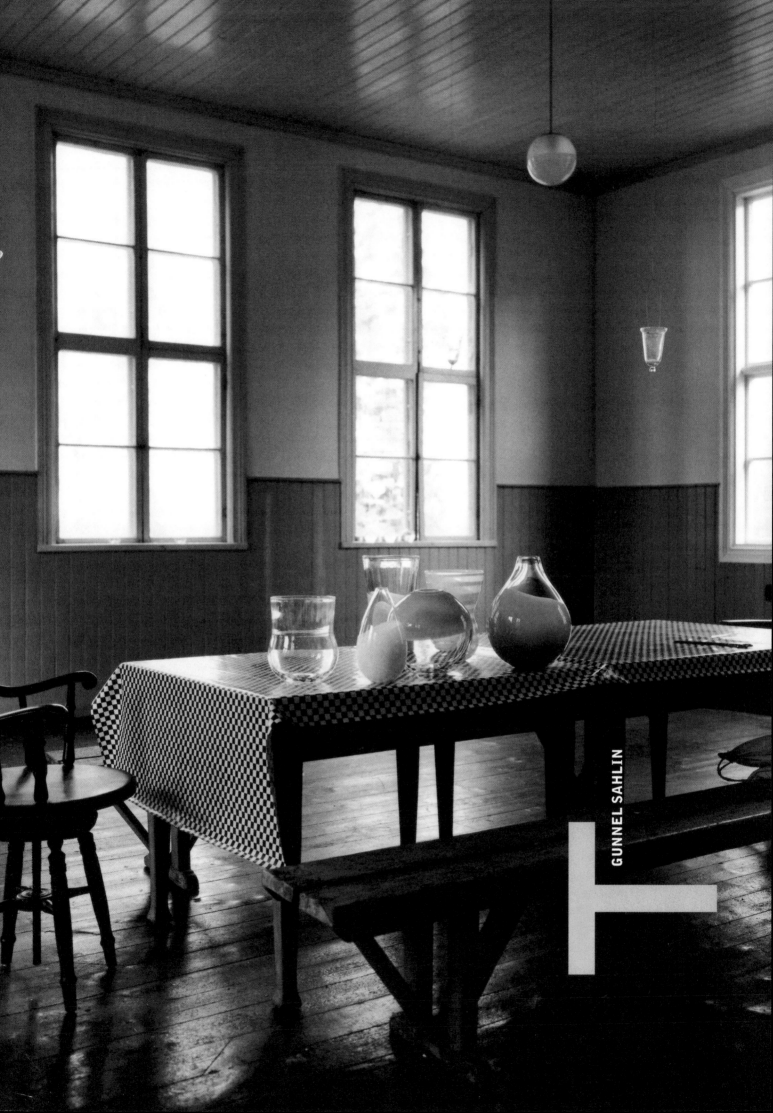

Page 208:
"A test piece that I had meant to throw away ended up in the garden instead."
Page 209:
Interior of Sahlin's summer house, an old school in Sörmland.

Below:
Gunnel Sahlin grew up in Umeå and describes herself as a bit of a country bumpkin, with both feet on the ground. Her father was a teacher and her mother a housewife. She has six brothers and sisters. "The others think I have a strange occupation!"

Generosity is the first word that comes into my mind when I meet Gunnel Sahlin at her dining table together with Dante, Billie, baby bottles, saucepan lids, and mashed bananas. The former is her son, the latter her cat, and both do what they can to attract our attention. There is an everyday, homely, and familiar feeling about the whole setting.

When Sahlin disappears into the kitchen to get Dante more food I take the opportunity to look at her candlesticks. They are nice to the touch and I want to dig into them and feel the black spiral pattern buried within the clear crystal.

"I like it when people feel like touching my things," she says, "because you must be allowed to. Glass should not be treated too reverently. It is more fun to use it than to just look. I want it to be playful and inviting."

She describes her fascination with glass and its various dimensions. "You can do one thing with the surface and something completely different inside. And everything can change in a different light. But it is also scary to work with, because you can never govern the outcome 100 percent but have to take it on trust. Glass is a living thing."

Working with textiles – Sahlin's original material – is "much easier". "I had no idea that it would turn out this way. In the mid-1980s the then marketing director of Kosta Boda had the idea that I – a textile artist – and Ann Wåhlström – a glass designer – ought to do something fun together. We were both living in New York where I was working for Swedish designer Katja Geiger (Katja of Sweden). I was designing patterns for sheets, towels, glass, and china. The fact that Kosta Boda wanted to do things involving complete table settings sounded very exciting, so I ended up in Småland where I began to explore glass. No one really placed any demands on me, nor did I know much, which led to a kind of open-endedness. I was strongly influenced by the Memphis Group, which had shown that everything was possible. Nevertheless, I would never have managed had it not been for the wonderful glassblowers in the smelting house. It was like coming to a big family where I could really be myself."

"Although glass and textiles are completely different materials I see some similarities. They are both introduced into an environment as a complement, to create a sense of unity. Regardless of which one I am working with I hope that my joy is apparent in the final product. It is hard for me to look at what I do and describe it in words, it's more a feeling."

It is in her unique pieces that this feeling is most clearly revealed. "There I don't have to concern myself with the demands of serial production – I am completely free." There is, however, a cross-fertilization between freedom and constraint. She tries to translate art glass concepts into mass-produced glass without compromising her identity.

"From the very beginning, I tried to find my own approach to glass. I saw the wonderful way it carried colour

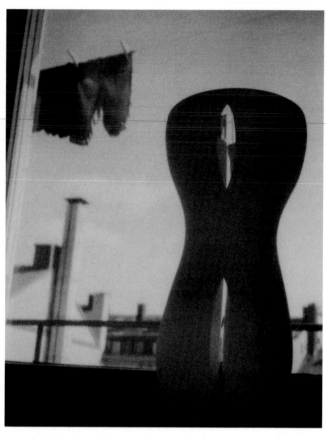

Left:
Terra Magica vase, 1997–98.
Right:
Flora Poetica vase, 1999.

American customers are very much
taken with Sahlin's shapes. One
supposedly exclaimed: "It's so right
for California!"

and had no interest in clear and colourless glass. I wanted to make glass in bright colours that lacked that solemn crystal feeling. In the beginning, people thought I was a bit mad – my style was not regarded as quite kosher since I managed to make crystal look almost like plastic. But attitudes changed once people started to buy it and the newspapers wrote nice things about it. It felt great to be allowed to play and be silly and mischievous in my design. Exactly as with children," she says, and gives the now sleeping Dante a kiss.

"Colour is a strong motor in my work. I am always yearning for new combinations and want to construct different stories with the aid of colour. In the beginning, I worked with strong colour contrasts – either black and white or in combination with the primary colours, red, blue, yellow, and green. After a few years the transparency of glass started to tempt me and my perception of colour changed. My *Latin Love* collection from the late-1980s contained ranges of green, blue, purple, turquoise, amber, and lime. The next major colour change was in the mid-1990s, when I was

working on the unique pieces in the *Terra Magica* range. There, earth tones such as grey, white, and beige were important – shades associated with nature. I achieved different nuances by working with a top colour and an undercolour in the same piece. Another innovation was to polish large symbols, such as a circle, into the surface. The area surrounding the polished part was sandblasted matte to accentuate the contrast with the shiny, polished one. When the opaque outer colour was gone, the underlying transparent color was revealed. That way I ended up with a fascinating peephole effect."

In the midst of *Terra Magica's* prevailing, almost corroded, palette a flash of shocking pink might suddenly appear. "It seemed important to introduce a jarring note that broke with the delicate impression. Something that made you sit up and take notice, something that sharpened your senses."

Today, Sahlin works freelance: glass for Kosta Boda, fabrics for Kinnasand, and carpets for Kasthall. Mostly glass however. "I hope to keep on developing my idiom. It is extremely important, but also very difficult. So many people stagnate, but it may help that I'm a slow starter. I started drinking coffee at the age of thirty, got my first apartment at thirty eight and my first child at forty five and, with it, a completely new outlook on life – which helps my development."

Associating with younger people has given her much food for thought and many new impulses. "In my work as professor at Konstfack, I receive as much as I give. It is a matter of helping the students relate to their own idiom. To help in the dialogue that they are conducting with themselves. Quite simply make them feel secure in their creative work. The way I myself felt, thanks to my parents who never interfered no matter what I looked like in my homemade clothes. Quite the contrary – they encouraged me to be completely myself." Her father did ask once, however, whether she actually meant to go out dressed in those old pyjama pants!

210

Amazon vase, 1992. "I am a big collector. I love things – they provide me with so many ideas. I am unable to throw anything away, even though I sometimes realize that I should. I have beautiful baskets, lots of flea market finds, and a urinal that I once found in a junkyard in Umeå."

Sahlin maintains that some everyday objects such as hospital and office equipment can sometimes be fantastic examples of good design. "Elegant, clean, and a bit cold – a kind of unsigned engineering design, often focusing on function, with design taking a backseat. Far from my own idiom, but I like it all the same."

Below:
Top right: *Duo* vases, 1999, and *Infusioner* vases, 1997.

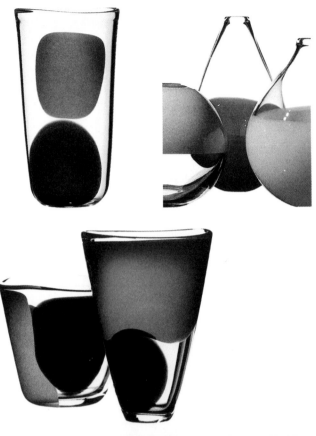

214

"To encourage and give off positive and happy vibrations is just as important as change and development. I think that's why I keep at it. I want to inspire people to change their homes and become a little happier in the process!" It is also important to awaken delight, to teach the meaning of aesthetics, and make them understand the way designers think. "I am trying to do my share by teaching, but I would like to find other ways to make a difference. But maybe it is better left to the glassworks to do this on a broad basis, reaching out to the general public."

She has been interested in design since childhood, thanks to her mother's interest in design and crafts and an aunt who liked art. "She often took me to Moderna Museet. That's how I became exposed to art." Sahlin found inspiration in Erik Höglund's[1] glass from the 1960s – "Mother's great favourite". The greatest source of inspiration was Marimekko[2]. "Because of them I developed an interest in design in general, and textiles in particular. As a twelve-year old I bought one of their fabrics and made an apron. There was something so grand, so explosive, and irreverent about them, such a contrast to the safe Swedish patterns. And contrast is what I love! The world of Marimekko has long been an enormously powerful and vital source of inspiration.

"In the 1970s, I was completely absorbed by handicraft and delved deep into the cultural traditions of Sweden, learning to weave, among other things. Then in the early 1980s another source of inspiration appeared in the form of Ettore Sottsass[3] and the Memphis Group with their clean break from existing convention."

She always carries a notebook in which she jots down her thoughts and ideas. "When the actual creative process starts I may already have a basic idea. I am the practical type, so the easiest way is to test it right away in the smelting house. I keep at it for a few hours and see what I get. Then when I look at the results, I either see something completely new or I realize that the basic concept must be developed in a certain way. Most of my decisions are made during the process itself and unexpected things may happen along the way. I feel quite euphoric when I am on the right trail."

It sounds so easy and romantic. "Yes, but sometimes I get stuck and my mind goes blank. Then I am lucky that I have a deadline, that way I can force myself. And you have no idea how alone I sometimes feel. I am the one who has to pick what is best and stand before the end products and say 'this is the one.' Will it hold up, will it sell? I am often too critical of myself and feel like rejecting everything. But luckily I have people to talk it over with whom I respect and trust. They are absolutely essential! Then there is all the practical stuff surrounding it. The shapes have to be exact; we have to do quality checks, and lots of test runs. As designers, we have to be there, alongside the craftsmen and the process. We offer reinforcement, support and, above all, we need each other."

Sahlin believes that it is good for you to venture into the unknown, "you have to dare to make mistakes," as this drives individual development. "I can't say that I am ever totally happy with the outcome and I ask myself whether I might have been better off doing it this way or that. I think that is the very pulse and motor of my creative work!"

215

1: See p.227.

2: The large patterns of Marimekko during the 1960s and 1970s rapidly became synonymous with Finnish fashion. The company made a strong comeback in the early 1990s thanks to its highly practical bags in solid colours. It looked like every design-conscious urban Swede carried one or another of its many pieces.

3: Italian designer and architect Ettore Sottsass, born in 1917, ranks among the most productive in the 20th century. Stretcher of limits and one of the most vocal critics of Modernism, he inspired several generations of young designers. In the 1960s and 1970s he attracted an increasing number of disciples among those opposed to the standardization of design and tended to go in a more anarchic and ironic direction. Sottsass was one of the co-founders of the Memphis Group in 1980 (p.30), which turned all traditional concepts on their head. With a blend of kitsch, classic architecture, unconventional shapes and colours they shed the bonds of Modernism and evidenced a new freedom in design.

THOMAS SANDELL

Thomas Sandell says "I do not understand those who design new houses to look old. As architects, we're meant to mirror our own time. No one would ever dream of putting a car or a tennis racket from the 1920s into production again, so why should we?"

218

Page 216–217:
**Thomas Sandell behind his and Gert
Wingårdh's proposal for a design for
Sergels Torg.**

Synonymous with Sandell – that applies to quite a few things these days. Furniture designer, architect, and interior designer, few men are as sought after as Thomas Sandell. Many view him as the man chiefly responsible for restoring Swedish design to the international limelight. "Swedish tradition, translated to a modern design idiom with an international outlook," as he himself sums up his work. He is a Modernist at heart, with clarity and honesty of design and materials. "I am intuitive rather than theoretical, however: I am driven more by feeling than theory."

Columns and columns have been devoted to Sandell and on the way to my first interview I am struck by the absurdity of asking him things I already know. That he emigrated to Skellefteå from Finland at the age of six months, and moved to Stockholm in 1981 when he started studying architecture. He opened his own successful business in 1989, and is – like many from Norrland – calm, quiet, and pleasant. Modest, willing to compromise, and well dressed, he can be seen in all design contexts worth mentioning. Few are as productive or have won as many awards, and he has just been elected to one of the most important positions in the field: president of SAR, the National Association of Swedish Architects[1].

"Please, tell me something I don't already know," I begin, and he counters with an unexpected comment for someone whose signature is Scandinavian blonde simplicity rooted in peasant culture. "Mexico," he says, pointing to my colourful belt that I bought there. "I have a special thing for Mexico right now. It is time for something new – I want more colour and more patterns. There you are!" He smiles a satisfied smile. "I have always been influenced by Karin and Carl Larsson. Just imagine a Southern version of old ticking stripes! I love having the power to surprise; that is something I seek in everything I do. When people tell me that my furniture pieces look like children's furniture, I take it as a compliment that there is a playful aspect to them. I want to transmit joy and lasting quality, a purity that you won't tire of for a long time. In brief, simplicity with a touch of something extra."

That "touch of something extra" might be a "stocking" in a different colour at the bottom of the leg on a simple chair. Or an updated and totally modernized design of something as honest and old-fashionedly Swedish as a rocking chair. But it might also be the exaggeration of a dimension, such as the extra deep seat in his latest armchair design for the furniture company B&B Italia. Sandell has successfully mastered the art of combining tradition with modernity, as he feels strongly about both. As viewer or user, you feel secure in recognizing the basis and are surprised and delighted by that "little extra something".

"Tradition must never be carried to excess. I don't understand those who design new houses to look old. As architects, we're meant to mirror our own time. No one would ever dream of putting a car or a tennis racket from the 1920s into production again, so why should we?"

He is hopeful because he sees a generational change taking place among those who commission houses, offices, and furniture. "Thank God for the 1960s generation that's now coming in with a completely new kind of taste and daring that will positively affect the whole design field. I could define certain periods when architecture was part of a larger context in our country – when it was naturally intertwined with politics and society. First in the early 1900s with the development of Modernist ideas following industrialization. Then in the 1930s with its great faith in the future and Per Albin Hansson wanting to build a Functionalist "people's home". Today young entrepreneurs are a strong driving force. To them, the important thing is communication; they view architecture as strategy, a means of communication, and a way to create a profile – as investment rather than expenditure. This is our chance as architects to really go for it and take advantage of their enormous and very real interest. You can't imagine how happy I was when I thought of this theory, Sandell says with a smile.

The Swedish design idiom is also in for some change, since front runners like Sandell, who are already frequent targets of plagiarism, are acquiring more and more experience abroad. Something does indeed happen to his designs when he encounters a different production capacity, "It is not just the production. They even have whole departments

219

SAR *1: SAR stands for National
Association of Swedish
Architects, a professional organization
for architects. Anybody may call him or
herself an architect today but it takes
more than just having designed and built
your own garage to be allowed to use the
quality designation SAR, however. After
completing a professional course of*

*study at a Swedish technical college or a
foreign equivalent you may apply for
membership or be elected. You also
have to have at least one year's
professional experience.*

*SIR is the equivalent organization for
interior design architects. Sandell is
one of a small number of individuals
who belong to both.*

This page:
Clockwise: *Miami* series of tables for
B&B Italia; housing at Gåshaga, outside
Stockholm, where inhabitants have the
option of transparent floors, "Architec-
ture should be seen, not blend into the
surroundings unnoticed", says Sandell;
the classic *Wedding stool* for Asplund;
the *Elena* chair for B&B Italia, with
upholstered or shod feet; detail of a
staircase from the Ericsson offices in
London, made in collaboration with
architect Gert Wingårdh.

Right:
Ängel rocking chair for Källemo;
Skär rug for Kasthall.

"I would love to design a church,
because ... it would be fun!"

220

Below:
Kantin Moneo, the dining room at Moderna Museet in Stockholm, designed by Sandell, was supposed to have red walls and furniture, inspired by Carl Larsson's dining room at Sundborn. That plan bit the dust when the museum's architect, Rafael Moneo, had to abandon his plans for a grey façade and make it red plaster instead. The City Art Commission actually wanted a yellow building, but Moneo refused.

If they insisted on colour, they would get the same red shade as the Grand Hôtel, which Moneo liked. Sandell finds that having politicians override the intentions of the architect is both "stupid and shows lack of respect". Sandell was then forced to reconsider his whole colour scheme. "I chose white, as a contrast to the red. The restaurant may be seen as a sort of veranda in the archipelago with its traditional white furniture."

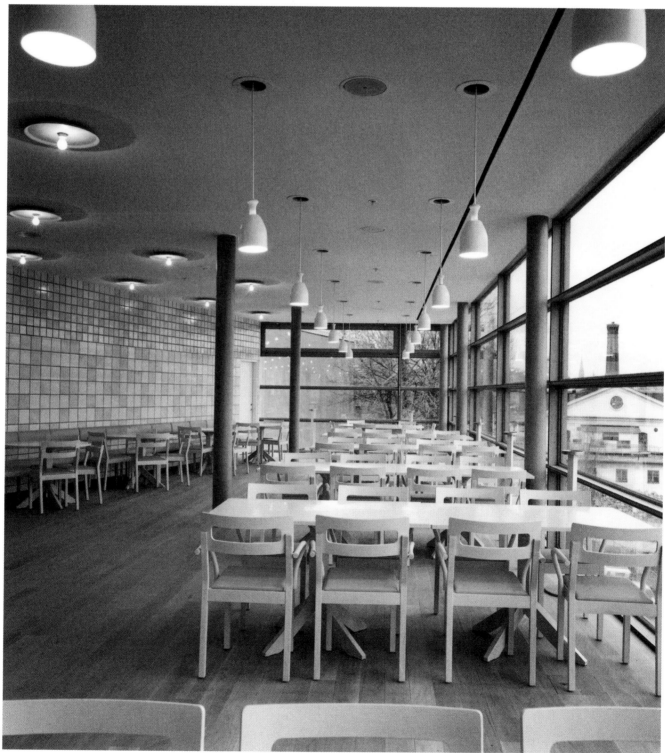

devoted to research and development, both with regard to new materials and colours. Small wonder then that your design tends to take yet another leap forward when a whole new world opens up before you!" Travel and new horizons are his best sources of inspiration. "When I'm abroad, I pay close attention to everything, even things I don't notice at home. I look and I register much more and my mind automatically starts processing ideas. As a consequence, I'm more exhausted than normal in the evenings when I travel."

Miami, his range of tables for B&B Italia, is a good example of this development. Having adhered faithfully to the Swedish criteria that a piece must not be too hard to produce, he was bawled out by the Italians when he presented his first sketch. "Too simple, too easy to copy!" they said and Sandell was told to do it again. "I could see what they were saying because, unlike us, they compete with technical solutions. Things look the same, but it is the small details and the finish that is decisive," he says. Even so, it really took me by surprise. As a Swede, it is something you're not used to."

The more restrictions are placed on a commission, the easier he finds it. "If someone says 'make a chair' my reaction is 'help!' But if I'm told that it has to be made of plastic and stackable it is much easier. The more freedom you have, the harder it is – it's as simple as that," Sandell says, pointing to the difference between a designer and an artist – and why he would not want to be the latter.

In making a piece of furniture he always starts from his own taste. "I make it the way I would want it myself – it always turns out better that way. I'm lucky that there are others who share my taste." For though it is his objects that have earned him fame, it is his furniture that the press writes about. "It is easier to become famous for products for the home as architecture doesn't have the same broad appeal. It is a commercial proposition, after all, and people buy new things more often than they buy a new house," he notes. "That's why it makes me happy when people appreciate my architecture. 1,400 people wanted to move to the forty condos that I designed for Lidingö's Gåshaga district. Several listed the architecture as the prime reason!"

He hopes to use his presidency of SAR to disseminate information about good architecture. "We have to meet the general public on a broader front. During 2001, named by the government as *Architectural Year 2001*, architects toured the country to give people in sparsely-populated areas a chance to share in our experience. The idea was for a mixture of SAR Seniors and architecture students to serve as advisers." Sandell would like to see a position created at the Museum of Architecture, an architect who would be on duty every weekend to offer free advice. He also hopes that SAR will be able to persuade the authorities to permit the construction of apartments on the roofs of commercial buildings, which would be both practical and exciting.

The idea of reaching out to a broader public is also part of his dream project for a large housing area with a far-reaching social mission. "That's what I would like to do most of all: make high-quality, modern architecture available to large numbers of people. Imagine translating my products for Ikea's "*PS*" collection into housing terms – that would be a challenge," Sandell says without much hope, for he knows how hard it is to achieve a democratic and financially reasonable solution in modern housing construction.

"Apart from that I don't have many goals. I take on almost anything, but not things that I don't feel for. I get involved at the beginning, as I think I am good at understanding what the client wants. Then one of my co-workers takes over. I find it easy to delegate to people I trust. I am probably a trifle lazy and restless; I want new challenges and so I like to work over a broad spectrum. When I talk to my furniture producers I think: 'doing furniture is really terrific!' – and I feel exactly the same about houses after a construction meeting."

It was never his goal to become an architect, he just slid into it, deserting his original ambition to become a diplomat or a dentist. "Two of my military service friends spent their weekend leave painting in the countryside instead of going home to their families. I tagged along and liked it. When they applied to study architecture at KTH (the Royal Institute of Technology in Stockholm) I did the same – and was the only one to get in!" At that time I had heard about Le Corbusier

222

2: Apropos of finish: in Sweden, we often find the foreign, exclusive, high-gloss finish seductive, while our own often give us splinters in our hands. Nevertheless, it is important to remember that Sweden outlawed some types of three-component lacquer in the 1950s for ecological reasons. The Italians and the French still have not done so. "Those who want to market their products in Germany, as many do, are always OK, since the Germans have the strictest environmental standards of all," according to Sandell.

and Alvar Aalto, but that was all I knew about architecture. "But I had always been interested in furniture, I remember saving for a long time in order to buy a Le Corbusier chair."

For the first five years after graduation, Sandell worked in an architect's office, making a name for himself by accepting outside projects. In 1990 he started Thomas Sandell Arkitektkontor AB. His time was spent with interiors for retail establishments, restaurants, and advertising agencies, plus furniture for Cappellini and Asplund, among others. Soon he was receiving commissions for private homes, office buildings, and housing projects. One day Jonas Bohlin asked for Sandell's help in starting up a department of design at the Beckman School. Ikea's "*PS*" collection was also a collaborative venture, this time with Stefan Ytterborn and Thomas Eriksson. Then foreign producers started to show an interest.

In 1995 Sandell joined up with advertiser Ulf Sandberg. Today they run an office of sixty employees. "Nowadays, architecture is about communication and profile, rather than building houses and furnishing them. It makes it interesting as you work even more broadly. We have recently signed a cooperative agreement with an international network of businesses within IT, corporate, and brand-name development. What's most important right now is having a good time!" says the most famous architect in Sweden at the moment.

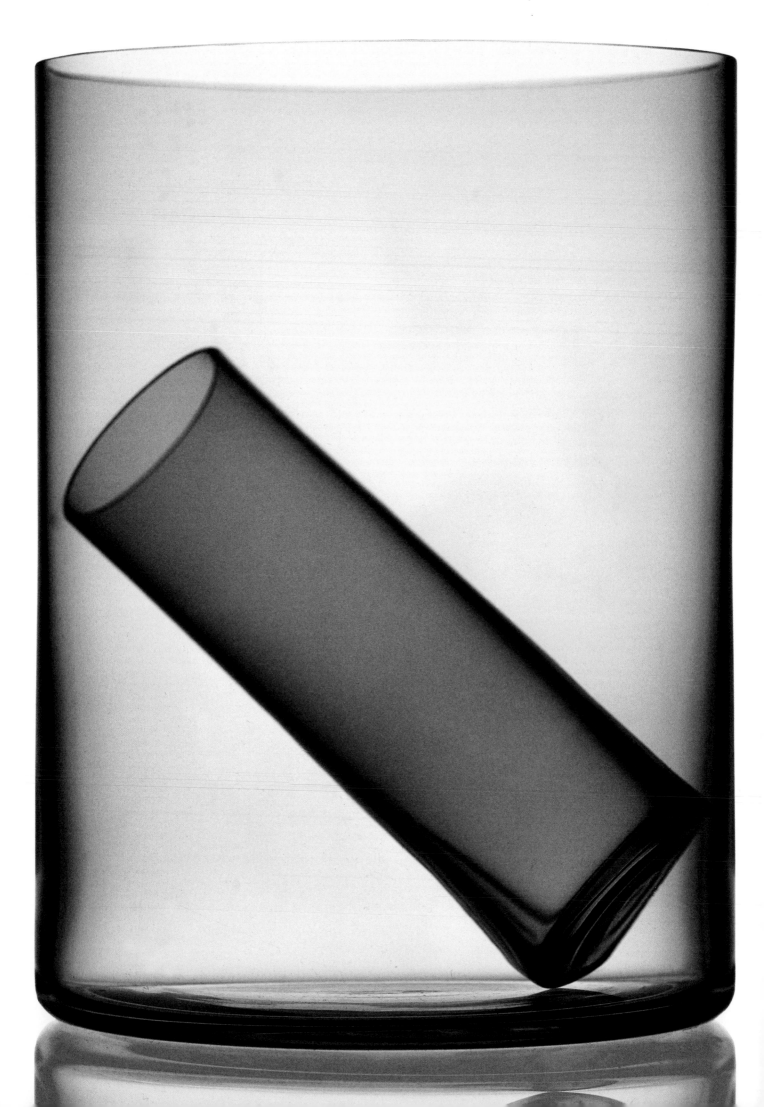

CARINA SETH ANDERSSON

"I don't do glass art. I want my products to be used."

226

Too bad that you insist on such awful colours! That's what an old lady told Carina Seth Andersson at one of her exhibitions. She found the pink, brown, and green shades of the glass vessels difficult to take. What was Seth Andersson's reaction? Did she answer with an acid remark, did she feel like throwing a right punch, did she burst into tears? Seth Andersson smiles at the memory and says that she likes people to have an opinion. "It obviously depends on who it is, though. In this case, I thought 'it's my exhibition. I can do what I want.' Otherwise I like constructive criticism – but, unfortunately, it is a rare commodity in Sweden. It's as if journalists are afraid of being critical – they prefer offering an objective account of what they see, they report rather than review."

As for Seth Andersson, she is used to the opposite: praise and wonderful reviews are everyday fare to her. The Finns have fallen like ninepins for her products for Iittala and it did not take Ikea long to copy her glass cylinders. "A sign that you have done something good. Of course I am unhappy about the copies of my cylinders, but I am not one to hold a grudge." The Victoria & Albert Museum in London even acquired the originals for their permanent collection – one of the best compliments ever. Her salad bowls in stainless steel for Hackman have become status symbols among Australian gay men and top the bridal registers at NK and Svenskt Tenn.

These cylinders are typical of Seth Andersson's production and idiom. She devotes her time mainly to containers: storage items with clean lines, as well as to teapots, vases, cups, decanters, bowls, platters, and bottles – all without ornamentation. She uses stainless steel, and clear or opaque glass in the shades commented on by the lady at the exhibition. One of these is a rose beige embedded between two layers of glass in a heavy, bulging bowl. This pink nuance is, like many of her colours, rather rare in glass. This is partly why her products are so interesting – a clean simple shape combined with an unexpected colour, an exaggerated diameter or an unusual material.

"I'm not a fan of unique pieces and want my objects to be placed in a context," Seth Andersson says. She makes things in series, or families, as she calls them, on the same principle as Russian dolls. They are obviously able to exist singly but are stronger in the company of others. Together they form a sophisticated, sculptural whole. "It is often in the in-between space that things happen," she says, while pointing out that the starker the idiom, the more difficult it is. "Everything shows up on a simple form."

Her design is as practical as she is. "I make products that I need myself, things that I lack." Her cup has no handle since she rarely grasps a cup that way. You have to be able to use the objects in a way that makes you feel good, she insists, and emphasizes that glass art is not for her.

She derives her inspiration from everyday things: a chat, a five-crown flea-market bargain, Erik Höglund's[1] glass from the 1960s, a detail of a Zen Buddhist symbol, or a graphic shape. "My inspiration grows while I ponder a task. Most jobs, especially creative ones, require time for you to build up both your physical strength and inner capacity. As to work habits, I will never be able to produce a steady stream of products as I need periods of calm and reflection to replenish my energy. When I am working I don't care how hectic it gets, as I know that I can take a break afterwards."

Seth Andersson talks about how strange it feels to be at an opening where her products are completely new to the visitors, but "old" to her. "I always think about a job for a long time and once I actually start work the product is almost finished in my mind. It might take another year and a half before it is launched. I think that people generally know very little about just how laborious the process from idea to finished product can be. I have been extremely lucky with very few conflicts in the course of the production process, but the 'can't-be-done' mentality of Swedish manufacturers sometimes drives me crazy. There is a completely different desire to try to please the designer in Finland, I think, both among producers and among craftsmen, who get to use and further develop their professional skill."

Seth Andersson knew at an early age that she wanted to be a designer. At first she thought that textiles would be the right field for her. During her time at the School of Textiles in

1: Erik Höglund (1932–98) was the artist responsible for the renewal of glass, first at Boda Glassworks from the 1950s to the 1970s, then – in a major comeback during the 1990s – as a freelance artist. The works of his latter period are characterized by human or animal-like motifs in strong and colourful designs.

Page 228–229:
Beakers and bowls designed for Reijmyre
glassworks, fall 2000.
This page:
Clockwise: white jugs with twin spouts;
bowls; wooden salad servers with handles
inset with steel to go with her salad bowls
for Hackmann; glass and beaker, all for
Reijmyre, fall 2000.

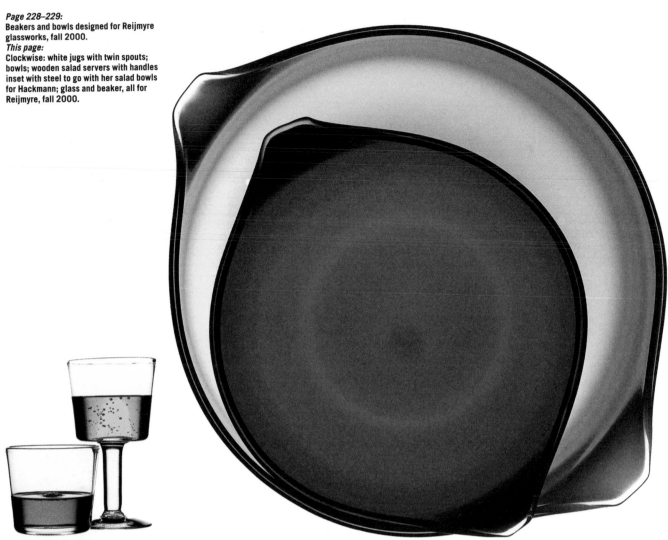

Borås she realized that, although she loved the material, it did not feel quite right. "I never really fell in love with it because I am more of a three-dimensional rather than two-dimensional type."

She applied to the Orrefors Glass School and was admitted. After six months, she became an assistant to glass artist Anders Wingårdh. He taught her everything about the fundamentals of the craft. "It is very important to know the material thoroughly; I often blow the glass myself just to show that it is possible to do it the way I want it."

In 1989 Seth Andersson started studying glass and ceramics at Konstfack where she spent four years in addition to an extra year. Then she started her own business and decided that she would "give it two years." Today, it has been six and Seth Andersson says: "I probably wouldn't say no to a permanent position at a glassworks eventually, but for the moment I am happy with my freelance work. I am drawn into various projects and get to know a number of companies that way. The best thing would be a long-term collaborative arrangement which would provide both parties with continuity and a chance to develop."

What happened next is seen by many as an absolute dream start for a recent Konstfack graduate. Seth Andersson attracted the attention of the press with her products for the design group Sprinkler (unfortunately now defunct) where she was one of nine members. Then, one day, she had a phone call from Stefan Ytterborn[2]. He wanted to find a glass product for the Milan fair where his business cbi, a producer, was to exhibit their products. "I had long been carrying around the idea of a cylinder in my head and I showed Stefan an extremely crude prototype of rolled-up sheets of paper fastened with paper clips. What a stroke of luck – he wanted what I had!"

This was more than just "the right product at the right time in the right place." The exhibition was a success, as was Seth Andersson's glass, which received mention in both the national and international press.

Her future appears to be bright. After giving birth to her second child in September of 1999 she began a comprehensive partnership with Reijmyre Glassworks[3]. In response to a commission from Stockholm Lab, headed by Thomas Eriksson, Seth Andersson developed a glass service consisting of wine and water glasses as well as a decanter. "The challenge was to utilize Reijmyre's great craftsmanship and apply it to a modern design. I am very happy with the result and with the work of the glassblowers," she says, caressing the first prototypes. "Parallel to this I am doing a piece of public art. I'll be leaving my job as a classroom teacher at the Beckman School of Design – I don't have enough time right now. As a freelance designer it is difficult to plan for the future, but a dream project would be doing something for the body in silver. Something simple and powerful."

2: Read more about Stefan Ytterborn on page 300.

3: Reijmyre Glassworks was founded in the forests of Östergötland in 1810 by the forester Graver and Baron von Ungern Stenberg. It experienced its first period of greatness in the late 1800s and its second in the mid-1900s when the ruby glass of designer Monica Bratt made the glassworks internationally famous. Today,

Reijmyre has successfully continued to build on its long tradition of glass for everyday use. It combines highly contemporary thinking with traditional designs rooted in the 18th century.

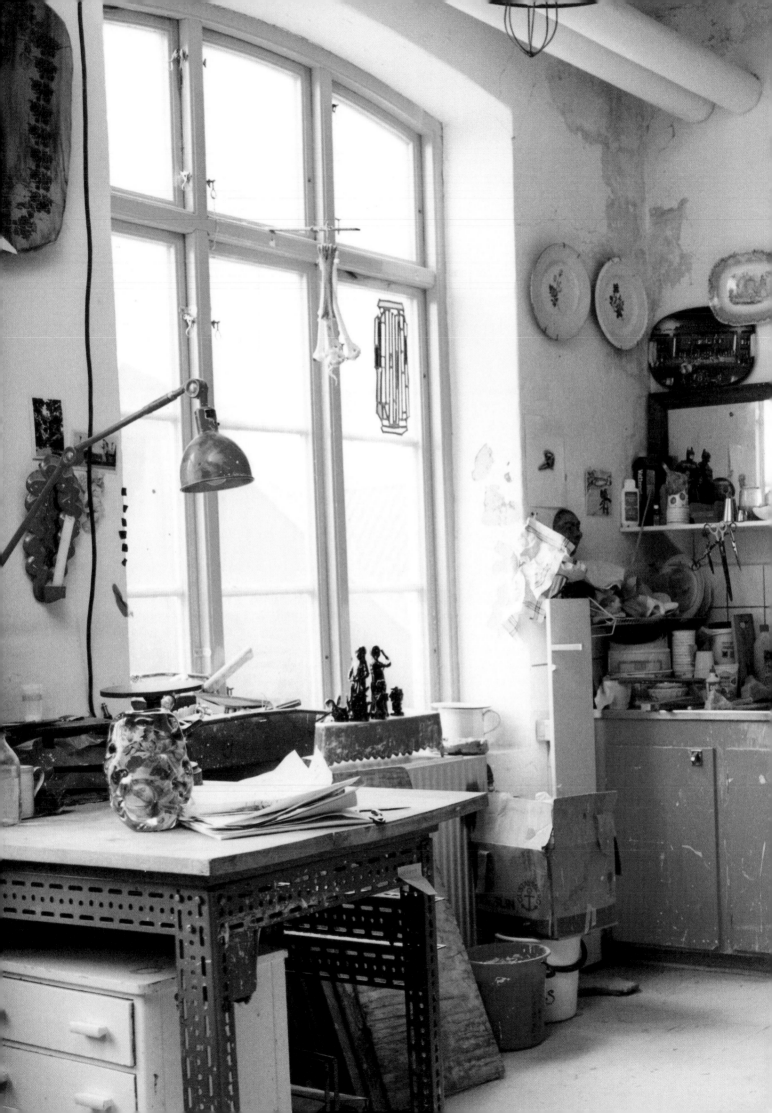

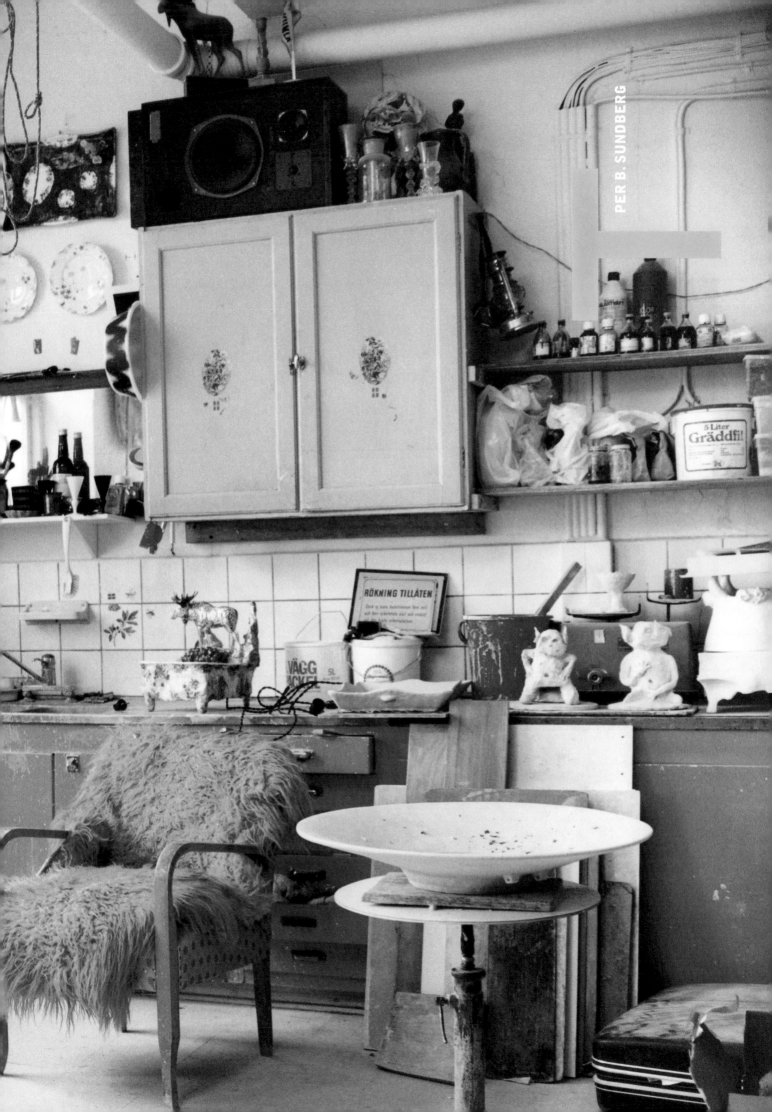

Page 232–233:
A venerable studio in the old office of the foreman at Gustavsberg china factory. "I keep all the things here that no one wants to see!"

Below:
Per B. Sundberg. Instead of high school,he opted for the local school for arts in Gnesta, then Cappellagården and, finally, Konstfack. An unforgettable summer course at the famous Pilchuck glass school in Seattle found him smiling and taking tea with Mrs Boeing and other well-to-do ladies.

Right:
Detail of vase with applications.

Jesus may appear when you least expect it, and a pike suddenly swims past a sea of flowers in Per B. Sundberg's *Objekt med hål i* (Object with hole). Another piece looks as if someone has chewed, spat out, and then played with several pounds of chewing gum, which has then hardened. His fully-functioning ceramic breakfast radio will hold live candles as well as a piece of cheese next to the tiny china animals that stand as if guarding it. At least the poodles do. The polar bear seems more absent-minded. Another radio sports a woman with flower tattoos against a wintry alpine landscape.

The term "personal" suddenly feels terribly flat as I try to describe Sundberg's idiom. The first thing to come to mind is "crazy" and then "idiosyncratic". It happens much too seldom that I see or experience something I have never come across before. Whenever I do, however, I never forget it. The common denominator of these experiences is that I am very affected without being able to say why, since I lack all basis for comparison. That is how I feel before Sundberg's glass and ceramic pieces.

To some extent, it is not too hard to try to explain his technique, but for the total experience you have to come close, look carefully, and preferably touch the objects. His glass vases or sculptures are often like peep-shows, revealing fascinating tableaux. Or else you can't make up your mind whether what you see is a koala bear or two female breasts. As I said before, Jesus or a pike – you never know what is lurking in the reeds.

Sundberg's world is composed of dreamt dreams, scribbles from a notebook of ideas, or things captured by his gaze. Maybe something insignificant or ugly that others would immediately have rejected. He also likes to take a chance at the moment of creation, focusing first on what is safe, what he knows, and then fearlessly hoping for the best. His risk-taking sometimes produces unsuspected and fantastic results – more often, it doesn't work at all. On average, three out of fifteen pieces meet with his approval – the rest are discarded.

"I try to find an expression that sort of insinuates itself, that affects people in some way. An expression that draws the viewer in with the aid of something that feels safe and vaguely familiar but still in a different form; starting with a tiny flower, for instance, or a ship on a rolling sea, before surprising him with something else. It is almost like drawing the individual into the shape, through an enticing surface," he says, showing me a picture of a black vase covered in little bulging spines that you immediately want to cut off.

His pieces sometimes inspire laughter and other times silent thoughtfulness. Some are upset by his irreverent and unconventional handling of glass and clay, "but it's mostly old ladies. I like it when people are frank, when someone says something that has never occurred to me. I like the idea that people could recognize something as 'a typical Sundberg piece' – that I leave a physical imprint on everything I do, that my pulse puts a personal stamp on the object."

He knows that his designs are not to everyone's liking and that they are expensive and take up space. "But," he says, "we can't all be making nice, likeable, and inexpensive things!" He once tested this thesis by making adorable little

swans in his studio at Fjäderholmarna. They sold like hot-cakes! "My friends teased me, but I needed the money."

"When I started at Orrefors in 1994 they thought I was joking. Nowadays the craftsmen, at least, have been brain-washed with my design and have even begun to appreciate it. But the market still finds it hard to take my aesthetics seriously. Those who hired me quit a long time ago, and I must admit that it hurts that no one quite understands what I'm doing. But I am highly visible in the press – which is a good thing, or they would probably have thrown me out!"

When Pelle, as he prefers to be called, discusses his employment at Orrefors it is with a kind of love-hate. As an artist, he is naturally free to indulge in experimentation and make unique pieces, but at the same time he feels the demand for sellable products that are marketable and can be machine-made breathing down his neck. He has done that – the problem is just that they don't sell as well as he and the marketing department would have wished. "That's hardly surprising, considering the fact that almost nobody carries my stuff. Which is due to the fact that the retailers also do not understand my designs, combined with the fact that I have not mastered the relationship between product and price – I just do as I feel. Besides, it just makes sense that everyone does what they are best at."

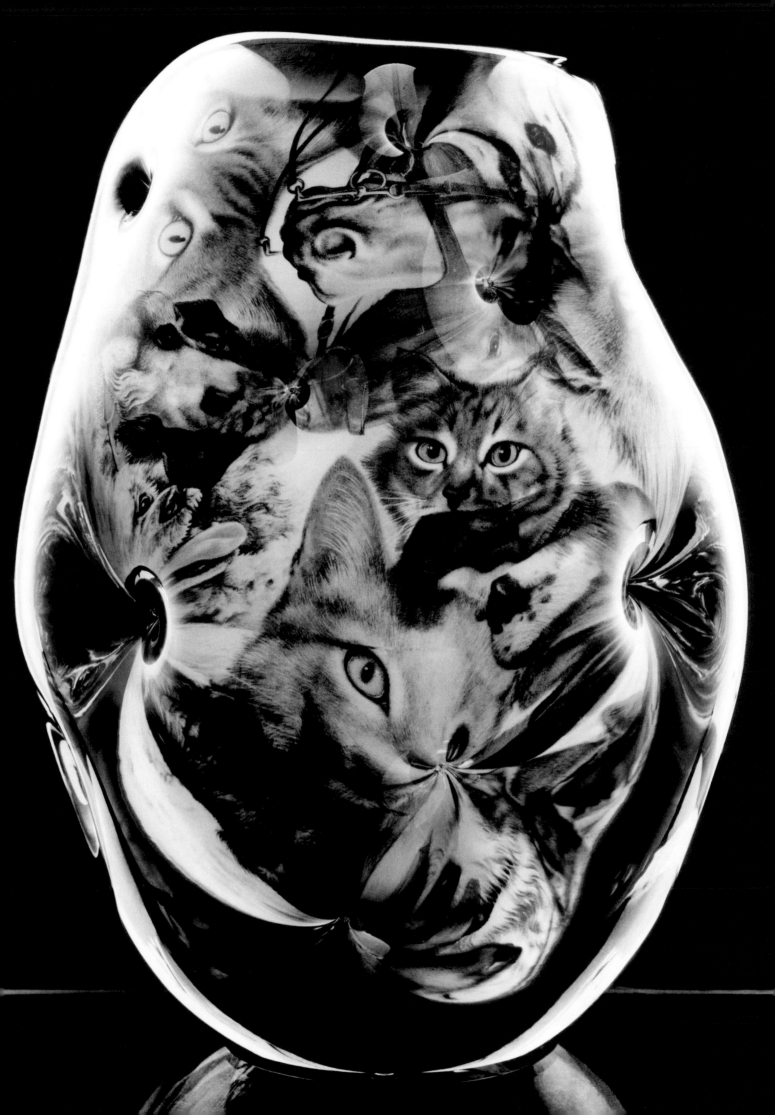

"When I started at Orrefors in 1994 they thought I was joking. Nowadays the craftsmen, at least, have been brainwashed with my design and have even begun to appreciate it."

This page:
Pelle likes to be part of the entire process. The first step in making a *Fabula* piece is to apply the pictures to the blank – the glass that will be turned into the object. "Everything is so small at that stage, I can only guess at the final, blown size. On average three out of fifteen pieces meet with my approval – the rest are discarded."

239

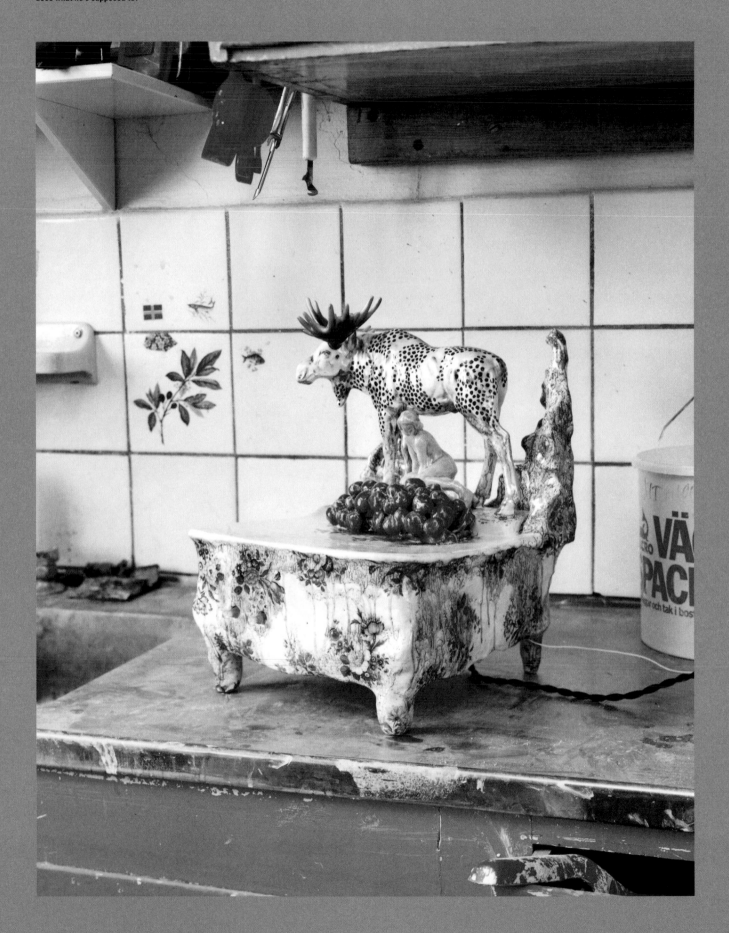

Below:
Radio case. Sundberg suddenly thinks of the radio repairman who helps him when the sets stop working deep inside their ceramic cases. "He has never commented on anything I have given him, he just does what he's supposed to!"

Left:
Starfish, a piece that is now
in serial production.

At the same time, he knows that he is very well off compared to many of his friends who are entirely on their own, without a steady producer. Much of their time is spent on trying to market themselves and their products, and that is not easy. "I could never manage," Pelle says.

Even if he should ever feel like joining the large group of free agents he will certainly hold on to something of his own – a 270-square-foot studio at the old Gustavsberg china factory a few miles east of Stockholm. There he is entirely his own man, with no hectoring. "Here I do only ceramics, which I like as a contrast to the glass. With clay I am more physical, I knead it, slap it and pull it. It feels great!"

His ceramics show distinct traces of the history of china, partly in the form of the motifs that are fired into the clay – the familiar flowers and kittens. He is endlessly fascinated by the little clay berries, flower stems, buds, and flowers found on magnificent old centrepieces. However he is also anxious to take the craft further, if only in a form distinctly his own.

His products – chandeliers of thin neon tubes, bathtubs and washbasins with inset illustrations, and many ceramic objects – usually end up in a barn in Rimbo[1]. Some have been exhibited and sold, but, for the rest, this is the sad fate that awaits them. "It is a big waste of energy, but what can you do if there are no buyers!" he sighs – and then laughs. He suddenly thinks of the radio repairman who helps him when the sets stop working deep inside their ceramic cases. "He has never commented, either by word or silently, about anything I have turned in, he just does what he's supposed to."

Pelle loves to tinker and has even invented a glass technique that has become his signature. He calls it *Fabula*, after the word "fabulate", which in Swedish means invent, fantasize, lie, talk nonsense, and exaggerate. He embeds

pictures and decals into the glass; a common technique in china manufacturing but never before used with glass.

"Will *Fabula* become as great a classic as graal in the future? I ask and Pelle laughs out loud. "Well, it will take a lot for it to become commonly accepted. Just like my design."

243

1: Rimbo is situated north of Stockholm and west of Norrtälje. It has a population of about 5,000 and it takes about an hour by bus from the Royal Institute of Technology.

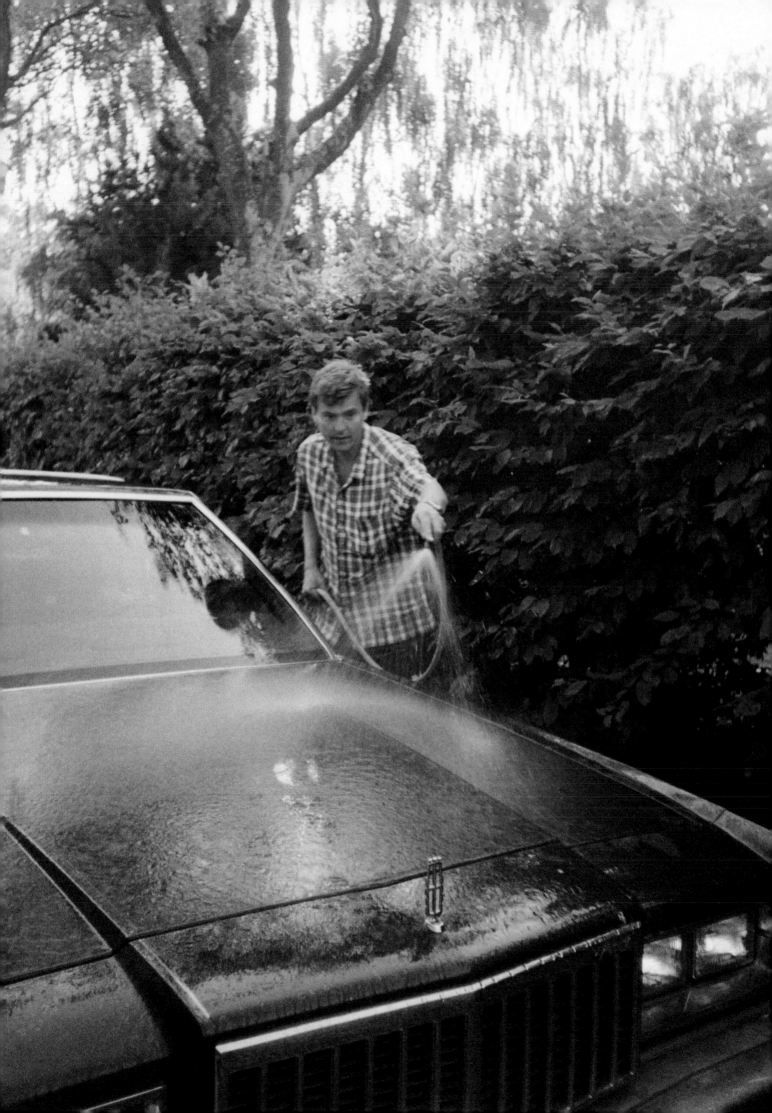

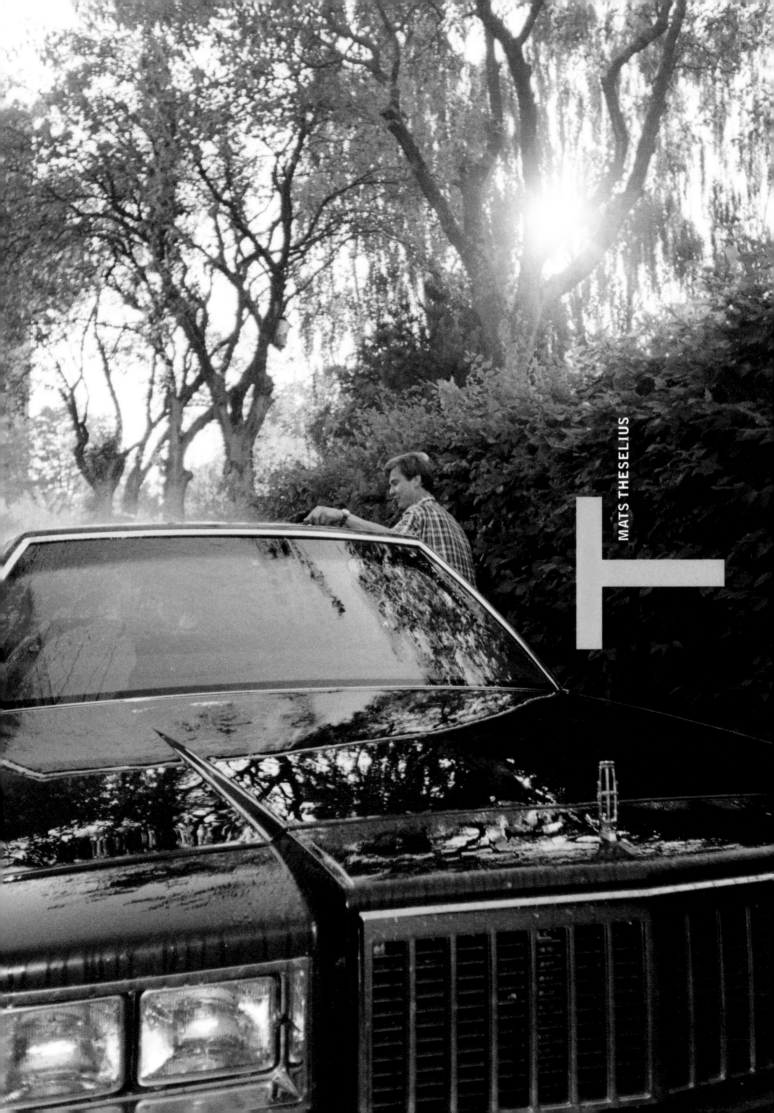

MATS THESELIUS

The surprising darling of the establishment is what Mats Theselius has been called. He even has his own fan club. I call it up, hoping at least for some stickers, but, alas, the club is dormant. It was started when his easy chairs came on the market in the early 1990s. The criteria for membership were simple: buy an easy chair and get free membership. Instead of something to put on my refrigerator I get a little brochure entitled *Mats Theselius' Guide to Mats Theselius.*

It turns out to contain pictures of almost everything he has produced. Furniture, carrot stands, down-filled toy seals, his daughter Maja, music, books, and stage appearances. Houses, exhibitions, visits to Japanese nightclubs with the karaoke microphone prominently featured, stage

design, parts of a collection of Russian "thingamajigs", a sculpture of a marble foot, and much, much more. The word "thingamajig" often pops up in his vocabulary, which is vast and delivered with rattling speed. His verbal and his artistic expression reveal a seemingly inexhaustible energy and breadth of thought that is as imposing as it is entertaining.

The first time we meet is after a public lecture on objects as agents of transport. He illustrates it with a simple example: a bottle of wine, capable of transporting our thoughts. The audience soon picks up on it and titters with delight. If he is able to stimulate our imagination – one of our most powerful agents of transcendence – he is also able to expand our inner capacity and offer us new experiences. His make-up table and slightly kitschy mirrors certainly help.

In the course of Stockholm's year as cultural capital of Europe, Theselius, working with film maker and theologian Görel Byström Janarv, was responsible for staging an intriguing project called *Swap your Life.* It was a kind of identity travel bureau that provided people with an opportunity to adopt another lifestyle. A company director could become a shepherd, an amateur bowler a full-time lace maker, and the advertising agency director a monk.

Theselius designed the yellow *National Geographic* storage unit, one of his most famous objects, while struggling to give up smoking. To suppress his desire for cigarettes, he submerged himself in the famous travel, culture, and discovery magazine of the same name. Whenever he felt the urge to smoke come over him he would imagine himself swimming with dolphins. After a while he needed a place to store his *National Geographic* copies – and the cupboard was born. Originally intended to house twenty-five years' worth, it could be adapted through the use of ingenious bases to take fifty, seventy-five, or even one hundred years. Truly a worthy homage to a high quality magazine.

Concerned both about the finances and the eating habits of passionate jazz fans, he once constructed a stand for healthy snacks, *Port de Crudité*, a ceramic tree on which various vegetables could be hung, laid or speared. This was later reduced to *Excalibur*, a somewhat simpler piece for a

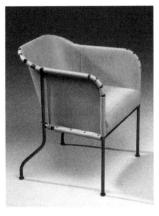
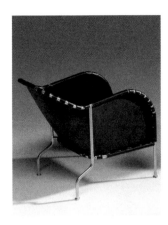
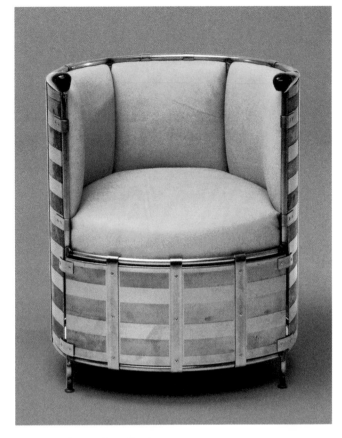
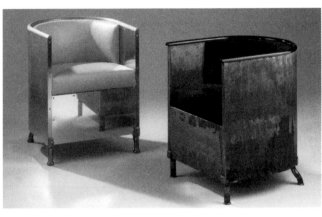

This page:
Some of Theselius' chair designs
(see key overleaf.) "What I do is to
make a kind of indecent proposal of
what I think a chair ought to look like.
If it works, it works."

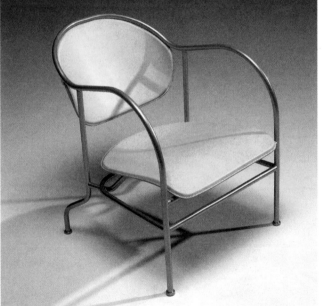
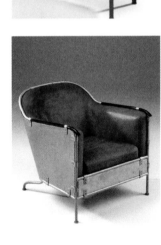

"Sometimes I miss an ideology, a thought behind the end product. Many just seem to prefer to follow a flow, a trend, the times."

carrot and some dip. The proprietors of the jazz club were not impressed and asked him to stick with their original order for tables and chairs. Both snack stands were nevertheless produced. Why abandon a brilliant idea?

Another example of the unexpected consequences of everyday problems in Theselius' world is his holder for "the world's best rye crispbread." He found that *1:ans idealbröd*, available from health food stores, took up too much space on the table. "So I called the factory and told them that if they would please make the diameter smaller, they could have my design for free – but they didn't get it either!"

Typical of Theselius is that at the same time as he is celebrated for his limited edition furniture pieces (selling for large amounts of money at the auction houses) he does not shy away from tackling everyday things. "I work from what I see, the things around me. I often see the big thing in the small and work as much for myself as for somebody else."

The starting point is always his own intuition, which often leads him blindly to begin with. Only later does he discover why he thought the way he did. He gives me an example of the way designs and ideas keep circling in his subconscious until they are suddenly plucked out and put into context. In 1998 he made a number of shoes in clay for an exhibition in Stockholm. Then he decided to make a real pair of boots in his own size – a European 47 – a high-quality item, tailored for the individual, as he thinks life itself should be. He contacted James Leddy, one of America's foremost bootmakers, whose customers had included John Wayne. Theselius' initial intention was to decorate the tops with Sami designs. Then he had the idea that he might capitalize on W.A. Bohlin's expressed interest in a joint project for their forthcoming exhibition in St Petersburg, where the jewellery firm was looking to re-establish itself. They took to the idea, and the boots were made with silver and gem decorations.

The subject of shoes is not exhausted, however, for between the clay shoes and the boots, he was asked by the German Association for the Blind to design some things that would be suitable for manufacture by the blind. The ideas circling in Theselius' head gave him the answer: a shoe brush in the shape of a shoe. The sighted would immediately see what the brush was for and the blind would be able to feel it just as easily. He made a variation for women and one for men, in wood with bristles on the underside; both in roughly size 34, and lacquered, to feel like a well-polished shoe.

His projects often involve collaboration with many people. One of his greatest problems is finding people who work well together and who follow the same concept.

"I am a creator, with multiple roles. When I work artistically I call myself an artist and when I design, I am a designer. I get my greatest kicks from the dynamics in a group where everyone is working toward the same goal." He finds working with other nationalities interesting and stimulating,

252

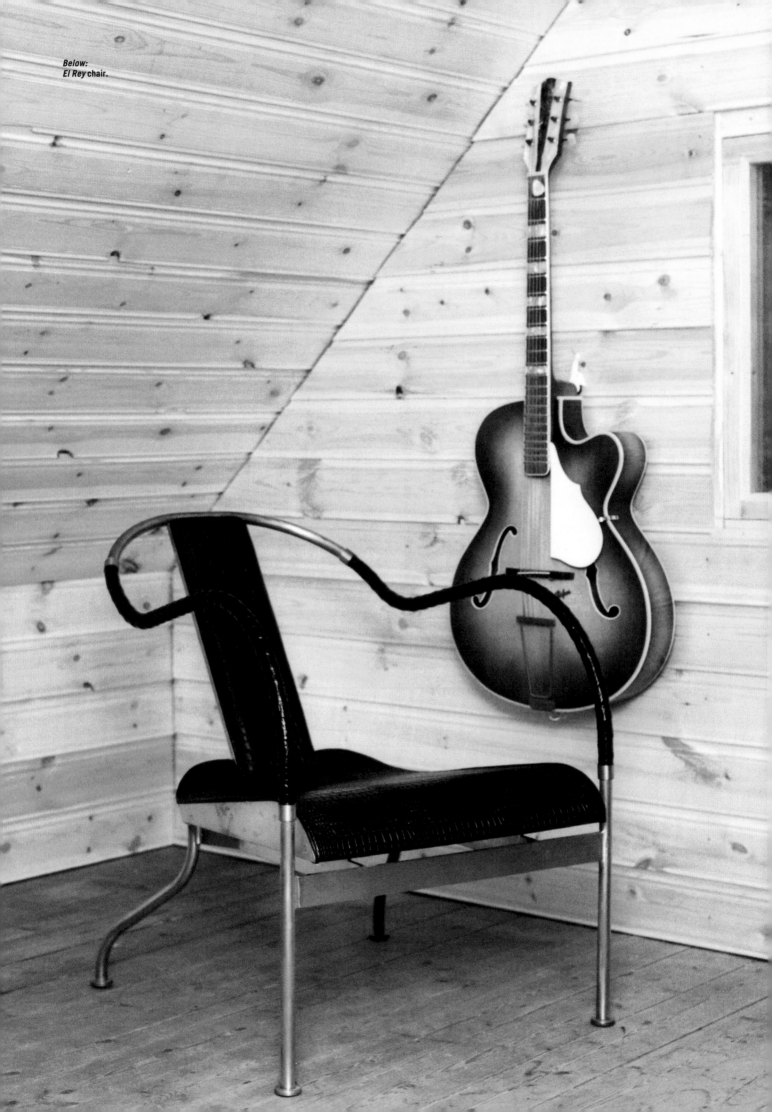

254

and has quite a few foreign experiences under his belt – both exhibitions and products. Theselius makes furniture and smaller items for various German companies, such as his plastic tumbler *Victoria* for Authentics. The short life span of the material bothers him, however. "You know that much of it will soon end up in a garbage container – I wish the manufacturers would be more honest about this." He points out that his glass for Bergdala Glassworks, on the other hand, is the optimum: "the only glass you'll ever need."

The discussion often becomes heated and he insists that much of what you see today is very predictable. "Sometimes I miss an ideology, a thought behind the end product. Many just seem to prefer to follow a flow, a trend, the times."

He also has a theory as to why it is that the furniture manufacturers devote more time these days to making a product recyclable – they know that most of what they make will not last and will soon have to be scrapped.

It may seem as if Theselius has just gone from strength to strength, but he describes his career and educational path as a series of coincidences. He wanted to study music, but ended up at Konstfack's department of interior architecture because it seemed to have the broadest programme. An Ikea fellowship led to his discovery of metal – "a material burdened by a lot of preconceived notions and tradition."

His exploration of metal led to *Mooseskin armchair*, which caught the eye of Sven Lundh and which, under his direction, became the beginning of a long line of easy chairs, chairs, and daybeds for Källemo[1]. The pieces attracted attention for their surprising combinations of materials and their strong personality, such as *The Ritz* in steel, car paint, wood, leather, and moose horn, *Bondkanapé* in mixed media and embroideries, and *Throne* in cast iron, enamel, mosaic, and leather with relief work by artist Ernst Billgren.

"What I do is to make a kind of indecent proposal of what I think a chair ought to look like. I experiment with general notions and cultural limitations – I pull them apart and put them together. You recognize it, but, at the same time, you don't; the basic shape of the chair is familiar, but not the material or the surface. Take *The Ritz*, for example, a Victorian armchair in steel and car paint." He often allows the construction to show; rivets turn into ornaments and the joints into decorations. "I have nothing to hide!"

Common to all Theselius' designs is the strength with which they maintain their identity, awaken associations, or a desire to ask questions. In that respect, I have rarely seen greater similarity between individual and product.

1: Källemo was founded as a carpenters' co-operative in Småland's Vaggeryd at the end of the Second World War. Until the end of the 1960s it specialized primarily in smaller pieces of furniture. Sven Lundh, who joined the company from the art world, re-organized Källemo in 1970, moved it to Värnamo, and set about developing a new range. Little by little he introduced the modern Swedish furniture market to a completely new notion of quality. He spoke of visual quality – that furniture should withstand the wear and tear of the eye, not just that of the test machines. Concrete, by Jonas Bohlin, 1981, is the foremost example. This notion of quality, typical of Källemo, is exemplified by Gunnar Asplund, Mats Theselius, John Kandell, Harri Koskinen, Lars Englund, and Sigurdúr Gustafsson.

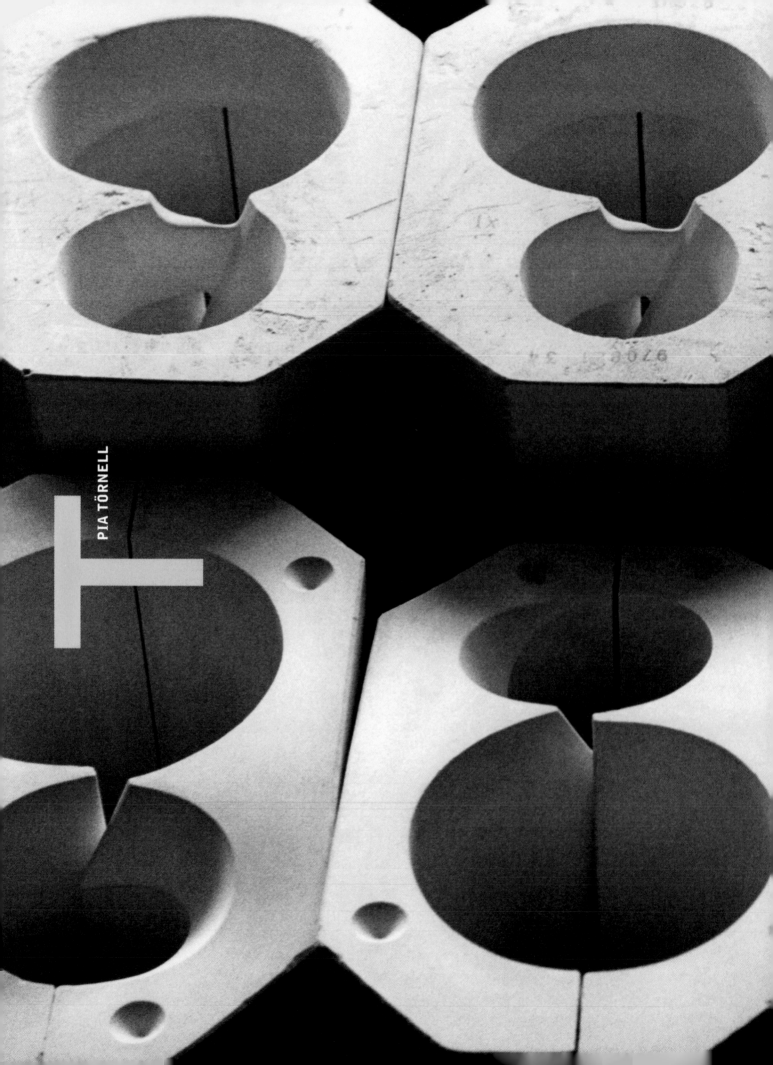

PIA TÖRNELL

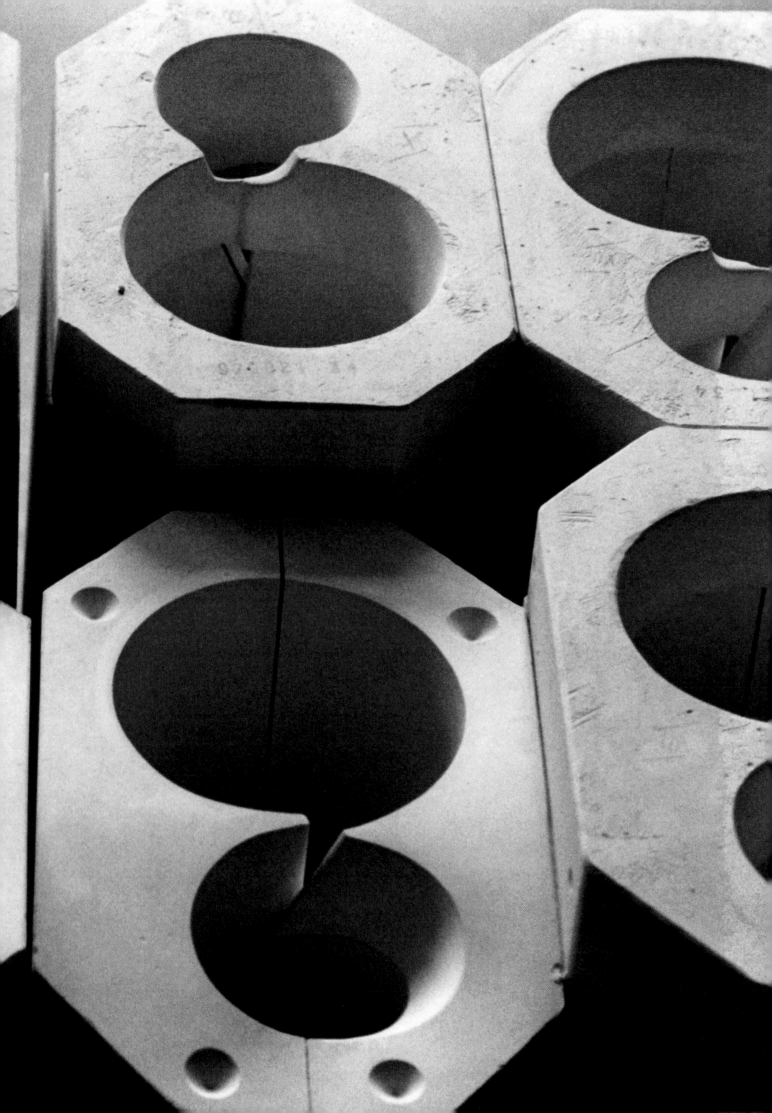

"When I made the special tiles for a public art project I did everything myself. Seven days a week for several months, stubborn as a mule, almost like a maniac. I had no idea it would take that long! I got tennis elbow, an inflamed wrist, and fluid on my knees!"

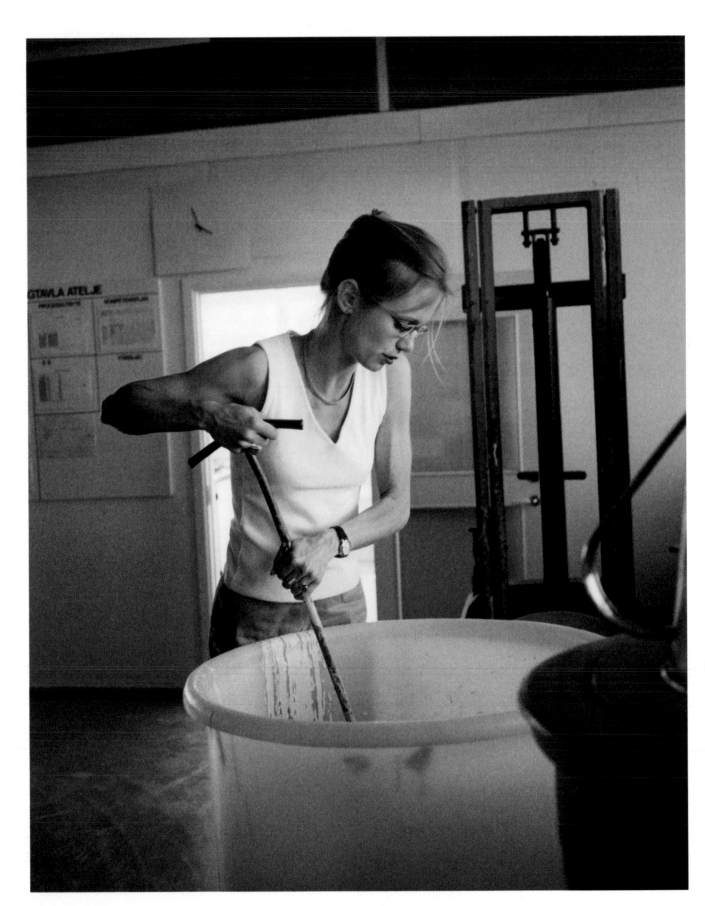

Golden section. Two minutes before ceramic artist Pia Törnell shows up at my office, I find myself thinking: "God, our cups are ugly!" The first thing I do is to offer an apology, but she claims to be used to it. "An office or a home may be designed to the max – but even so, they tend to forget or not care about the little extras. Strange, you tend to forget anything beyond the décor itself." As if that was not enough – I'm out of coffee. Luckily, Törnell takes tea.

"When I grow up I'll get an education, then I'll study at Konstfack!" These words were uttered with great conviction by Törnell when she was just seven years old. "The way I was brought up it was always an unspoken assumption that you had to have a university education, and that Konstfack, where my grandmother had been a student, didn't quite count. I probably thought that I should do the right thing by the norms of my surroundings, but at the same time I was yearning for something else. I just didn't know what. Least of all did I suspect that I would become a designer."

There is something well mannered and very structured about Törnell's way of expressing herself. It is hard at first to associate her with the ceramic pieces that I had been handling at Rörstrand[1] only a few days earlier. The curving, sinuous shapes in combination with the material breathe a kind of hard softness. Her vase *Mantello* is paper-thin and rolled into two holes, creating two vases in one, with a rough matte outside and a shiny smooth glaze on the inside. The thin stoneware of her award-winning *Cirrus* appears so fragile that the clerk lifts it down before I have had time to make a move in that direction. When I say that I am afraid to touch it, Törnell says "it's not actually *that* fragile." But, she insists, you must be able to see both the strength of the form and the fragility of the material.

Her idiom is characterized by a pared-down natural grace, where lines and proportions convey an impression of beauty, a kind of Golden Section[2] that the eye naturally embraces. In short, harmony. And clay is the perfect material for this. You can add to it and subtract from it indefinitely, until you've got it just right.

The production process really reveals her knowledge of the material and her logical approach. Her objects often call for sophisticated moulds. *Cirrus*, for instance, needed one that is composed of thirteen parts. So forget about a potter's wheel – "It's simply not my thing. First I produce a sketch and then I make models out of clay, plaster, paper, or wood, then I make a mould and cast it."

She describes her design process as a search. She finds her way slowly until she gets it just right, when the shape feels natural and obvious. "I work very much like a sculptor. All three-dimensional form is sculpture in a way." She often starts with the shape, then colour, decoration, and surface.

1: Rörstrand was founded in 1726 by Johann Wolff of Holstein in order to start producing china domestically and thus compete with porcelain imported from China. At the time, most of the Swedish population used wooden or pewter plates – china was reserved for the wealthy classes. Technical know-how was initially limited to faience, a kind of glazed earthenware. The first faience service was produced in the 1740s and the successful production of flintware, with its greater resemblance to porcelain, followed fifty years later (See p.170). Today the company is the second oldest china factory still in operation in Europe. Its products helped establish the concepts Swedish Grace and Swedish Modern and still keep these notions alive today.

2: The Golden Section theory goes back to Pythagoras and Plato. It refers to a form whose balance and harmony make it naturally pleasing to the eye, and therefore to the senses. However, it was Euclid, in the 4th century BC, who formulated the exact geometrical thesis for the divine proportion.

"So forget about a potter's wheel — it's simply not my thing."

Page 262:
Cirrus vase. The Röhsska Museum in Gothenburg was so taken with *Cirrus* that they immediately wanted it for their permanent collection.
Page 263:
Stoneware tiles for an exhibition at Galleri Doktor Glas, 1998.

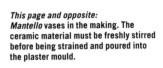

This page and opposite:
Mantello vases in the making. The ceramic material must be freshly stirred before being strained and poured into the plaster mould.

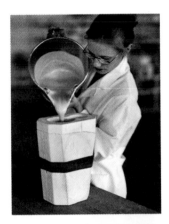

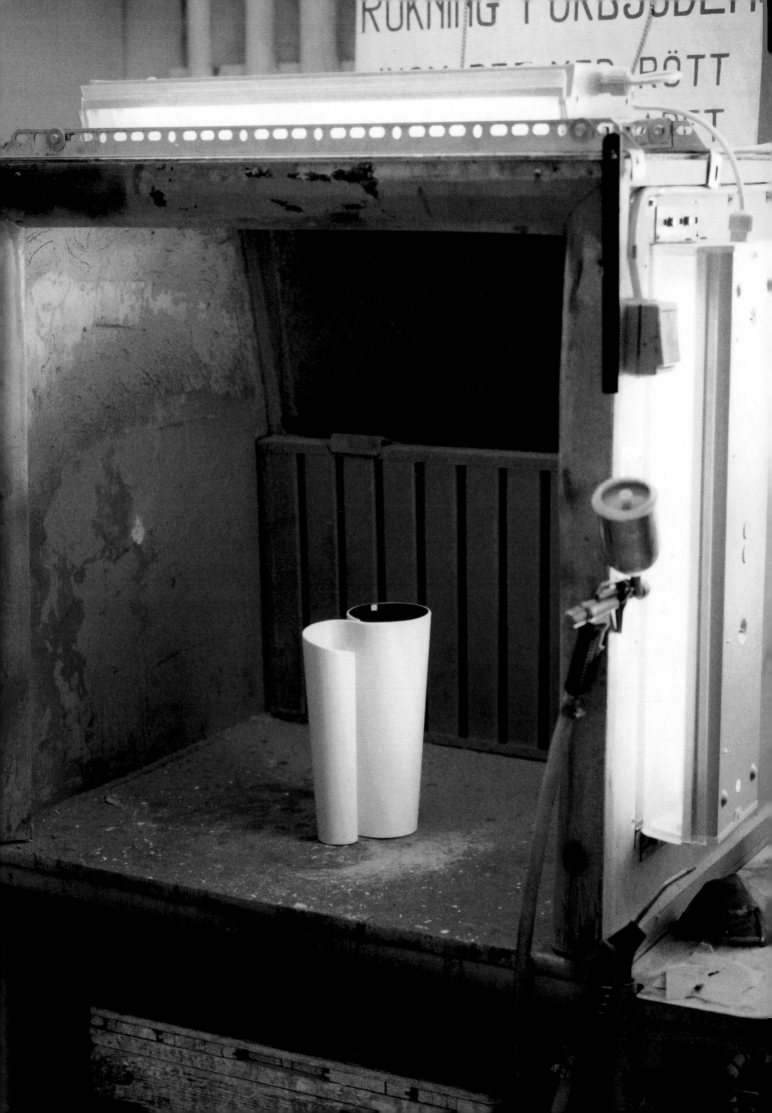

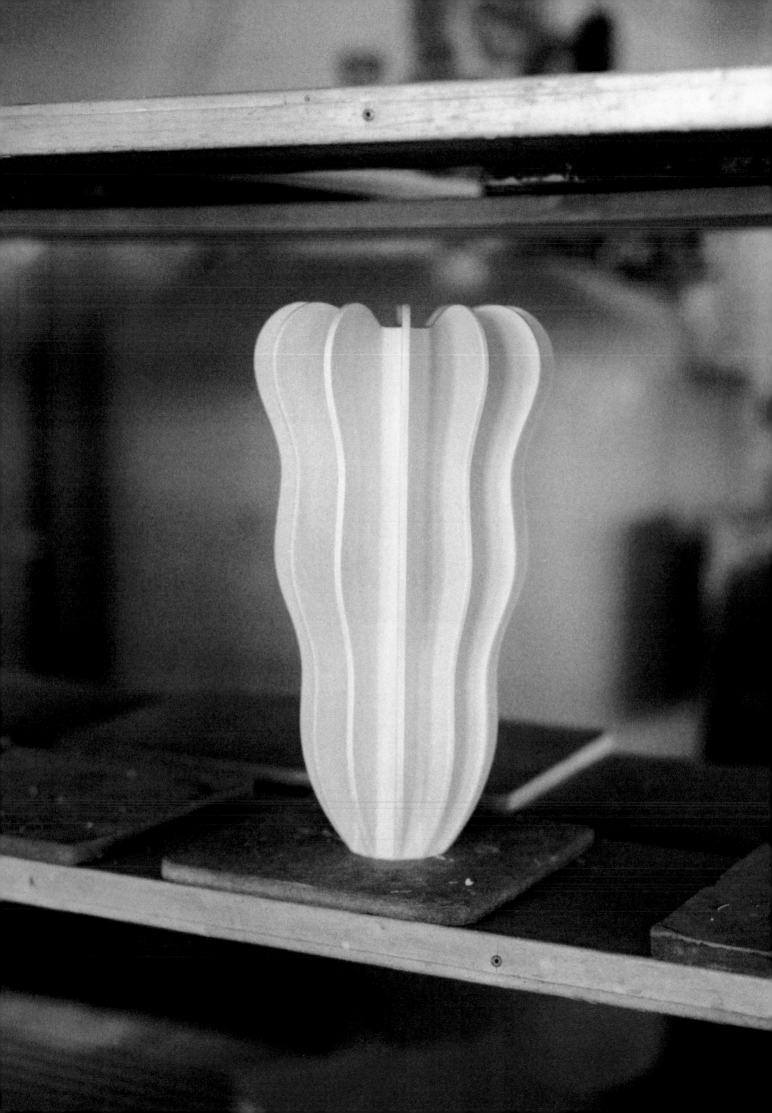

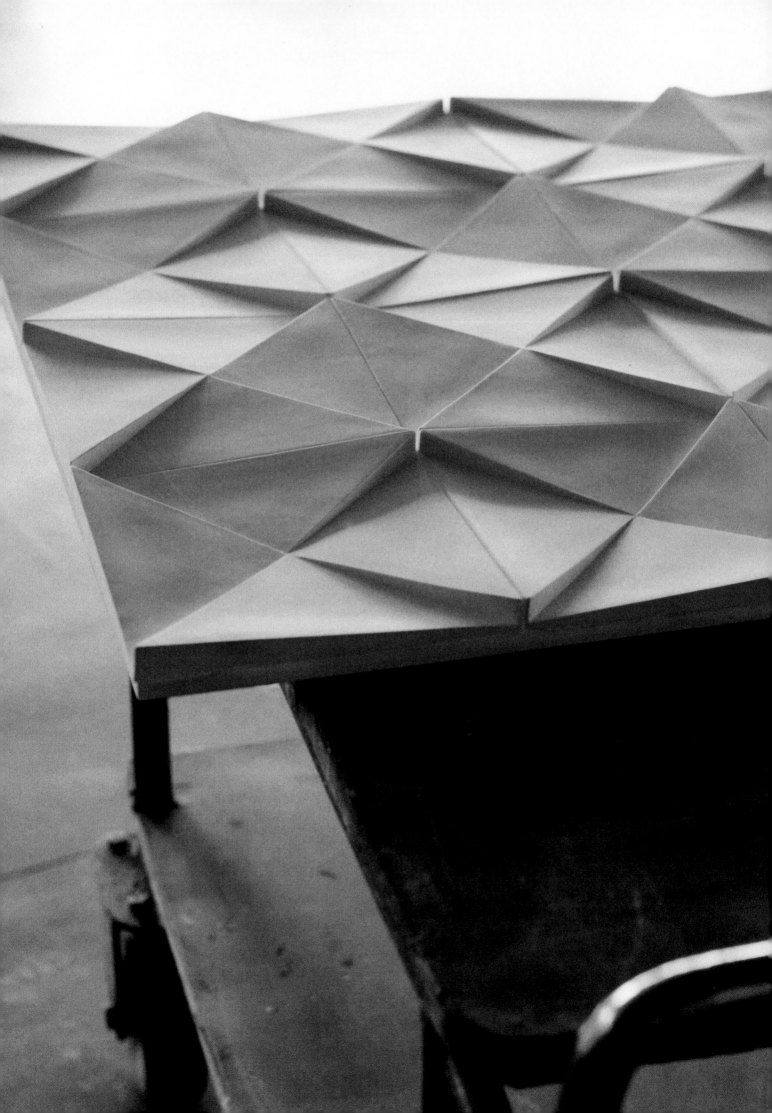

"I find it much harder to arrive at a pattern than a shape. On my own pieces, I find that it gets in the way. Of course there is such a thing as good decoration, but it sometimes feels as if its purpose is to hide a bad shape. But people are willing to pay three times as much for a tiny gold rim!"

Törnell describes light as absolutely essential. "It imbues the shape with life and creates a mood in the object. On a matte surface, it can be incredibly subtle and sensuous. The *Cirrus* shape is totally dependent on light and the shadows that arise as a result. What I want to catch is the combination of sheer fragility and the architectural aspect. Strictly controlled softness."

She attended a technical high school, but began to feel increasingly at a loose end there. She applied to KTH, the Royal Institute of Technology, was admitted, finished the preparatory course, and quit. "It was as if I were two people, one in school and a completely different one in my spare time. I felt that I had to take that step into the uncertain and unknown outside world in order to be true to myself." As a result, she took a daytime adult education art course and worked as a cloakroom attendant at the Royal Dramatic Theatre in the evenings. Then she attended several art schools and spent a few years of working on her own.

Eventually she wanted to move on. "In art, you are very much alone and without guidelines, which is stressful. I had done a couple of illustrations for a magazine and the feeling of being part of a whole was great. So I went up to Konstfack and saw one of the glass and ceramic studios. 'This is where I want to be,' I thought. But by the first month of my pottery course I knew that I was in the wrong place. I tried to switch to painting, but they wouldn't let me. A good thing, too, as I finally found my voice and my relationship to ceramics."

She sums up her impression of Konstfack as a place with a creative atmosphere, freedom, and energy. The mention of freedom prompts me to ask what she thinks about the difference between a designer and an artist – a difference that some find extremely important. "The way you define the different roles depends mainly on the balance between your personal expression relative to function. Viewed on a scale, the industrial designer would be at one extreme, then the designer, the craftsman, and at the other extreme, with the greatest amount of personal expression, the artist. But why waste time on definitions when everything is as important as everything else, only has a different purpose?"

When Törnell works with décor in public settings she is able to escape the manufacturing demands of serial production. She simply takes a leave of absence from Rörstrand in order to focus 100 percent on the job at hand. "This is where I have to work as an artist, from A to Z – unlike in the industrial production process where I turn responsibility for the final result over to someone else."

Her jobs have included special tiles for the Museum of Architecture cafeteria and for the Institute of Education in Stockholm. "I did it all myself. Seven days a week for several months, stubborn as a mule, like a maniac. I had no idea it would take that long! I got tennis elbow, an inflamed wrist, and fluid on my knees. I would gladly take on a similar project, but with a different timeframe and also an assistant!"

Törnell is at her most free in her exhibitions where she really transcends the normal borders of ceramics. "I have been experimenting with ultra-thin, translucent porcelain, among other things. The thinness, in combination with the light in the material and the matte surface, produces an almost immaterial impression. It is no longer just 'a thing', not just matter, but something else. It almost vibrates – it is alive." Törnell makes ceramics sound like poetry.

Below:
Arcus candlesticks. "*Arcus* is still one of my favourites. When I made it I had arches in mind and was surprised when so many people associated it with a walking figure with long arms. It's funny what different associations people make!"

Törnell made the original *Arcus* for an exhibition of sacred spaces during her time at Konstfack. Designer Tom Hedqvist spotted it and wanted to include it in the *Element* collection, a range of products by the leading names of the early 1990s. At the time it was made in cast-iron, now it is in ceramic.

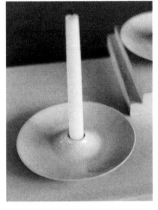

This page:
Clockwise: A sculptural object awaiting a central core in order to become a stylized flower; the candlestick *ReLight;* stoneware tiles*;* Törnell's latest dinner service *Grade* for Rörstrand with eleven parts in china, wood, and stainless steel (and opposite).

PASI VÄLIMAA

Patiently. There is a suggestion of a frown between his eyebrows and his gaze fixed firmly fixed on the stitches through his round glasses. A male embroiderer in his thirties – the old picture taken from an article on Pasi Välimaa that I have come across in the course of my research must be among the more unusual. The combination of men and textiles still seems a bit strange. From 1980 to 2000 the Konstfack textile department counted eleven men among its 207 students. "It never made me feel like an outsider or odd in any way," Välimaa says, "even though some people look at me strangely when I tell them what I do for a living."

There were other reasons why he kept a low profile during his time at school, including outside projects involving stage design and exhibitions. Another was the bitter aftertaste of the professor's words during his first class: the students should start considering right away what they wanted to be known for after graduation – because it was so hard to make a go of it out there. "She only added to the complexes and the already shaky self-confidence of the textile students

by further downgrading handicraft," he says, "we ought to be proud of the Swedish textile tradition and its deep roots."

He also had a hard time coming to terms with the fear of beauty that prevailed at Konstfack. Ugliness was considered more honest and realistic – but it would never occur to Välimaa to do something where beauty was not central.

He passionately maintains that Finnish author Mika Waltari was right when he wrote about beauty and the need for it, saying that adorning oneself and making existence more beautiful is a primitive human instinct. Beauty fulfills a powerful need and gives pleasure.

He is prepared to go all out for beauty, the hub of his creative work, from the very beginning. Beauty and sensuousness. He wants it to feel good to touch his textiles and have them around. "Today, beauty is often thought of as banal and uninteresting. I usually say that nothing can be too beautiful, but that you have to give beauty content in order to create a sense of delight and not just empty superficiality.

I have never understood why it is that some people devote so much time and money to a beautiful external appearance – like going to the hairdresser or wearing a lovely piece of jewellery – and at the same time don't care about the cups they use for their coffee everyday. However, you have to respect different views on what constitutes beauty. We may have an opinion, but we shouldn't be judgmental – to insist that one view is the only right one is a completely Fascist idea. It is probably easier for us who work as artists and designers to define what is beautiful, since our eyes have been trained to see beauty. Our work always involves being open and curious about anything that feels alive."

The living element is yet another of Välimaa's fundamental theses. It must show that a hand has been at work, that one stitch is not identical to the next, that the first Christmas pig on the print is not exactly like the second one. "Handicraft has heightened my ability to express the irregular and spontaneous – also in industrial production."

He calls himself a textile artist and works more like a craftsman than a designer – if you define the latter as someone who turns his ideas over to industrial production.

"Today, beauty is often thought of as banal and uninteresting. I often maintain that nothing can be too beautiful, but that you have to endow beauty with a content, charge it in order to create a sense of delight and not just empty superficiality. I have never understood why it is that some people devote so much time and money to their appearance – like going to the hairdresser or wearing a lovely piece of jewellery – when they don't care about the cups they use for their coffee everyday."

"We ought to be proud of the Swedish textile tradition and its deep roots!"

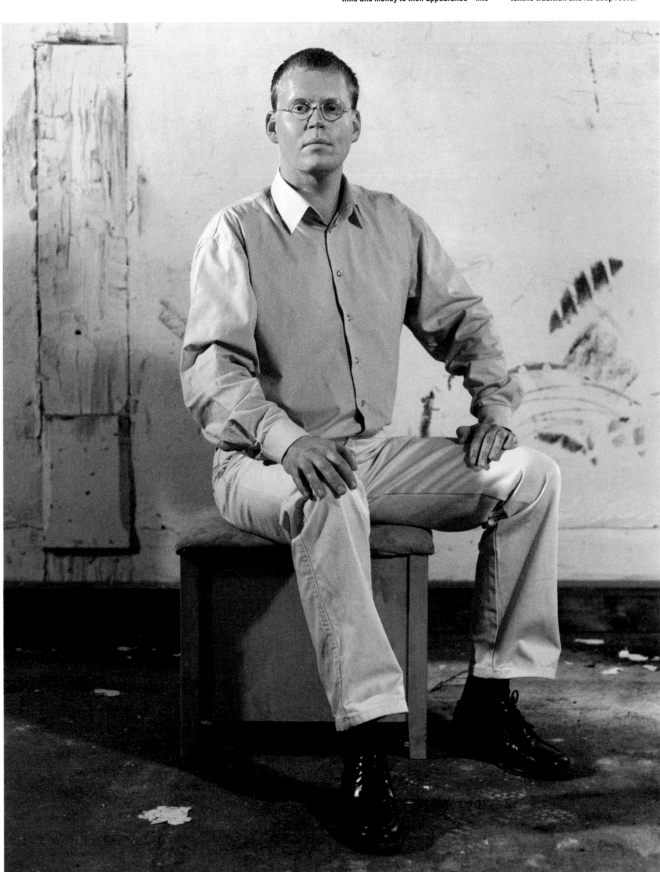

Page 272:
Välimaa's partner's son made this bed for one of his exhibitions. All of it came from the forest.

Page 273:
It took Välimaa a month to make between 5,000 and 6,000 French knots on transparent material for an exhibition at Galleri Doktor Glas. "From a distance they looked like distinct dots, but up close everything started to flicker, like little flies. A couple was standing in front of it and I heard the woman say: 'Imagine, he's been sitting there doing all those stitches!' Her husband replied: 'This guy's crazy!'"

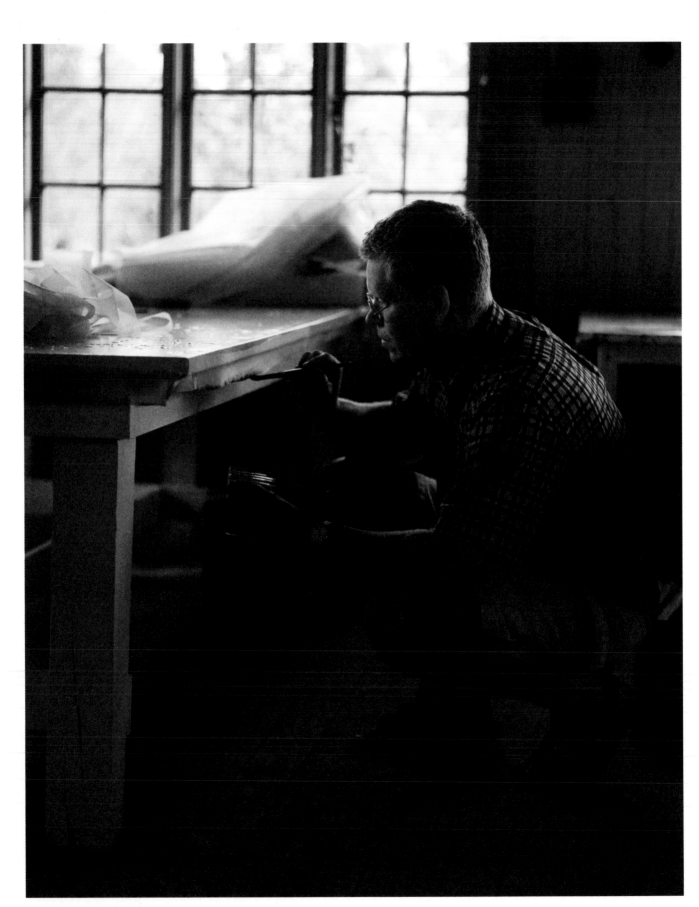

"The best thing about industrially
produced products is that they reach a
lot of people."

Below:
A sketch for a giant-sized linen napkin
for Klässbols Linneväveri.

"I prefer working on my own, with total control of the whole process. This is how I develop and learn more about materials and techniques," he says, describing periods of back pain from carrying heavy loads in the dye room in the old Askersund school that he calls his home. It also contains a 13-foot loom that is excruciatingly hard to work – one of the drawbacks of total control.

His collaboration with industry so far – including Klässbols, Väveri, and Kasthall – has worked well, in spite of a certain nervousness. "It obviously calls for occasional compromise – it is not always easy to make an idea fit available techniques. When I wanted to make a linen napkin for the Cultural Capital of the Year collection, *Helt Enkelt*[1], the format turned out to be 3 feet x 3 feet – somewhere between a small tablecloth and a giant napkin."

He would never put up with being totally overruled by industry and insists that designers must stand their ground and make the companies try harder. The end result is better products, with everybody the winner. "The best thing about mass-produced products is that they reach a lot of people. But it's even more important that they are good, and last."

Välimaa cares deeply about quality and describes his attempts to make his surroundings more aesthetically pleasing when he was little. It already came naturally to him even then. He lived with his parents and sister in Nystad, Finland, forty three miles north of Åbo. He composed bouquets for his grandmother's florist's shop, made window displays for his father's shoe store, sang with his sister in cafés in return for free soda, and did amateur theatricals three nights a week. He was a good student, but hated pre-determined drawing and wood-working assignments such as: "Make a butter knife out of this piece of wood." When his sister's drawing of a tulip was graded as a fail for not being shown opened – wrong, according to the teacher – he was furious.

In the summer of 1987 he got his first summer job in Sweden, at an old people's home, where he ended up working nights off and on for ten years. He returned the following summer and stayed to study theatre, literature, and art history at Stockholm University. Then came a job as stage

designer. He applied to Nyckelviksskolan art school where he fell in love with textile techniques and materials. After that no doubts remained and he applied to Konstfack.

"I really lead a life of luxury – imagine, doing what I love most of all," he says, adding that he is not talking about financial luxury. His greatest expenses are a relatively modest rent and the cost of the materials. Inspiration is free, courtesy of the forests of Närke, as are the blueberries.

Nature is important in more ways than one. "It is as if Nature confirms my ideas. I remember once I had spent a lot of time working on squares when the sunlight coming in through the window suddenly drew exactly the same square on the wall. Another time I made a pattern that reminded me

1: The Helt Enkelt *collection was the tribute of K98 – Stockholm, Cultural Capital of Europe 1998 – to Swedish design. It consisted of eleven functional objects in Swedish materials for everyday use. Focus was on superior quality and beautiful design.*
Participating designers included – in addition to Välimaa – Elisabeth Björkbom, graphic designer; Jan Olssson Loftén, Malin Wåhlander, and Olle Gyllang, industrial designers, Pia Kristoffersson and Anna Livén, designers; Glenn Roll, goldsmith; Carina Seth Andersson, glass designer; Nygårds Anna Bengtsson, fashion designer; and Fredrika Berghult, photographer and journalist.

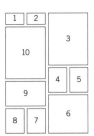

1–8 Interiors of the old school outside
 Askersund where Välimaa lives
 and works.
 9 Organza strips, which Välimaa used
 for a wall hanging (see p.278).
 10 Carpet *Fields 1* for Kasthall.

of pebbles in water. On a beach in Portugal I found the pattern in real life. It almost sounds like a religious experience!"

The inspiration for Välimaa's latest rug collection for Kasthall is based on several field studies. "I was in an aeroplane, looking down, and saw the way two ploughed fields came together. That became a design." He was given free reign to produce this and had thousands of ideas about how it might be done. After a visit to the factory he decided to use tufting to reproduce the feeling of the ground.

Translating the feeling of the experienced image into production was quite difficult. "The fear is always there. 'What if it doesn't turn out the way I imagined?' Like when you have woven a large piece and then unwind it from the loom and suddenly see the whole after being immersed in the details." He was happy with the rugs, however, "I just hope that people won't be afraid to step on them."

It took him a month to make between 5,000 and 6,000 French knots[2] on transparent material for an exhibition at Galleri Doktor Glas. "From a distance they looked like distinct dots, but up close everything started to flicker, like little flies. A couple were standing in front of it and I heard the woman say: 'Imagine, he's been sitting there doing all those stitches!' Her partner replied: 'This guy's crazy!'" He laughs aloud at the memory.

He enjoys the slow, exacting steps of the process. "I may spend days dyeing a piece of material, only to cut away everything except for a small piece in the middle." He finds the minute details of vital importance. "Many designers do gigantic patterns for textiles and wallpaper, but they often end up absorbing all the space in a small room. So I am developing scaled-down patterns. Tiny, – but with a visible nerve and weight."

Alongside the small-scale designs he also does large pieces. "Doing just one thing would bore me stiff." At the moment, he is interested in *rya* rugs. He describes their functions through the ages: on the floor, hung on walls to cut out drafts between the logs, and on beds, with the reverse side up and the shag against the body. "Imagine if you could modernize the old function of a *rya* rug as a bed cover".

With all of Välimaa's pieces, the reverse is as important as the front. "They are beautiful in different ways, and if you tire of one side, you can always turn it over!"

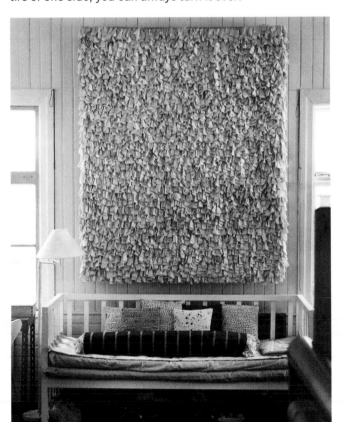

2: In a French knot, the thread is
wound a few times around the needle,
which is then passed back through the
fabric. The result is a little swirl of
thread, a kind of large knot.

276

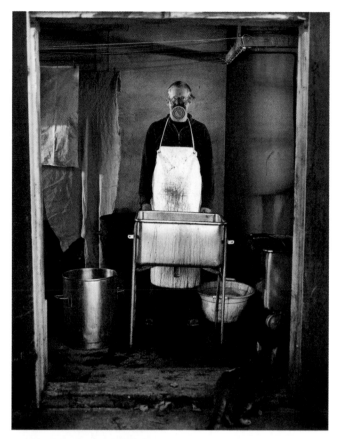

Below:
Experimental work in progress.
Right:
Organza wall hanging.

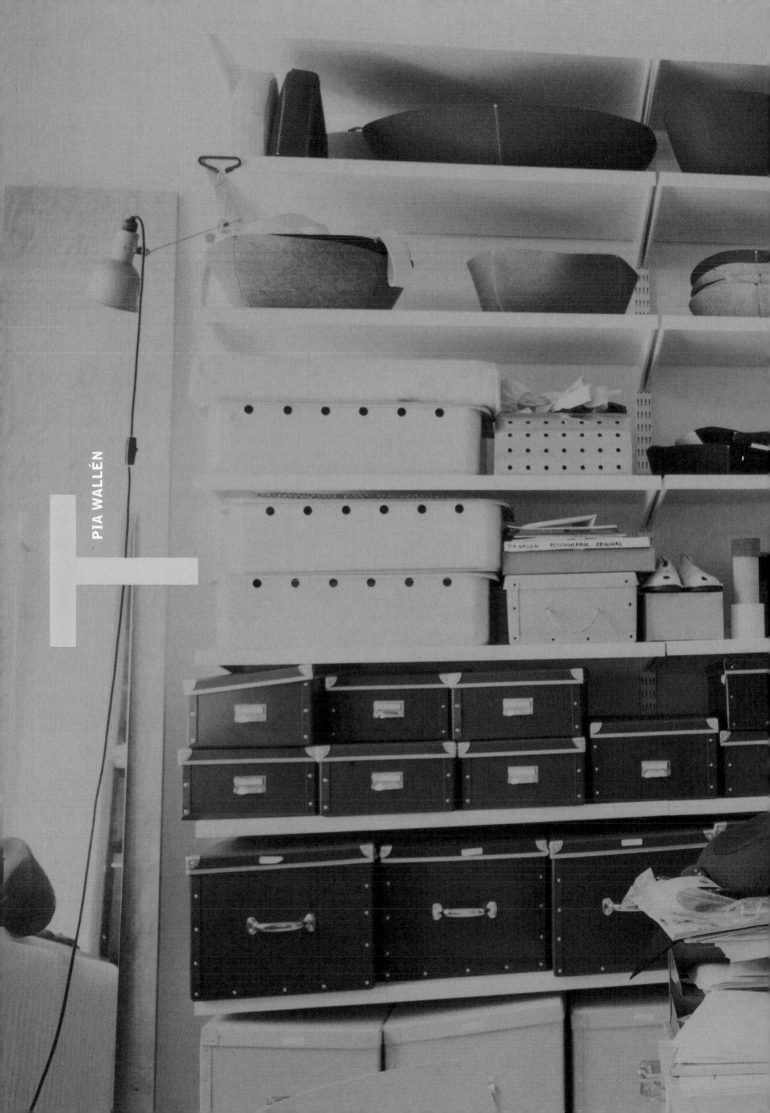

PIA WALLÉN

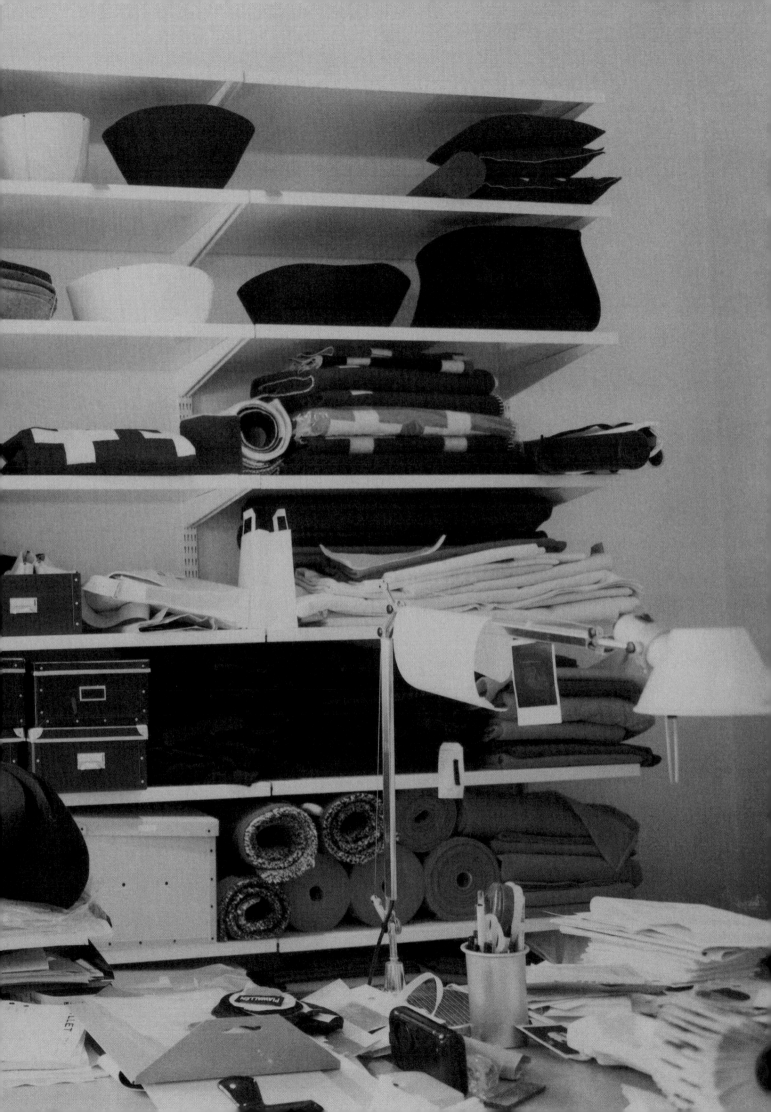

"It is as if I always have felt in the back of my mind and I can't imagine doing something that does not involve it."

A bowl in felt. Who but Pia Wallén would ever think of such a thing? I have to bite my tongue not to mention words like felt queen, felt freak, and felt fetishist – but I just did. There is no denying that she is the leading explorer of the world's oldest textile material – she uses it for everything from clothing and shoes to interior decoration and jewellery. She has created a style so distinctly her own that the trained eye has no difficulty spotting "a Pia Wallén". It is a powerful brand name.

No wonder then that she has been praised for upholding a cultural tradition, for everything she does is founded on her love for this ancient textile. Felting is older than weaving, and the material is still valued for its original, insulating properties by the nomads of the Russian steppe. "Tradition is a source of inspiration rather than something that's written all over what I do – it's in the back of my mind but the focus is on our own time. I am especially proud – as the only woman – every time my name is mentioned in the same breath as some of our foremost architects and glass designers. It's one way of raising the status of textile art. I also hope that it will inspire other women designers or people in textiles – which is usually one and the same thing!"

Wallén talks of herself as someone "who just has the ideas" as she herself is barely able to sew. She knitted her way through her years at the Beckman School with the aid of a knitting machine. When she graduated in the spring of 1983, she presented what was certainly a most unusual graduate collection. Or rather, one that was ahead of its time. Clothes with clean lines, and graphic patterns, knitted and felted[1] – as far removed from the sharp colours and shiny ideals of the 1980s as possible. This remained her style, both in clothing, blankets, pillows, and furniture until 1993. "The factory that I was doing work for went bankrupt. I was devastated. At the same time, I felt that it was time for something new. So I started to work with wool cloth which meant that my work automatically became more sober as the material tended toward military hues."

Then she discovered industrial felt – made using a mechanical compression technique. Another success. "Felt, as a material, has given me my greatest professional kick,"

says Wallén. Her slipper design – now found all over the world – is one example. Bowls, bags, and shoes are others. "I had been toiling with the slipper design for ages, working with an expert on construction, testing I don't know how many different constructions. When we finally had it under control, we felt like we had just invented the shoe!" She laughs at the memory. "Today I feel like a 'slipper celebrity' – there are no two ways about it."

Celebrity. You immediately jump to the conclusion that the enormous interest from abroad, especially in Japan, has brought economic security and that it has freed her from having to worry about sales and production, allowing her to

283

1: Fulling is a mechanical process using wool, which causes the fibres to mat together and become extremely compact. The manual process is called felting. The wool is soaked in a soapy solution and rubbed vigorously until the fibres mat together. Woven wool is called cloth, if thin – frieze or home-spun, if coarse.

2: The royalty is a fee the designer receives for each item sold. The standard royalty varies according to the business and today falls somewhere between three and seven percent of the net wholesale price – that is the price the producer asks of the retailer. The retailer then generally multiplies this sum by 2.5, to arrive at the price the *consumer pays. This mark-up is supposed to cover rent, marketing, staff, and administrative costs. If an item therefore costs 1000 crowns in the store, the designer receives around twenty crowns for his idea and all associated labour. Hopefully the designer will receive a greater share of the profits in the future.*

"It is the context that separates the artist from the designer. Both of us have a concept that we follow, the artist in a more intellectual context and me, the designer, in a more functional one."

Below:
Bowls for an exhibition at Krapperups art gallery in spring 2000.

Right:
Pia's blanket *Crux* caused a major uproar when it was introduced as part of the first *Element* collection in 1991. Production in the red/white colour combination had to be halted. A United Nations convention prohibits the indiscriminate use of a red cross on a white background. Today, it is available in less provocative colours such as black, beige, blue, and orange. Shown here is the permitted side of the provocative colour combination.

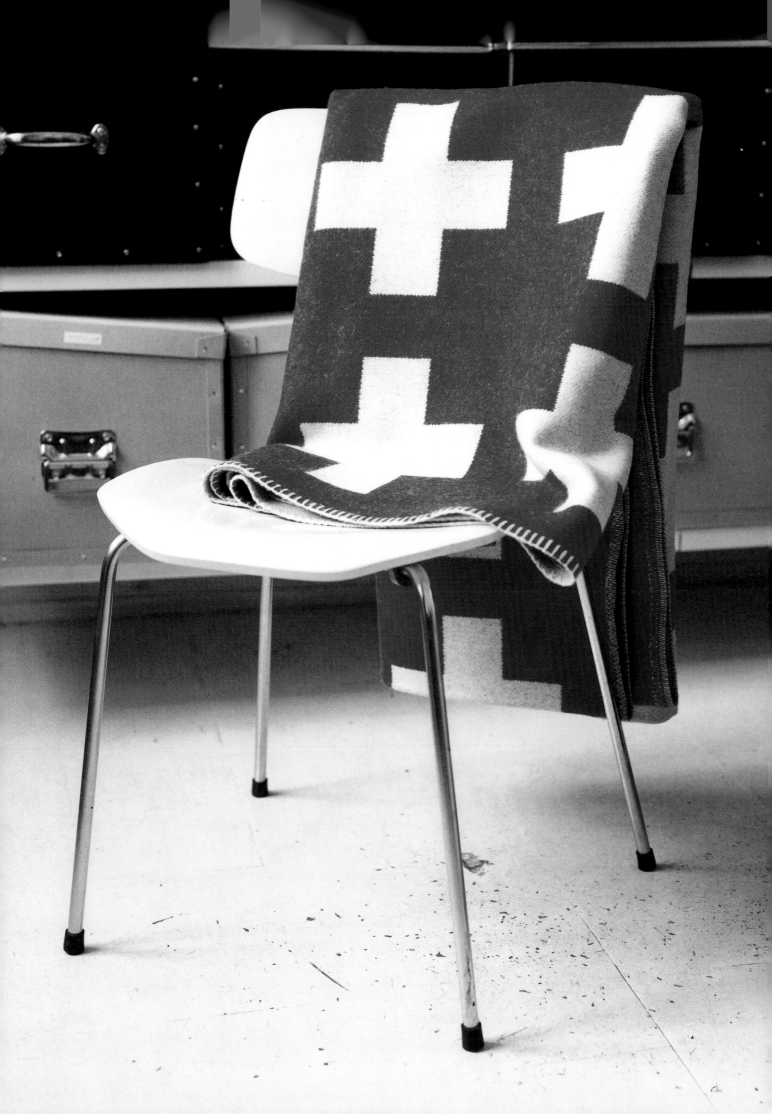

just give herself over to creative work. Not so. "If you out-source the components, you end up having less and less say as a designer. Besides, today's prevailing royalties[2] are a slap in the face." If she were to take over production – as she would like to – it would require a costly outlay. She is afraid that it would be like when she was just starting out, doing everything herself, with no time for new ideas or creative work. "If I try again, I don't want that to happen," she says emphatically. She would also like to be able to govern the way her products are presented in the stores. This is not easy, since everybody stocks different items and seldom the range as a whole. "One way would be to have a store of my own, where all my products form a whole."

Wallén also likes making forays, as she calls it, into other materials. For example, when she was asked to make a glass vase for Ikea's "*PS*" collection. "When it was finished, my first thought was 'how about adding some felt?' It is as if I always have felt in the back of my mind and can't imagine doing something that doesn't involve it."

It was the same with the work she did with goldsmith Maria Elmqvist, where they combined silver and felt. In a joint exhibition they explored what constitutes a piece of jewellery. Does it have to be a brooch with a pin or could it be part of the dress itself? Could the handles of the handbag also serve as a bracelet? The result was shoes and dresses perforated with eyelets, fabulous evening bags, and large pieces of jewellery. "We simply wanted to indulge in our tastes for luxury, and realize ideas that may not have tallied with normal production demands," Wallén says. She explains that she feels no creative constraints in the initial ideas phase of the design process. "But after all these years, the demands of production are so ingrained in me that I know right away whether it is feasible or not."

Back to the bowl. How did the idea first occur to her? "I had been invited by British designer Jasper Morrison to do a job for Cappellini[3]. I wanted to make a 'cozy kit', a kind of snuggly collection, all in felt. A large bowl containing slippers, a pillow, and a blanket. Unfortunately I was told that 'Signor Cappellini has no desire to become a slipper

producer,' so the bowl just sat at home until my cats discovered that they loved it. So I had the idea of making a variety for dogs that you could also keep, say, newspapers in."

The bowl – her favourite product after the slippers – is constructed on the tennis ball principle, to which she is very partial, where two or more parts are joined to make a sphere. "I saw a copy of my bowl in a foreign interior design magazine – the only difference was that this one had a handle. Instead of crying my eyes out because I had not been the one to come up with such a brilliant idea, I took it one step further. It became a handbag based on my bowl, with a handle inspired by the copy."

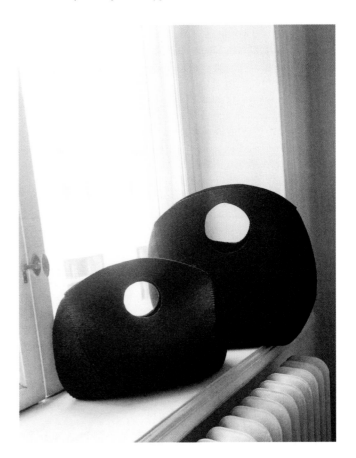

3: The Italian company Cappellini is one of the leading design businesses in the world. Founded in 1946 by the Cappellini family for the craft manufacture of period furniture, it changed over to the industrial production of modern furniture in wood in 1960, and then expanded to encompass all kinds of materials in the mid-1970s. Cappellini's range consists of three collections: Progetto Ogetto, Cappellini, and Mondo. Designers include Marc Newson, Konstantin Grcic, Thomas Sandell, Tom Dixon, Ross Lovegrove, Shiro Kuramata, Piero Lissoni, Jasper Morrison, Thomas Eriksson, James Irvine, and Ola Rune.

Below:
Bracelet, designed by Wallén and
executed by goldsmith Maria Elmqvist.

Below:
A prototype of the *rya* rug, *TV*. Wallén
was tired of vacuuming so often and her
solution was to make a mixed-colour rug.

Right:
Wallén devotes half her time to fashion
and the rest to product design. Her idiom
remains the same.

Sometimes she wonders why she didn't think of an idea first. "A lot of people have taken up felt, and there are times when I think: 'Help! Their ideas are always so fresh, so good! What if they start thinking of me as a pathetic old felt lady?'" she says with a giggle and a shudder. "There may come a time when I am through with the material – who knows? My relationship with felt feels like a marriage. As long as the ideas keep coming, I'll continue! It is the material itself that spurs me on – the endless possibilities it offers provide such a challenge. I'm still in love!"

She describes how various techniques, such as perforation, may suggest new shapes and products. "I derive more inspiration from walking around a factory floor than from Nature. Most of all from my own needs, though: we need a new pillow, my husband needs a jacket, I need a sundress and my daughter needs a new coat. The consumers sort of get a free ride." But it is not all about new ideas. "I always try to develop and improve on my ideas, try to lengthen their life, by adding a rubber sole to my slipper, for instance."

Wallén is drawn to symbols that she finds in folkloric textiles and then refines them into more graphic designs. "The cross and the circle have always fascinated me. Both are beautiful and have powerful emotive connotations. Heaven and earth, hope and faith, care and love. My husband often asks me to give up doing crosses, but I have been doing them for so long. They are so me!"

288

ANN WÅHLSTRÖM

Pure mobility. In the spring of 2000 something unusual happened in Sweden. You could find posters announcing this strange phenomenon in the streets and public squares of Växjö, Malmö, and Stockholm.

What happened was that a contemporary designer – a woman, who was still very active – was the subject of a large retrospective exhibition. Ann Wåhlström had decided to go for broke and realize something unheard of in the Swedish design world: *Cyklon. Twenty years with hot glass – a retrospective. Cyklon* (Cyclone) is one of her most recent collections for Kosta Boda[1]. It is also how she described her situation after a long illness. "My head felt really rusty and I wanted to find my way back to some kind of base – this was my way of taking my own temperature. The exhibition also served as an important launching pad for the future. I didn't want to do anything pretentious or museum-oriented, which is easy when you use the word 'retrospective.'

"I wanted to see if I could discover my main thread – and I did. Or rather, I found two parallel threads, for I evidently have two different moods, and you have to allow them both a chance to express themselves. I also wanted to show the public the process involved: the joy and hard work of the creative process. Inspiration, sketches, colour samples, prototypes, rejected ideas. Not just the 'perfect' end result." In this context she stresses the importance of sketching – both for explaining the idea and for polishing the lines.

It is always daunting to see so much by one person at one time. Both of her main threads are clearly evident. One is organic and billowing, with sharp colours and surface applications. "A third dimension ups the ante and makes for more action," she explains. Here we find movement and her fascination with beaches, the sea, antiquity, and ancient Persian glass. One of the platforms is completely dominated by *Blue snails, green sea-horses*, recalling the under-water world of Jacques Cousteau. The glass actually gives the impression of moving, like the coral reefs of the South Seas.

The other thread is more restrained and architectural. The lines are straighter, and the colours more subdued. Clear glass, smoke grey, and purple heather. Wåhlström is often "clean-cut" when the trend calls for the exact opposite. "I can't explain what makes me settle on one or the other of my main threads. That's what happens when you are guided by feeling! I probably started to yearn for pared-down things in the heyday of Postmodernism. At the same time, I was very influenced by it. The expression of the Memphis Group (see p.215) was wonderful – especially when you compared it with the conventional thinking of the glass industry!"

Wåhlström looks back at her career with satisfaction, even though she concludes that she should have spent more time on items made entirely by machine. "It is very difficult, though. If someone at Kosta Boda says 'the dinner plate machine is idle – make something!' – it often results in a total block. It is always much harder to start from what somebody else wants than from your own idea."

A recurring theme in her work is spirals of all kinds. "I have been drawing spirals ever since I was little. There is life in them, a twist that I can keep changing indefinitely. A kind of eternity, found in everything from whirlpools to sea shells."

I always ask myself: "Why did this thing sell, but not that one? My soul is equally invested in both." The answer may be that the market may not have been quite ready for it – but surely that cannot be the whole explanation. "Even when I am convinced that my product is in line with the prevailing taste in design, it sometimes fails. And the other way around. It shows how important it is for the industry – i.e. the glassworks – to be aware of what works and when. But, then, financial people are seldom aesthetes – so it's not all that easy!"

She likes to talk about marketing, administration, and sales. "I have lots of views on everything and I like to keep a dialogue going. I simply can't stop myself from butting in whenever I have an idea or an opinion on something. I have tried to influence where my things are sold, for example. I feel much more at home in design stores than in glass shops and galleries. It's a question of finding new customers, both for myself and for the glassworks, to highlight the brand name and make it accessible. Kosta Boda must invest in visibility. It is important to have different outlets for the idioms of the various designers in the glassworks' stable."

292

1: Kosta Glassworks was founded in 1742 by the governors of the counties of Kronoberg and Kalmar, respectively Anders Koskull and Georg Bogislaus Staël von Holstein. Four German master glassblowers originally represented the craft, and production included "carafes, wine glasses, inkwells, square bottles, tea pots, window panes, butter containers, oil and vinegar cruets, wine barrels, and chamber pots".

Apprentices and journeymen, often related by blood, assisted the master glassblowers. Not until the mid-1800s were Swedes thought to be ready to take up their places among the foreign master blowers. The occupational categories of the time included smelting house boy, inputter, carrier, fetcher, press hand, poker, heater, blank maker, fine grinder, polisher, stopper, driller, sorter, cracker, driver, bottle picker, gas stoker, and glass inspector.

Kosta merged with Boda in 1976.

"To discover the nature of glass, after dealing with ceramics, and to penetrate this new and magical world gave me the same happiness as first learning to ride a bike. The material suited my nature – it was quick, impatient, and spontaneous."

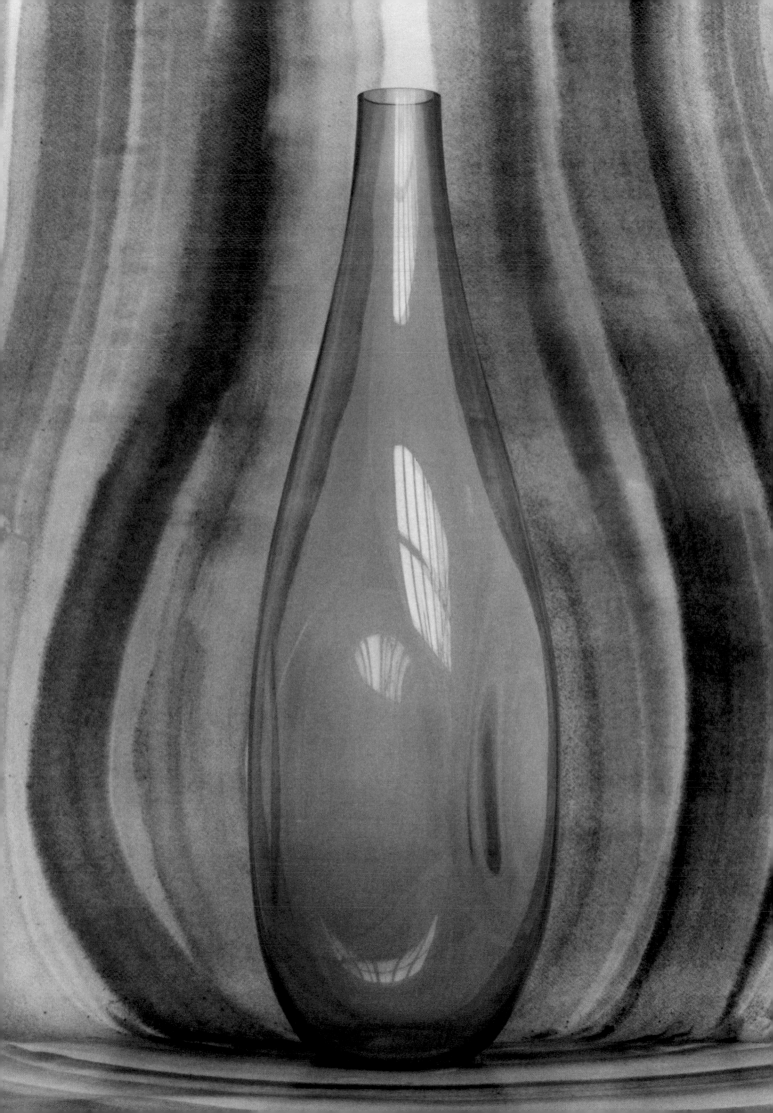

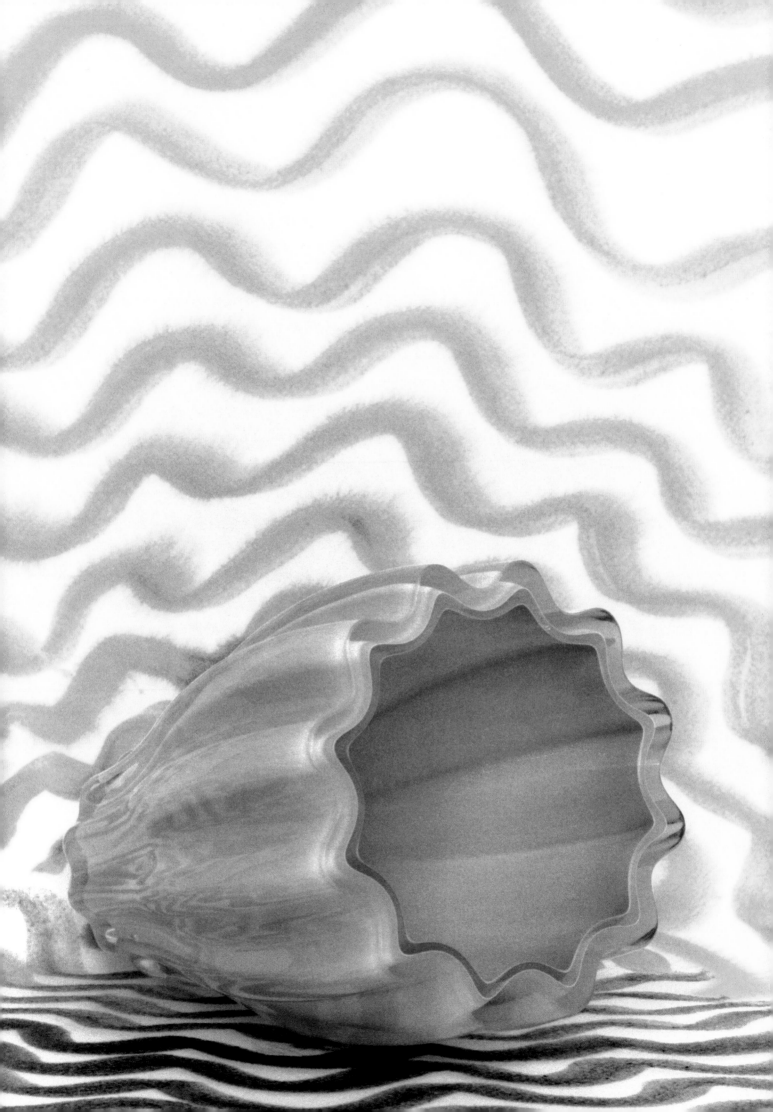

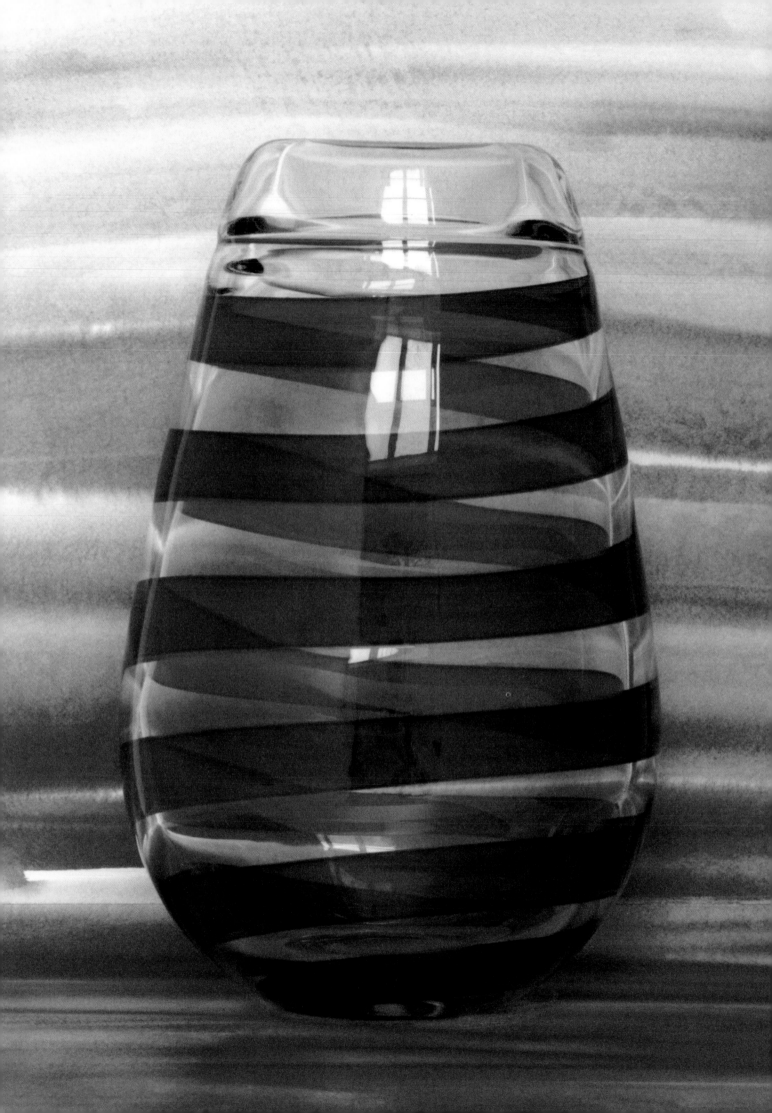

Wåhlström was long convinced that she wanted to be a ceramist, having spent a year at Capellagården on Öland. But at a summer course in glassblowing at Orrefors she heard about the Pilchuck Glass School outside Seattle, well known in glass circles. She scraped together some money and went. In the process she discovered a new, free, and utterly un-Swedish, glass world. "At Pilchuck you started by referring to yourself as an 'artist' and felt your way until you succeeded. There were no rules – just lots of energy and spontaneity. After that, I had the best of two worlds. The foundation of the Swedish craft tradition and American freedom!"

"To discover the nature of glass, after dealing with ceramics, and to penetrate this new and magical world gave me the same happiness as first learning to ride a bike. The material suited my nature – it was quick, impatient, and spontaneous. It may be hard for an outsider to understand fully the fascinating world of the smelting house. It is hot, intense, and everyone has his or her specific task. Every piece takes five or six people working together as a team. It's wonderful when suddenly, together, they manage to produce something exquisite out of what, a short while ago, was nothing but some sand mixed with soda and lime."

She was discovered by the American glass artist, Dale Chihuly[2], who allowed her to attend his courses as a special student at the Rhode Island School of Design in 1980. After applying to Konstfack a couple of times she was finally admitted and spent a year as a special student under Bertil Vallien, among others. "It suited me to stay only a year – I was quite a lone wolf, concentrating on improving my technique."

She then returned to the US and worked in a design office in New York and as an artist's assistant. It was "as much fun, as important and valuable as formal education," she says. Every free moment was spent on glass, and in 1985 she had a solo exhibition in SoHo. The then director of Kosta Boda was so impressed that he managed to lure her to Småland. At the time, the glassworks was interested in working with a total concept that included glass, ceramics, and textiles. Wåhlström and her friend Gunnel Sahlin, a textile designer, received an offer they could not refuse. "I went

for it – in spite of my fear of deep forests. Unfortunately, we only worked for four months before the project collapsed."

Wåhlström stayed on, however, still dreaming of working in a larger and wider context, preferably with functional everyday items. "I don't quite know what I want to be when I grow up, but one thing is certain: I want to have fun!"

2: Born in 1941, American Dale Chihuly is of Hungarian, Czech, Slovakian, Swedish, and Norwegian descent. Many consider him to be the world's greatest living glass artist. He is responsible for revolutionizing both techniques and expression, and he often produces colossal, architectural installations. Chihuly is able to do things work with glass to create pieces that were considered beyond the realm of possibility.

This page:
Clockwise: *Seashell*, 1993; *Sea Anenome*, 1993; *Major & Minor*, 1995; *Calebass*, 1995.
Right:
Strada, 2000, Battuto technique.

"I really like the clean-cut and pared-down, but it becomes boring in the long run. Sometimes I am seized by a desire to add some curlicues."

298

In 1991 Wåhlström made some glass for the Element collection, a line of high-quality basics by a number of well-known designers. Her "idol", Jasper Morrison, liked her work and invited her to join a similar project, Progetto Ogetto, for the Italian company Cappellini. She made some metal candlesticks – a material she had previously used for some vases for Silver & Stål. Morrison is a British furniture and product designer,whose designs are elegant and clean-cut, but never boring. They are often reminiscent of the blonde and functional aspect of Scandinavian design. His idiom is usually simplified and he is often known as a purist. His products range from household items and furniture to a streetcar for the city of Hannover. His producers include Alessi, Cappellini, Flos, Magis, Rosenthal, Vitra, and Sweden's Asplund. He is often credited with introducing Swedish designers into the international community and creating a bridge of credibility for Swedish self-confidence.

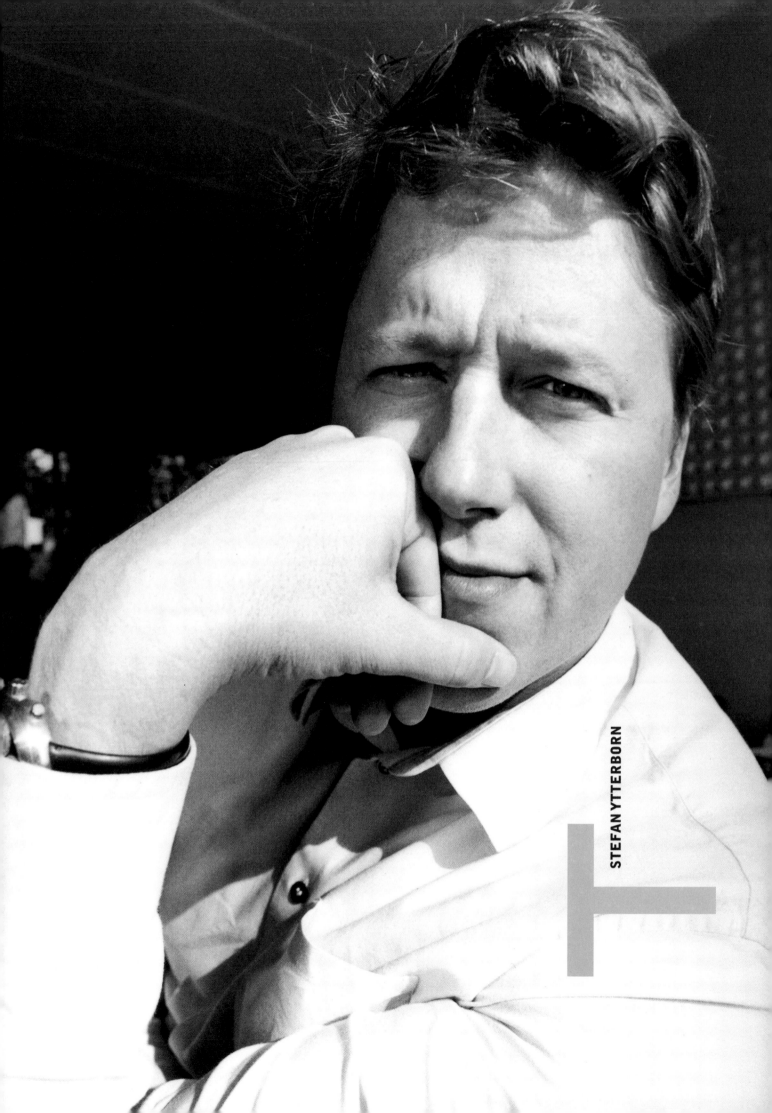

STEFAN YTTERBORN

Facilitator. For Stefan Ytterborn the word is right on the mark. You wonder where contemporary Swedish design would be today had he decided to become an army officer. Most likely hidden from sight, undeveloped, and absent from the international arena and the press. This may be a totally subjective view, but after seeing what he has accomplished and after seeing him in action it would be hard to disagree. He is an enthusiastic taker of initiatives, and holder of opinions, a persuader, and an ideas man, – a real energizer.

It all started in the mid-1980s with a book on 17th-century Swedish furniture which opened his eyes to the way everything is interconnected. How design reflects the social climate and why Baroque is different from Rococo which, in turn, is different from the Gustavian style, and so on.

"I suddenly understood how society develops. How the objects around us are affected by the times we live in and how the product, the individual, and the surrounding world are all interconnected." During his travels in Europe on Venetian-blind business he soon discovered that it was furniture by people like Xavier Marsical and Philippe Starck that best reflected the ideals of the 1980s.

His one-man business, cbi, was sharing quarters with a gallery owner at the time. Every time Ytterborn expected a visit from a prominent international furniture VIP the gallery owner was asked to vacate his part of the premises posthaste. "Of course I lied a little at the fairs – so what? I claimed to have a large organization, because I was convinced that that was the only way to get them to come here," Ytterborn says without blushing. "And it worked. I became the Swedish agent for a number of Spanish and French furniture producers." Evidently there was a crying need for their products on the Swedish market and, before long, many public settings and design-conscious homes boasted pieces from cbi.

As the economy started to decline, Ytterborn's interest began to focus more and more on Swedish design. "My architect-oriented business died overnight in March, 1990. The following month I attended the Milan furniture fair where a dramatic funereal atmosphere prevailed. It was terrible – everyone was deadly pale and silent, in shock after years of excesses, vulgarity, and lavish parties. A decade, characterized by escalating prices and little or no distinction between art and design, was suddenly over."

Never at a loose end, he decided to open Klara, a store with "sensible and OK things at sensible and OK prices for everybody." It was another success. At the same time the idea of exporting Swedish design was taking root. "I tried to interest business in a joint design effort, but no one seemed interested," Ytterborn says. He did not insist, but made sure that it happened anyway – under his own direction. He had already put together a collection of products by twelve young Swedish designers in 1992, which he now introduced at the Milan fair under the cbi label. The products were simple, and consumed few resources; they were fun, unpretentious, and practical. "The reaction was fantastic, everybody responded as if we had come up with the answer to an unformulated question of what the future would bring."

Buoyed by numerous positive reviews in the international design press, Ytterborn made two decisions: he would devote himself full-time to design and would work in the international arena (to limit yourself to Sweden is not a valid business concept). His ambition was to make room for Swedish design, to define it, and introduce it abroad. "After being on my own for so long – both a costly and exhausting proposition – I invited others to join me. I got in touch with people in the same situation as cbi: Asplund, Box Design, David design, and Forminord. Small, design-conscious producers who would benefit from sharing the costs of everything from marketing and booth rental to transport agencies."

He named the new cooperative Swecode (Swedish Contemporary Design). Its goal was to develop "a forum and an exhibition format for the best of contemporary Swedish design within the areas of furniture and lighting." Swecode exhibited at the 1995 furniture fairs in Cologne and Milan and was a huge success. Seen through foreign eyes, it was a compilation of the best of contemporary Swedish design.

Ikea's "*PS*" collection was presented amid much interest at the Milan fair that same year. This, too, was Ytter-

302

Swedish design will have a hard time remaining on top, in Ytterborn's opinion, and will not be able to influence development as it did in the 1990s.

"We could potentially be one of the world's five or six most interesting design countries – provided that we get our act together. Our greatest problem is that Swedish industry is unimaginative and small-scale, made up of small,

low-tech players. The degree of refinement of Swedish furniture is extremely low as a result. Our designers must get out there – they have to view the whole world as a potential client. Once they come into contact with production possibilities that are radically different from those in Sweden, their design will develop." He is also convinced that designers should

become better at analyzing both their product ideas and the businesses they are courting. "It is not enough to say 'I have a good idea' – you have to be able to back it up with good arguments from the perspective of the company's business development needs. The design schools ought to teach students the art of convincing and selling as well as market economy."

Below:
Ytterborn & Fuentes managed to persuade Swedish McDonald's to break with their red and yellow interior design philosophy in exchange for a blonde and contemporary look. Two of the famous re-designed restaurants – this one by Claesson Koivisto Rune – are located on Kungsgatan in Stockholm.

born's doing. "There was no doubt that Swecode could help disseminate young Swedish design – but never on the same scale as Ikea. After reading an article on 'Kamprad's boys' in summer 1992 I got in touch with Lennart Ekmark, then director of collections and design, and outlined my idea about an Ikea collection of young, Swedish designers. In 1993 I got the go-ahead and enlisted Thomas Sandell and Thomas Eriksson to help with the selection process with an eye to the launch in 1995." It was an uphill battle, as Kamprad himself had not quite sanctioned the project. Ytterborn left the project in 1996 claiming that it was too ambitious.

While working on "*PS*" he discovered that manufacturing and production were not his thing. "It was as if my frustration about the fact that no one in the business understood me finally gave me the incentive to go on to other things," he says, adding that people in the furniture industry think he's a pain. He recently overheard someone at one of his seminars saying 'So, that's Ytterborn, the aggressive one.' "Maybe I've frightened people off and not been very tactical – but nothing happens if you aren't."

When Ytterborn sold his share in Klara and cbi and then started Ytterborn & Fuentes in 1996, a business specializing in design strategy, many young designers were worried. Whom would they now consult? Who would produce their things? Who would now put forth worthwhile ideas and lambast Swedish industry for its lack of initiative?

The seed of Ytterborn & Fuentes was planted when Ytterborn and art director Oscar Fuentes re-launched the timeless designs of Finnish designer Kaj Franck in 1994, this time with a new strategy for the collection, marketing, and distribution that involved opening events at Klara and similar stores around the country. Thanks to this re-discovery, many of us have some of Franck's coloured glasses at home.

Ytterborn then continued with development-related jobs for the entire Hackman group: Iittala, Arabia, and Rörstrand. Polarn o Pyret, Swedish McDonald's, Ericsson, Assi Domän, and others sat up and took notice. "We are trying to make companies aware of the importance of design as a tool of competition. We offer insightful design, consciously shaped, based on a clearly formulated objective," Ytterborn explains, adding that about half of the designers and architects in the various jobs are Swedes, including Björn Dahlström, Carina Seth Andersson, Jonas Bohlin, and Claesson Koivisto Rune.

Ytterborn thus continues, untiring in his efforts to create jobs for Swedish creative artists and help spread their designs around the world.

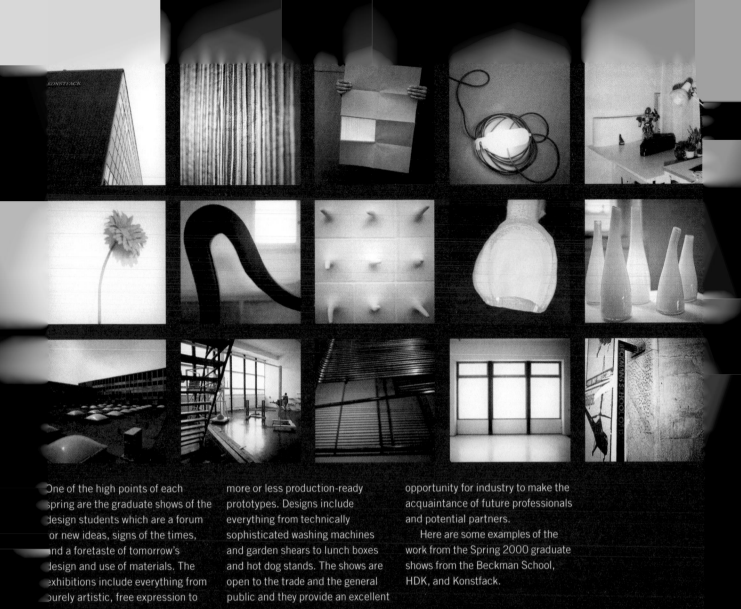

One of the high points of each spring are the graduate shows of the design students which are a forum for new ideas, signs of the times, and a foretaste of tomorrow's design and use of materials. The exhibitions include everything from purely artistic, free expression to more or less production-ready prototypes. Designs include everything from technically sophisticated washing machines and garden shears to lunch boxes and hot dog stands. The shows are open to the trade and the general public and they provide an excellent opportunity for industry to make the acquaintance of future professionals and potential partners.

Here are some examples of the work from the Spring 2000 graduate shows from the Beckman School, HDK, and Konstfack.

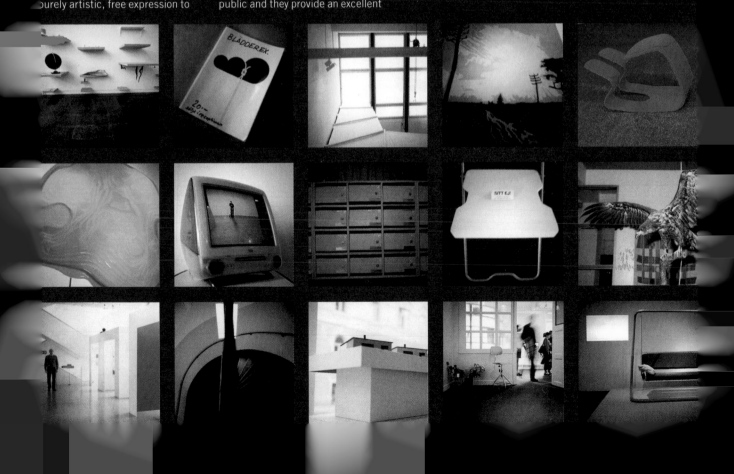

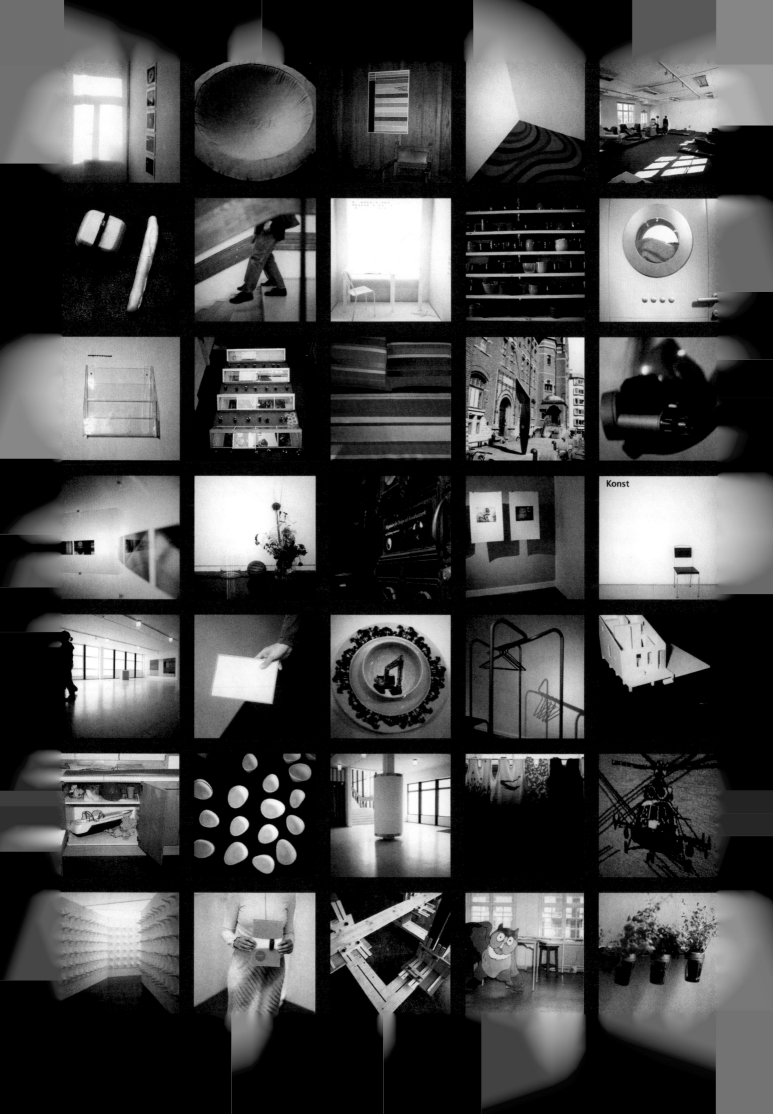

The Importance of Aesthetic Training

By Tom Hedqvist

I am drawn to ordinary things. To things that make no demands, that are next to invisible, yet tend to be part of almost everything. The ordinary, the trivial interest me. The reverse side of the coin. Nothingness. Back streets and the in-between spaces that no one bothers with and which are left to their own devices. All of this exerts a special power of attraction for me. For one thing, I can go there because it suits me, whenever I need to, for strictly private reasons.

Then there are the other things which I have to accept. Things that I get for free and that I am actually entitled to: spaces that are created to receive us. The rooms we all have paid for and co-own. Hospital rooms, waiting rooms – rooms for worry and anxiety, for sorrow and care. Rooms which we are expected to find our way to and where we are supposed to find a place reserved for ourselves. All of them planned and thought out – from the optimum seat height, to the art reproduction on the wall, down to the smallest artificial begonia.

The new interior of the subway carriage on an early winter morning. And the new social insurance office, bank, or post office; contemporary, with lots of blonde pieces of furniture that no longer speak the language of power they once did. With their well-trained staff in uniforms that specially allow for individual details. Staff who want us to feel comfortable and like the new strategy, who want us to believe that someone actually cares that it is our money they are handling.

The idea of celebrating modernity is alive and livelier than ever now that we are living in a new era, with its taste for paradigm and broad band. With the air waves criss-crossed by calls from cell phones. The times may be brand new – but they have seldom seemed as paradoxical. The risk associated with being able to afford whatever we want is spreading and during the next economic downturn will become more apparent than it was after the 1980s. More so, because we are living in a new era, because new technology calls for new design – which calls for new things all around us, in order to be seen as progressive and available to all, regardless of class. The new, open society has created more job opportunities for a wider segment of the population since the breakthrough of industrialism. And technology has enabled us to create new things. We can design, manufacture, price, sell, and send them across the world. We can order them wherever we are, but we can also return them if we don't like them.

What is it we need then? What is it we need to partake in these changing times? Who asked for all these objects? Who begged and pleaded for more of the same, of what we already have, and to be able to choose between several identical varieties? The lack of logic and ethics in this is mind-boggling.

I can safely claim that I grew up in an artistic environment, surrounded by discussions on aesthetics and art, with ample opportunity for studies and practical application, and with the unspoken notion of talent in the air. The aesthetic environment was ever present. The assimilation process was generous and always defined by good taste. There was no shortage of material things, but they were never a priority. A trained eye was always more important. The art of stripping away was also highly prized. Not always in order to replace it with something else – there was also a point to emptiness.

I was trained to edit, and, indirectly, to study what was to seem like a two-way proposition. Both advantage and disadvantage – where disadvantage also had a value. Where the reverse possessed the forgiving qualities that kept everything from toppling over from its own self-righteousness. And when the eye had had its fill, there was always Nature. Which also had two sides. I was brought up to see and to reject.

Is it possible for a government design policy to change the everyday lives of its citizens? Is it possible to train someone to find it unacceptable that they should get lost in a hospital because the signs don't make sense? Can you be trained to insist on the right to beauty in an environment overflowing with things you don't need and never even wanted? Can quality replace quantity without becoming dull and boring? Is it possible for democratic design to become part of a deliberate and successful policy and not just the long-range, successful business concept of an individual company? Can the government afford not to take itself seriously; can it allow commitment to die down and the trend to wane? Can it afford to leave well enough alone? I don't think so. I think it is already too late.

Becoming a designer in this new era and in this new society that is now taking shape is more demanding than ever before. The treacherous ability to produce almost anything,

anywhere, is growing. As is the market – and the number of consumers. We need intelligent conditioning and training in alternative options to prevent rapid over-consumption and the depletion of global resources. We need training in seeking alternative answers. Aesthetics must become the subject of intelligent debate. Everybody must have the right to be trained in debating the issues of consumption, composition, and design from an ethical and moral viewpoint as part of the school curriculum. Those who go on to study design must develop and hone their skills against a clearly delineated government design policy.

In the end it is up to all of us to champion the right to beauty as a democratic social issue. We must want it, find it necessary, and believe it possible. We can afford it – but cannot let it go.

I am standing in the Irish pub at Stockholm's Central Station. I have my bottle of beer and my peanuts and have found a seat at a counter opposite the bar. There is a large mirror with decorative texts in a 19th-century English typeface. The premises are reflected in the glass. On either side of the mirror are wall lamps, copies of kerosene lamps, giving off a faint glow. Around each lamp is a plastic holly wreath with dark green leaves and red berries. It is the day before Christmas Eve, 1999. There is stream of people with shopping bags bulging with packages. But there are also many who seem to be going nowhere. Their eyes are flickering dimly, searching the room. The karaoke is going strong, with Christmas music from all over the world. The tempo and the sound level are high. The atmosphere is friendly and full of expectation. Everyone is having a good time. The holidays have started. The staff are dressed as Irishmen in striped collarless shirts, waistcoats, and little bowler hats. The pub is full, but everyone receives a full measure of their attention.

In the background, a dartboard attracts a lot of activity and a green billiard table can be seen in the next room. A sign above the bar offers a luxurious dinner, à la the Orient Express, next door. On the walls are pictures of Ireland at the turn of the century. Miners and draymen are posing in sepia photos in patinated mahogany frames. All over the low ceiling brass-coloured fans with leaded lamps are swirling, throwing a diffuse multi-coloured light over the dense cigarette smoke. Some people are dancing, a bit uncertainly on the worn plank floor that is strewn with pine needles. Others are playing cards on the beer-spattered dark brown tables.

A model of Big Ben shows 7:40. I hurry to get onto the 7:45 commuter train.

Tom Hedqvist is Director of the Beckman School of Design.

We would like to have devoted another 300 pages to more designers and their products. However, the question is whether even this would have been enough for all the creative artists we have encountered in the course of this book: whose work follows the classical Swedish design tradition or demonstrates its rich variety. In the pages that follow we have selected a few individuals who deserve some attention.

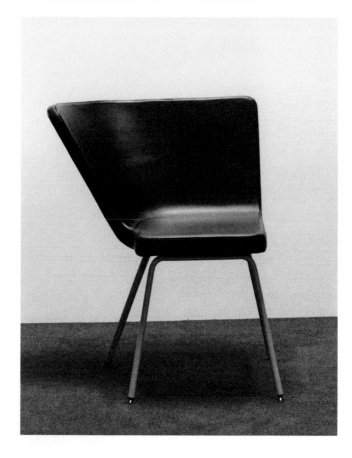

310

Clockwise: In 1948, Bengt-Johan Gullberg had the idea of making lamps from strips of fabric wound around a metal frame. Today, eleven different models of the *Gullbergslampan* are in production.

Tony Almén and Peter Gest have made *2K*, a glass-fronted cabinet for the new era, for Karl Andersson & Söner. It is available in seven colours and also in several smaller, wall-hung versions.

Thomas Laurien made the most beautiful of birdbaths. Add your own pedestal.

Ceramic logs by Jakob Robertsson from Galleri Inger Molin.

Ulf Scherin's chest of drawers *Greith*. It is available in several sizes.

Anna Kraitz' *Franslampa*, which she produces herself. A stylized version of the lamps of by-gone eras. It may be mounted both as a ceiling and a floor lamp.

Peter Andersson had barely had time to complete his studies at Konstfack in 1999 before his chair *Slack* was put into production by Miljö Expo.

"Good textiles are like good art – they provoke thought", the Saldo group says of their fabrics. Discussing colour with the visually handicapped in the *Blind* fabric is one example of a thought-provoking idea. Saldo asked several well-known authors to describe their impression of the colour yellow. Their words were then printed in Braille on a bright yellow background, allowing both sighted and blind people to experience the colour. The textiles of Saldo thus combine content, aesthetics, and function.

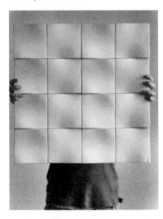

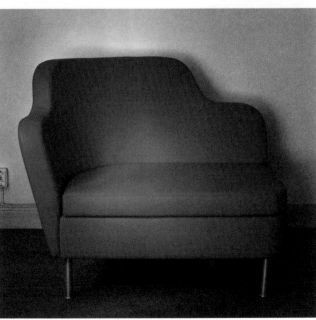

This page:
Clockwise: "The inspiration for my *Planglasvävar* was a jade shroud, unearthed at an archeological excavation in China", says Annika Jarring. Window glass has been joined with silicone rubber to form a wavy, transparent mosaic. Available at Konsthantverkarna.

Anne Nilsson's containers *Ginza* for Orrefors. Quintessentially Swedish, it offers clean and cool function.

Eva Hild's stoneware in thin, shell-like shapes. Quiet, yet in motion. "The inner form is every bit as important as the outer", she says.

Anna, a seat designed by Anna Kraitz, produced by Källemo. "I wanted to design a piece adapted to my own way of sitting, with my legs pulled up beside me."

Pia Nixholm's tiles *Blob* may become wavy walls or be broken into razor-sharp edges, depending on the way they are mounted. Nixholm makes them to order.

Producers are listed on page 317.

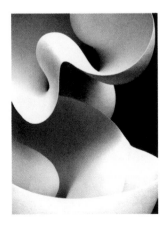

Page 309:
Johanna Egnell started to sell the *Mocca* beakers before graduating from the Beckman School in spring 2000. Today they are produced by David design. The same shape – a kind of irregular ellipsis – has been used in bowls and tables.

Below:
Clockwise: Thomas Bernstrand's urge to swing from the chandelier inspired the lamp, *Do swing*.

The Simplicitas company is convinced that "Simplicity equals genius". They make stainless-steel products, created by Swedish designers to exacting standards. So far, they have made a cheese-slicer, a butter knife, a mirror and a shelf, among other things. Also Björn Dahlström's *Futura* cufflinks.

"After a bad day, everything picks up when you come home and score a three-point goal in the basket," says Niklas Eriksson about the *Kollekt* storage basket, available at Agata.

Lars Englund describes his *Skelder* lamp for Källemo as a spin-off from his work as a sculptor. It is a polycarbonate globe with a silicone rubber frame.

Jakob Robertsson's salt and pepper shakers, two pieces in one. Available at Agata.

Timeless elegance in *Look*, a sofa designed by Ulla Christiansson for Norell.

Olle Gyllang's scythe in wood and plastic is uniquely lightweight and adjustable. He first made it in 1994, and has been refining it ever since, and is now looking for a suitable producer.

Matti Klenell is the designer behind "a light for the illumination of and around books" entitled *Enlightenment*. It is produced by Agata.

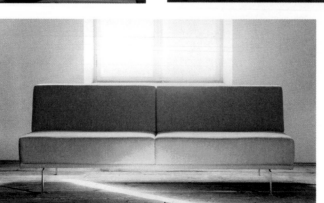

312

GUNILLA ALLARD
Architect SIR (National Association of Swedish Interior Architects) and stage designer.
Born: 1957 near Linköping.
Education: Konstfack, Architecture and Furniture Design, 1983–88; visiting student, Royal Danish Academy of Fine Arts, Copenhagen, 1985. Specializing in: design, stage design, and exhibition design.
Products for: Lammhults, Kasthall, Marbodal.
Public commissions: specially designed furniture for Linköping City Library.
Represented: Nationalmuseum, Röhsska Museum, Danish Museum of Decorative Art, Copenhagen.
Miscellaneous: Went to the Film Institute at the age of twenty saying: "Hi! I want to work with film!" And they let her.
Contact: tel. +46 (0)472 26 95 00
www.lammhults.se

MICHAEL ASPLUND
Producer.
Born: 1957 in Stockholm.
Education: Frans Schartau School of Commerce, Marketing; Påhlman's Commercial Institute.
Companies/Groups: Asplund, Living in Sweden, Swecode.
Miscellaneous: Since 1994 regular exhibitor with Asplund and Swecode at international furniture fairs. Started career as an art dealer; dresses in black, but has a white home.
Contact: tel. +46 (0)8 662 52 84

THOMAS ASPLUND
Producer.
Born: 1962 in Stockholm.
Education: Business track in high school, then bank employee.
Companies/Groups: Asplund, Living in Sweden, Swecode.
Miscellaneous: Since 1990 co-director with his brother Michael of retail business and producer Asplund. Greatest source of pride: Having left banking and not worn a tie since. Collects cookbooks and loves cheese.
Contact: tel. +46 (0)8 662 52 84

LENA BERGSTRÖM
Designer.
Born: 1961 in Umeå.
Education: Konstfack, Textiles, 1985–89; University of Art and Design, Helsinki, 1989.
Specializing in: Design.
Products for: Designer's Eye, Kasthall, Klässbol, Ljungbergs, Orrefors.
Public commissions: Textile art for Skandia and SE Bank, Stockholm and Astra, Lund.
Represented: Nationalmuseum, Röhsska Museum.
Miscellaneous: Loves the sun. Most enjoyable exhibitions were her first solo glass exhibition at Galleri Glas Ett in Stockholm 1996, and "Swedish Style in Tokyo", April 1999, an initiative of the Swedish Ambassador and Mrs Krister Kumlin.
Contact: tel. +46 (0)481 340 00
www.orrefors.se

JONAS BOHLIN
Architect SIR.
Born: 1953 in Stockholm.
Education: Konstfack, Interior Architecture and Furniture Design, 1976–81.
Specializing in: Rooms and objects.
Products for: Own production, Kasthall, Källemo, Lammhults, Rörstrand.
Public commissions: Stockholm restaurants Rolfs Kök and Sturehof, furnishing of Swedish Society of Crafts and Design at Stockholm's Skeppsholmen.
Represented: Nationalmuseum, Malmö Konstmuseum, Röhsska Museum, Danish Museum of Decorative Art, Copenhagen, Centre Culturel Suédois, Paris.
Miscellaneous: Past president of SIR (National Association of Swedish Interior Architects), 1991–93. Passionate sailor. Received the prestigious Georg Jensen Award in 1988.
Contact: tel. +46 (0)8 615 23 90
info@jonasbohlindesign.se

DAVID CARLSSON
Producer.
Born: 1963 in Lund.
Education: Social science track in secondary school and life in general.
Companies/Groups: David design, Swecode (1994–98).
Miscellaneous: Since 1994 exhibitor at international furniture fairs. Works as consultant in overall concepts. Likes going barefoot and fiddling with his compost heap, finding the right soil mix for his collection of roses.
Contact: tel. +46 (0)40 30 00 00
info@david.se
www.david.se

MÅRTEN CLAESSON
Architect SIR.
Born: 1970 on Lidingö.
Education: Konstfack, Interior Architecture and Furniture Design, 1990–94; Parsons School of Design, New York, Architectural and Environmental Design and Product Design, 1992.
Specializing in: Private homes, interiors, retail space, furniture, and objects.
Products for: Asplund, Ateljé Lyktan, Boffi, David design, Offecct, Skandiform, Snickar-Per, Swedese, Örsjö.
Public commissions: Kungsgatan McDonalds, Gucci and Liljevalch Bookshop, Stockholm, furnishing of Swedish ambassadorial residence, Berlin.
Represented: Nationalmuseum.
Miscellaneous: Decided to become an architect at age thirteen after seeing a picture of Frank Lloyd Wright's "FallingWater" in an encyclopedia. Writer and lecturer on architecture and design.
Contact: tel. +46 (0)8 644 58 63
arkitektkontor@claesson-koivisto-rune.se

BJÖRN DAHLSTRÖM
Designer.
Born: 1957 in Stockholm.
Education: Self-taught.
Specializing in: Furniture, objects, industrial products, and graphic design.

Products for: Arla, Atlas Copco, cbi, Fjällraäven, Fontana Arte, Hackman, Kasthall, Magis, Mobileffe, Playsam, Skeppshult.
Represented: Nationalmuseum, Röhsska Museum, Museum für Angewandte Kunst, Berlin, Stedelijk Museum, Amsterdam, Victoria & Albert Museum, London.
Miscellaneous: Björn is an on/off sportsman. He finds inspiration in something even freer than design – art!
Contact: tel. +46 (0)8 673 42 00
bjorn@dahlstromdesign.se
www.dahlstromdesign.se

THOMAS ERIKSSON
Architect SAR (Swedish Association of Architects).
Born: 1959 in Örnsköldsvik.
Education: KTH (Royal Institute of Technology), School of Architecture, 1981–85.
Specializing in: Concept development, private homes, commercial property, interiors, aeroplane interiors, retail space, furniture.
Products for: Asplund, Cappellini, cbi, Ikea, Kasthall.
Public commissions: SAS airport lounges, retail concept for Thorn and Nokia, Nordiska Galleriet, Spårvagnshallarna conference centre; conversion and furnishing of advertising agency.
Represented: Nationalmuseum, Museum of Modern Art, New York.
Miscellaneous: Played the part of Gustaf Löwenhielm in Inger Åby's film *Gustav III – Teaterkung och Drömmare*, also featuring Sven Lindberg and Peter Haber. It received the Prix Italia in 1984.
Contact: tel. +46 (0)8 555 518 00
the@teark.se
www.stockholmdesignlab.se

ANKI GNEIB
Architect SIR.
Born: 1965 in London.
Education: Konstfack, Interior Architecture and Furniture Design, 1988–93; visiting student, Middlesex Polytechnic, London, 1992.
Specializing in: Interiors, design.
Products for: Arvesund, Trädesign, Asplund, Fogia, Interstop, Room.
Miscellaneous: Spent her first nine years in London. Her grandfather was named Johansson, but finding it too lacklustre, he gave his son the surname Gneib, named for a Walloon relative.
Contact: pohl.gneib@telia.com

JOHN HAMBERG
Producer.
Born: 1945 in Stockholm.
Education: STI, Stockholm Technical Institute, 1965–68.
Company: DesignTorget.
Miscellaneous: Previously active as engineer and carpenter with his own shop. An ardent art lover, partial to the art of Peter Freudenthal.
Contact: tel. +46 (0)8 462 35 20
www.designtorget.se

SANNA HANSSON
Designer.
Born: 1971 in Agra, India.
Education: RMI Bergh School of

Communication, 1991–92; Beckman School, Design, 1992–95; Parsons School of Design, New York, 1993.
Specializing in: Design and design consulting.
Products for: Källemo, Kasthall, own production.
Public commissions: Hyllan Y/Why?, Royal Library, Copenhagen.
Miscellaneous: Assistant to Tom Dixon in London 1994.
Contact: sanna@sannahansson.com

JERRY HELLSTRÖM
Producer.
Born: 1939 in Stockholm.
Education: Konstfack, Interior Architecture and Furniture Design, 1956–60.
Company: DesignTorget.
Miscellaneous: Also architect SIR with his own business since 1987. Passionate sailor.
Contact: tel. +46 (0)8 462 35 20
www.designtorget.se

JOHN KANDELL
Architect SIR.
Born: 1925, died 1991.
Education: Graduated from Konstfack 1947, Interior Architecture and Furniture Design; Department of Sculpture until 1949.
Specializing in: Architecture, design.
Products for: Sven Ivar Lind, Haglund & Söner, Westbergs Möbler, Källemo.
Public commissions: Interior décor of Sailors' Chapel, Helsingborg, Fersen's Palace, Stockholm, Nordic Investment Bank, Helsinki.
Represented: Nationalmuseum, Röhsska Museum, Museums of Malmö, Norrköping, Borås, and Jönköping, Museums of Decorative Art in Copenhagen, Oslo, and Trondheim.
Miscellaneous: Recipient of numerous prominent awards during his lifetime. Recipient of government stipend, 1989.

EERO KOIVISTO
Architect SIR,
Born: 1958 in Karlstad.
Education: Konstfack, Interior Architecture and Furniture Design 1990–94; University of Art and Design, Helsinki, Environmental Planning and Product Design 1993, Design Leadership 1995; Parsons School of Design, New York, Architectural and Environmental Design + Product Design, 1992.
Specializing in: Private housing, interiors, retail spaces, furniture, and objects.
Products for: Asplund, Ateljé Lyktan, Boffi, David design, Nola, Offecct, Skandiform, Snickar-Per, Swedese, Örsjö.
Public commissions: McDonalds, Kungsgatan, Gucci, Stockholm, Liljevalch bookshop, furnishing of ambassadorial residence, Berlin.
Represented: Nationalmuseum.
Miscellaneous: "I like Donald Judd and Harold Budd," Eero says, including the fact that the artist's name rhymes with that of the composer.
Contact: tel. +46 (0)8 644 58 63
arkitektkontor@aclaesson-koivisto-rune.se

GUNILLA LAGERHEM ULLBERG
Designer.
Born: 1955 in Stockholm.
Education: School of Textiles, Borås, 1978; Konstfack, Textiles, 1978–83.
Specializing in: Design.
Products for: Hemslöjden, Kasthall, Kinnasand, NK, Svenskt Tenn.
Public commissions: Norrtälje Hospital, Royal Palace.
Represented: Nationalmuseum, Prefectural Museum, Toyama, Japan.
Miscellaneous: Has made special carpets for churches. Lives with three children, husband and dog in 732 square feet. "Luckily, we have a large summer house!"
Contact: tel. +46 (0)320 143 30
www.kasthall.se

EVA LILJA LÖWENHIELM
Designer.
Born: 1969 in Stockholm.
Education: RMI Bergh School of Communication, 1990–91; Beckman School, Design, 1993–96.
Specializing in: Product and furniture design, interiors, graphic design.
Products for: DesignTorget, Ikea, Reijmyre Glassworks, Room.
Miscellaneous: Has made display stands and showcases for James Bond Footwear.
Contact: eva.II@swipnet.se

ÅSA LINDSTRÖM
Ceramist.
Born 1956 in Stockholm.
Education: Konstfack, Ceramics and Glass, 1984–90
Specializing in: Ceramics and public art.
Products for: Rörstrand, own production.
Public commissions: Karolinska Hospital, Ängbyplan subway station.
Represented: Nationalmuseum.
Miscellaneous: Member, Konsthantverkarna and Blås & Knåda, co-owner of a smelting house. Would like to learn salsa and buy a house on Gotland.
Contact: Repslagargatan 13, SE-118 46 Stockholm, Sweden.

JONAS LINDVALL
Architect SIR.
Born: 1963 in Malmö.
Education: HDK, Interior Architecture, 1989–93; visiting student, Royal College of Art, London; Royal Danish Academy of Fine Art, Copenhagen, 1992–93.
Specializing in: Private homes, commercial property, interiors, retail space, furniture, objects.
Products for: David design, Kockums Industrier, Skandiform.
Public commissions: Restaurant Izakaya Koi, Optiker Månsson, Flos Interstudio, Malmö.
Represented: Nationalmuseum, Malmö Museum of Art, Victoria & Albert Museum, London.
Miscellaneous: Selected by *Forum* architecture journal as one of four leading stars among the new generation of architects. Loves neckties. Owns a shaggy bearded collie named Pompe.
Contact: tel. +46 (0)40 30 21 00
info@vertigo.m.se

314

MATTIAS LJUNGGREN
Architect SIR.
Born: 1956 on Gotland.
Education: Konstfack, Interior
Architecture and Furniture Design,
1985–90.
Specializing in: Interior planning and
product design.
Products for: Berga Form, own
production, Källemo.
Represented: Nationalmuseum,
Röhsska Museum, Museums of
Decorative Art, Oslo and Copenhagen.
Miscellaneous: Is partial to materials
typical of Gotland such as ash, maple,
walnut, and limestone.
Contact: tel. +46 (0)708 99 22 22.

ANN MORSING
Architect SIR.
Born: 1956 in Uppsala.
Education: Konstfack, Interior
Architecture and Furniture Design,
1981–86.
Specializing in: Interiors, furniture,
exhibitions, decoration.
Products for: Box Design.
Companies/Groups: Box Design,
Living in Sweden, Swecode.
Miscellaneous: Has exhibited at
furniture fairs in Amsterdam,
Cologne, Milan, and New York, among
other places.
Contact: tel. +46 (0)8 640 12 12.

BEBAN NORD
Architect SIR.
Born: 1956 in Stockholm.
Education: Nyckelviksskolan,
1979–80; Konstfack, Interior Architec-
ture and Furniture Design, 1981–86.
Specializing in: Interiors, furniture,
exhibitions, decoration.
Products for: Box Design.
Companies/Groups: Box Design,
Living in Sweden, Swecode.
Miscellaneous: Has exhibited at
furniture fairs in Amsterdam,
Cologne, Milan, and New York, among
other places. Has two basset hounds,
three fish, and three children.
Contact: tel. +46 (0)8 640 12 12.

INGEGERD RÅMAN
Designer.
Born: 1943 in Stockholm.
Education: Capellagården, 1962;
Konstfack, Ceramics and Glass,
1962–68; Istituto Statale D'Arte per
la Ceramica, Faenza, 1965–66.
Specializing in: Design.
Products for: Skruf, Orrefors,
Gustavsberg.
Public commissions: Glasses include
sets for Foreign Ministry and Parlia-
ment, also glass, metal and textiles
for the 100th anniversary of the
Consumer Co-op movement.
Represented: Nationalmuseum,
Röhsska Museum, Riihimäki Glass
Museum, Finland, Stedelijk Museum,
Amsterdam, Victoria & Albert
Museum, London.
Miscellaneous: Received nineteen
Excellent Swedish Design Awards,
1983–99. Was given honorary title of
Professor by the Swedish Govern-
ment in 1995. Reads cookbooks when
she cannot sleep.
Contact: Långa gatan 12, SE-115 21
Stockholm, Sweden or
www.orrefors.se

ERIK NIRVAN RICHTER
Architect SAR.
Born: 1954 in Stockholm.
Education: Royal Institute of Technol-
ogy, School of Architecture, 1975–80;
Carl Malmsten School, 1986–87;
Osho Therapy and Meditation cours-
es, 1996–98.
Specializing in: Unified interiors with-
in the Norrgavel concept.
Represented: Nationalmuseum.
Public commissions: Klocka Fjällgård,
Ånn.
Miscellaneous: Has four children.
Insists that meditation could replace
downhill skiing.
Contact: tel. +46 (0)40 667 53 50
www.norrgavel.se

OLA RUNE
Architect SIR.
Born: 1963 in Lycksele.
Education: Konstfack, Interior
Architecture and Furniture Design,
1990–94; one year at Royal Danish
Academy of Fine Art, Copenhagen,
1992.
Specializing in: Private housing,
interiors, retail spaces, furniture, and
objects.
Products for: Asplund, Ateljé Lyktan,
Boffi, David design, Nola, Offecct,
Skandiform, Snickar-Per, Swedese,
Örsjö.
Public commissions: McDonalds,
Kungsgatan, Gucci and Liljevalch
bookshop, Stockholm, furnishing of
ambassadorial residence, Berlin.
Represented: Nationalmuseum.
Miscellaneous: Has studied tailoring
and likes to make his own suits.
Teaches at the Beckman School.
Contact: tel. +46 (0)8 644 58 63
arkitektkontor@claesson-koivisto-
rune

MARTTI RYTKÖNEN
Designer and glass artist.
Born: 1960 in Ylomantsi, Karelia
Education: Kyrkerud Folk High School,
Art and Design track, 1987–89; Kon-
stfack, Ceramics and Glass, 1990–94.
Specializing in: Glass and textiles.
Products for: Orrefors. First pieces
for Kosta Boda released in spring
2001.
Public commissions: Decoration,
Ljungby Hospital together with art
metalworker Lars Larsson.
Represented: Nationalmuseum,
Röhsska Museum.
Miscellaneous: Loves Moomin Trolls
and fishing.
Contact: tel. +46 (0)481 340 00
www.orrefors.se

GUNNEL SAHLIN
Designer.
Born: 1954 in Umeå.
Education: Dragonskolan and
Nyckelviksskolan 1975–78; Konst-
fack, Textiles, 1980–84; Pilchuck
Glass School, 1987.
Specializing in: Design.
Products for: Kosta Boda, Kasthall,
Kinnasand.
Represented: Nastionalmuseum, Små-
land Museum, Tel Aviv Museum, Art
Gallery of Western Australia, Perth.
Miscellaneous: Professor in design,
specializing in glass, at Konstfack.
Wanted to become a handicraft

consultant at one time. Was not
allowed to join the choir in school.
"Later I attended a summer course
on the theme 'Everybody can sing!'"
Contact: tel. +46 (0)478 345 00
www.kostaboda.se

THOMAS SANDELL
Architect SAR and SIR.
Born: 1959 in Jakobstad, Finland.
Education: Royal Institute of Technol-
ogy, School of Architecture, 1981–85.
Specializing in: Private homes, office
buildings, housing areas, interiors,
retail space, furniture.
Products for: Artek, Asplund, B&B,
Italia, Cappellini, Gärsnäs, Ikea,
Kasthall, Källemo, Zero.
Public commissions: Restaurant
interior, Moderna Museet and Muse-
um of Architecture, Åhlens
department store, Polarn & Pyret,
restaurants Rolfs Kök and East,
Stockholm (collaborative project).
Represented: Museum of
Architecture, Nationalmuseum,
Röhsska Museum, Victoria & Albert
Museum and Design Museum, London.
Miscellaneous: Wanted to become a
diplomat. Loves cross-country skiing,
but no longer competes.
Contact: tel. +46 (0)8 506 217 00
studio@sandellsandberg.se
www.sandellsandberg.se

CARINA SETH ANDERSSON
Designer.
Born: 1965 in Stockholm.
Education: Konstfack, Ceramics and
Glass, 1989–94.
Specializing in: Design.
Products for: cbi, own production,
Hackman, Iittala, Reijmyre.
Public commissions: Decoration,
Swedish Radiation Protection Author-
ity, Stockholm, National Chemicals
Inspectorate, National Board of
Student Aid, Sundsvall, College of
Architecture and Design, Lund
University.
Represented: Nationalmuseum,
Röhsska Museum, National Public Art
Council, Victoria & Albert
Museum, London.
Miscellaneous: Finds the tango com-
patible with her temperament.
Contact: tel. +46 (0)70 497 11 66
c.s.a@chello.se

CHRISTIAN SPRINGFELDT
Producer.
Born: 1958 in Västerås.
Education: Practical work experience
from the fashion industry. It included
running a wholesale business and an
agency for Italian brands.
Companies/Groups: cbi, Klara, Living
in Sweden, Swecode.
Miscellaneous: Comes from a family
of small entrepreneurs. Has four sib-
lings and was one of very few Ziggy
Stardust imitators in Västerås during
the 1970s.
Contact: tel. +46 (0)8 611 52 52
www.klara-cbi.se

PER B. SUNDBERG
Artist.
Born: 1964 in Stockholm.
Education: Capellagården 1983–85;
Konstfack, Ceramics and Glass,
1985–90 and 1991–92; Pilchuck

Glass School, Seattle, 1998.
Specializing in: Design, exhibitions,
decoration, and interiors.
Products for: Orrefors and own pro-
duction of ceramics.
Public commissions: Sorry. Did not
quite have the nerve for Norrtälje
Hospital.
Represented: Nationalmuseum,
Röhsska Museum, National Art Coun-
cil, Musée des Arts Décoratifs de
Montréal.
Miscellaneous: Was asked by Swedish
pop singer Stakka Bo to select a
fabula vase for Madonna. Chose the
yellow one on page 243, which now
adorns her home in London.
Contact: Åsögatan 129, SE-116 24
Stockholm. Sweden.

MATS THESELIUS
Designer.
Born: 1956 in Stockholm.
Education: Konstfack, Interior Architec-
ture and Furniture Design, 1979–84.
Specializing in: Interiors, furniture,
objects, business concepts, exhibitions,
research projects, lectures, books.
Products for: Arvesund Trädesign,
Bergdala Glassworks, W.A. Bohlin,
David design, Källemo, Luxo/Boréns,
Authentics, Brühl & Sippold, Möve.
Represented: Nationalmuseum,
Malmö Museum of Art, Röhsska
Museum, Art Collection of Russia,
Danish Museum of Decorative Art,
Copenhagen, Museum für Ange-
wandte Kunst, Cologne.
Miscellaneous: Height: 6 feet 3 inches,
single father of fourteen-year old
daughter, general interests, loves
travelling.
Contact: mats@theselius.com

PIA TÖRNELL
Designer and ceramist.
Born: 1963 in Stockholm.
Education: Konstfack, Ceramics and
Glass, 1989–94.
Specializing in: Ceramic commissions
and design.
Products for: Arabia, Rörstrand, as
well as ceramics in own production.
Public commissions: Tile work at the
Stockholm Institute of Education and
the Museum of Architecture,
Stockholm.
Represented: Nationalmuseum,
Röhsska Museum.
Miscellaneous: Lives at Kinnekulle on
the southern shore of Lake Vänern
and has a church on her property.
Contact: Tel. +46 (0)510 54 42 51

PASI VÄLIMAA
Textile artist.
Born: 1968 in Nystad, Finland.
Education: Stockhom University, Art,
Theatre and Literature, 1989–91;
Nyckelviksskolan, 1992–93; Konst-
fack, textiles, 1993–97.
Specializing in: Textiles.
Public commissions: Curtain for
Farsta High School, glass pattern for
The South Hospital, Stockholm.
Represented: National Public Art
Council.
Miscellaneous: Exhibitor at the Inter-
national Triennale of Tapestry in Lödz,
2001, his largest exhibition so far.
Likes picking mushrooms.
Contact: tel. +46 (0)583 204 07

PIA WALLÉN
Designer.
Born: 1957 in Umeå.
Education: Beckman School, Fashion,
1980–83.
Specializing in: Design.
Products for: Asplund and own
production.
Public commissions: Curtain for the
auditorium at Moderna Museet and
the Museum of Architecture.
Represented: Nationalmuseum,
Röhsska Museum, Museum für Ange-
wandte Kunst, Cologne.
Miscellaneous: received a ten-year
annual stipend of 100,000 crowns
awarded by the Arts Grants Commit-
tee. Has two cats, Elsa and Siri, and a
daughter named Xi – meaning
happiness.
Contact: tel. +46 (0)8 665 33 29.

ANN WÅHLSTRÖM
Designer.
Born: 1957 in Stockholm.
Education: Capellagården, 1977–78;
Orrefors Glass School and Pilchuck
Glass School, Seattle, 1979; Rhode
Island School of Design, 1980;
Konstfack, 1981.
Specializing in: Design.
Products for: Boda Nova, Cappellini,
Ikea, Kinnasand, Kosta Boda.
Public commissions: Uppsala Univer-
sity Hospital.
Represented: Nationalmuseum,
Småland Museum, Montreal Museum
of Decorative Arts, Chicago
Atheneum, Museum of Architecture &
Design, Art Gallery of Western
Australia, Perth.
Miscellaneous: Has taught at the
Pilchuck Glass School and the
Beckman School. Collects cookbooks
"not to follow the recipes but to gain
inspiration."
Contact: tel. +46 (0)478 345 00
www.kostaboda.se

STEFAN YTTERBORN
Design strategist.
Born: 1963 in Stockholm.
Education: IHM Business School,
Stockholm, 1990–92.
Projects initiated/Companies/Groups:
cbi, Hackman Tools, Ikea, PS, Klara,
Swecode, Ytterborn & Fuentes, and
numerous exhibitions.
Miscellaneous: Frequent lecturer on
design, spent several years wind-
surfing in Australia, has competed in
the Swedish championships in slalom
and founded "City" bicycling club
some years ago.
Contact: tel. +46 (0)8 545 066 00
s.ytterborn@ytterborn-fuentes.com
www.ytterborn-fuentes.com

PÅL ALLAN
Born 1964 in Stockholm.
Allan specializes in still-life photography, working for Swedish and international magazines. Does advertising for Orrefors and other businesses. He has lived and worked in New York. Has contributed to several books, among them a cookbook *Modern asiatisk mat* (Bonnier Alba, 1996) and a bartender's guide *Skakande upplevelser* (Bonniers, 1999).

CARL BENGTSSON
Born 1952 in Stockholm.
Specializes primarily in fashion, but also does interiors and design for Swedish and international magazines. Bengtsson lived and worked in Paris for more than seven years and is known for the record jackets he did during the 1980s. Together with a colleague he has published a book on photographer Henry B. Goodwin (Prisma, 1998).

PELLE BERGSTRÖM
Born 1956 in Malmö.
Bergström began as a printer's apprentice before attending the Graphic Institute and Konstfack. He started his career as a press photographer. Today he works exclusively with still life.
He is the recipient of several fellowships and artists' grants and has been represented in group shows as well as solo exhibitions. Published *Järn* (Atlantis, 1994). He works for Swedish and international magazines such as *Stockholm New* and *Wallpaper*. His international clients include Hermès.

JH ENGSTRÖM
Born 1969 in Hagfors.
Studied at the School of Photography and Film in Gothenburg. Had a solo exhibition at Gallery F48, participated in a group show at Kulturhuset and has received an Arts Grants Committee working fellowship. He has published *Härbärge* (Bokförlaget DN, 1997) and works editorially for Bibel and Pop among others. Engström also devotes himself to commercial photography ands independent projects.

ÅKE E:SON LINDMAN
Born 1953 in Stockholm.
Architectural photographer. Represented in group shows as well as solo exhibitions, most recently in Madrid in spring 2000. Works for Swedish and international magazines such as *Forum, Stockholm New*, and *Wallpaper*.
Has illustrated a number of books on architecture. Books published include *Stockholm Modern* and *Ö-design* (Wahlström & Widstrand, 1998 and 2000, respectively), both in collaboration with journalist Ingrid Sommar.

OSCAR FALK
Born 1973 in Stockholm.
Does fashion photography for Swedish magazines as well as fashion-related advertising for H&M, Indiska, and SAS airlines, among others. Participated in an exhibition at *Forum för form* in Stockholm where all proceeds from sales benefited the Red Cross. Is presently discussing a potential joint book project with a friend. "We have arrived at a point where we state with some degree of certainty that we *will* be doing a book!"

ANDREAS VON GEGERFELT
Born 1971 in Stockholm.
Works mainly within fashion and advertising, but finds the independent projects, which he does as time and money allow, more fun. His solo (and singular) exhibitions include one in the canteen of Norrlands Bar & Grill. Passionate hang-glider.

BERNO HJÄLMRUD
Born 1960 on Gotland.
Educated at Konstfack. Several exhibitions at Galleri Up, the Museum of Photography, and Örebro Konsthall. Likes to photograph people and still life in various settings. Works frequently in advertising, where his clients include Ikea and Habitat. Also does editorial work for the monthly *MånadsJournalen* and other magazines.

JONAS ISFÄLT
Born 1974 in Guatemala.
Studied professional photography through Folkuniversitet in Stockholm as well as at the International Centre of Photography in New York. Specializes in portraits and has done work for the city section of Svenska Dagbladet among other things. He has exhibited jointly with Tobias Nilsson at Vägg sex:7 in Stockholm. He is currently working on a short film and an independent book/exhibition.

GERRY JOHANSSON
Born 1945 in Örebro.
Originally trained as a graphic designer but always had a strong interest in photography. Has been a full-time photographer since 1985. Has published photographic journals, has had a number of group and solo exhibitions, and contributed to books by others as well as publishing some of his own. Received the 1994 Environmental Protection Agency Award "Nature and environmental photographer of the year." Today he is involved in a number of projects such as "Japan Today" (EU-Japan Fest Japan Committee).

TOBIAS NILSSON
Born 1973 in Närtuna.
Started as press photographer for Norrtälje Tidning, then studied professional photography through Folkuniversitetet in Stockholm and at the International Center of Photography in New York. Likes to work editorially with portraits and fashion photography among other things. Also devotes himself to projects of his own, tending toward art photography.

MIKAEL OLSSON
Born 1969 in Lerum.
Attended the School of Photography and Film at Göteborg University. Active as photographer and artist, exhibiting both in Sweden and abroad. He is a long-distance runner.

KRISTIAN POHL
Born 1961 in Stockholm.
Attended Scandinavian Photo School and Konstfack. Pohl has produced a number of exhibitions based on his travels in the developing world and war-torn areas for the Red Cross and the Swedish International Development Authority. Has received grants from Arts Grants Committee and Kodak, among others. He owns his own production company and takes part in two to three film productions a year. His portraits are frequently featured in various magazines.

GÖSTA REILAND
Born 1964 in Stockholm.
Began his career by taking pictures of radar screens while in the military. He spent eight years in New York studying art and making a living mainly as a photographer's assistant. Does mostly advertising and design. Has recently devoted himself to film, including commercials and music video. Likes to spend his free time on Gotland, banding birds.

EWA-MARIE RUNDQUIST
Born 1958 in Vindeln.
Studied professional photography at Folkuniversitetet, Stockholm. She then put photography aside for a few years in order to take up painting. She is the mother of three and a fashion and portrait photographer for magazines and advertising. She is a contributor to several cookbooks, among them *Rosendals trädgårdscafé* (Tiden, 1994) and most recently *La Pizza – den sanna historien från Neapel* (Prisma, 2000).

ERIK UNDÉHN
Born 1976 in Västerås.
Started his photographic career for the now defunct entertainment paper *CityNytt*. Having tired of this, he went to New York to study at the International Centre of Photography. Moved to London where he dabbled in a number of photographic projects while working as a chef. After a spell of this, Undéhn decided to devote himself full-time to photography.

1: THE FRIENDS OF THE DESIGN MUSEUM (FORMMUSEETS VÄNNER)
was founded in 1989 with Princess Christina, Mrs Magnusson as the chairman. Its purpose was – and still is – to establish a museum for crafts, design, and industrial design in Stockholm. Once this is a reality, the organization will offer support through acquisitions, and by underwriting the printing of important publications within the field of design. While waiting to find a permanent home, the discussion and exhibition activities of the organization have been held in several different venues. Hope was rekindled in 1997 when eight government departments agreed to put forward an action plan that stressed the general importance to society of architecture and design. The report was published in 2000. It recommended the establishment of a permanent design museum in 2001. For information about membership of the Friends of the Design Museum – only 150 crowns a year – please call tel. +46 (0)8 440 53 70.

THE SWEDISH SOCIETY OF CRAFTS AND DESIGN (FÖRENINGEN SVENSK FORM)
is a non-profit organization with a government mandate to promote Swedish design at home and abroad. Its task is to create public awareness, disseminate information, and engage in marketing efforts within the whole field of cultural design, covering the areas of architecture, interior architecture, industrial design, industrial art design, crafts, and graphic design. This is done through discussions, exhibitions, seminars, visits, and meetings held throughout the country. It is for professionals within the field, as well as producers and the general public.
The organization also publishes *Form*, Scandinavia's largest design journal. Its premises on Skeppsholmen include a comprehensive picture archive as well as a café and a design shop. Read more in the chapter on design history and at www.svenskform.se.

THE FORM/DESIGN CENTRE
in Malmö was opened in 1964 by the Skåne and Blekinge branch of Svensk Form. It is host to a large number of exhibitions within the fields of architecture, design, industrial design, and crafts. It also includes a design shop, a periodicals café as well as lectures and discussions, all in a historical environment going back to the 16th and 19th centuries. The Centre is an extremely active forum for design, offering important free educational activities.

In 1987 Svensk Form instituted the **EXCELLENT SWEDISH DESIGN** Award for the purpose of rewarding good design, stimulating cooperation between designer and industry and increasing public awareness of the importance to society of design. The award is given out annually in the following categories: furniture, industrial design, textiles, lighting, industrial art design, graphic design, visual identity, web design, etc. The most prestigious prizes are the Design Award, the Special Jury Award, and Honorary Mention. The jury consists of a co-opted member plus representatives of the following design organizations: SID – Swedish Society of Industrial designers; SIR – Association of Swedish Interior Architects; KIF – Swedish Association of Craftsmen and Industrial Designers, Swedish Advertising Association; Promise – Producers of Interactive Media in Sweden; and Swedish Illustrators Association. Some eighty entries are selected out of an average of about 500. For an additional fee, the product becomes part of a touring exhibition, guaranteeing it greater exposure around the country.

Svensk Form has instituted an additional award and exhibition. **YOUNG SWEDISH DESIGN** is given to "designers on their way." It is sponsored by Ikea who views it as "an investment for the future." The only requirement is that the entrant must be under thirty (or a student at one of the schools). Entries do not have to be in production – prototypes are accepted. This gives not yet graduated design students and recently established designers an equal chance to show what they are capable of. The categories are textiles, industrial design, fashion, metal, glass and ceramics, architecture, interior design, and furniture as well as graphic design, illustration, moving pictures, and applied photography. Some fifty products are included in the touring exhibition and a winner is selected in each category.

2: BOOKS AND CATALOGUES
Åren som gått – Nordiska Kompaniet. Ann Marie Herlitz-Gezelius. Signum, 1992.
Bauhaus. Magdalena Droste. Taschen, 1991.
Den svenska formen. Redaktör Monica Boman. Carlssons, 1985.
Design. Penny Sparke. Bonniers, 1999.
Design Directory Scandinavia. Bernd Polster. Pavilion, 1999.
Design=Ekonomi. Olle Eksell. Arena, 1999.
Formens rörelse. Redaktör Kerstin Wickman. Carlssons, 1995.
Funktionalismen i verkligheten. Gotthard Johansson. Bonniers, 1931.
Gunnel Sahlin och Kosta Boda. Britton, Rafstedt, Turander. Tåg Publishing, 2000.
Handla! Ilstedt, von Wright, Wickman m fl. Nerenius & Santérus, 1997.
Hemma i Sverige 1900–2000. Uuve Snidare. Prisma, 2000.
Ikea "PS"-katalog. Ikea, 1995.
Konstnär i industrin. Gunilla Frick. Nordiska museet, 1986.
Kosta 250 år, en jubileumsskrift. Redaktör Margareta Artéus. Kosta Boda, 1992.
Marc Newson. Rawsthorn m fl.

Booth-Clibborn Editions, 1999.
*Meddelanden från Svenska Slöjd-
föreningen,* 1897.
Miljonprogrammet. Mats
Theselius. Mama, 1993.
Möbeldesign under 1900-talet.
Sembach m fl. Taschen, 1990.
Möbelordlista. Möbelinstitutets
rapport nr 38.
Möbelstilarna. Erik Andrén.
Nordiska museet, 1981.*Modern
arkitektur. Funktionalismens
uppgång och fall.* Christer Bodén.
ArchiLibris, 1989.
*Modernismens genombrott i
svensk arkitektur.* Eva Rudberg.
Stockholmia, 1999.
Mötesplats för form och design.
Delbetänkande SOU 1999:123.
Fritzes, 1999.
Nordiska profiler. Nationalmu-
seums utställningskatalog nr 571.
*Ø-design, en guide till form runt
sundet.* Ingrid Sommar.
Wahlström & Widstrand, 2000.
*Orrefors. Etthundra år av svensk
glaskonst.* Redaktör Kerstin Wick-
man. Byggförlaget, 1998.
Orrefors. Glasbrukets historia.
Redaktör Kerstin Wickman.
Byggförlaget, 1998.
Rörstrand. Ann Marie Herlitz-
Gezelius. Signum, 1989.
*Stockholm Modern, en guide till
stans design.* Ingrid Sommar.
Wahlström & Widstrand, 1998.
Stockholmsutställningen 1930.
*Sven Duchamps – expert på
auraproduktion.* Ivar Björkman.
Stockholms Universitet, 1999.
Svenska Möbler 1890–1990.
Redaktör Monica Boman.
Signum, 1991.
*Svenska Slöjdföreningen och
konstindustrin före 1905.* Gunilla
Frick. Nordiska museet, 1978.
Svenskt Möbellexikon. Henschen,
Blomberg. Norden, 1961.
1000 chairs. Charlotte & Peter
Fiell. Taschen, 1997.
Upplevt. Greger Paulsson. Natur
och Kultur, 1974.
*Utvärdering av Sveriges designut-
bildningar.* Rapport från expert-
gruppen, Högskoleverket, 1999.
Villa Spies. Mikael Askergren.
Eriksson & Ronnefalk, 1996.
World Design. Abendroth, Phillips
m. fl. Chronicle Books, 2000.

PERIODICALS
Arkitektur
Blueprint
Domus
Elle Decoration
Elle Interiör
Form, Design Journal
Forum
Hus & Hem
I.D. Magazine
Nest
Residence
Sköna Hem
Stockholm New
Wallpaper

WEBSITES
There are a large number of
websites with information. We
would like to recommend one
both for learning more and for
shopping:
www.scandinaviandesign.com

**3: THE BECKMAN SCHOOL OF
DESIGN** in Stockholm was found-
ed in 1939 by artist Anders Beck-
man and fashion illustrator and
textile designer Göta Trägårdh. The
school has three three-year cours-
es of study – advertising, fashion,
and design. The latter was added
in 1993 in order to satisfy the
growing need for designers of
products within the area of indus-
trial design and other utilitarian
objects. The emphasis is on devel-
oping and perfecting the student's
artistic and personal idiom in con-
tinuous dialogue with various
manufacturing businesses. The
school is scheduled to receive
undergraduate degree-granting
status.
www.beckmansschool.se

**THE CARL MALMSTEN CENTRE
FOR WOOD TECHNOLOGY &
DESIGN** was founded as
Olofsskolan in 1927 by renowned
furniture designer, pedagogue, and
writer Carl Malmsten to preserve
and develop traditional knowledge
and skills within furniture-making
– one of Sweden's oldest crafts.
Today the school has college
status and is tied to Linköping
University. The 120- credit degree
programme offers five different
specializations: furniture carpen-
try, furniture design, furniture
restoration, furniture upholstery,
and guitar making.
www.cmv.se

**THE INDUSTRIAL DESIGN LINE
AT THE TECHNICAL COLLEGE
AT LUND** was opened in 1999. It
is a five-year course of study
comprising industrial design as
well as design of products for the
home such as furniture and light-
ing. Studies include ergonomics,
materials, technology, the indus-
trial process, economics, energy,
and ecology, among other sub-
jects. In 1998 Ikea donated 250
million Swedish crowns for edu-
cational purposes as well as a
new building, the Lund Design
Centre, which will also house the
school and will be designed by the
architectural firm of Gunilla
Svensson.
www.design.lth.se

KONSTFACK, The University
College of Arts, Crafts, and Design
in Stockholm is the oldest college
of art, crafts, and design education
in Sweden. Founded by the Handi-
craft Society in 1844 it became a

national institution 100 years later.
It includes both a bachelor's and a
master's programme. Konstfack
has an extensive exchange pro-
gramme for both students and fac-
ulty consisting of some sixty
schools in twenty-one countries. It
offers ten specializations: anima-
tion, art education, colour and
design, graphic design and illus-
tration, industrial design, interior
architecture and furniture design,
ceramics and glass, metal design,
and textiles.
www.konstfack.se

**THE INSTITUTE OF DESIGN IN
UMEÅ** celebrated its tenth
anniversary in 1999. It has a three
+ two system, meaning that after
the basic education in industrial
design the students are eligible for
a two-year master's programme
within one of three areas: trans-
portation design, advanced prod-
uct design, or interaction design.
The master's programmes are
conducted entirely in English and
attract a large number of foreign
students. The school has a tradi-
tion of close cooperation with
industry.
www.dh.umea.se

**THE SCHOOL OF DESIGN AND
CRAFTS (HDK)** in Gothenburg
was founded in 1848 as the Handi-
craft Society School. Today, HDK is
an institution within Göteborg Uni-
versity. The system is the same as
in Umeå – three + two. HDK
offers a total of seven different
programmes: graphic design,
industrial design, interior architec-
ture, and product design, as well
as more crafts-related tracks such
as ceramic art, jewellery design
and silversmithing, and textile art.
The school is near the Röhsska
Museum with which it has a long
tradition of close cooperation.
www.hdk.gu.se

THE SCHOOL OF TEXTILES in
Borås is part of the university col-
lege in the same city. It traces its
origin to the Technical Weaving
School founded in 1866. Today, it
offers studies in fashion design,
textile design, and textile economy,
and training for textile engineers
and hand weavers. All pro-
grammes are for 120 credits and
most can be continued at a higher
level. The institution also conducts
research within fibre technology
and related areas.
www.hb.se

Architecture may be studied at
KTH in Stockholm, LTH in Lund, and
CTH in Gothenburg.

A&E Design, tel. +46 (0)8 673 01 59
Agata Formgivning och Konsthantverk, tel. +46 (0)8 643 09 80, www.agata.nu
Albert Samuelsson & Co, tel. +46 (0)371 368 00,
www.skeppshultcykeln.com
Andersson & Söner, Karl, tel. +46 (0)36 13 25 30, www.karl-andersson.se
Arvesund Trädesign, tel. +46 (0)8 441 41 48, www.arvesund.se
Asplund, tel. +46 (0)8 662 52 84
Ateljé Lyktan, tel. +46 (0)44 28 98 00, www.atelje-lyktan.se
B&B Italia, www.bebitalia.it, återförsäljare: Asplund
Berga Form, tel. +46 (0)491 500 50, www.berga-form.se
Bergdala Glasbruk, tel. +46 (0)478 316 50
Bernstrand & Co, tel. +46 (0)8 641 91 10, www.bernstrand.nu
Blås & Knåda, tel. +46 (0)8 642 77 67, www.blas-knada.com
Boda Nova, tel. +46 (0)42 36 11 00, www.bodanova.com
Box Design, tel. +46 (0)8 640 12 12, www.box-design.com
Bruno Mathsson International, tel. +46 (0)370 187 50,
www.bruno-mathsson-int.com
Cappellini, www.cappellini.it, agent: Nordiska Galleriet
cbi/klara, tel. +46 (0)8 611 52 52, www.klara-cbi.se
David design, tel. +46 (0)40 30 00 00, www.david.se
Designer's Eye, tel. +46 (0)44 730 95
DesignTorget, tel. +46 (0)8 462 35 20, www.designtorget.se
ErgonomiDesignGruppen, tel. +46 (0)8 26 25 25, www.ergodesign.se
Fogia, tel. +46 (0)8 556 091 00, www.fogia.se
Galleri Inger Molin, tel. +46 (0)8 528 008 30
Gemla Möbler, tel. +46 (0)476 214 00, www.gemlaab.se
Greith, tel. +46 (0)8 611 41 22, www.greith.se
Gullberg Form, +46 (0)8 544 302 30, www.gullbergform.se
Gustavsberg, +46 (0)8 570 356 63, www.hpfigustavsberg.se
Gyllang Industridesign, Olle, tel. +46 (0)643 62 29
Gårdstunet, tel. +46 (0)60 15 80 20, www.vistet.com
Gärsnäs, tel. +46 (0)414 530 00, www.garsnas.se
Hackman, tel. +46 (0)510 823 00, www.hackman.fi
Handarbetets Vänner, tel. +46 (0)8 667 10 13,
www.handarbetetsvanner.se
Hild, Eva, tel. +46 (0)33 26 16 25
Iittala, tel. +46 (0)510 823 00, www.iittala.fi
Ikea, tel. +46 (0)771 880 880, www.ikea.se
Interstop, tel. +46 (0)504 415 10, www.interstop.se
Johansfors glasbruk, tel. +46 (0)471 402 70
Kasthall Mattor och Golv, tel. +46 (0)320 20 59 00, www.kasthall.se
Kinnasand, tel. +46 (0)320 303 00
Klässbol Linneväveri, tel. +46 (0)570 46 01 85, www.klassbols-linne.se
Kockums Industri/Angra, tel. +46 (0)40 23 13 44
Konsthantverkarna, tel. +46 (0)8 611 03 70,
www.konsthantverkarna.a.se
Kosta Boda, tel. +46 (0)478 345 00, www.kostaboda.se
Kraitz, Anna, tel. +46 (0)8 462 07 79
Källemo, tel. +46 (0)370 150 00, www.kallemo.se
Lammhults Möbel, tel. +46 (0)472 26 95 00, www.lammhults.se
Laurien, Thomas/Serum designstudio, tel. +46 (0)31 81 18 33
Ljungbergs Textiltryck, tel. +46 (0)302 340 20
Luxo/Boréns, tel. +46 (0)33 29 70 00, www.luxo.se
Marbodal, tel. +46 (0)502 170 00, www.marbodal.se
Miljö Expo, tel. +46 (0)495 494 00, www.miljoexpo.se
Nixholm Design, Pia, tel. +46 (0)70 521 16 73
NK, tel. +46 (0)8 762 80 00, +46 (0)31 710 10 00, www.nk.se
Nordiska Galleriet, tel. +46 (0)8 442 83 60,
www.nordiskagalleriet.se
Norell Möbel, tel. +46 (0)380 404 80, www.norellmobel.se
Norrgavel, tel. +46 (0)46 15 05 55, www.norrgavel.se
Offecct Interiör, tel. +46 (0)504 125 20, www.offecct.se
Orrefors, tel. +46 (0)481 340 00, www.orrefors.se
Örsjö Industri, +46 (0)481 202 10
Reijmyre glasbruk, tel. +46 (0)11 871 85
Room, tel. +46 (0)8 692 50 00, www.room.se
Rörstrand, tel. +46 (0)510 823 00, www.rorstrand.se
Saldo, tel. +46 (0)44 12 61 81, www.saldo.com
Simplicitas, tel. +46 (0)8 661 00 91, www.simplicitas.se
Skandiform, tel. +46 (0)44 855 50, www.skandiform.se
Skruf glasbruk, tel. +46 (0)478 201 33
Snickar-Per, tel. +46 (0)370 411 80, www.snickar-per.se
Snowcrash, tel. +46 (0)8 442 98 10, www.snowcrash.se
Svensk Hemslöjd, tel. +46 (0)8 23 21 15, www.svenskhemslojd.com
Svenskt Tenn, tel. +46 (0)8 670 16 00, www.svenskttenn.se
Swedese, tel. +46 (0)393 797 00, www.swedese.se
10-Gruppen, tel. +46 (0)8 643 25 04, www.tiogruppen.com

318

Dedicated to Lars Axelsson

Fashion and design are two fundamental components in the corporate profile of Nordiska Kompaniet. Supporting the publication of *Swedish Design* is therefore a way for NK to emphasize the value it places on design.

The department store has been the natural choice of the discriminating consumer ever since it was founded in 1902.

NK has played an important historical role in the triumphal march of primarily Swedish glass on both the national and the international market. This, combined with the strength of their corporate name, has made NK an important arena for displays that push the borderlines within retail business, both in Sweden and abroad.

Nordiska Kompaniet is committed to safeguarding and creating the conditions necessary to ensure the continued development and success of Swedish design.

This English translation of the original Swedish book has been made possible by contributions from:

Offecct, Thomas Eriksson Arkitekter, Källemo, Lammhults, Rörstrand, scandinaviandesign.com, Skandiform, Swedese, and Norrgavel.

Printing, reproduction, and binding: Fälth & Hässler, Värnamo, 2002. Paper: Gothic Art, 150 grams, matte laminate (dust jacket) Lessebo Linné natural, 150 grams (insert). Typeface: Trade Gothic, Trade Gothic Bold (Jackson Burke 1954), Bell Gothic Bold (Chauncey H. Griffith, 1938), and Bell Centennial Address (Matthew Carter, 1978). Conceived by: Susanne Helgeson and Annica Kvint. Text: Susanne Helgeson. Art Direction/Graphic design: Kent Nyberg and Johannes Svartholm. Production: Kent Nyberg, Johannes Svartholm, Björn Larsson and Susanne Helgeson. Translation: Kjersti Board

SUSANNE HELGESON was born in Uppsala in 1964. She lived in Paris for two years before studying economics and law at Stockholm University. She worked in marketing for ten years as a project director and writer, and after six months working in advertising in Italy she started her own art and design business, again as a project director and writer. Today she works as an editor for *Form the Design Magazine* and freelances for other magazines. *Swedish Design* is her first book.

KENT NYBERG was born in Borås in 1958. He was a student at the Beckman School of Design from 1979 to 1982. In 1984 he started Style for Every Mood together with Johan Vipper and their innovative graphic design for record covers earned him a Grammis Award in 1996. Today he runs his own graphic design and marketing business, specializing in corporate profiles and books. He has won several prizes for his book designs *Rosendals trädgårdskafé* (The Garden Café at Rosendal), *Melker's Mat* (Melker's Food), and the boxed set *Monica Zetterlund – Ett lingonris som satts i cocktailglas* (Monica Zetterlund – A Lingonberry Twig in a Cocktail glass.)

Swedish Design soundtrack:
St Germain *Tourist*, De La Soul *Art Official Intelligence: Mosaic Thump*, *Real Ibiza 1–3*, Nithin Sawhney *Beyond Skin*, Mats Nileskär *Soul (P3)*, *The Look Of Love* The Burt Bacharach Collection, Mr. Vegas *Heads High*, EPMD *Back In Business*, Café Del Mar *Volumen Seis & Siete*, ESG *A South Bronx Story*, Maxwell's *Urban Hang Suite*, Capleton *More Fire*, Miles Davis *Kind of Blue*, Daniel "Papa Dee" Wahlgren *P3 Rytm*, olika HedKandi-samlingar; *Winter Chill*, *Beach House*, *Serve Chilled 1&2*.

ACKNOWLEDGMENTS

For valuable advice, texts, and/or fact checking: Michael Ernstell, Peter Hallén, Peje Hasselquist, Cathrine von Hausswolff, Tom Hedqvist, Katarina Hedrén, Sara Ilstedt Hjelm, Ulla Kandell, Ulrika Knutson, Annica Kvint, Lotta Lewenhaupt, Sven Lundh, Ingrid Sommar, Fredrik Swärd, and Stefan Ytterborn.

For much work for scant remuneration to: illustrator Jonas Banker and the photographers – Pål Allan, Carl Bengtsson, Pelle Bergström, JH Engström, Oskar Falk, Andrea von Gegerfeldt, Berno Hjälmrud, Jonas Isfält, Gerry Johansson, Tobias Nilsson, Mikael Olsson, Kristian Pohl, Gösta Reiland, Ewa-Marie Rundquist, and Erik Undéhn.

A special thanks to Åke E:son Lindman for the loan of many pictures of interiors and architecture.

We are equally indebted to those who have so generously shared both pictures and information: A&E Design, Artek, Arvesund Trädesign, Ateljé Lyktan, Bahco, Staffan Berglund Arkitektkontor, Bernadotte Design, Blås & Knåda, Boda Nova, Bukowskis, Ergonomi Design Gruppen, Eriksson & Ronnefalk Publishers, Stefan Frank-Jensen, Stefano Giovannoni, Gustavsberg Museum of Porcelain, Hackman Rörstrand, Hasselblad, Johan Huldt, Ikea, Georg Jensen Museum, Sture Johansson, Stig T. Karlsson, Kasthall, the Klara staff, Konsthantverkarna, Anders Kornestedt, Kosta Boda, Björn Kusoffsky, Källemo, Lammhult, Carl Malmsten School, Marimekko, Bruno Mathsson International, Jasper Morrison, Fredrik Nilsson/Furniture, Stig-Göran Nilsson, Orrefors (special thanks to Per Larsson and Karin Lindahl), Roland Persson, Sigurd Persson, Reijmyre Glassworks, Royal Scandinavia, Röhss Museum, Rörstrand, Saab, SAR, Silver & Stål, SIS, Skruf Glassworks, Sottsass Associati, Stockholm Design Lab, Stockholm New, Stockholmia Publishers, Svenskt Tenn, Group of Ten, and *Wallpaper*.

Finally, our very special thanks to the Swedish Society for Crafts and Design for allowing us the use of their archival material at a greatly reduced rental fee. Without their generosity, the chapter on the history of Swedish design would not have been nearly as lavishly illustrated.

PICTURE CREDITS

Cover: Carl Bengtsson. Flycovers: Andreas von Gegerfelt, Tobias Nilsson, Jonas Isfält, Carl Bengtsson. P. 1, Andreas von Gegerfelt, Ewa-Marie Rundquist; p. 2, Erik Undéhn; p. 3, Gösta Reiland; p. 4, Tobias Nilsson; p. 5–7, Jonas Isfält; p. 8, Carl Bengtsson; p. 9, Pål Allan; p. 10, Gösta Reiland; p. 11, Mikael Olsson; p. 16, Jonas Banker/Agent Form; p. 22, Föreningen Svensk Form, Nationalmuseum, Bahco, IMS; p. 23, Föreningen Svensk Form, Nationalmuseum, Carl Larsson-gården Sundborn, Röhsska museet, Åke E:son Lindman, Orrefors; p. 24, Föreningen Svensk Form, Nationalmuseum, Bukowskis arkiv, Åke E:son Lindman; p. 25, Föreningen Svensk Form, SIS, Orrefors, Åke E:son Lindman, Hackman Rörstrand, Artek, IMS, Arkitekturmuseet; p. 26, Föreningen Svensk Form, Bertil Norberg–Föreningen Svensk Form, Erik Undéhn, Åke E:son Lindman, Orrefors; p. 27, Orrefors, Gustavsbergs porslinsmuseum, Svenskt Tenn, Saab, Bruno Mathsson International, Gustavsbergs porslinsmuseum, Hasselblad, Georg Jensen Museum; p. 28, Gustavsbergs porslinsmuseum, Föreningen Svensk Form, Pehr Hasselrot/Sten Vilson/Pål-Nils Nilsson–Föreningen Svensk Form, Orrefors; p. 29, Orrefors, Ikea, Föreningen Svensk Form, Atelje-Olsson/Hans Hammarskiöld/Ola Terje/Håkan Alexandersson–Föreningen Svensk Form, Kasthall arkiv, Bruno Mathsson International, Bernadotte Design; p. 30, Carl Johan Rönn/Björn Lindberg–Föreningen Svensk Form, Föreningen Svensk Form, Sture Johanneson, Orrefors, Staffan Berglund, 10-Gruppen; p. 31, Johan Huldt, Lars Larsson/Torbjörn Zadig–Föreningen Svensk Form, Föreningen Svensk Form, Erik Undéhn, ErgonomiDesignGruppen, KF, Vin&Sprit, Sottsass Associati, Åke E:son Lindman, Källemo; p. 32, 10-gruppen, Silver & Stål, Föreningen Svensk Form, BodaNova, Åke E:son Lindman, Thomas Eriksson Arkitektkontor, Erik Undéhn, Fredrik Swärd, Asplund, Arvesund Trädesign, Björn Kusoffsky, Föreningen Svensk Form; p. 33, Lammhult, Asplund, Pia Wallén, Björn Kusoffsky, Källemo, Ytterborn & Fuentes, Camilla Wessman, Åke E:son Lindman, Patrik Engquist, Ikea; p. 34, Åke E:son Lindman, Stockholm New, Skruf, Björn Keller, Stefan Frank-Jensen, Stockholm Design Lab; p. 35, Åke E:son Lindman, Box Design, Wallpaper, Ytterborn & Fuentes, Bas Retail, Stockholm Design Lab; p. 36–37, Gerry Johansson; p. 38, Jonas Banker/Agent Form; p. 42–43, 45–47, Berno Hjälmrud; p. 44, Föreningen Svensk Form, Nationalmuseum; p. 47, Föreningen Svensk Form, Royal Copenhagen; p. 48–49, Asplund; p. 50, Tobias Nilsson; p. 51, Marc Newson, Alessi; p. 52–55, Pelle Bergström; p. 56–67, Ewa-Marie Rundquist; p. 62, Orrefors; p. 68–79, Carl Bengtsson; p. 77, Hackman Rörstrand, Jonas Bohlin; p. 80–87, Andreas von Gegerfelt; p. 87, Box Design; p. 88–95, Tobias Nilsson; p. 91, cbi; p. 96–103, Berno Hjälmrud; p. 103, David design, Boffi; p. 104–105, Gerry Johansson; p. 106–115, Andreas von Gegerfelt; p. 109, Björn Dahlström Design; p. 113, Björn Dahlström Design; p. 116–123, Mikael Olsson; p. 121, David design, Per Söderberg; p. 124–125, 127, Gösta Reiland; p. 128, Jonas Banker/Agent Form; p. 131, Duni; p. 132, 134, 137, 138–139, Ewa-Marie Rundquist; p. 133, 136, Stockholm Design Lab; p. 137, Ikea, Thomas Eriksson, Åke E:son Lindman; p. 139, Thomas Eriksson; p. 140, 142–143, Kristian Pohl; p. 144–145, Pål Allan; p. 145, Snowcrash; p. 146–147, Gerry Johansson; p. 148, Åke E:son Lindman; p. 149–151, Ulla Kandell, Stig T. Karlsson; 151, Stig-Göran Nilsson; p. 152–158, Jonas Isfält; p. 156, Kasthall, Kinnasand; p. 157, 159, Gunilla Lagerhem Ullberg; p. 160, Ewa Lilja Löwenhielm; p. 161, Ikea, Åke E:son Lindman; p. 162–169, Tobias Nilsson; p. 168, Johannes Svartholm; p. 172–174, 176–177, 179, Mikael Olsson; p. 178, 179, Jonas Lindvall; p. 179, Åke E:son Lindman; p. 180–182, Pål Allan; p. 183, Åke E:son Lindman; p. 184–191, Tobias Nilsson; p. 192–197, Jonas Isfält; p. 194, Orrefors; p. 195, Orrefors; p. 197, Venini; p. 198–201, 204–205, JH Engström; p. 201, Orrefors; p. 202–203, Roland Persson; p. 206–215, Ewa-Marie Rundquist; p. 213, Kosta Boda; p. 215, Marimekko; p. 216–218, 220, 223, Berno Hjälmrud; p. 220, SandellSandberg, B&B Italia, View/Dennis Gilbert; p. 221, Källemo, Kasthall, Åke E:son Lindman; p. 222, SandellSandberg; p. 224–226, 228–231, Pål Allan; p. 227, Kosta Boda; p. 231, Reijmyre arkiv; p. 232–243, Gösta Reiland; p. 243, Roland Persson, Orrefors; p. 244–245, Gerry Johansson; p. 246–250, 252–255, Mikael Olsson; p. 252, Källemo; p. 256–267, Andreas von Gegerfelt; p. 268–274, 276–279, Tobias Nilsson; p. 275, Pasi Välimaa; p. 280–289, JH Engström; p. 288, Pia Wallén Design; p. 290–299, Carl Bengtsson; p. 292, Kosta Boda; p. 297, Pilchuck Glass School; p. 300–301, Berno Hjälmrud; p. 303, Åke E:son Lindman; p. 304–305, Oskar Falk/Mikael Olsson; p. 306, Jonas Banker/Agent Form; p. 309–312, Erik Undéhn; p. 310, Mischa Pedan, Karl Andersson & Söner, Mathias Pettersson, Peraxel Persson, Saldo; p. 311, Orrefors, Eva Hild; p. 312, Bianca Pilet, Simplicitas, Agata, Norell; p. 313, Kent Nyberg.
Gerry Johanssons interiors on pages 36–37, 104–105, 146–147, 244–245 has been photographed at Källemo, Kinnasand, Kosta Boda and Lammhults.

PÅL ALLAN:

SANNA
HANSSON
MATTIAS
LJUNGGREN
CARINA SETH
ANDERSSON

 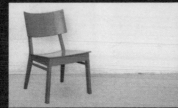

CARL
BENGTSSON:

JONAS
BOHLIN
ANN
WÅHLSTRÖM

PELLE
BERGSTRÖM:

ASPLUND

JH ENGSTRÖM:

INGEGERD
RÅMAN
PIA
WALLÉN

ANDREAS VON
GEGERFELT:

BOX DESIGN
BJÖRN
DAHLSTRÖM
PIA
TÖRNELL

BERNO
HJÄLMRUD:

GUNILLA ALLARD
CLAESSON
KOIVISTO RUNE
THOMAS SANDELL
STEFAN
YTTERBORN

JONAS ISFÄLT:

GUNILLA
LAGERHEM
ULLBERG
MARTTI
RYTKÖNEN